ROUTE 66

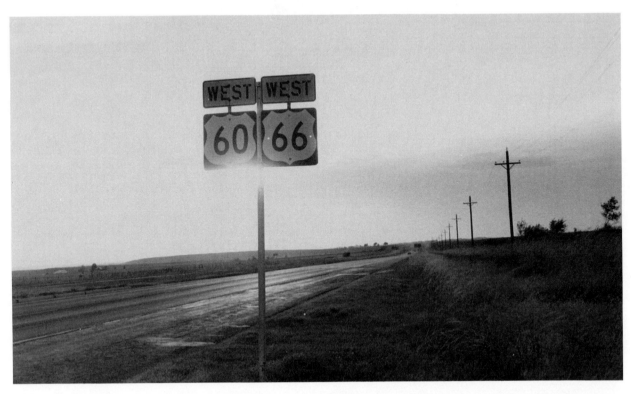

Chelsea, Oklahoma

"When we traveled, as long as I stayed on highway 66, I knew I could get back home."—ETHEL CARPENTER, AMARILLO, TEXAS.

ROUTE 66
THE HIGHWAY AND ITS PEOPLE

PHOTOGRAPHIC ESSAY BY QUINTA SCOTT
TEXT BY SUSAN CROCE KELLY

UNIVERSITY OF OKLAHOMA PRESS : NORMAN AND LONDON

BY QUINTA SCOTT

(With Howard S. Miller) *The Eads Bridge* (Columbia, Mo., 1979)
(With M. M. Costantin) *Sidestreets* (Saint Louis, 1981)
(With Susan Croce Kelly) *Route 66: The Highway and Its People* (Norman, 1988)
(With Elaine Viets) *Images of Saint Louis* (Columbia, Mo., 1989)

Library of Congress Cataloging-in-Publication Data

Scott, Quinta, 1941–
 Route 66: the highway and its people.

 Bibliography: p. 195.
 Includes index.
 1. United States Highway 66—History.
2. United States—Social life and customs—20th
century. 3. United States—Description and
travel—Views. I. Kelly, Susan Croce, 1947–
II. Title. III. Title: Route sixty-six.
HE356.U55S25 1988 388.1'0973 88–40208
ISBN 0–8061–2133–5 (cloth)
ISBN 0–8061–2291–9 (pbk.)

The paper in this book meets the guidelines for permanence and durability of the Committee on Production Guidelines for Book Longevity of the Council on Library Resources, Inc. ⊗

To Brendan Kelly, who believes it's OK for moms to follow old highways and have adventures of their own.

To Barrie, whose support with a clear head and patient heart makes all things possible, and to Kalon, whose spirit of adventure has grown with this project.

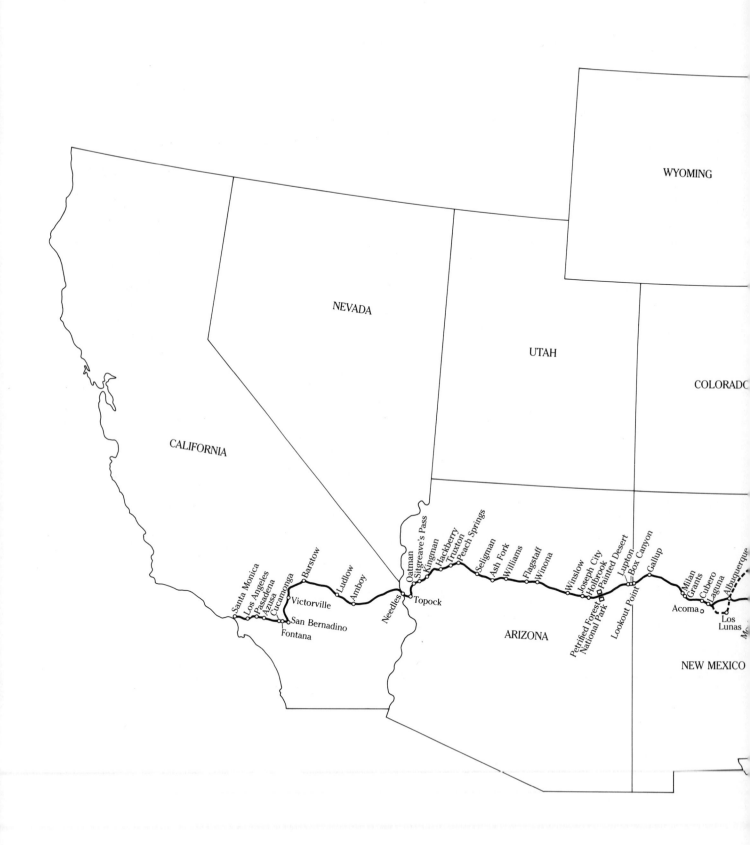

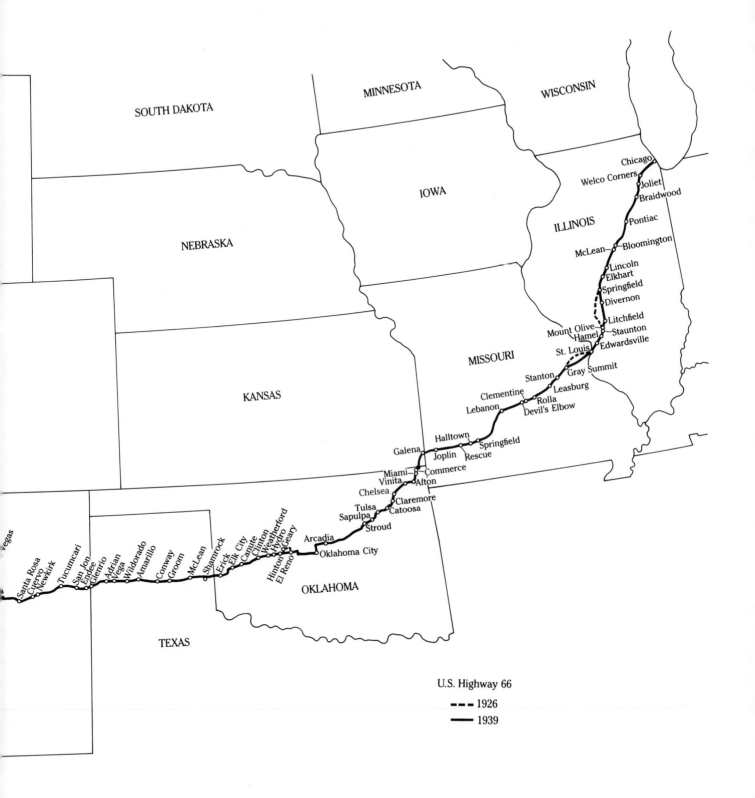

SOUTH DAKOTA

MINNESOTA

WISCONSIN

IOWA

NEBRASKA

ILLINOIS

Chicago
Welco Corners
Joliet
Braidwood
Pontiac
McLean — Bloomington
Lincoln
Elkhart
Springfield
Divernon
Litchfield
Mount Olive — Staunton
Hamel
St. Louis — Edwardsville

MISSOURI

Stanton — Gray Summit
Leasburg
Clementine — Rolla
Lebanon — Devil's Elbow

KANSAS

Halltown
Springfield
Galena — Joplin
Rescue
Miami — Commerce
Vinita — Afton
Chelsea
Claremore
Tulsa — Catoosa
Sapulpa
Stroud
Arcadia
Oklahoma City

Vegas
Santa Rosa
Cuervo
Newkirk
Tucumcari
San Jon
Endee
Glenrio
Adrian
Vega
Wildorado
Amarillo
Conway
Groom
McLean
Shamrock
Erick
Elk City
Canute
Clinton
Weatherford
Hydro
Hinton
El Reno Geary

OKLAHOMA

TEXAS

U.S. Highway 66

- - - 1926
——— 1939

CONTENTS

Chapter 1. BIRTH *Page* 3

2. PAVING 18

3. BUSINESS AND BALLYHOO 32

4. DUST BOWL 57

5. WARTIME 75

PHOTOGRAPHIC ESSAY 83

6. BOOMTIME 148

7. HIGHWAY HYPE 162

8. INTERSTATE 178

NOTES 191

SELECTED BIBLIOGRAPHY 195

ACKNOWLEDGMENTS 203

INDEX 205

TEXT ILLUSTRATIONS

Cyrus Avery *Page* 5
Ozark Trail meeting, Tulsa, Oklahoma 8
Split-log drag 11
Map of the Federal Highway System 16
Replica of "Illinois, U.S. 66" sign 19
Plank road 21
Bunion Derby, Tulsa, Oklahoma 35
Rossi Dance Hall, Braidwood, Illinois 39
Camp Joy, Lebanon, Missouri 42
Postcard of the Gallup Ceremonial 49
Tobe Turpen's Trading Post,
Gallup, New Mexico 51
Sign painter Jack Fuss, Flagstaff, Arizona 53
Family on the road. On U.S. 66, near
Weatherford, in western Oklahoma 58
Roadside camp of migrant workers,
Lincoln County, Oklahoma 60
Leon Little's service station,
Hinton, Oklahoma 63
U-Drop Inn, Shamrock, Texas 66

Café and service station,
Clines Corners, New Mexico 69
La Villa De Cubero, Cubero, New Mexico 70
Camp Joy, Lebanon, Missouri 151
Munger Moss Motel, Lebanon, Missouri 152
Leon Little's café, service station, and
motel, Hinton, Oklahoma 157
Holbrook Bus Station, Holbrook, Arizona 158
Meramec Caverns sign, Stroud, Oklahoma 166
Will Rogers caravan 169
66 Terminal, Staunton, Illinois 170
For Men Only sign, Winslow, Arizona 172
Christensen's Cliff Dwellings Trading Post,
Lookout Point, New Mexico 174
Atkinson Trading Post,
Box Canyon, Arizona 176
"Drive U.S. 66, The Will Rogers Highway"
brochure 180
Last brochure published by the
U.S. Highway 66 Association 185

PHOTOGRAPHIC ESSAY ILLUSTRATIONS

Chelsea, Oklahoma — *Frontispiece*

Welco Corners, Illinois — *Page* 85

Michael Burns, Springfield, Illinois — 86

Elkhart, Illinois — 87

Lucenta Tire, Braidwood, Illinois — 88

Steak 'n Shake, Bloomington, Illinois — 89

Fenton Craner, Elkhart, Illinois — 90

Art's Motel, Divernon, Illinois — 91

Russell and Ola Soulsby, Mount Olive, Illinois — 92

66 Terminal, Staunton, Illinois — 93

Site Service Station, Edwardsville, Illinois — 94

"66" Park-In Theatre, Saint Louis, Missouri — 95

Coral Court Motel, Saint Louis, Missouri — 96

Gardenway Motel, Gray Summit, Missouri — 97

John's Modern Cabins, Clementine, Missouri — 98

Amy Thompson, Clementine, Missouri — 99

Hooker Cutoff, Devil's Elbow, Missouri — 100

Jessie Hudson and Ramona Lehman, Lebanon, Missouri — 101

Sheldon ("Red") Chaney, Springfield, Missouri — 102

Las Vegas Hotel and Barber Shop, Halltown, Missouri — 103

Modern Cabins, Rescue, Missouri — 104

The Reverend William Pennock, Galena, Kansas — 105

Picher, Oklahoma — 106

Norma Cullison, Claremore, Oklahoma — 107

Park Plaza Courts, Tulsa, Oklahoma — 108

Leon Little's service station and motel, Hinton, Oklahoma — 109

Lucille Hamons, Hydro, Oklahoma — 110

Reptile Village sign, Erick, Oklahoma — 111

Star Motel, Elk City, Oklahoma — 112

Tower station, U-Drop Inn, Shamrock, Texas — 113

Truck Center, Groom, Texas — 114

Ruby Denton, Groom, Texas — 115

Conway, Texas — 116

Sundown Motel, Amarillo, Texas — 117

Last Motel in Texas/First Motel in Texas, East Glenrio, Texas — 118

Homer Ehresman, East Glenrio, Texas — 119

Coronado Court, Tucumcari, New Mexico — 120

Spanish cemetery, Newkirk, New Mexico — 121

Café, Cuervo, New Mexico — 122

Save 5 Cents, Santa Rosa, New Mexico — 123

Floyd Shaw, Santa Rosa, New Mexico — 124

Sign, Club Café, Santa Rosa, New Mexico 125
Hi-way Host Motel,
Albuquerque, New Mexico 126
Uranium Café, Grants, New Mexico 127
LeRoy Atkinson, Box Canyon, Arizona 128
Trading Post and Motel, Lupton, Arizona 129
Allen Hensley and Dennis Hensley,
Holbrook, Arizona 130
Wigwam Village, Holbrook, Arizona 131
Richard Mester, Holbrook, Arizona 132
Here It Is, Jackrabbit Trading Post,
Joseph City, Arizona 133
Store for Men, Winslow, Arizona 134
Joseph Joe's Big Indian Trading Post,
Winslow, Arizona 135

Garage, Peach Springs, Arizona 136
Beatrice Boyd, Peach Springs, Arizona 137
Ed's Camp, Sitgreave's Pass, Arizona 138
Café, Needles, California 139
H. B. ("Buster") Burris, Amboy, California 140
Roy's Café and Motel, Amboy, California 141
Ludlow Crossing, Ludlow, California 142
El Rancho Motel, Barstow, California 143
Duane Meyer, Cucamonga, California 144
McDonald's Hamburger, Azusa, California 145
Santa Monica Pier,
Santa Monica, California 146

ROUTE 66

ROUTE 66

If you ever plan to motor west;
travel my way, take the highway that's the best.
Get your kicks on Route Sixty-Six!

It winds from Chicago to L.A.,
more than two thousand miles all the way.
Get your kicks on Route Sixty-Six!

Now you go thru Saint Looey Joplin, Missouri
and Oklahoma City is mighty pretty.
You'll see Amarillo, Gallup, New Mexico;
Flagstaff, Arizona; don't forget Winona,
Kingman, Barstow, San Bernardino.

Won't you get hip to this timely tip:
When you make that California trip.
Get your kicks on Route Sixty-Six!
Get your kicks on Route Sixty-Six!

CHAPTER 1 : **BIRTH**

THE MIRACLE was not the automobile. The miracle of the early twentieth century was the construction of a vast network of highways that gave automobiles someplace to go. With the routing and paving of those highways, Americans in one part of the country could see what people were doing in others: what they ate, wore, lived in, and looked like. After the highways came, remote places were no longer so remote: cities became readily accessible to small towns, and people on one side of the country could stay in touch with relatives on the other.

The development of a comprehensive network of U.S. highways took more than a century to happen. Americans had begun calling for good roads about 1800 but lost interest in highways temporarily when railroads enabled people to travel relatively quickly and cheaply across the country. The call for better roads picked up again shortly after the Civil War, when bicycles became a popular means of transportation. Automobiles, introduced in America around the turn of the century, generated a new ground swell of enthusiasm for good roads, and as the movement gained strength, highway improvement became a popular cause in all parts of the country. At first, highway building was a local venture and roads were marked and maintained by booster groups supported through individual donations. Those roads, bearing descriptive lo-

cal names like the Ozark Trail or Old Wire Road, were graded and marked from town to town wherever support was greatest, with little thought given to regional or national coherence. It was 1925 by the time the country adopted a plan for a national highway system, and it was almost 1940 before those highways were paved from coast to coast.

U.S. Highway 66 was a product of the grass-roots movement for better roads and was one of the main arteries of the 1926 National Highway System.[1] It was the "great diagonal highway"[2] that sliced through the Middle West, rolled across the Great Plains, straddled the deserts of the Southwest, and stopped at the very edge of the Pacific Ocean. Route 66 was also something else: it was a real highway that grew to be a symbol for the American people's heritage of travel and their national legacy of bettering themselves by moving west.

Unlike other national highways Route 66 did not follow a single trade route established by generations of travel. It traversed sections of several old trails at its eastern and western ends, but it cut out on its own through the young state of Oklahoma and covered a lot of empty space before it finally reached California.

Route 66 began in Chicago, under the trees in Grant Park, on the shore of Lake Michigan. It moved grandly south through the city, into Al

Capone's town of Cicero, and out onto the rich prairie land of northern Illinois. It went through the coal-mining town where John Mitchell organized the United Mine Workers and the state capitol where Abraham Lincoln practiced law. Then it moved south across the Mississippi River into Saint Louis and followed the ridges into the Missouri Ozarks. It passed caves, small towns, dairy farms, and lead mines and moved into the Old West of the cattle drives, taking off a corner of Kansas on the way. In Oklahoma, the highway connected Vinita to Tulsa and Oklahoma City and then ran flat and straight across a land where the few trees grew leaning toward the north, blown that way by the state's prevailing southern wind.

From Oklahoma, U.S. 66 carried cars and trucks across the dusty Texas Panhandle, through Shamrock and Amarillo to the barren plains of eastern New Mexico, where white settlers had not arrived until almost the turn of the century. The highway then climbed up and across the Sandia Mountains and dropped down into the enchanted world of mesas, buttes, and a pueblo people who regarded Coronado and de Soto as recent visitors. On the high deserts of Arizona the road climbed past a few lonesome towns—named for the railroad men who had been there first—on its way to Flagstaff, a piney village in the San Francisco Mountains. From Flagstaff, the road descended through more Indian lands, down through Kingman, and then up again over the Black Mountains to Needles and the low-lying Mojave Desert. It snaked westward across the desert, following the railroad section stops Essex, Cadiz, and Amboy to Barstow and then south to Victorville. From Victorville, the highway wound upward to the Cajon Pass and then down to San Bernardino. It continued west through Fontana, Cucamonga, Pasadena, and Los Angeles to Santa Monica and a small green park overlooking the ocean where a brass plaque dedicated Route 66 as the Will Rogers Highway.

The highway undoubtedly traversed some of the most romantic and remote country in the United States. That fact alone, however, was not enough to locate the road in the American imagination. More important was the way Route 66 came to be part of the uprootings and major changes in American life that took place during the first half of the twentieth century. The Roaring Twenties, the Great Depression, the war years of the 1940s, and the normalcy of the 1950s all manifested themselves in various forms on Route 66 and left their imprint. Over those years there were also a few farsighted individuals who understood the impact of Route 66 on the American experience. The first of those men was Cyrus Stevens Avery, who knew the desperate need of rural America for good roads and envisioned the potential effect of a major highway through the Southwest. A prominent citizen of Tulsa, Avery became a leader in the effort to develop the national highway system. From that vantage he became godfather to U.S. Highway 66: he was influential in designating the route, getting the road paved, and organizing a booster organization for it.

During the 1920s, when travel by automobile was as much an adventure for many Americans as flagpole sitting or a solo cross-Atlantic flight, Route 66 had a promoter. The megaphone man was C. C. Pyle, a pioneer publicist and sports impresario, who staged a coast-to-coast footrace that followed Highway 66 from Los Angeles to Chicago, on the way to New York City. For the better part of a year, that race was reported and ballyhooed in newspapers, radio broadcasts, and movie theater newsreels around the world.

A decade later, when Route 66 was the main road taken by destitute farmers and shopowners in their flight from the rain-starved Middle West, a Californian named John Steinbeck chronicled that migration in a novel that became an American classic, *The Grapes of Wrath.*

Kicks on Route 66," became a musical map for the next generation of highway travelers.

And the magic continued. Even though Route 66 had begun to crumble under the weight of the wartime traffic and was too narrow for the post-war car designs, it was still the main road West in the 1950s and 1960s, when American workers found themselves blessed with the newly acquired right of paid vacations. The Grand Canyon, the Petrified Forest, and other national parks of the Southwest; the Indians; Las Vegas; Hollywood; and, later, Disneyland were all stops on Route 66, and all attracted millions of vacationers down the highway. During those same years television was beginning to mesmerize America, and Sterling Siliphant turned the idea of travel on Route 66 into a highly popular TV series featuring two young men in a Corvette.

From the beginning the presence of the highway—and those who traveled it—was immensely important to the towns and people it linked together. Into the rural Middle West and sparsely populated Southwest, Route 66 brought travelers and automobiles and a kind of prosperity that the land never could have provided. And in return for that, the people paid attention to the road. They worked to get it paved, they publicized it to the rest of the country, they fought for its continued existence, and, when the time came, they lamented its demise.

To understand how Route 66 came to be, its role in the American experience, and why people in the Southwest cared so much about that highway, it is important to understand the genesis of the national highway system and what a difference roads and road improvements could mean to the region.

The early good-roads movement, which had been quelled by the construction of railroads across the country and the advent of the Civil War, reemerged in the 1880s. A new invention, the bicycle, was driving the demands for better

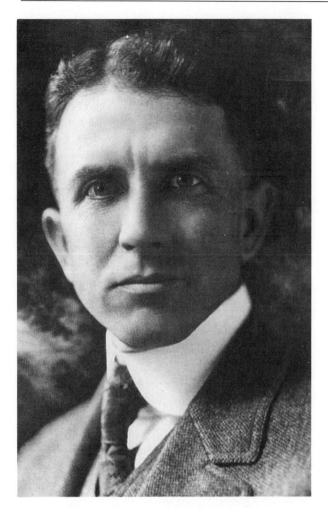

Cyrus Avery, 1927: Avery's public life in the teens and twenties was dedicated to highways. In his business life, he had a real estate business, a tourist court, a car agency, and an oil business. SOURCE: Ruth Sigler Avery, Tulsa, Oklahoma.

Still later, after a war had caused millions more men and women to travel Route 66 (in uniform or en route to jobs in West Coast armaments factories), a young songwriter composed a short piece about his postwar return trip down U.S. 66. Bobby Troup's jazz classic, "Get Your

roads in those years.[3] The League of American Wheelmen was organized to encourage development of good roads and bicycle side paths and, in fact, had gotten a few states to designate funds for highway building.

It was the appearance of automobiles and the beginnings of related industries, however, that finally brought better roads. The first automobiles were built in the United States in 1893. In 1901 it took six days for an adventurer to drive from Kokomo, Indiana, to New York City (a distance of about 700 miles). The first transcontinental automobile trip occurred in 1903. In both instances the best roads the drivers encountered were gravel. Much of the time the roads were muddy tracks, and often the route was unmarked, but the events were highly publicized, and the interest in road building increased. Between 1905 and 1913 an affluent Bostonian and early aficionado of automobile travel, Charles J. Glidden, joined forces with the American Automobile Association to promote the concept of automobile touring and, incidentally, the need for better roads as well as for better automobiles.[4]

Suddenly roads were important to a whole lot of people. Encouraged by new car owners and the fledgling automobile industry, men began to look for better ways to surface roads than the traditional wooden planks, bricks, gravel, or graded dirt. Asphalt and cement were developed as road-surfacing materials around the turn of the century, but it was not until 1909—the year after the introduction of Henry Ford's Model T—that Portland cement concrete (as it was referred to by the road builders) was used to pave a public road. That spring concrete was spread along one mile of Woodward Avenue, which led from Detroit to Wayne County's State Fair Grounds, in Michigan.[5] After that, land-grant colleges began to teach highway construction, and universities like Purdue and the Massachusetts Institute of Technology sponsored "road schools" for public officials who wanted to learn the latest paving methods.

During that same era big business saw in the highway movement an opportunity to increase its markets. Carl Graham Fisher, whose company was the leading supplier of acetylene for automobile headlights, was a flamboyant example of this movement. Fisher, founder of the Indianapolis Motor Speedway and the 500-mile race, was a crusader for coast-to-coast paved roads. In 1912 he persuaded leaders of other highway-related businesses to contribute four million dollars to build the Lincoln Highway as the first all-weather, paved, no-toll route across the northern half of the United States. In 1913, Fisher led a caravan meandering across the country's dirt and gravel roadways to publicize his project. Everywhere he stopped, people were tremendously enthusiastic—and they all wanted him to set the route of the Lincoln Highway through their towns. Later, when the routing issue was resolved—leaving more towns off the Lincoln Highway than on—a problem arose: Fisher's highway fund provided enough money to lay a few miles of pavement for demonstration but not enough to pave the whole road. This showed that road building was more costly than private citizens could afford. (Eventually, the federal government had to get involved, and, in 1923, the U.S. Bureau of Public Roads took on the task of finishing and refurbishing the route.)[6] Despite this shortcoming the Lincoln Highway movement demonstrated the public's support for national highways.

Organizations such as the American Automobile Association, the National Grange, the National Association of Rural Letter Carriers, and the Travelers Protective Association of America became the focal points for a new good-roads movement aimed at improving highway conditions. This national movement was supported by

hundreds of local good-roads groups, all intent on raising funds to pave the roads to and through their own communities. One of the earliest of the good-roads programs was led by W. H. ("Coin") Harvey, of Monte Ne, Arkansas. As early as 1910, Colonel Harvey envisioned a network of highways throughout the Southwest. In 1915 enthusiasts for Harvey's plan met in Monte Ne to form the Ozark Trails Association. A later newspaper report related that two routes were proposed for the Ozark Trail and that in the towns that wished to be on the route "hundreds of people fell in line and worked like fury for the Ozark Trail. This resulted in the overnight improvement of long stretches of highway."[7] Support was so strong that thousands of people gathered annually for a half-dozen or more years on behalf of this particular cause. One of them was Cy Avery. In fact, Avery was so interested in the Ozark Trails Association that he managed to bring the annual gathering to Tulsa in 1919 and to get himself elected vice-president of the organization at that time.

Similar trail organizations grew up all over the country, setting routes and marking them. In the mid-1920s the Bureau of Public Roads estimated that there were about 250 marked trails in the United States, sponsored by organizations that issued maps, advertising, or other promotional material. Because there was little or no correlation among the trail associations or their "trails," travelers often faced overlapping maps and several sets of markers along the same stretch of road. Sometimes the markers were symbols, such as the Indian head that marked the Pontiac Trail, in Illinois, but more often they were a series of colored stripes on the nearest fence post. Worse, it was possible that a traveler could find the same identifying colors on two different roads. By 1925 the public was confused and disgusted with this system of marking roads. The costs were often considerable, and trail associations counted on contributions from people along the routes to pay for the road markings and other publicity. Nonetheless, the good-roads movement was important as part of the foundation that became the federal highway system.

During this era the federal government slowly assessed its position and formulated a role for itself in highway construction. Almost a century before, the issue of the Maysville Road, in Kentucky, had caused the federal government to withdraw from what was then seen as the business of the states. Now, with the tremendous cost of road building and the demand for road improvements beyond the capability of a man and a mule, the situation had obviously changed.

In the 1890s the secretary of agriculture opened an Office of Public Road Inquiry to study the situation and answer the growing demands for better roads in the United States. Within a few years the name was changed to the Bureau of Public Roads, still under the auspices of the Agriculture Department. Public oratory after the turn of the century focused on the need for road building to bring farmers closer to their city markets, to enable farm children to receive better educations, and to bring mail directly to rural doorsteps. Despite the rhetoric, however, there was little misunderstanding about what was really at stake. Farmers and the Populist movement supported road improvements largely because that would break the monopolistic control of the railroads over the farmers. That was a real, if lesser, issue. The greater issue was that Americans were having a good time driving their own automobiles, and they wanted better roads on which to drive.

Coincidentally, a 1915 Joint Congressional Committee reported that the continuation of financial road building aid from the federal government to the states was, after all, constitutional.[8] In 1916, President Woodrow Wilson signed a bill

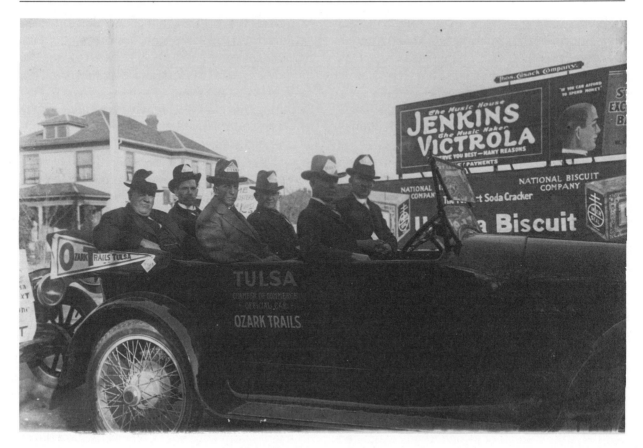

Ozark Trail meeting, Tulsa, Oklahoma, 1916: Members of the Tulsa Chamber of Commerce at an Ozark Trail meeting in Tulsa in 1916. Cyrus Avery is the second from the left in the front row. SOURCE: Ruth Sigler Avery, Tulsa, Oklahoma.

calling for a national system of highways and providing the groundwork for public financing. This law, the Federal Aid Road Act of 1916, had a number of significant provisions, including the following:

- Any rural road was eligible for federal aid if it was intended to carry the mail. (There was no mention of urban streets.)

- States must match federal road-building dollars equally.

- Appropriations were to be made on the basis of the region, the population, and the miles of post roads.

- States had to have an organized highway department to be eligible for federal aid.

- States had the right to decide primary routes.

- The federal government would inspect any completed project.

The 1916 law was followed by a 1921 federal-aid law that required the states to designate a connected system of main rural roads that would be eligible for federal monies, with the caveat that these main roads amount to not more than 7 percent of all the rural roads in the state. These two acts effectively laid the bureaucratic groundwork for the first system of federal highways.[9]

Then, as now, however, Congress and the bureaucrats had to be constantly reassured by the public. Even with the road-aid requirements laid out and the funds appropriated ($75 million in 1916 for a five-year period and a similar amount in 1921, with the requirement that states maintain any federal-aid roads), nothing much happened until 1924.

By that year road building had become a major political issue all over the country. In Louisiana, Huey Long made history and achieved near-sainthood for his ability to get bridges built and roads paved. In other rural states, such as Missouri and the newly settled state of Oklahoma (where the small communities were even more isolated and farther apart), the demand for better roads was an important social and political issue.

In Oklahoma, especially, roads were a problem. A state since only 1907, Oklahoma had not developed the network of pioneer trails, wagon roads, and railroads that crisscrossed the rest of the country. Then when the territory was finally opened for homesteading (it happened quickly—the western half of the state was populated in a matter of days in 1889, and the eastern half was populated almost as quickly after oil was discovered in 1901), the roads that did develop were haphazard, inadequate, and poorly maintained, and the people of the state knew it.

In 1912, several years before he became involved with Coin Harvey's Ozark Trail, Cy Avery badgered Governor Lee Cruce to declare a holiday "to pull Oklahoma out of the mud" (similar holidays were being held in other states) and also persuaded the *Tulsa World* to help raise twenty-five thousand dollars—and the public interest—for roads.

The holiday was a success, and from then on, road building became a primary pursuit for Avery. Much of his long life was spent building and improving and talking about highways. From his first effort to draw attention to Oklahoma road conditions in 1912, he became active in two trail associations and the national trails movement, helped pass laws to provide for county roads, was named state highway commissioner, became a power in the national association of state highway officials and, finally, was one of five men who actually designed the national highway system. He was also the driving force behind the designation and numbering of U.S. Highway 66.

A native of Pennsylvania, Avery moved to Indian Territory at the age of fourteen, after his father was bankrupted in the Panic of 1873. He grew up in the rolling country of southwest Missouri and northeast Oklahoma, helping his father farm, attending school, and teaching for three years to earn enough money to go to college. Avery worked his way through William Jewell College, in Liberty, Missouri. After he graduated, he married and returned to Oklahoma as an insurance representative, in Oklahoma City.[10] In 1904, Avery moved back to the hill country where he had grown up, taking his wife, Essie, and their son, Leighton (the first of their three children) to Vinita, Oklahoma, a small community in the midst of the oil fields. There Avery opened his own insurance company. He also began speculating in farmland and the infant oil industry, organizing the Avery Oil and Gas Company, with Henry Sinclair as his partner.

Three years later, as Oklahoma became the forty-sixth state, the Averys made their final move, this time to Tulsa, which had grown into a thriving community from what he had described earlier as a "little town without lights" that had "pigs

running loose in the streets."[11] In Tulsa, Avery started a farm-loan agency, acquired extensive landholdings, and built a reputation as the expert on northeastern Oklahoma farmland.

All of his life Cy Avery impressed people with his energy, his enthusiasm, and his willingness to take on projects he thought were important. Since all of his interests—oil, farmland, and real estate—necessitated traveling through the countryside (the oil business also required the movement of heavy trucks and equipment), it was no wonder that he became interested in road building. As bad as the roads were in the rest of the United States, they were probably worse in Oklahoma, simply because the state had remained unsettled and undeveloped longer than anywhere else.

Avery grew up in a country that was sparsely populated, ruled by a territorial government, and not well served by the usual amenities of American civilization, such as railroads, highways, schools, and mail service. Roads belonged to the various Indian tribes and did not connect from one tribe's land to another's. The few railroads ran south through Indian Territory to the Texas cattle ranges and north to Kansas City, carrying livestock to market and to slaughterhouses.

As Avery grew to adulthood, the roads became more traveled but no better cared for. Road signs, if they existed at all, were crudely painted stripes on fence posts at strategic corners, so if a person was not watching closely, he could easily become lost. Even careful scrutiny could not produce markers that had blown down, washed away, or were not there in the first place. When a person did know which way to go, the dirt roads were often impassable in rainy weather. Even years later, when the Averys moved to Tulsa, the roads running southeast from there to Muskogee, northeast to Vinita, and west to Sapulpa were fenced up by the Indian tribes, and the pub-

lic was compelled to detour down a lane between two stretches of barbed wire.[12]

In 1912, impressed by what was going on in Missouri, Avery had persuaded the Oklahoma governor and the local paper to focus attention on roads. A year later, as a result of that accomplishment, his friends got together and submitted his name as a candidate for Tulsa County Commissioner. Despite the fact that he warned he "wouldn't spend a dime to get the job!" Avery was elected and then named chairman of the three-man county commission.[13] Once in office, he found that state laws left him powerless to really affect road construction, so he set out to secure local control over road building. Enlisting aid from the growing number of road boosters throughout the state, Avery encouraged the Oklahoma legislature to pass a law that gave commissioners the right to build the roads they needed in their counties.[14]

When he was elected to a second two-year term as county commissioner, he became a road builder in earnest. He developed the first system for dragging roads in Oklahoma with what was known as the split-log drag, based on a system invented in Missouri. The drag was a horse- or mule-drawn device that, when pulled across a damp roadbed, dramatically improved the condition of the thoroughfare. Once they had the equipment, Avery's board of county commissioners developed a system for using the drags to keep the roads in reasonably good condition. Essentially, the county paid to have a number of the split-log drags made and then had them delivered to farmers along the main roads. Farmers were then allowed one dollar a mile for dragging the roads after each rain.[15]

Years later Avery's oldest son, Leighton, recalled that the secret to using one of the drags was to get in there when it was damp but not muddy. "A dragger had to know how to tighten

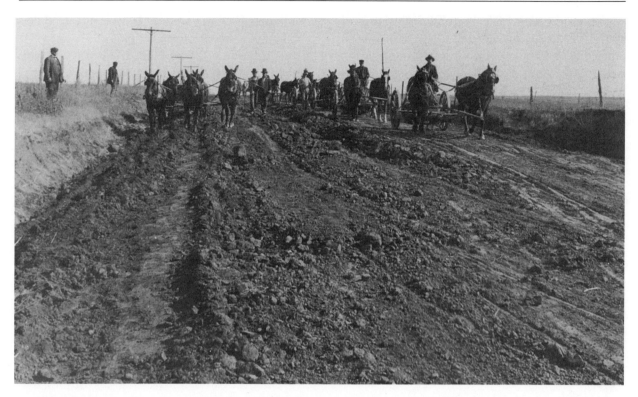

Split-log drag: Cyrus Avery's split-log drag could be pulled by either a team of horses or a truck. Avery's son, Leighton, used a Model T truck on the roads around the Avery farm, east of Tulsa. SOURCE: Ruth Sigler Avery, Tulsa, Oklahoma.

the chains a little bit, or loosen them so to change the pressure on the equipment," said Leighton, who had taken his shifts with the drag at the Avery farm, outside Tulsa. "It was tough work, but it was a better alternative than the people of Oklahoma had ever had previously."[16] By the end of Cy Avery's second term, Tulsa County had 150 miles of roads that were dragged regularly and maintained by local farmers in such good condition that they were passable within twenty-four hours of a major rainstorm.[17]

Nor did he stop with simply building the roads. Although Avery never lived on the acreage he owned outside Tulsa or, as an adult, on the prop-

erty in the northeast part of the state that he and his father had settled, he maintained a lifelong interest in his farms and in improved farming and production methods, even to writing and publishing two books on grasses. A study of grasses, of course, leads to an understanding of erosion control. In 1913, early in his term as Tulsa county commissioner, Avery purchased a supply of unhulled sweet clover and sowed it along the county highways, an early move toward highway beautification and drainage control.[18]

Before his tenure as county commissioner was at an end, Avery was consumed by road fever. He was a director of a local booster organization

known as the Tulsa Commercial Club and a director of the Tulsa Automobile Club, among other civic endeavors. He worked closely with a new Road Committee of the Chamber of Commerce, which was organized to raise separate funds to support the building and maintaining of roads in eastern Oklahoma. Avery and his Chamber of Commerce associates were instrumental in the formation of Coin Harvey's Ozark Trails Association, which encouraged the maintaining and marking of a highway from Springfield, Missouri, through Tulsa and Oklahoma City, Oklahoma, to Amarillo, Texas.

Avery's pivotal role in this organization and his later ability to organize and lead groups of volunteers were evident in a contemporary report of a 1917 Ozark Trails' convention held in Oklahoma City. The *Daily Oklahoman* reported that a "spirited contest" over whether the next convention was to be held in Tulsa or Amarillo continued until Avery spoke:

After a fifteen minute speech on Tulsa as a great convention city, Avery nominated as the place for the next meeting the magnificent city of—Amarillo, Texas. This unexpected finale to the splendid address, anticipated only by the speaker and three other men, set the convention wild and terminated this remarkable meeting by giving Amarillo the convention, and giving to Tulsa the unstinted praise and loyalty of more than two thousand delegates to the convention.[19]

The same year that he got everyone's attention at the Ozark Trails Convention, Avery helped organize the Albert Pike Highway Association, which supported a highway from Colorado Springs, Colorado, through Tulsa, Oklahoma, to Fort Smith and Hot Springs, Arkansas, roughly along what is today U.S. 64. As president of that organization he was part of a national group of highway associations. In 1921 he was elected president of the national group: the Associated Highways Associations of America, which was made up of representatives from forty-two different highway associations.

During this period and his later involvement in designing the national highway system, Avery's primary goal remained the same: to improve the roads that came into Tulsa. At the same time, though, his vision was growing with his experience, and he was beginning to realize that good roads were important for more than just transportation. At the meeting of the national highway association where Avery was elected president, the group resolved to become a "constructive association with a promotive aim in view . . . and the aim shall be 'selling' of roads for automobile travel."[20] It was also at this meeting that Avery first articulated an idea that was to stay with him throughout his highway days—the idea that tourism and highways were twin parts of the greater whole. The highway promoter clearly saw that the more tourists who traveled on U.S. roads, the louder the public clamor for highway improvements would be. Later Avery was to turn this argument inside-out with equal effect: that is, better roads would automatically draw more tourists—and their money—into Tulsa and the Southwest.

The good-roads activities complemented Avery's duties as a county commissioner and added further visibility to his other road-promotion efforts. In 1923 he was appointed a State Highway Commissioner of Oklahoma and became first chairman of a new three-man State Highway Commission. In that position he laid out a state highway system, organized the maintenance of those roads, established a statewide system for marking, and eventually had markers placed along the highways.[21] As highway commissioner, Avery supported a 1924 law that linked highway funds to a gasoline tax. He also continued to take an interest in and learn about the technology of road paving.

Road building was expensive in Oklahoma,

Avery said, because of the unique requirements of the oil industry. He believed that, owing to extensive oil-field development, Oklahoma had the heaviest truck traffic in the country and, consequently, that road surfaces had to be thick enough to withstand the wear and tear. He was also quick to take advantage of other people's good ideas: he adopted a system developed in Wisconsin of using numbers to mark highways and the California road-construction program for his state.[22]

Through these kinds of activities carried out in behalf of the people of Oklahoma, Avery became one of the leaders of another, and far more important, highway-booster group: the American Association of State Highway Officials. That organization, which included highway officials and engineers from all the states, was formed in 1914 in an effort to bring some sense to the every-which-way condition of highway construction. From the outset it recommended federal legislation and developed administrative and engineering principals and standards for highway construction.[23]

As a member of the American Association of State Highway Officials, Avery participated in one of the most significant events in modern highway construction. At its tenth annual meeting, in November, 1924, the association petitioned the U.S. secretary of agriculture to do something about roads. Specifically, they asked the secretary to undertake "the selection and designation of a comprehensive system of through interstate routes, and to devise a comprehensive and uniform scheme for designating such routes in such a manner as to give them a conspicuous place among the highways of the country as roads of interstate and national significance."[24] The organization also recommended that no more trail organizations be allowed to put signs on federal-aid highways, thus assuring the success of a highway-numbering system.

The secretary of agriculture obliged the highway men and appointed a joint board of state and federal highway officials to designate and number a national system of highways from existing thoroughfares and to adopt a standardized system of signs and markers for those roads. From the board, committees were appointed to oversee various aspects of the project.

The first job of the joint board was to set routes; the second was to assign numbers. When they met for the first time in April, 1925, the members of the board already knew that the national highway system could not include all of the approximately 250 marked trails. Rather than hold a series of hearings themselves, they had the various highway departments hold regional meetings in San Francisco, Kansas City, Chicago, Atlanta, New York, and Boston. At these meetings booster groups and town fathers pleaded their cases for highway pavement. In addition, representatives from each state were given blank maps to mark, received transcripts of the board meetings, and had the right—through the Association of State Highway Officials—to confirm the roads and system of marking.[25] Out of this process came proposals for 81,096 miles of federally-supported highways. The joint board cut the mileage to just over 50,000 and then turned it back to the states for approval. Eventually, a highway system with 75,884 miles of pavement was approved.

As a member of the association's executive committee, Avery was appointed to the joint board and had power of approval over the final highway plan. He was also named a member of the executive committee for designating the roads in the Mississippi Valley area. On that committee his task was to connect major population centers with well-marked, paved, highways.

With few exceptions, the job of designating which routes would become part of the national highway system was not difficult, and with even fewer exceptions, the designated roads had al-

ready been widely used by travelers and the committee's choice was accepted. One of the exceptions was the route that eventually became U.S. 66.

While he was overseeing the system in general and his region in particular, Avery—along with Frank Sheets, chief engineer for Illinois, and B. H. Piepmeier, chief engineer for Missouri—created a road of his own, one that sliced through the Middle West and stopped at the Pacific Coast of southern California. This particular road did not follow a major historic route. Avery simply routed it through his hometown, Tulsa, because he thought Oklahoma needed a major U.S. highway. He conceived his road in the face of tradition: the Santa Fe Trail—still the path of most traffic to the Southwest—had gone to the north through Kansas City and the state of Kansas to Denver; the Butterfield Stage route had run far to the south. The 1849 California Road from Fort Smith, Arkansas, was the closest parallel for what eventually became U.S. 66, but it had an intermittant history, thanks to the Civil War and the establishment of Indian Territory. For decades, since the resettlement of the Five Civilized Tribes into Indian Territory, nearly all roads had gone around the place that later became Oklahoma.

Nor did Avery have general support for his highway, not even from all the people in Oklahoma. The chairman of the Oklahoma Good Roads Committee wrote that Avery's road "has never been recognized as a tourist route, and was created at the instance of Mr. Avery who wanted an east and west route through his home city of Tulsa and Oklahoma City, the State capital."[26]

The Oklahoma highway also raised another issue: all the other designated federal highways were to run north-south or east-west across the United States. Avery's road did not even follow that simple system: its eastern terminus was actually in the north, in Chicago, which was strictly against the rules established by the joint board.

Avery, along with colleagues Piepmeier and Sheets, argued that the trade routes ran north and south from Tulsa to Chicago and not east to Fort Smith or Louisville. In the end Avery prevailed.

The first description of Avery's road—then unnamed—was carried in the report of the Joint Board of Interstate Highways on October 30, 1925. The report described the road as running from Chicago to Bloomington and Springfield, Illinois; Saint Louis, Rolla, Springfield, and Joplin, Missouri; Vinita, Tulsa, Oklahoma City, El Reno, and Sayre, Oklahoma; Amarillo, Texas; Tucumcari, Santa Fe, Los Lunas, and Gallup, New Mexico; Holbrook and Flagstaff, Arizona; and Barstow and Los Angeles, California. That description officially set the route but left plenty of room for more controversy later on, when it came time for paving and deciding which smaller towns would be on the main road between the cities.

Once the roads were set, they had to be numbered, a fairly uncomplicated procedure as far as outsiders were concerned. The numbering process, however, caused an uproar, and one of the biggest battles was fought over Cy Avery's road.

Avery, Sheets, and Piepmeier decided that the highway from Los Angeles to Chicago should carry the single number 60. Officials from Virginia and Kentucky thought that Avery's idea was a bad one and that any highway that had one end in Los Angeles should have the other end on the East Coast. This controversy was not over pavement: the Road Designation Committee had already planned that there would be a paved highway from Los Angeles to Newport News, Virginia, as well as to Chicago, and that the two roads would separate in Springfield, Missouri. The controversy was over highway numbers.

For a time suggestions were made that the road from Los Angeles, California, to Springfield, Missouri, to Newport News, Virginia, carry the number 60, and that the road from Springfield,

Missouri, to Chicago, Illinois, be 60-North. This was totally unacceptable to Avery and his cohorts, who thought "60-North" sounded like a side road and not a main thoroughfare.

Avery's past successes, his national role, and his belief in the correctness of his position made him confident: he and Piepmeier went so far as to put men to work marking the route through their states with signs that said U.S. 60. In Missouri, the State Highway Department printed six hundred thousand road maps that actually showed Highway 60 going through the state from Joplin to Saint Louis. This action aroused the ire of W. C. Markham, executive secretary of the American Association of State Highway Officials, as well as the officials in North Carolina and Kentucky. Markham wrote Avery, "The selection of the interstate system of highways, while it was more or less contentious, was nothing in comparison to the contention that is going on between the States in reference to this numbering system."[27]

A few days later Piepmeier wrote Avery that North Carolina and Kentucky "are making a very strenuous fight for the through routing of No. 60. . . . We cannot afford to lose Route 60. In fact, I will have it marked very shortly. . . . Mr. Sheets agrees to our numbering. I think if we three stand pat we will mark No. 60 through to Chicago."[28]

Two days later Piepmeier wrote again, even more concerned about the fate of the highway number:

In my judgment this is one of the biggest highways in the country. There is more travel between Los Angeles and Chicago, or in that vicinity, than any other transcontinental route. . . . I would rather accept anything than this [Route 60 north and south] designation. I object to any other number than sixty, because that has been established. We should use one of the zero numbers and this is one of the biggest roads. You know our plan was to designate all of the big roads with zero numbers. . . . I hope you will stay with me.[29]

Even though Avery was on the Executive Committee and had been one of a committee of five men who laid out and marked the roads on the U.S. map, he apparently saw the need to call in reinforcements. During this period he wrote to Oklahoma Congressman Elmer Thomas that

the people of Oklahoma do not buy goods, do their banking nor trading with men in Tennessee, Kentucky, North Carolina or even Arkansas. . . . U.S. 60 is going to be one of the greatest traffic lines in the United States. It is on the most direct and easiest line following along where there is the greatest wealth and is headed both East and West along the direct [sic] of business interest.[30]

By the end of March, several congressmen were beginning to take an interest in the road squabbles. Thomas H. MacDonald, chief of the Bureau of Public Roads, cautioned Avery that congressional involvement might lead to a legislative attempt to defeat the whole plan for a national highway system. MacDonald, who remained head of the U.S. federal road system for decades, was put out with Avery and wrote:

Personally, I think that more time has been spent on this matter than it deserves. I do not feel that it makes one bit of difference to the States along the route from Chicago to Los Angeles whether it is Route No. 60 or 62 or any other number so long as the number is carried continuously, and that has been conceded . . . it seems to me that Route 60 with an outlet to Chicago and to the east coast is a greater advantage to Oklahoma than either one alone.[31]

Avery countered by suggesting that his road be called Route 60 and the route from Springfield, Missouri, to the East Coast be 60-South but could get no support for this from his friend Piepmeier. In late May, Piepmeier wrote Avery that "I am willing to accept 62, 66 or 60, from Chicago to Los Angeles, and nothing else. They can number the road from Springfield to Newport News any-

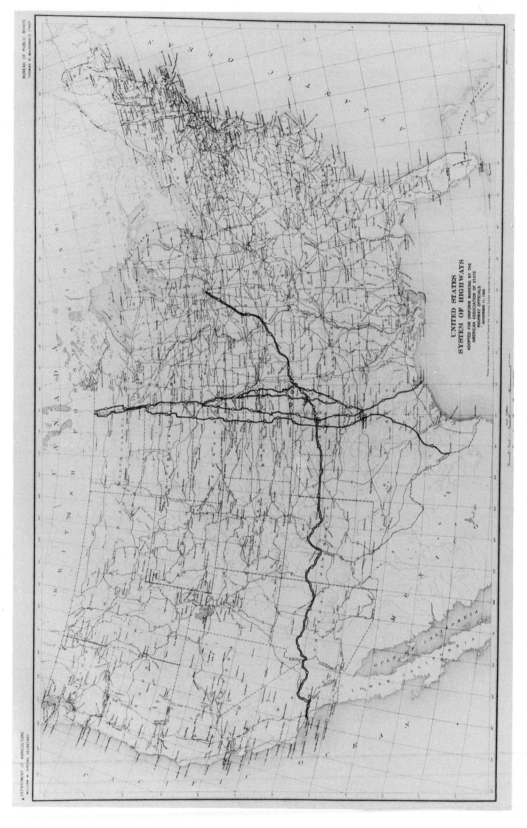

Map of the Federal Highway System, November 11, 1926: Cyrus Avery traced U.S. 66 and other federal highways passing through Oklahoma on his copy of the map. SOURCE: Ruth Sigler Avery, Tulsa, Oklahoma.

thing they choose. That is my position and I hope you will agree with me and that we can get something settled at once."[32] Avery acquiesced and carried Piepmeier's request to MacDonald.

On July 23, he received his answer: E. W. James, chief of the Public Roads Bureau's Division of Design, wrote that "Kentucky has just assented to an arrangement which will require the assignment of number 60 to the route from Springfield, Missouri, across Kentucky and Virginia to Newport News, with the understanding that the route from Chicago to Los Angeles will be given number 66."[33] A confirming letter from Markham on the same date urged Avery to take their final offer so they could get on with marking the roads and making maps.[34]

This time Avery agreed, and a letter ballot was duly sent to the Executive Committee of the American Association of State Highway Officials.

On August 11, Markham sent a memorandum to the state highway departments of eleven states, including the eight between Los Angeles and Chicago, plus Kentucky, West Virginia, and Virginia. "Please be informed," wrote Markham, "that the Executive Committee has settled a controversy of long standing in reference to the use of Number 60 by assigning Number 60 to the route from Virginia Beach . . . to Springfield, Mo.; and Number 66 to the route from Chicago . . . to Los Angeles."[35]

Where did the number 66 come from? Nowhere in particular, as it happened. At a meeting of the Oklahoma, Missouri, and Illinois officials in spring, 1926, Oklahoma's Chief Highway Engineer John M. Page discovered that number 66 had not yet been given to a national highway. Although 66 had not been the first choice, it was acceptable.

In the end Avery was pleased with the results of his twenty-four months of labor. He wrote to the chief of the Division of Design for the Bureau of Public Roads: "We assure you that U.S. 66 will be a road through Oklahoma that the U.S. Government will be proud of."[36]

The highway system as designed and numbered by Cy Avery and his associates was accepted by the secretary of agriculture, and in November, 1926, it became the law of the land.

See also *The Signpost*, Jan. 1993
for article, "Birthplace of Route 66"
by James R. Powell, for add'l info.

See also *Route 66 Magazine*, Summer. 1996
p. 16 for article by Jim Ross on this subject —
Rte 60 vs. 66 in 1926

CHAPTER 2 : PAVING

MICHAEL BURNS, an octogenarian oil dealer in Springfield, Illinois, was a young boy when his father went into business to fix tires and sell gasoline and fuel oil, but he remembered what it was like to talk with people who were driving through central Illinois on their way across the country.

"Not many people traveled in the early twenties," explained Burns from behind his cluttered desk inside a dilapidated building that had once fronted on Route 66. "The roads were no good, tires were no good, cars would get hot, and the highways were not marked. People would stop here and ask, and they wouldn't know if a town was in Kansas or New York.

"One day there were two fellows who came in here and asked if this was Springfield. I said, 'Yes,' and they told me to go ahead and service their car. When I told them it came to fourteen gallons of gas and two gallons of heavy oil, they were stunned. 'My golly!' they said. 'We left home this morning and we was only forty or fifty miles from Springfield.' They had turned wrong and had come to Springfield, Illinois, instead of Springfield, Missouri.

"That happened in those days," said Burns. "A lot of people turned wrong."

The welfare of those pioneer automobile tourists was in fact the official reason for development of the national highway system. Cy Avery's joint board established the routes, including U.S. 66, so that local officials across the country could coordinate marking systems and maps and people would not get lost as they traveled from one state to another. The first and most obvious action taken as the result of the joint board's work was adoption of the white-and-black shield to mark the national highways. This meant that drivers would have a readily recognizable way to determine what road they were traveling and which direction they were going, no matter what state or county they happened to be passing through. It did not mean, however, that the marked road would be paved. Although in 1916 and again in 1921 federal funds had been set aside for paving, none of those dollars were specifically earmarked for the national highways. A conscious decision had been made in Congress to leave final road-paving choices to the states and their subdivisions.

Though Burns had become fat and successful during more than a half century in the oil business, he never forgot the early days, and he never tired of talking about them. "The first roads were terrible," he repeated, with a wave of his meaty hand. "Tubes blew out all the time. Tires were no good. The roads was full of ruts. They was no good, either."

Burns and his father made their living back then by patching those tires that "blew out all

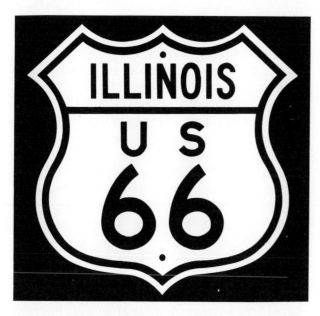

Replica of "Illinois, U.S. 66" sign: Sign issued by the Illinois Highway Department, in 1978, in response to demands for old 66 signs after their removal from the highways. In California, in 1982, hand-painted, plywood signs appeared on Foothill Boulevard, in Fontana. SOURCE: Susan Croce Kelly.

the time," selling gasoline to the travelers who passed by, and hauling oil, kerosene, and gasoline to the farmers in rural Illinois. They were pleased and excited one day in the early 1920s when they heard that state highway engineers had put down a test patch of concrete cement on the highway out by the State Fair Grounds, north of Springfield. They were even more pleased in the years that followed as they watched new concrete pavement flow across their state and down the road that linked Chicago to Springfield and Springfield to Saint Louis.

During the 1920s, Illinois state engineers set yearly records by laying more than a thousand miles of pavement, and in 1929 every county in Illinois had at least one paved road. In 1930, Illinois had about seventy-five hundred miles of

roads under pavement and was the only state—except for the fifteen miles through the southeast corner of Kansas—where Cy Avery's highway was completely hard-surfaced.[1]

Although it was 1938 before U.S. 66 was paved all the way through to the Santa Monica Pier, in California, traffic did not wait. The number of vehicles continued to increase, and the drivers assumed that eventually, with enough encouragement and complaints, the pavement would catch up. In the meantime, people had to have a spirit of adventure, not to mention a sense of humor and a working knowledge of automobile mechanics, to undertake a cross-country journey in the 1920s. Road conditions, to say the least, were difficult.

Whit Lee, who later pioneered in the trucking industry, operated a small bus line in western Oklahoma during the late 1920s, "back in the mud days in the hills of Oklahoma," according to Lee's son Bob. "In those days Highway 66, as it is now known, was a very difficult road to travel, particularly when it rained. It was just mud, and clay mud."

Bob Lee eventually became president and chairman of Leeway Trucking, but he grew up working on the buses, collecting dimes from passengers in exchange for pillows on long trips west. "Back before the road was paved, Pickwick Stages, in Pennsylvania, had the idea of coast-to-coast bus routes. They bought my Dad out when they got as far as Oklahoma City. Then they came through with larger buses than we had ever used—eighteen passengers as I recall—and those buses really got mired in the mud.

"There was a real mud hill at Geary. If it was raining, the buses wouldn't leave Clinton [about forty miles east] because they couldn't get up the hill to Geary. A lot of buses got stuck in the mud there, and they had to put the people up in hotels until the buses could be pulled out.

"Pickwick operated through Oklahoma for

about two-and-a-half years, but they couldn't take the mud. Finally, they came to Dad and said, 'Take it back. We just don't want it.' So Dad took it back, and we went back to eleven-passenger buses."

Farther west, Russell Byrd drove a bus from Los Angeles to Denver, Colorado, in the early prepavement days, following U.S. 66 most of the way. Byrd said that he did not worry about rain causing muddy roads in Arizona because there was plenty of sand, but in New Mexico, he faced clay, "and that's different." Even so, it was not unusual in Arizona for weather and road conditions to prevent his buses from getting through. Outside Hackberry, for example, where the road went through a creek, the current was sometimes too swift for Byrd and his bus to ford easily. He often had to wait for the current to slow before he dared to take his bus across. The pioneer driver recalled that when the Hackberry creek was running hard, he would take off his shoes and socks and put his feet into the water to judge its swiftness. "I could feel the rocks hitting my feet as they bounced downstream. If they were really going, I'd wait before I'd risk taking the bus across," said Byrd.

He learned a lesson on his first trip across the Mojave Desert that he never had to repeat. "The first time I went into Needles off the desert, I looked back in the bus and couldn't recognize the passengers. They were all covered with dust," said Byrd. "Later one of the other drivers told me how to regulate the air by opening up the wing windows, closing the windows in the center of the bus, and opening the ones in the back. I never had dust again after that."

Byrd's career as a driver began in the days when he had to know how to build the bus himself. He also had to keep a map in his head because there were no signs to mark the turns. Before he retired, he was honored as one of a hundred of the world's finest drivers, and many of his safety suggestions had been adopted

nationally by most of the country's large bus systems.[2]

Drivers of private vehicles faced equally tough conditions when they set out to go across the country. In the early 1920s, in Los Angeles, California, a young fellow named George Greider set his wife behind him on the back of a motorcycle and took off on the old Beale Wagon Route to go home to Topeka, Kansas. The trail, which had been surveyed by Army Captain Edward Beale in 1857, followed the thirty-fifth parallel over the Cajon Pass, through the Mojave Desert, and across northern Arizona. It was roughly the route that became U.S. 66.

"It was not Highway 66 at that time," said Greider. "It was not a road even, not through the desert or Arizona or New Mexico. We went north out of Los Angeles on a concrete slab that was fairly new. It wasn't wide enough for traffic, but two cars could pass without going off. That slab lasted all the way to the top of Cajon Pass, and we really moved on that little slab of paving.

"When we came to the end of it at the top of the rise, the terrain flattened out and the pavement just stopped. There were no signs—nothing— and we just drove off into the sand. The sand was real deep, and the motorcycle came to a stop four feet from the end of the slab. We stood there awhile. There were two ruts in the sand from there on. There were a few signs, and through the desert and prairie there were two ruts in the sand for miles and miles, hundreds of miles. There was not a sign of civilization at all: no roadwork, no fences, no grading, no highway."

Greider's experience, while perhaps more grim because he rode a motorcycle, was not unusual. Richard Warren, a retired banker from West Lafayette, Indiana, remembered trips to California with his parents during the 1920s, when part of the road in Arizona was merely wooden planks laid in the desert sand. "If two automobiles met, each kept one set of wheels on the planks," re-

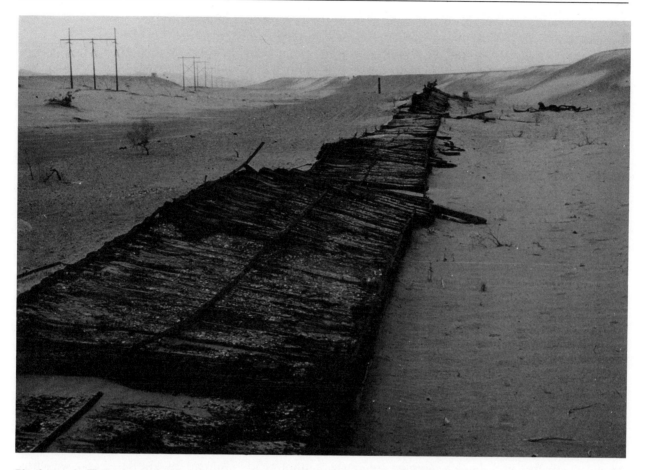

Plank road: This remnant of the plank road was found and photographed by J. N. ("Jim") Slack on the California-Arizona border in July, 1963. SOURCE: Lucille Slack, Tulsa, Oklahoma.

called Warren, "so as not to get all four of either vehicle mired in the sand."

Andy Wolf, who grew up in Maryland and later moved to Arizona, drove a 1924 Dodge Roadster with a cloth convertible top from Kingman to Flagstaff in the early 1930s. "There were no paved roads in Arizona, but they had surfaced some dips through creeks to keep people from going into quicksand," recounted Wolf. "I found a pace I could drive so that when the car came up and out of a dip, both doors flew open. Then when it landed back on the road the doors would fly shut

again." In that prepaving era, the sixty-mile trip from Flagstaff east to Winslow, Arizona, took all day, and standard equipment for any automobile included tire tools, a lug wrench, patching equipment, and a pump. A longer trip called for camping gear as well.

That those early days of cross-country travel were aggravating could not be disputed; that they were a promise of better things to come kept people from giving up altogether. The new consumer-gasoline industry supported the call for road building and issued not only maps but

regular updates on the paving progress of various highways. In 1929 a Texaco road report on U.S. 66 gave notice that Illinois and Kansas were concreted, that Missouri was two-thirds paved, and that Oklahoma was one-fourth paved. In Texas, Route 66 had yet to see a cement mixer, and only 64.1 miles of pavement had been poured anywhere on the westernmost 1,221 miles of the highway that stretched across New Mexico, Arizona, and California.[3]

Several factors affected the progress that a state made on paving its roads, even its national highways. Funding, which had to match federal dollars on a fifty-fifty basis, was always an issue. Simple know-how was also an issue, since the whole field of highway construction in the United States was not even a half-century old. Finally, given the other two factors, politics entered into the decisions as to which roads would be given priority to be paved. Although U.S. 66 was of vital importance to the Texas panhandle, for example, other roads certainly had more value to the state as a whole and were paved first.

By the mid-1920s all of the forty-eight states had created their own highway departments—primarily because federal appropriations laws required them—and had appointed highway officials. At first these departments existed just to administer state grants-in-aid to the local units, but they later took on responsibility for construction with state funds and finally assumed authority for all operations that involved state money. This system reflected standard government policy and philosophy: the people first turned to their local and state governments for road paving. When it became clear that the magnitude of the job required federal involvement, that involvement was designed to help, rather than supplant, the states' efforts.[4] Although considerably strained by the federal relief programs of the 1930s, that policy of state support remained

more-or-less intact until the coming of the interstate highways in the late 1950s and 1960s.

Cy Avery, in Tulsa, was one of the people who had been on the front lines of developing the new field of highway engineering and construction. The work that he and his colleagues across the country accomplished during the years preceding 1920 helped set the stage for the large construction programs of later years.[5] With his tremendous energy, enthusiasm, and curiosity, Avery organized highway departments, first in Tulsa County and then in the state of Oklahoma. He upgraded and surfaced some of the early roads, bringing in new equipment from other places and traveling across the country to see how it was done in California and Wisconsin. He also wrote tax laws that provided the local financial support for road construction in Oklahoma. He was a pioneer engineer, as were all the men out there grading and rolling and surfacing the fledgling road projects. During that era road construction progressed not according to some grand plan but strictly as a result of the judgment and growing experience of people like Avery. Basic knowledge was not yet available from which to develop scientific methods,[6] although the Bureau of Public Roads was busy amassing road-construction data; organizations were springing up to encourage communication of new knowledge; and federal efforts, such as the work of the joint board, were pointing toward standardization of materials and road-building specifications.

As construction of U.S. 66 progressed and became standardized, pavement was laid in two lanes, each nine feet wide. Where the highway was concrete (which it eventually became in most places), the slabs were six to ten inches thick, depending on the subgrade. In the beginning, the slabs were thicker in the center of the highway than on the edges, but this changed as

it became evident that heavy trucks caused the road to crack and break on the thinner edges. Each lane was separated by a center line to control cracking, and abutting slabs were tied together with steel bars.[7] These basic specifications evolved over the years as engineers learned more about what they were doing, as the effect of automobiles on road surfaces became known, and as the level of sophistication and general understanding increased. Soil studies, for example, were not undertaken on a regular basis until after 1930, although a century earlier, pioneer engineers like Sir Thomas Telford, in England, had pointed out the necessity of studying soils in conjunction with building roads.[8]

Part of these changes in understanding and attitude had to do with economics. Just after World War I, the goal was to build two-lane roads that connected the population centers. This was done in some fashion by the 1930s (although U.S. 66 was not completely paved until almost 1940), but the highways were not adequate for the amount and kinds of traffic that they carried. Many states built highways cheaply, with the intention of going back later and upgrading them. That did not work, given the nature of public funds, and the cheaply built highways were far more expensive to maintain than the ones that cost more up front.[9]

This last was certainly the case in Oklahoma, where Avery oversaw much of the early highway construction. He was quick to dispute the idea that early engineers had not known what they were doing. "Engineers were just as good then as now," he insisted to a newspaper reporter late in his long life. "We knew the shortest distance between two points is a straight line. I've taken a lot of kidding about the roads we built then, but we had to worry about money as much as we did engineering.

"Highways were routed around hills instead of through them, bridges were built eighteen feet wide, and section lines were followed despite the resulting right-angle turns because these things made roads cheaper. There wasn't any of this big earth-moving machinery then, and we could build miles of road for what it would have cost to cut through one little hill. If we had made the bridges two feet wider, we couldn't have built as many bridges. We had just so much money, and there never was enough."[10]

There never was enough money, but there were always more vehicles and more demand. Vehicle owners wanted better, faster pavement, and business people in the Southwest began to see what Avery had known from the beginning: that better roads brought people with money to spend and leave behind. While the decisions on which roadways would receive the limited funds were in the hands of the state and local governments, Cy Avery was not above doing what he could to influence those decisions and reinforce the ones he felt were right. Always a planner and organizer, he figured that a booster organization modeled after the earlier Good Roads Associations could generate enough interest and make enough noise to channel the priorities and the dollars into U.S. 66 as the road to be paved first.

Before the ink had dried on the papers that announced the National Highway System, Avery was planning the next step. Working with John T. Woodruff of Springfield, Missouri, an old crony from the Ozark Trails Association, he invited people from eight states to help organize a Route 66 highway association.

"The keynote was speed," Avery later explained. "Not fast cars and what goes with them but actual haste in getting roads located and built."[11]

Invitations went out officially from the Chambers of Commerce of Springfield and Tulsa. People from five of the eight Route 66 states ar-

rived in Tulsa on February 4, 1927, to see what they could do to expedite the building of their highway. No one from Illinois attended the meeting, but the Illinois section of U.S. 66 had already been paved. No one was present from California or Arizona, either. It could have been that they felt they were too far from Tulsa, or it could also have been that people at the ends did not view the road in quite the same light as those in the middle. Nonetheless, there was a full complement of people from Missouri, Oklahoma, Kansas, Texas, and New Mexico. There was even a delegation from Arkansas who had come to lend their support for a national highway to the North and West.

Throughout the day, Avery dominated the gathering. He was the keynote speaker. In recognition of his role in setting and numbering their highway, the delegates passed a resolution of appreciation for his work on 66 and the National Highway System. Later, as a symbolic gesture, he reached into his pocket and grandly extracted a five-dollar bill from his wallet, which he presented with a flourish to become the first member of the Association. Finally, as chairman of the permanent organization committee, he recommended that the Highway 66 Association be called The Main Street of America, a name that was to appear on brochures, maps, postcards, and in travel guidebooks for the next half-century. The only thing Avery did not do was to get himself elected president of the 66 Association. Oklahoma politics and a new governor who was not a strong backer of the highway commission chairman probably influenced Avery's move to nominate John Woodruff instead. Elected by acclamation, Woodruff retained his office for two terms and then was succeeded by the father of Route 66.

Three months after the meeting in Tulsa, the U.S. 66 Highway Association met again, this time in Springfield, where the assembled delegates approved articles of incorporation and set two goals for the organization. Number one was to promote the paving of U.S. Highway 66 between Chicago and Los Angeles. Number two was to publicize the road.

From the beginning, promotion and publicity were the main tools of the 66 Association. The Association met every two to three months during that first year. Each meeting was held in a different Highway 66 town, and each created glowing visions of a well-paved future and the glory of life along Route 66. In every town local people and members of the press were more than willing to support and publicize the cause.

In June, 1927, five hundred people converged on Amarillo, Texas, to cheer on the paving of Route 66. Woodruff, who had stopped off en route to make a quick speech to the loyalists in Tulsa, noted that the pavement was completed from Chicago to St. Louis. He also said that 190 of the 300 Missouri miles had been concreted and that "if development of the highway continues, I'm sure it will be entirely paved by the end of 1928."[12] His prediction was off by a decade, but his enthusiasm was right on target. Four months after the Amarillo meeting, the 66 Association met in Albuquerque, New Mexico, and a Pickwick bus brought a load of delegates down the dirt-and-gravel highway from Missouri, Oklahoma, and Texas.[13]

The 66 Association led the cheers; meanwhile, across the country, local taxes were being matched with federal dollars, and the slab was being laid. Not as quickly as Avery and Woodruff would have liked, and certainly not as solid, but, nonetheless, progress was evident.

The pavement was actually completed on the eastern and western ends of U.S. 66 first. The Illinois and California sections of Route 66 were hard-surfaced early. In Missouri, Kansas, Oklahoma, Texas, New Mexico, and Arizona, officials paved what they could and finally finished the

job with federal support and crews provided by various federal works programs during the Great Depression.

The easternmost of the Route 66 states, Illinois, had hard roads even before the highway was numbered. The "Land of Lincoln," with its rich deep topsoil, had been in need of a hard road. Otto Sternagle, who had lived at the edge of old 66 in southern Illinois all his life, remembered, "Years ago in winter, you couldn't travel these roads. The damn mud was that thick," he said, holding one hand about two feet above the other. "Them was rough days, even with a horse and wagon. I used to push cars out of the ruts, and they'd pay me fifty cents or a dollar." Sternagle sat on a wooden bench in his garden with his arms folded across his chest and one leg crossed over the other. From his bench he could see his garden, the building next door that had begun as a service station but become a tavern, the old highway, and across the way, a couple of slag heaps (which rose up from the flat landscape like small, grim mountains) from the coal mines where he had worked for thirty years.

"That building used to be a gas station, and my mother ran it," he said. "They had to cut the building in two and move it when they put in the hard road." The engineers had not moved the roadbed very far when they paved 66 for the first time in Illinois, just far enough to cut across the front of the little gas station, which had been there since 1919. "In them days you could buy six gallons of gas for a dollar," said Sternagle. "Them days you had three kinds of gas: cheap gas, regular, and ethyl. Cheap gas was green." The road was quiet in front of Sternagle's place; few cars traveled that first incarnation of U.S. 66 anymore, and when one did pass by, it was easy to hear the blip, blip, blip made by the tires crossing the tarry joints between the concrete slabs.

Sternagle remembered the mud and the con-struction of the hard road; others recalled that the first pavement in that part of southern Illinois was not Portland cement concrete laid down in slabs, but brick, at least in some places. "Over by Edwardsville, that road was laid by two colored fellows. They did it so fast it was ridiculous," said a banker from Litchfield.

In Hamel, the road was bricked and then black-topped. Bill Henke, an employee of the Illinois State Highway Maintenance Department, had occasion to come across the old brick pavement years later in his day-to-day job of patching the road. "I can't remember when they built the original road," said Henke, "but I remember when they put the bricks down. Nineteen thirty-two—that's when they put the bricks down, right through the Depression. I don't know if they was put down to create work or if the engineers thought that the brick pavement would last better than the concrete."

During that era brick was still an acceptable paving material, but, in Illinois, the explanation seemed to be that some highly placed state official was in the brick business. When he left office, the pavement reverted to concrete.

In Missouri, the first concrete pavement on a rural road was a 7.4-mile slab laid down in 1920 in the lead- and zinc-mining southwest corner of the state, between Joplin and Carthage. It cost $120,693 and was paid, as had been established in the 1916 Federal Aid law, half by the federal government and half by state tax monies.[14] It was originally named Missouri Route 14, but after 1926 it became part of Route 66. The pavement was eighteen feet wide (two nine-foot lanes), with a lip curling up on each side.

Shortly after that patch of road was paved, George Morris drove his brother and his brother's new bride down that way to catch a train for their honeymoon. "I took my Model T and hauled them down to Joplin from out in Dade County," remembered Morris, a leathery, easy-

going Ozarker who spent most of his life running fish hatcheries for the state. He had little to say about his brother's wedding, but he raved about finding the new hard-surfaced road. "That concrete highway—I'd never seen one before. After I left them off and went home, I drove over it and then turned around and drove down that road again. I liked riding on it."

Missouri roads were paved under the auspices of a 1921 "Centennial Road Law," which called for hard-surfacing of the primary and state highways and improving the others. After George Morris's concrete slab had proved its usefulness to the satisfaction of the experts, the State Highway Commission approved plans of the chief highway engineer for the location and design of fifteen hundred miles of roads for the state's primary system. The plans included "a higher type of primary road . . . between St. Louis and Joplin . . . [to] start at or near the end of the pavement on what is known as the Manchester Road in Saint Louis County, thence south through or near Rolla, Lebanon and Springfield to or near the Carthage–Webb City–Joplin population district."[15] In 1927, U.S. 66 in Missouri had been upgraded to what was termed an "all-weather" road, but Morris had to wait until 1931 before he could travel all the way to Saint Louis on concrete.

In 1930 only 23 percent of the total U.S. highway mileage was surfaced, and only 3 percent had "high type" surfaces, such as Portland cement concrete, bituminous concrete, brick, or block.[16] The rest was mud, gravel, macadam, or a variety of other less-than-adequate combinations. Up until that time, road policy and the federal laws that followed mainly had to do with improving the roads.

During the next decade—and this was the time when most of U.S. 66 received its first hard surface—the emphasis shifted from engineering concerns to relief. More than four million people were out of work in 1930, and the number rose as the months passed. Throughout the decade the federal government funneled more and more money into state road-construction programs in an effort to put people to work.

In 1930, Congress authorized $80 million as a "temporary advance" to the states to match federal-aid dollars and hence to sustain employment by keeping roadwork going.[17] In 1932 a public-works appropriation provided $120 million to the states for work on federal-aid highways "to furnish the maximum possible direct employment." A 1933 act specified that the road-building projects should employ the maximum number of people, and that the manpower on a given job be set according to the number of unemployed people in the locale.[18]

A 1934 law tried to restore the balance between normal and emergency road activities, with little success, although it did carry regular to-be-matched federal-aid appropriations for the first time since 1930. In 1935, relief and recovery considerations had supplanted the original guiding principles of federal-aid policy. Between 1934 and 1939 federal relief agencies spent hundreds of millions of dollars on roads and streets. During that period one agency alone—the Works Progress Administration—was responsible for improving 280,000 miles of roads and streets, including bridges, culverts, guardrails, and curbs.[19] Many of the people building the roads for the federal government were the same ones who had begun the job. The Works Progress Administrator for the Northeast Oklahoma District for two years in the early thirties was none other than Cyrus Stevens Avery.

During his term, Avery gave a speech to local citizens to celebrate the paving of a strip of highway near Vinita. "It is fortunate for all of you," he orated, "that the U.S. government, in order to relieve the unemployed and assist the country in returning to normalcy, have made the appropria-

tions for building a federal highway. The state highway department is to be commended for the program they have laid out and for the expenditure of these funds."[20] The state highway department deserved credit, to be sure, but Avery's laudatory thoughts probably also extended to those fine fellows who had designated the federal highway through Vinita in the first place.

For U.S. Highway 66, the road-building era of the 1930s was a mixed blessing. On the credit side, the highway did get paved, all two thousand miles of it, from Chicago to Los Angeles. On the debit side, engineering advances during the 1920s and 1930s led to passage of the Hayden-Cartwright Act, in 1934, which designated funds for scientific highway-use surveys and long-range planning. Once completed, the surveys pointed the way toward the bypassing of small towns, construction of the nation's interstate highway system, and ultimately sounded the death knell for Route 66.

Nonetheless, the influx of federal dollars and new federal programs allowed work on U.S. 66 to proceed west from Missouri, including a sixty-five-mile stretch between Rolla and Lebanon, which was finished in 1930. To commemorate completion of the slab in Missouri, the 66 Association sponsored a giant celebration in Rolla on Saint Patrick's Day, 1931. More than seven thousand people turned out for the occasion, which included dances, a parade, dinners, speeches, and the highway dedication. Missouri Governor Henry Caulfield took the opportunity to ask for creation of a state highway patrol. Avery, who by this time had weathered a storm of Oklahoma politics and was president of the 66 Association, reviewed the history of the route from the marking of the Ozark Trail. The whole crowd was treated to a parade of covered wagons and motor cars that stretched for two miles along the newly paved highway.[21]

That celebration in Rolla probably was the big-gest, but neither the first nor the last, gathering of citizens who felt a need to cheer on the completion of decent highways through their states. In Kansas, the thirteen miles of U.S. 66 were concreted with little ballyhoo almost as soon as the road was numbered, but in Oklahoma, where 66 was born, paving—like almost everything else—became a political issue, took longer, and received a lot more public attention.

Like the road in Missouri and Kansas, Route 66 in Oklahoma was first built in 18-foot-wide slabs (two nine-foot lanes). In May, 1931, the state let the contract to finish the last few miles of pavement between Oklahoma City and the Texas border, but several stretches on the eastern side of the state were not paved for another half-dozen years.

As was the rule elsewhere, the final authority for where pavement went down in Oklahoma was left in the hands of the county governments. In most of the other states, roadways had evolved over more than a century of travel and traffic, and there was little dispute over which roads were the most important. In Oklahoma, where whole towns had sprung up overnight during the land rush, roads did not necessarily follow traditional patterns. In fact, there might be three or four equally traveled routes between two major towns. As a result, when the time came for paving, the decision about to where to pour the concrete was not automatic, and public efforts were made to sway the decisions of state highway engineers.

To facilitate the paving, local businessmen in many towns turned out in force and began grading roadways and spreading gravel. They reasoned that if they could upgrade their piece of the highway, it was more likely to be chosen by the state highway department as a route to be paved. In many parts of Oklahoma, these exertions did make a difference. "Politics was what determined which way 66 would go," recalled local historian and writer Kent Ruth, years af-

ter the grading and graveling of the roadway at Geary. "There were three suggested routes from Oklahoma City to Amarillo. The north route—the old Postal Road—that's what won, through Bethany, Yukon, past those grain elevators. There was lots of local boosterism. Everything was dirt roads then, and they sure wanted pavement.

"The amount of volunteer work that went into building up 66 in those days was amazing," continued Ruth. The local Geary Businessmen's Club had even built a free campground for travelers who came through that part of the state. In addition, they had graded and graveled the road that led south from Geary to a long, controversial, suspension toll bridge across the Canadian River. "Everybody had to work on the road," Ruth remembered. "If a businessman couldn't work, he would hire a kid. That gave the high school boys a chance to get out of school for a day or so."

In 1927 the road Geary citizens had graded and graveled became U.S. 66, and in 1929 it was still the only improved stretch in that rolling, windy section of western Oklahoma. It was important because it led to the only high-water bridge across the Canadian River for miles. The bridge had been built by local politician George D. Key in 1922, and it remained a toll bridge despite the protests of captive travelers.

In 1928, when Cy Avery declined to run for president of the 66 Association, the *Tulsa Tribune* speculated that Key, chairman of the State Democratic Central Committee and one of the governor's political cabinet, was a prime player in keeping Avery on the sidelines.[22] In this case, however, politics did not prevail, at least not G. D. Key's politics: construction of a free bridge across the Canadian River began in 1932, about the same time that the highway was paved in that region. Completed in 1933, the 3,994-foot bridge was the longest in the state, and it was reached by a paved, concrete highway that followed a straight course west from El Reno, bypassing Geary, the Businessmen's Club campground, the toll bridge, and a tiny community known as Bridgeport.[23]

Roads and highways were important everywhere in the United States during the 1930s, but perhaps nowhere was a single road more important to the people of an area than Highway 66 was to the men and women of Oklahoma. Sixty-six did carry destitute farm people to California. At the same time, because it bore the weight of the migration, Route 66 also was the reason that many, many other down-and-out Oklahomans were able to stay in Oklahoma. Route 66 gave them jobs. To the more innovative, the highway brought customers for a variety of enterprises, from Indian craft shops to cafes, motels, and service stations. To others, the road's own need to be paved and the federal government's willingness to use that need as a conduit for relief action provided enough work and income to last through the hard times.

In the heart of Oklahoma City, Grady Bell sat on the step of a weathered Mobil station and recalled his father being part of the highway building crews. "Dad, he built roads," said Bell. "He worked on 66 clean across the state of Oklahoma." Bell sat there and thought about how the street in front of his shoe soles used to be old Highway 66. The station, he said, was built in 1907 and started out as a grocery store. It used to be red and white, he offered, before it had weathered to the same nondescript gray-blue of his often-washed coveralls.

"I used to hitchhike up and down this street," said Bell. "I went from Chandler, Oklahoma, to California in 1949. It wasn't hard to get a ride, not like it is now. I went out there to look for work," he continued. "And I found it, too. But I came back to Oklahoma because I went broke. Most everybody who goes to California comes back

broke." Bell, who was raised in Chandler, grew up on a farm with parents who had come to the area and homesteaded during the land run in 1889. "We like to starved to death back during the Depression," said Bell. "We moved to town off the farm, and Dad worked on WPA. He built roads. He hauled dirt with a team and dirt shovel, and he done that from about 1930 to 1938. That road was built with teams and wagons."

Another Oklahoma farm boy, LeRoy Martin, helped build the road around Elk City when he was fifteen years old. "At that time they used horses, and that's what I did," Martin said. "I drove a team of horses hitched to what's called a Fresno, a piece of equipment that would scoop and dump dirt.

"It was a dirt highway to start with, you know, but then they run concrete in, and we went along. We helped put the dirt on to get it ready for concrete, and they concreted along behind us."

Allie Abla, who as a child had come to Oklahoma in a covered wagon, remembered the way the road was paved in his hometown of Erick. "They run it in slabs, just a section of it at a time, twenty or thirty feet long," said Abla, a tall man in overalls and a jean jacket. "Then the concrete would expand in hot weather, and cold weather it would draw up. It had to have space. I worked out there on the highway when they done it. We had to take it out if we didn't leave space because it'd buckle up."

Abla's sister, Rosetti Gephard, listened to her brother talk about paving the road and added her sense of what happened when they finished. "I remember they had a parade up through here when they cut the line between Texas and Oklahoma. Our club had a float on a flatbedded truck. We covered the truck with dirt and set out little bushes."

Down the road, in Canute, barber Garland Lowry had his own memories: "We had a street dance under the railroad trestle when they finished the pavement, the night before they opened it up to traffic. It took plum two or three years to get that road paved through town."

The last part of U.S. 66 to be paved in Oklahoma was a short section from Miami to Afton, which was completed in autumn 1937. With Oklahoma's penchant for celebrating such occasions, twenty-five hundred people turned out on September 14, 1937, to watch Governor E. W. Marland preside over a ribbon-cutting ceremony at the U.S. 66 bridge, on the outskirts of Tulsa. Later that day the city of Tulsa held a parade, with old cars leading the way, to celebrate completion.[24]

In 1929 there had been no concrete on U.S. 66 in Texas. "In 1930," according to Marita Bumpers, a former cafe owner in Shamrock, Texas, "they hadn't put 66 through. We had to open four wire gates between here and Amarillo." Not long after that the state began purchasing rights-of-way and grading the roadbed, and then construction followed. "It was something," she said, "the first time we got to go to Amarillo on the pavement."

Around 1934, Jesse Smith, a rodeo cowboy and farmer from McLean, Texas, worked on the roads with the WPA. "I loaded caliche [a chalky gravel] by hand, with a pair of mules and a little old two-wheel car," said Smith. "There would be two men with shovels on each side of the car, and we'd put the caliche down on the road." Smith spent enough time on the WPA payroll that he helped build several roads and did some dam work, too.

"When 66 opened at Shamrock, they had a parade to open it," said Smith. "I was in Shamrock then." Shamrock's first big parade was in 1938. It was a Saint Patrick's Day celebration, and it became an annual event that drew ranchers and townspeople from miles around.

Route 66 was paved in New Mexico about the same time it was completed in Texas. Several

years earlier New Mexico had created a State Tourist Bureau to lure vacationers into the "land of enchantment."[25] In 1935, Clyde Tingley was elected governor on a good-roads platform, and that same year the state government established a New Mexico Relief and Security Authority to help the unemployed secure work on federal projects, the great majority of which were road-related.[26] When Tingley was sworn into office, U.S. 66 in New Mexico was a combination of dirt, gravel, and some pavement. In December, 1937, paving was completed, and the old road, which had made an S-curve north to Las Vegas and Santa Fe, New Mexico, and then south to Los Lunas before it continued west to Grants and Gallup, was straightened between Santa Rosa and Grants and shortened by ninety-eight miles.[27]

Floyd Shaw, who had been an engineering student at Texas Tech University before he moved to New Mexico, was one of the surveyors for the U.S. 66 paving crews. "I didn't have my engineering degree," recalled Shaw, who later owned and operated the Club Café, a popular highway restaurant in Santa Rosa, "but I had enough knowledge to do surveying. I got a job with the state highway department and was the instrument man on the survey team. I worked there six years—most of it was on Highway 66.

"I started surveying twelve miles east of Santa Rosa, went on through town and then went west. When I first started on 66 there was no road to Albuquerque. There was the trail road [National Old Trails Highway], and you had to go around by Santa Fe to get to Albuquerque." By the time Shaw's job with the road crews was finished, the newly paved highway had been straightened and went directly to Albuquerque, missing Santa Fe altogether.

"When you construct a highway, during the construction itself there has to be a certain amount of surveying," he said. "I was actually on the construction crew. First they run through and

make the surveys, then they establish the line of the road, then they come back and build the grade. And then they put the surface on top of that."

Even though it was late in the 1930s when Shaw was doing roadwork, he said that much of the construction was done with animals rather than machinery. "A lot of the dirt was moved by trucks, but the finish work was done with mules and horses," he noted.

In Arizona, Bill Nelson remembered his father working as a cook for the road crews during the late 1920s. He also remembered, as a child, watching the teams of mules that were used to haul grading equipment across the northern part of the state. "They done a lot of work with mules," said Nelson, a leathery old boy with pale blue eyes. He has grown up to work on the Arizona Highway Department's maintenance crews himself, taking care of the same highway that his father had helped build.

The first pavement went down on U.S. 66 in Arizona in the 1920s, just outside Hackberry, a small community west of Nelson's hometown of Truxton. The bulk of the road construction in Arizona, however, did not happen until after 1930.

Even when federal funds became available, the road builders stuck to regular pavement and put off building bridges as long as possible. This meant that in eastern Arizona they built concrete dips through creeks and washes—instead of bridges across them—when they surfaced the highway. "That's where tourists would get into trouble," said Dick Mester, a former mayor of Holbrook. "They would see water in the dip, and when they tried to go around the water they would get in quicksand. As long as the water wasn't rushing or too deep, they could stay in the concrete and do just fine."

Robert Goldenstein, who was fourteen when his family moved to an Indian trading store, at Valentine, in 1936, noted that before the highway

crews built the bridges and paved the road in the western part of the state, Route 66 was "just dirt all through Arizona. A trip to Kingman [about fifty miles] might take two days if the washes was running." Goldenstein did not suffer for too long: by the end of 1937, U.S. 66 was a hard-surfaced highway from one edge of Arizona to the other.

Route 66 in California was hard-surfaced by 1934. That state, in fact, had taken an earlier and more serious interest in road paving than any Route 66 state but Illinois. As early as 1909 the legislature had authorized bonds for road building, and programs were already underway at that time to connect the far-flung cities of the westernmost state. The California highway commissioners began building with concrete early in the hopes that their original roads would last for decades. Unfortunately, they cut costs in the wrong places and learned the hard way that four inches of fifteen-foot-wide concrete was not thick enough and was far too narrow to bear the traffic.[28] So they started over in California before many state highway departments had even begun.

The path that U.S. 66 cut from Needles through the Mojave Desert to the Cajon Pass and the Pacific was a hard-surfaced road by 1934, replacing an original narrow strip that had followed a string of telephone poles across the desert. That road, perhaps more than other roads in southern California, carried a heavy load of traffic: in 1925,

Los Angeles had one automobile for every three people, and while not all those cars came in from the east, a good number certainly did. Moreover, the Los Angeles population doubled between 1920 and 1930, while the state as a whole showed only a 65 percent increase in population.[29] Again, at least some of that population had to have arrived by way of U.S. Highway 66.

And so, while the impetus to lay out the highway from Chicago to Los Angeles came from an Oklahoman, the pavement came first to California on the west and Illinois on the east, leaving travelers to struggle through red clay, sand, gravel, high creeks, and low bridges until the end of the Great Depression. When U.S. Highway 66 finally was fully paved in 1938, a person could step into an automobile on the edge of Lake Michigan, turn on the ignition key, put a foot on the gas pedal, and begin driving. For five days the person could drive south and then west, crossing farmland, woodland, plains, mountains, and desert but never, for one mile, leaving the hard surface of the road. The whole trip was on pavement.

The paving of Route 66 was the second dream —after the fact of the highway itself—come true. And it was the beginning of another kind of dream, a personal one, for thousands of people in the states through which the highway ran, for these people saw nickels and dimes and dollars in every car that rolled down the pavement.

CHAPTER 3 : **BUSINESS AND BALLYHOO**

DURING THE 1920s, when she was a small child, June Morris would often run down to the south edge of her grandfather's Miller, Missouri, farm to watch crews of men and mules and machinery as they graded and graveled the local highway and then covered it with a smooth surface of Portland cement concrete. Later, when she was a little older, she would sit on her grandfather's big front porch on summer afternoons and watch the traffic flash past on the road that had become U.S. Highway 66. On some days the telephone operators from the small towns to the east or west would ring up to pass on the news, and she and her friends would scramble down to the highway's edge to see the sights. Living next to Route 66 during her childhood, she saw matinee idol Douglas Fairbanks motoring east from Hollywood with his sweetheart—and America's—Mary Pickford; she watched a slow-moving flatbed truck carrying the great mirror to the Mount Palomar Observatory, in California; she waved at circus caravans and a variety of marathoners traveling cross-country for a cause of one kind or another. For a rural kid, Highway 66 was always the best show in town.

On other days June Morris would sit quietly on her grandfather's porch, probably sipping a lemonade, and listen to the local farm people who had arrived in their horse-drawn wagons to sit with her grandparents and share the marvel of the highway. More than once, as they contemplated the traffic passing on the concrete slab that edged the farm, she heard the men discussing ways to harness that stream of energy. "If I just had a dime for every one of those cars," June Morris would hear the old men say, "I'd never have to work again."

Ballyhoo and business—movie stars to look at and money to be made—were a big part of what Route 66 was all about.

In the 1920s a well-marked national highway was as much a novelty to Americans as a circus or a world's fair. Almost anything that happened on Route 66 attracted national attention and made its ways into the newspapers and newsreels of the day. Consequently, Route 66 played a leading role in any number of performances, most of them geared to luring business down the road or—in the case of Cyrus Avery and the Route 66 Association—to securing more pavement. For sheer outrageousness and worldwide publicity, nothing—not Avery, or the enthusiastic local publicists—ever matched the event that took place on Route 66 in 1928. In that year, when federal highway signs were barely posted and long before the highway was completely paved, sports promotion pioneer C. C. Pyle staged a thirty-four-hundred-mile footrace that began in Los Angeles, followed Route 66 through Chi-

cago, and ended in New York City three months later.

In those days, everybody in the United States seemed to be promoting something. Whether it was sports heroes or highways, everybody had a gimmick, and almost everybody had a willing audience. There were reasons for this: the birth and growth of the automobile industry had spurred the advertising profession to new heights, and seemingly unlimited advertising dollars encouraged a surge in billboards, brochures, flyers, magazines, and newspapers, including, in 1925, the first set of advertising jingles planted along a Minnesota roadside by the Burma Shave company.

Teleprinters and teletypewriters, radio, and moving pictures were beginning to give people a common knowledge of the day's events and a common culture. Heroes were being made daily as the world's records were being broken at a fantastic rate: Route 66 was commissioned the year after Richard Byrd and Floyd Bennett made the first successful flight over the North Pole, the year before Charles Lindbergh made the first solo, transatlantic flight, and two years before Babe Ruth hit sixty home runs for the New York Yankees. It was laid out at a time when people like Shipwreck Kelly gained national attention by sitting on top of a Baltimore flagpole for twenty-three days and seven hours. That made 1928 a natural time for Pyle's "Bunion Derby," a race guaranteed to make heroes out of ordinary people and an event so outrageous that it could not help but attract national attention.

The son of a nationally known evangelical Methodist minister, Pyle was well versed in what it took to get people to listen and pay attention. He began his career by buying up several movie theaters in central Illinois, but he made a name for himself when he persuaded University of Illinois football superstar Red Grange to turn pro and join the Chicago Bears. Pyle managed

Grange, the Bears, and himself into the national limelight. Besides Grange, Pyle also managed a number of other athletes into celebrity status. Sometimes criticized for promoting personalities over sports, "Cold Cash" Pyle was flamboyant and successful; his record was hard to argue against, even when the project in question was as preposterous as a thirty-four-hundred-mile marathon.

In 1927, when Pyle began to talk about his Great Transcontinental Footrace, he approached the Highway 66 Association for support. Pyle's idea was that runners from all over the world would gather in Los Angeles, run from town to town along the length of U.S. 66 to Chicago, and then run northeast, ending at Madison Square Garden, in New York City. The prize: $25,000 to the winner and worldwide publicity for the towns that chose to feed and bed the runners. The 66 Association, figuring that the publicity would show up the deplorable condition of the highway and force the appropriate government bodies into providing dollars and action, bought the idea. They even let Pyle hire their own promotion man, Lon Scott, to help build up enthusiasm for the race. Scott, to the dismay of Mr. Pyle, spent more time promoting the highway than he spent promoting the race.[1]

Despite Scott's lack of support, however, 500,000 spectators lined up on March 4, 1928, to watch Pyle's 275 starters run once around Ascott Speedway, in Los Angeles, and then take off on the first leg of one of the most amazing odysseys in sports history.[2] Along with well-known athletes from around the world, the original field—which had dropped to 199 by the second day—included an old man who walked with a cane, a young man who played the ukulele and was accompanied by two hound dogs, a long-haired actor who ran in the flowing robes of his biblical movie roles, a youth—the youngest participant—who celebrated his sixteenth birthday en

route, and a number of American Indians known for their long-distance running ability. There was a variety of other runners, many of whom saw the prize money as the answer to all their financial woes. Many of the athletes' trainers and families drove along with the runners, as did a hospital van, a sleeping bus for the press, Pyle's own luxury bus, a food van, and several other vehicles.

The Great Transcontinental Footrace was a true Highway 66 event. It included all the elements of the unusual, the commonplace, the exciting, and the crass. The runners were given heroes' welcomes in small towns that had never before had the world come to their front doors; they were greeted with proclamations by governors; town bands gave concerts and parades in their honor; and they were the subjects of a continuous stream of newsreel film, newspaper and magazine articles, and radio reports. They saw several of their number hit by automobiles, stopped in a Mojave Desert town that had no water to give them, saw the food concessionaire quit, had the race rerouted around towns that chose not to provide financial support, and saw Pyle's personal traveling van repossessed (although he did make a deal with the bank and got it back the next day). But that was all part of the times and part of the world that was growing up to be Route 66.

Day-by-day the runners made their grueling way east. Somewhere in the Texas Panhandle, an Oklahoma boy named Andy Payne moved into second place. Weeks later, when the footsore group finally shuffled into New York City and reached the finish line, Payne was first. A Cherokee Indian who had grown up on a farm in northeastern Oklahoma, near Claremore, Payne had entered the race for the same reason as many of the other nonprofessionals: he needed the money. The Depression may not have come officially to the United States until 1929, but much of rural America was suffering through most of the

twenties. Payne, who had left the family farm and hitchhiked to California to find a job that never materialized, saw the $25,000 race prize—long shot though it was—as one way to help out his family and also pay for a wedding for himself and the sweetheart he had left back home.[3]

It was fitting that the prize went to a Sooner: of all the states that the course went through, the people in Oklahoma made the most of the event. More populous than the states to the west but less "in touch" than those to the east and north, Oklahoma small towns were full of people who were eager to see what was happening in the rest of the world, and they looked to Route 66—as they would for thirty years—to fill that need. Route 66 was a highway, but it often served as a window for the rural people along its path, giving them a view of what was happening "out there" that they could not get as well from newsreels, radio, or even television. When Route 66 was bypassed, the window closed, leaving those small towns sitting stagnant and alone. But that all came later; in 1928, Highway 66 was good news to the isolated rural areas, and being there on the shoulder of the highway promised to be exciting if Mr. Pyle's Bunion Derby was any indication of what was to come.

When the runners reached Oklahoma City, more than a thousand cars followed them into town, and huge crowds lined the streets to welcome the athletes and cheer them on. At the state fairgrounds a special tent was set up for the runners, bands played, and the governor gave a prize to the first man into town. Not to be outdone by the state capital, Will Rogers offered a prize to the first runner into his hometown of Claremore. In all parts of the state children were let out of school, and people left their farms and offices to watch the field of runners lope past on still-unpaved Route 66.

"I was eighteen or nineteen when the runners from the Bunion Derby came through here,"

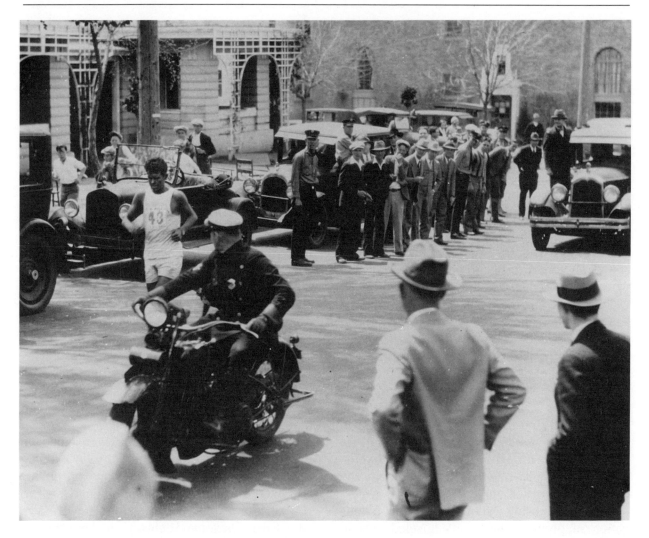

Bunion Derby, Tulsa, Oklahoma, 1927: Andy Payne ran east along Eleventh Street in Tulsa. Photographer: Hugh Davis, Catoosa, Oklahoma.

recalled Hugh Davis, of Catoosa, Oklahoma, a retired director of the Tulsa Zoo. "They were the biggest athletes in the world. We perched up on a wall for hours and watched the runners come along."

Eldred Condry, who came back to Route 66 after a military career to run a small motel in Tulsa, was born in 1910 in northeastern Okla-

homa. Seated on a green overstuffed couch in the shades-drawn living room of the motel manager's apartment, he said: "I remember the highway and Andy Payne. I was raised down in Lincoln County, at Stroud. I was standing right on the curb when Andy Payne came by and all the rest of the boys. You couldn't hardly get along the main street of Stroud that day. It was something!"

Jeffie Blair treasured the day she saw them run through Texola, Oklahoma, a dusty collection of buildings not too many miles from the Texas Panhandle. "I was standing right up the street. They came in here by the railroad tracks, then came down this street and around the corner on Route 66," she said. Jeffie stayed in Texola after the runners went by, grew up there, and eventually became postmistress. The year that she graduated from the eighth grade, she watched them pave the gravel road where the Bunion Derby had exploded into town. Much later she watched the town quietly close down as Interstate 40 lured away the traffic, but in all that time she never forgot those runners. "The one that won it," she recalled, "Andy Payne—he was an Oklahoma boy. He won $25,000."

A month and a half after they left Oklahoma—almost ninety days after they ran out of the Ascott Speedway, in Los Angeles—55 men out of the original field of 275 stumbled into Madison Square Garden, in New York City. There were no crowds in New York, no bands, and no official welcomes. Of the 55 finishers, only the first 10 received prize money, and they had to wait six days while Pyle arranged his finances so that the checks could be written, so great had been the drain on his pocketbook.

Despite the disinterest of New Yorkers, a delegation of proud Oklahomans traveled east to watch race winner Payne accept his $25,000 check. Payne went home a hero, Pyle—although he lost money on the exercise—went down in history as the P. T. Barnum of sports, and Route 66 was a little bit better known than it had been before. Pyle's Great Transcontinental Footrace was undoubtedly the biggest organized event ever to take place on Route 66, but both before and afterward, there were plenty of others.

Any circumstance that brought people down the highway was bound to benefit more than those intimately involved in the event, and the highway people knew that. Over the years, most often through the framework of the Route 66 Association, they worked together to promote Indian shows, athletic events, rodeos, regional fairs, tourist attractions, Pyle's footrace—anything that would make Route 66 seem like a destination as well as a way to get somewhere. The early speeches that Cyrus Avery had made at cities along the slab and the nonstop celebrations that were held by the Route 66 Association in the late twenties had been the first steps in fixing Route 66 as an entity in the minds of traveling America. "The Main Street of America" was a slogan that carried the same subtle message that made McDonald's Hamburgers great forty years later: Main Street (like the Golden Arches) was home. If a person was on Route 66, he was in a familiar place, and he was safe.

Members of the 66 Association spoke at every event even remotely connected to the highway; they held their own celebrations, which they used to garner local and national publicity; and they advertised. The U.S. 66 Highway Association paid for its first national advertisement in the July 16, 1932, issue of the *Saturday Evening Post*. The ad, which cost two thousand dollars and filled the left-hand column on page fifty-two of that issue, urged Americans to travel down "the Great Diagonal Highway" to Los Angeles and the 1932 Olympic Games. Noted the ad: "You stay on pavement longest going west. You get on pavement first going east."[4] Within a week of publication, the Route 66 Association office, in Tulsa, received more than seven hundred of the ad's cut-out-and-send-in coupons from people seeking more information.[5]

When he laid out U.S. 66 through country where life was rough and poverty was the norm, Avery knew that a highway would bring business to the Southwest. He probably did not realize,

however, the important role it would play in keeping towns and people alive through the tough years of the 1920s and 1930s.

In much of rural America, as noted above, the 1920s were hard times. The technology that had brought automobiles and highways also revolutionized farming, forcing small farmers to mechanize, upgrade, and buy more land just to stay in business. Many who could not afford to make the switch lost their land or sold it, and by 1929, 42 percent of America's farmers were tenants rather than owners.[6] As a result, neither the farmers nor their small rural communities saw much of the prosperity of the Roaring Twenties (which actually existed among only a narrow segment of the population anyway). In 1929, 60 percent of America's families earned less than two thousand dollars a year—24 percent of the total—and 21 percent earned less than one thousand.[7]

Had life been easy along Route 66, C. C. Pyle's footrace would have made money—but it probably would not have been remembered so vividly. Likewise, the move to highway businesses might not have been so quick, or so significant, for so many people. As it was, the near-poverty in which many people lived during the 1920s and the destitution of the 1930s caused them to look for new sources of income. One place they looked was Route 66. The move was a natural one: as cars improved and the roads were paved, travel increased. And all those people in all those cars needed places to eat, sleep, and buy gasoline. In 1925 the American Automobile Association predicted that tourists would spend $2.5 billion in communities along the highways during the summer months. The prediction for 1927 was $3.3 billion.[8] And so it was that while the rest of the country was suffering, people who lived near the highways saw opportunities—and dollars—rolling in their direction.

In 1920 no one really knew what a highway business was: they were not even sure about highways. By 1930, though, people had begun to find out. From Illinois to California, they enthusiastically joined in the retail petroleum business, selling gasoline and oil and other services to passing tourists. Almost as soon as they opened the gas stations, they began to build tourist courts for the travelers to sleep in and cafés where they could eat. Others learned to take advantage of resources offered by the passing parade, and the big bands played their way across the country in dance halls that sprang up in small Route 66 towns. Still others used the road itself, starting bus lines to carry people and truck lines to carry products more efficiently than the railroads could manage. And in the great American Southwest, they capitalized on native curiosities and mankind's ability to marvel at the unknown. Those first pioneering efforts at pumping gas, serving hamburgers, and offering souvenirs and overnight accommodations were the foundation for a whole new industry of highway service, one that did not seem to be affected by the vagaries of the economy the way similar businesses would have been in town.

In 1921, when a national system of paved highways was still not much more than a dream, Cyrus Avery built twenty-five one-room tourist cabins, a service station, and a restaurant on the edge of a farm that he owned outside Tulsa. "Each one of the individual units had a fireplace out in front of the door to fix meals and things like that," remembered Leighton Avery. "For washing, though, the guests had to go over to a central building which had showers and tubs—concrete tubs." People at the tourist court were expected to provide their own cooking utensils and food, plus bed linens, towels, and wash cloths. Nobody was surprised at that—most automobile travelers were used to camping out in those days, and

cabins, cooking space, and a bathhouse were real luxuries.

Leighton's wife, Ruth, remembered that Avery's fledgling highway businesses became local attractions as well. She said, "People would drive out from Tulsa, and while the station attendants were servicing the car, they would go in and have a full meal at the restaurant. The restaurant served marvelous fried chicken, mashed potatoes, hot biscuits, the whole bit. It wasn't just an ordinary place: it was one of the outstanding places to eat. That was when cars were new and people traveled for luxury and for excursions. That would be your day's trip from Tulsa, and you would eat your meal, get the gas filled up, and you would come back home. This was a full adventure." The Avery establishment was seven miles outside of town.

During those years Leighton Avery worked at the filling station. "I pumped gas, but the main thing that I did all during that time was to haul lumber and concrete to build the place. When high school got out for the year, my father bought a Model T, and we hauled all the rock, hauled the lumber, everything of that type. We hauled a lot of heavy rocks; some were surface rocks, but there were also limestone rocks that were pretty good sized." In the summer Leighton's cousins also worked at the station. "They enjoyed that work at the filling station where they could make some extra money," he said, but he noted that the station had a full-time employee who was not a member of the family.

Characteristically farsighted, Avery was one of the earliest highway businessmen. The businesses he chose—food, fuel, and lodging—were archetypal Route 66 enterprises. His method of operation, however, was not typical of most of those who followed him into the tourist mercantile. Avery, already financially successful from his real-estate and oil dealings, was able to pay other people to build his place and—his son

and his nephews notwithstanding—to hire other people to operate the businesses. The vast majority of those who established businesses on Route 66 were families with little money who not only constructed the buildings themselves but put in long hours serving the motorists and, more than likely, lived on the premises.

Peter Rossi, son and grandson of Italian immigrants, was one of those people. Rossi came to the highway instead of going underground to the Braidwood, Illinois, coal mines that had lured his grandfather from Turin in 1878. His grandfather and father had escaped from the mines to operate a successful macaroni factory, but in the 1920s, when young Rossi was ready to earn a living, he pegged his future on Route 66.

In the course of his career along the highway, Rossi built a grocery store, a service station, a restaurant, two motels, and a dance hall. His first venture was the dance hall. "It was in a grove of trees near the highway," said the short, chunky, bald man with the blue eyes of a northern Italian and the outgoing manner of a person with long years' experience in dealing with the public. "We built a couple of cabins near there, and my mother used to rent them out. They had no showers, no baths, nothing like that—just outside toilets."

Rossi said he brought in all the biggest bands to his dance hall, including people like Louis Panico, Danny Russo, and Art Kassel. "My dad and I would go to Chicago to the Music Corporation of America to book the bands, then I'd put up posters and run ads in the local papers to get people to come." More often than not, though, the bands stopped at dance halls like Rossi's to pay their way down Route 66 from Chicago to Las Vegas or Los Angeles.

Rossi's dance hall opened in 1927; in 1935, it burned down. "It was a big wooden building, and a bunch of leaves had blown underneath," said Rossi. "We didn't rebuild. It had gotten to be

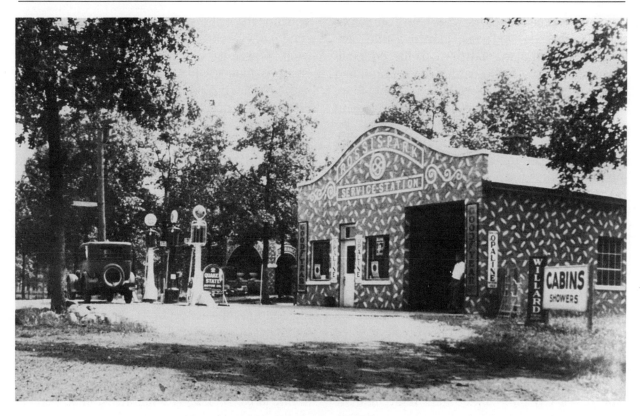

Rossi Dance Hall, Braidwood, Illinois: Peter Rossi was a builder. He built the dance hall, a service station, and a motel on Highway 66. SOURCE: Mary Rossi Ogg, Braidwood, Illinois.

too much trouble. In the beginning we said, 'You Find Your Romance for Ten Cents a Dance,' and we was making money then. Before it was over we got down to as low as letting them in for ten cents, and they danced for four hours." At those rates he could barely afford to pay his bands. Rossi was convinced that the end of Prohibition, in 1933, also marked the end of dance halls. "After liquor came back, every tavern would have a two- or three-piece group, and a few people would go to one or to another, and my dance hall would be sitting there mostly empty, and I would have a big band to pay."

Dance halls like Rossi's were highway businesses that reflected the times. They were inordi-nately successful during the 1920s and early 1930s, and then they all but disappeared as people's tastes and circumstances changed. Other businesses were as much a part of the highway as the pavement itself. The retail petroleum industry, for example, grew up with the good-roads movement, coming into its own just about the time that the National Highway Act was passed.

All along U.S. Highway 66 were petroleum pioneers, many of whom expanded or altered their businesses as the highway changed. Wyatt Patterson, patriarch of an oil-distribution and retail-gasoline business in Williamsville, Illinois, was one of those pioneers. Patterson had "done a little of everything I could to make money" be-

fore he became one of the state's first oilmen in 1926. He had operated a restaurant in a little town near Peoria, Illinois, had been in the concrete business ("that was too hard of work"), and had finally hired on with his brother-in-law and Standard Oil. "Then this wholesale business came up for sale in Williamsville, and my brother-in-law told me about it," Patterson said, adding, "The man who started this place had a daughter, and his wife thought the girl should be in the movies, so she made him sell out and go to California. The girl did get a few bit parts, but the guy who sold me the business became a beer delivery-man, and then he ended up becoming a drunk and died." So much, as far as Wyatt Patterson was concerned, for going to California to be in the movies.

A prominently displayed plaque in the brown-brick headquarters of Patterson Propane attested to fifty years with Shell Oil; another recognized fifty-five. "We bought from Shell," said Patterson, who was also mayor of Williamsville for a time and had a city park named after him, "and we used their brand name, but we were independent. We sold to everybody. We still do. Shell calls us a jobber, which means that we buy it from them on a contract, then we sell it.

"Just before we moved to Williamsville, they started putting up Shell signs, and they built a bulk [storage] plant in just about every county seat in Illinois. I got my brother to come down from Chicago and join me here, and when we bought this place, they wanted us to take a deal-ership on a commission basis, but we wouldn't do it."

Despite the automobile boom, the Pattersons sold far more kerosene than gasoline in their first years of business. "Everybody used kerosene for lamps and stoves," said Patterson, "and during the 1920s my brother, two drivers, and me all drove the trucks out to deliver to our customers."

Not too long after they bought the distribu-torship, the Pattersons began building stations where they could sell their products retail as well. "There weren't very many drive-in service stations then," said Wyatt Patterson. "Most gas was sold at curb pumps, and most of those were in front of grocery stores."

Tradition says that the first gas station, as well as the first motel, was born in the vicinity of Route 66. One of those first service stations—if not the first—was reported to have been built by the innovative Automobile Gasoline Company, of Saint Louis, in 1905.[9] The number of stations grew but not rapidly: in 1919 as much gas was still being sold in the United States at general stores and other similar establishments as at gas stations. That percentage changed rapidly during the 1920s, however, as people like Patterson saw the opportunity to separate the retail gasoline business from general merchandise stores. At the same time curbside pumps were losing favor with the general public: automobiles lined up on the street for service caused some of the earliest traffic jams. By 1929 gas stations sold 92 percent of the gas in the United States.[10]

Like others who had come to the highway, Pat-terson managed to keep his business going dur-ing the Depression, although it took some inge-nuity on his part. "The crash did not really affect Williamsville as much as a lot of other places," he noted. "The people here have good land, and they make good money." Despite the relative wealth of the area, though, the Depression found Patterson taking bushels of corn—worth eigh-teen cents at the time—in trade for fifty cents worth of gasoline. "I'd turn around and sell the corn to the grain elevator, and sometimes I'd get as much as twenty-five cents for it. Then I used that money to gamble farm futures on the Chi-cago Board of Trade." He stopped and took a breath. "I was a year and a half getting my money out, but I got it all back."

Dealing with the hometown folks was one thing

for Wyatt Patterson; dealing with the transients of the Depression was something else again. "In the early thirties the migrants came through here—hundreds of them," he remembered. "They promised us a lot of money and needed a lot of gasoline. They'd cry and promise to pay back what we gave them," he said, "and none ever did."

Wyatt Patterson managed to survive the Depression; another pioneer highway business down the road not only survived but actually grew during those hard years. John Geske and his father-in-law bought a wholesale oil business in 1928. Like Patterson, they saw opportunity in selling their products retail as well as wholesale. Unlike Patterson, however, and perhaps unlike anyone else in the country at that time, they aimed their business at a specific, fairly new group of people on the highways: the over-the-road truckers. Truck stops did not really become a significant part of highway business until after World War II, when four-lane highways and the new interstate system enabled truckers and trucking companies to carry goods easily across the country.[11] Nonetheless, even in 1928 there was plenty of truck traffic on a busy highway between two major industrial centers like Chicago and Saint Louis. "We had started an oil jobbership and were looking for an outlet for our products, so we leased a station on the highway at McLean," said Geske, by this time a grandfather who had relinquished operation of the family business to his son-in-law and grandson. "We saw that to make it prosper we would have to make it an all-night station. The truckers, who were the main people on the roads after dark, started telling each other to stop there."

To capitalize on the trucking market, Geske's father-in-law, J. P. Walters, began visiting the headquarters of trucking firms around the country. He developed a rapport with management of many of the companies and agreed to store their spare tires at his garage. "That meant," explained Geske, "if a truck had a problem we could pull out their own tire and put it on. Tire service was a must for us from the start. In those days the tires didn't last very long."

They named the place Dixie. "There was a time in this part of the country when people thought if they went south they would find more hospitality, so we thought Dixie was a good name. And it has proved to be that way. Dixie has had a friendly ring over the years," said Geske. "Besides, if we decided to sell out, the place wouldn't have our name on it."

As soon as it became an all-night establishment, the Dixie began serving coffee and sandwiches. "Then, of course," Geske said, "if you have coffee and sandwiches, pretty soon you have to have plate lunches, too." Food became such a popular part of the Dixie business that they took out a wall and expanded the dining room into the garage.

"From the beginning," said Geske, "we had grease spots on the counter from where truckers put their arms down while they ate or drank coffee. You had to be a mechanic in those days to get from Saint Louis to Chicago in a truck." At first they designated a special seating area for the truckers, but the truckers felt discriminated against and balked. "So we took down the sign," recalled Geske, "but they still congregated in one section, and ever since we've had two seating areas, one for truckers and one for car travelers, plus a counter—the truckers seemed to like that."

Like many other 66 businessmen in those early days, Geske and Walters used just the money they had and no more. Explained Geske: "Little by little we got on top. When we developed a little more cash flow, we began giving a line of credit to truckers. When we could do that, it helped our business a lot."

Whatever Geske and Walters did, it worked. The Dixie flourished. During the Great Depres-

sion business barely slowed down, and by the end of the 1930s the Dixie staff was serving meals to and pumping gas for a thousand people on a Saturday night.[12] "The place was always owned and operated by people with their own money in the business," Geske pointed out. "You can't buy that kind of interest, and I'm sure that was good for our business."

Illinois, with one of the first complete systems of paved roads in the country, was a natural place for people to go into the oil-and-gasoline business. However, since the trip from Chicago to Saint Louis was only a day's drive on Route 66, Illinois was not such a good place to provide campgrounds or overnight stops. In Missouri, on the other hand, where Route 66 took off for the great Southwest, the overnight camping–tourist

court–motel business boomed, and plentiful natural resources, such as oak forests and Ozark rock, enabled individuals to build a cabin or two or a small motel with a minimum of capital.

In the late 1920s, Emis Spears gave up life in Nebraska City and set out, along with his bride, Lois, and his parents, Charles and Lida Spears, in search of a place to open a tourist camp. Driving two new Model T Fords, they camped their way across the country, traveling first through the West and Southwest, then circling back into Oklahoma and Missouri, following the newly designated but still unpaved U.S. Highway 66. When they arrived in Lebanon, Missouri, the Spearses parked at the edge of the highway and took turns counting the cars that went past. The numbers must have suited them because they

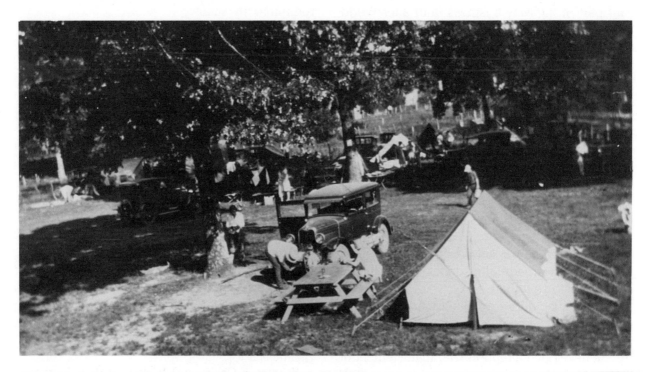

Camp Joy, Lebanon, Missouri, 1927: The Rural Mail Carriers Convention was held at Camp Joy in 1927. Photographer: Emis Spears. SOURCE: Joy Spears Fishel, Conway, Missouri.

decided to stay: they bought a square block of land alongside the highway and opened a campground. They named the place Camp Joy and began their venture by renting tents for fifty cents a night.

"They were making money hand over fist," reported Joy Spears Fishel, Emis and Lois Spearses' daughter, who had been named after the campground, "so my father and grandfather started building cabins right away. Tourism was in its infancy then," she said, "and there probably weren't more than a handful of places where you could stay in an individual unit. My father and grandfather built all those places almost single-handedly." Her parents had paid cash for the land, and as they could, they paid cash for the raw materials they needed to expand and improve the property. "They never bought so much as one piece of lumber that they didn't pay cash for," she said. That meant that Camp Joy, like most other tourist courts, was continually under construction or being improved.

Although there were exceptions, lodgings for automobile traveling Americans followed a consistent pattern in their evolution: from packing your own camping gear and stopping at whim along the roadside, to the development of public campgrounds, to private campgrounds, to tourist cabins, to tourist courts, and then—after World War II—the beginning of modern-day motels.[13]

The first cabins that the Spearses built were freestanding structures with no garages. Before long, however, drive-in car sheds were added; later, the sheds were turned into drive-in garages, with sliding doors into the motel rooms. Then as cars got wider and longer and would not fit into the drive-ins, fire walls were put in, and the garages were turned into more sleeping rooms. "Whatever happened, they just pumped the money back into the business. You have to do that," said Joy Fishel, "to keep any business growing.

"Daddy used to talk about fighting my grandfather to put running water in those cottages," she said. "Originally there was a bathhouse in the middle, and grandfather thought that was plenty. Dad eventually overrode him and put running water in the cabins. Later, when he saw that we should put in air conditioning, it was the same thing, but as soon as those things were done, my grandfather took full credit for the ideas!"

For a long time after cabins had replaced the tents as sleeping places, travelers still carried their own cooking equipment, fixed their dinners on outdoor fireplaces, and brought their own bed linens. "My mother and grandmother handmade all the curtains and the linens, and after people quit bringing their own linens, my mother and grandmother did all the laundry there for years," recalled Mrs. Fishel. Nor was it long before the travelers' cooking utensils could be left behind: Emis's aunt Daisy Henderson moved to Lebanon and opened a café in her house, across the street from the camp.

The entrance to the green lawns and tidy cabins of the Spearses' tourist camp was through an archway that said "Camp Joy" on the front side and "Teach Your Baby to Say Camp Joy" on the back. That sign and dozens of arrow-shaped cutouts were made by Joy Spears Fishel's father and grandfather during the long, less busy winter months. "One of the big events in my life was going with my grandfather in the spring to put up new arrow signs," said Mrs. Fishel. "We'd go way off up the road. He would check his speedometer, paint the number of miles on the sign in the back of the car, and then nail it to a tree."

Operating a motel was definitely a family business, and most of the time it took the energy of the whole family to keep a place going. The adults painted signs, built and remodeled the cabins, and made curtains, and the children did whatever they felt was appropriate. "I started renting cottages and carrying the ice water to the

units when I was nine or ten years old," she re-
called. "I've carried tons of ice water, and so has
my younger brother, Clark.

"I remember the glass pitchers and how we
washed them with muriatic acid to get the lime
out so they would be sparkling clean. My daddy
would buy ice in hundred-pound blocks and
keep it in an icebox. We'd take an ice pick to
crack the ice small enough for the pitcher, and
then I'd carry ice water to the rooms. They tipped
pretty good for it, too. They'd give a little ol' kid a
dime for bringing a pitcher of ice water." Indeed,
summertime along Route 66 often meant tem-
peratures of one hundred degrees or more, even a
thousand miles from the desert. Ice water and—
when it was available—air conditioning were
key items to keep tourists stopping at any of the
motels, and many of the stations lured custom-
ers by advertising free ice water for those who
stopped.

The customers in those early days often seemed
to be friends, if not a part of the family. "When I
was a child, we kept swings and lawn chairs on
the grounds," said Joy Fishel. "In the evenings
after supper, people would get out and visit. We
got really acquainted with a lot of our guests,
and they got acquainted with each other. TV
made a big difference, TV and air conditioning.
After those came in, people didn't want to get to-
gether and visit any more."

The Spearses, along with their counterparts in
the oil business in Illinois, were pioneers in de-
veloping the traditional highway businesses of
providing food, lodging, and fuel. During the
same period, though, another highway industry
was being born. Less orthodox and far less de-
finable was the living to be made by selling trav-
elers things they might want but did not really
need. This industry ranged from adventures, such
as were to be found by visiting Lester Dill's Mera-
mec Caverns, in Stanton, Missouri, to souvenirs
and crafts objects, like the baskets made at Clem-

entine, Missouri, by Amy Thompson and her
family.

Amy lived in a mobile home on the old high-
way southwest of Fort Leonard Wood, at Clemen-
tine, a community about six dwellings long and
not quite that wide. She had lived thereabouts
most of her life, ever since her family came to
the highway in 1929 from Cabool, a town deep in
the Missouri Ozarks. "My parents moved around
quite a bit," recalled Amy, a careworn widow
with the face and skin of someone who had spent
much time outdoors. "My brother had come up
here. He said it would be better up here to sell
our things.

"We made baskets, chairs, and things like that
and sold them on the highway. My father made
baskets probably about twenty-five years, and my
husband did, too." Supple strips of Ozark white
oak were the preferred raw material, she said, al-
though they learned to use other wood as well.
Theirs were the traditional Ozark baskets, some
with flat bottoms, some rounded: egg baskets
that a farm wife could carry over her arm and
wide, flat ones to hold kindling or fruit. Amy's
brother even wove baby cradles from the white-
oak strips. People in passing automobiles were
intrigued by the basketmakers and their wares,
and eventually Amy's brother opened a shop on
Route 66 where he sold his products, made more
baskets, and did woodworking.

Mrs. Thompson said that during the 1930s,
when the rest of rural Missouri was suffering,
their business was good. "People would come
along the road from California, New York, Flor-
ida. They would buy baskets, have us send bas-
kets through the mail; we made them to order all
the time. In the Depression we made it better
than almost anyone in the country here. That's
why other people got into the basket business.
Then business stayed good during the war."

The basket business that boomed on Route 66
in Missouri was not so very different from the

Indian-pottery business in New Mexico and Arizona, except that it was more limited and shorter-lasting. In both cases the crafts had been around for generations, but it took the advent of the automobile, highway pavement, and the American tourist to turn them into a way of making a living.

The pavement was also responsible for the birth of another highway industry: trucking. The first trucks had appeared around the turn of the century, when Americans began hooking wagons to the backs of their cars, but they were not particularly popular. They broke down often, and because of general road conditions, their initial usefulness was limited to city deliveries. By the time the United States entered World War I in 1917, there were only 300,000 trucks in the entire country.[14] Wartime experience with the new vehicles, however, plus better roads and mechanical improvements, changed public opinion, and after the war the truck population increased rapidly. In 1920 there were more than a million trucks in use. Nonetheless, trucking was still an embryo industry with no formal regulations to govern the materials to be transported, the qualifications of the drivers, the size or the weight of the vehicles, and no real understanding of the potential value of trucks to everyday life.

In 1926, when Frank Campbell decided to start a trucking company, he was pretty much a cowboy looking for ways to make money with his two trucks. Despite the fact that his hometown of Springfield, Missouri, was a thriving farm center on newly designated U.S. 66, neither he nor his customers were quite sure what he should be doing. In those first years he spent summers hauling timber for the telephone company. Winters he began to transport butter from a local creamery to Kroeger food-store headquarters, in Cincinnati.

"There wasn't nothin' to do in the winter and wasn't no long-distance trucks yet. We did some moving, anything that would bring in a nickel," he remembered. He was a deep-voiced old man and sat behind a big desk, just across the wall from where dozens of his trucks were parked and serviced. "Then after butter, we started haulin' meat out of the Swift Packing Company from Kansas City to Springfield."

Although that was still in the days before trucking had come under any kind of regulation, hauling meat proved to be a real challenge for Campbell's fledgling company. "The Frisco railroad was strong in Springfield," he pointed out, "and any merchant that used the trucklines was called on by a delegation from the railroad. We used to deliver before daylight—leave our load inside the screen—then go back after daylight and get the bills signed." Eventually the railroads became organized in their antitruck tactics, and the "visiting delegations" were joined by high-pressure lobbying in state capitals and in Washington to limit the size of trucks allowed on the roads. Around 1930 states began imposing length restrictions on tractor trailers.[15] Then the federal government got involved and passed the Motor Carrier Act of 1935, which called for safety and economic regulation of interstate carriers.

The paved highway through Springfield enabled Campbell to expand his business from two trucks and odd jobs in the 1920s to a network that served forty-five terminals in nineteen states by the late 1970s. Likewise, the pavement through Oklahoma—or lack of it—was a key element in the success of another early-day transportation business. Route 66 was a rough road in many places, none more so than the stretch west from Oklahoma City to Amarillo, the route where Whit Lee operated a bus line. About the time Franklin Campbell bought his first truck, Lee quit his job as a cowboy, bought a buggy, and went into business taking people from the railhead, near Hammond, to destinations in that part of central Oklahoma. By chance Lee happened to see a

local rancher, unfamiliar with the nuances of driving, run a new car into a stopped train. On the spot, Lee traded his horse, buggy, and a hundred dollars for the rancher's car. He operated the new taxi service for a while and then moved his family down Route 66 from Hammon to Clinton, Oklahoma.

In Clinton, Lee sold used cars and then opened a Hudson agency and taxi service. Almost immediately, he had more customers than his taxi could hold, most of them seeking rides to Oklahoma City, ninety miles away. So he innovated, taking advantage of his association with Hudson automobiles. "Dad got the idea that he would take a Hudson Brougham, which carried seven passengers, cut it in the middle, and put in two extra seats," related Lee's son Bob. "That gave him space for eleven passengers and one driver." By late 1925, Lee—with associate Hugh White— was operating a bus line from Clinton fifty miles east to El Reno, where passengers caught an interurban train to Oklahoma City. Within two years White had been bought out, and the company was renamed LeeWay Stages. The Lees moved LeeWay Stages to Oklahoma City in 1930, where it became the main service to Amarillo and then carried passengers on to Albuquerque and Raton, New Mexico. By that time thirty-three million people were riding buses in the United States, and buses had become an important means of cross-country travel, despite the uncertain conditions of the roads.[16]

"The Depression saved us in the bus business," said Bob Lee. "People couldn't drive as much as they used to, so they rode the bus. The Depression kept us alive." But just barely. Lee's father often rode the bus himself to collect cash fares from customers. "Dad would make a round trip from Oklahoma City to Amarillo and back, and hopefully would come up with enough money to meet the payroll that week," Lee said ruefully. Often as not, he would find himself handing out free rides on those same trips. "A fellow would get on a bus or go talk to Dad, give him a story, and promise to pay later. This went on, not just with bus rides but with everything," related Lee. "The Savings and Loan Association, which had been a big lender to Dad, listened to him when he walked in and said, 'Look, you can have the buses, or I can pay you back if and when. But I will pay you back.' The Savings and Loan didn't want a bus, so that's how it started. That's how you operated—on faith—and I'd say 95 percent of the people out there paid off their debts. That's been the life-style out there: faith and a belief that everybody's honest. It's one of the great characteristics of Oklahoma and West Texas people."

Faith was important, but out west of Shamrock, Texas, and especially west of Amarillo, the people counted on the highway: there was not much of anything else around. East of Amarillo all the way to Chicago the country edging Route 66 supported other kinds of commerce, particularly various types of mining and farming, although the methods and results varied tremendously from soil-rich Illinois to rocky, wooded Missouri and the dry plains of Oklahoma and Texas. Travelers who followed Route 66 south and west saw the changes in the countryside, saw the towns move farther apart, saw the trees bowed over from the unceasing south wind in Oklahoma, and knew the Cap Rock—the place in the Texas Panhandle where Highway 66 rolled down off the land of farms and ranches into the beginnings of the desert grassland and red-rock country that dominated New Mexico. From there, all the way to Albuquerque, the land supported few people and fewer towns.

The railroad had not reached that part of the world until after 1900, and the population, such as there was, had followed the railroad. There were only 423,000 people in the whole state of New Mexico in 1930, and most of them were west of Albuquerque.[17] As people migrated into east-

ern New Mexico from Texas or from other parts of the country, they either ranched or turned to the highway for their living, opening what were becoming traditional highway businesses: service stations, tourist courts, and cafés. Despite the Depression, people could find work to do along Route 66. Some of them became well-to-do; others took advantage of Route 66 many times, opening dozens of businesses in as many years at various points along the highway. When one business did not work out or needed to be moved, they were able to start another one. And all that time, the traffic just kept coming.

Joseph Smith was reared in an almost quintessential Route 66 environment, in Santa Rosa, New Mexico: his mother ran a hotel next to the railroad tracks on one side of the highway, and his father ran a campground, a motel, and a service station on the other. Smith's father, a Texas rancher who had come to New Mexico during territorial days, had moved his family into town when it was time for his children to attend high school, buying the hotel for them to live in and building the tourist court across the street. "It was Camp Verde and Hotel Verde," said Smith, a distinguished white-haired man who eventually became a petroleum wholesaler and moved to Albuquerque. "The buildings were all painted green at the camp, but the hotel was white— white adobe. Local salesmen stayed at the hotel, and traveling tourists would stay at the campground. Our biggest group of travelers came from Oklahoma and Arkansas, all on their way to California. We had people out of the oil fields in Texas and Oklahoma—they were rich. The poor farmers who came through blown out of the Dust Bowl, they didn't have any money at all."

When Smith was in high school, he worked like most other tourist-court kids: he delivered ice, newspapers, and groceries; swept out the tourist-court office; and at four o'clock every afternoon, built a wood fire for the hot-water heater and kept it going until about nine at night. "Some of the cabins had to share common showers, and they cost $1.25 per night," he said. "The other ones had private showers with hot water piped in, and they were $1.75."

The campground had a service station in front, an office, and a grocery store, in addition to the cabins and the shower house. "In the evenings," he remembered, "the tourists would come and visit. In the winter they'd come into the little office and sit around a potbellied stove. In the summer we had chairs and benches along the front of the store, and they would all visit about the day's travels. I'd learn a lot about the country by listening."

When the service station opened, they handled three separate lines of gasoline: Mobil, Continental, and Standard. "After a year or two," Smith recalled, "the oil companies came in and said, 'Choose,' and my dad chose Standard. We were station number 115." As station number 115, the elder Smith was a dealer. Later, when Joseph Smith went to work for Standard Oil, he worked his way up to manager of a Standard-owned station. "In those days, they built their stations," he said, "and we had to wear white uniforms and shined shoes, and they taught us things like salesmanship and business. I started by cleaning restrooms and windshields. If I stayed with them and progressed, I would become assistant manager and manager." World War II interrupted Smith's career, and when he returned from military service, he put in a request for a wholesale business instead of a station. That was done, and he became proprietor of Smith Oil Company, in Santa Rosa, eventually owning several retail stations in addition to his jobber business.

That was the way it was east of Albuquerque: people came to the highway. West of Albuquerque, it almost seemed as though the highway came to the people instead, as natural wonders, age-old arts and crafts, and unusual ways of

life became the focus for highway business. Route 66 came to the Acoma Reservation where Juana Leno grew up, and it brought her customers for the pots, water jugs, and dishes that she made. Pottery, a traditional Acoma craft, had been handed down to Juana by her mother and her grandmother. From them she learned which berries to use for coloring the pots, where to dig for the clay, and how to build the fire just so when the dried pots were ready to be fired. She learned how to make coils of clay and how to mold them into the traditional wafer-thin Acoma pottery, and she learned the designs that her mother and her grandmother had been taught by their elders.

"When I come home from boarding school every summer, my sister and I would set up stands and sell our pottery to the tourists over on the highway," she remembered. She was a stocky, dark-skinned woman with gray curled hair and gold-wire glasses. "The pots on 66 were cheap: twenty-five cents apiece, or thirty-five cents. Ashtrays we used to sell for twenty-five cents now bring five or six dollars, and tiny flower vases bring fourteen or fifteen dollars.

"Sometimes we would do pretty good and sell maybe ten pieces. We'd get up before sunrise and put the pots in the fire. About eight or nine o'clock we'd get them out, and then we would walk across the pasture two miles, carrying the pots on our backs in a box, and sometimes on our heads." Occasionally, a buyer from Tucson would come to her village of Acomita, bringing blankets and shawls to trade for their pottery. "We would usually trade something to him," remembered Mrs. Leno, "sometimes clothes, but also money. Some of the other traders who came around used to trade dishes and that sort of thing."

Mrs. Leno grew up, married, had children, and spent much of her adult life working as a housekeeper for well-to-do Anglo people near the Acoma Reservation or working as a maid in the motels that dotted the edge of the highway. During all that time she continued to make pottery, perfecting the craft that her mother and her grandmother had taught her and employing the traditional raw materials and methods for her pots.

Although the highway provided an easy outlet to the Indian women for their wares, the impetus to sell their craft objects had begun decades earlier, when Fred Harvey and the Santa Fe Railroad promoted railroad tours through the exotic Southwest and learned that art was a valuable way of selling prospective tourists train rides to New Mexico.[18] Harvey House hotels and restaurants, strategically located at the Grand Canyon, Santa Fe, Albuquerque, Gallup, and other western communities, purchased large amounts of native artwork, which they in turn sold to tourists who stopped there. In 1902, when the Alvarado Hotel opened in Albuquerque, one of the features of the place was a museum with $75,000 worth of Indian curios on display.[19] What Harvey and the railroads began, however, the highway continued.

Two factors combined almost by accident to make Indian crafts such as Mrs. Leno's pottery a major highway business. The first thing that happened was a general renewal of interest in Indian art. In 1925 an Indian Arts Fund was established in New Mexico. It was dedicated to preserving, collecting, and studying all Indian art.[20] A couple of years later the Indian schools began encouraging students to learn more about and practice their native arts and crafts.[21]

While culturally oriented New Mexicans were busy encouraging the Indian artists, businessmen—taking a hint from the Harvey operation—saw profit opportunities. In 1922 the Gallup Chamber of Commerce, with the support of two influential cultural groups, organized the first Inter-Tribal Indian Ceremonial to attract tourists to

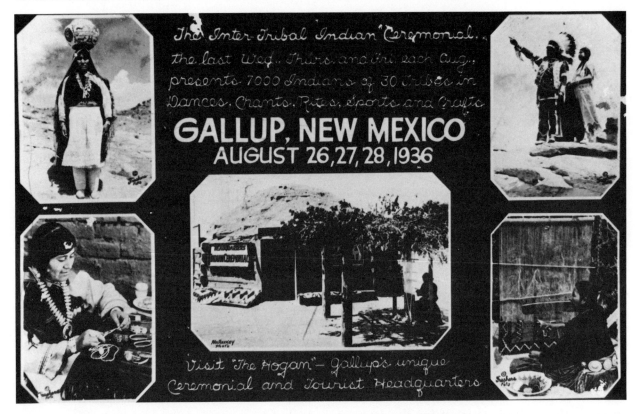

The Inter-Tribal Indian Ceremonial...
the last Wed., Thurs. and Fri. each Aug.,
presents 7000 Indians of 30 tribes in
Dances, Chants, Rites, Sports and Crafts

GALLUP, NEW MEXICO
AUGUST 26, 27, 28, 1936

Visit "The Hogan" — Gallup's unique
Ceremonial and Tourist Headquarters

1936 postcard of the Gallup Ceremonial. SOURCE: Hugh Davis, Catoosa, Oklahoma.

the area and introduce them to the Indians.[22] The Ceremonial, which became an annual August affair, included several days of competition and exhibitions by various tribes, showing off different aspects of Indian life, not the least of which were native arts and crafts.

During the first years, when the road to Gallup was dirt and gravel, the Ceremonial limped along as a strictly local promotion. As improvements in the road and automobiles made travel easier, the Ceremonial gained popularity. In 1939 it was singled out by the New Mexico legislature as the state's outstanding tourist attraction and given status as an official state agency with an annual appropriation from state funds.[23] Eventually it was relocated to its own home in New Mexico's Red Rock State Park, north across Highway 66 from Gallup.

"The Ceremonial was started by Mike and Dean Kirk, C. G. Wallace, John Kennedy's father, old man Turpen, C. N. Cotton—all of them traders," said Martin Link, who became Ceremonial administrator following a career as museum director for the Navajo tribe.

"It was begun as a tourist attraction and to educate the American public in Indian arts and crafts. It is the only celebration of this kind with more emphasis on top quality arts and crafts

than on the dancing, and it is all done for the Indians. If I owned a Kachina doll, for example, and entered it in the art competititon and won, the prize money would go back to the maker, not to me."

Because of Gallup's location between the vast Navajo reservation and the thoroughfare that became U.S. 66, it was a natural site for an annual Indian festival. Many of the town's leading businessmen in the 1920s were either Indian traders themselves or the sons and nephews of men who had spent much of their lives pursuing the mercantile trade on the reservation. They were the ones who originated and supported the annual Ceremonial and the ones who stood to gain the most from the traffic it brought into town.

Although there had been Indian traders in the United States since the country was born, it was late in the nineteenth century—after the acquisition of New Mexico Territory, after the Civil War, and after most of the Indian wars—that the traders became a force in western New Mexico and Arizona. Armed with licenses from the federal government, they were chartered to do business with specific tribes in specific locations. In the early days they provided Pendleton blankets, cloth, foodstuffs, and tools to the Indians in exchange for cattle, wool, and sheep. In the 1920s, when their Indian customers began to own automobiles and trucks, the traders left the reservations and moved into town. From that point, when the clients lost their total dependence on the government's licensees, the trading business began to change.

When Tobe Turpen's father moved off the reservation into Gallup in 1926, he opened his trading store on the north side of town, the area where the Indians came to do business. In those days traders like Turpen would buy the spring crop of lambs on speculation—and issue credit. Likewise, when the Indians came to purchase supplies, they paid with slips of paper that carried notations on how many dollars' worth of credit the individual had at Turpen's trading company. The craft objects appeared between times—before the roundup and after the credit slips were used up.

"We got into the jewelry business because Indians brought that stuff into our store when they didn't have any money," recalled Turpen, a third-generation Indian trader and namesake for the founder of his company. Seeing Turpen in his carpeted office, which was richly decorated with fine Indian crafts and was just down the hall from a showroom filled with quantities of shining turquoise and silver Navajo jewelry, tightly woven baskets, brown and black Acoma pottery, carved Kachinas, and multicolored Navajo rugs, made it difficult to imagine a time when those items were less than welcome, but even as late as the 1920s, Indian craft items were not easy to sell. Hence the Ceremonial.

By the 1930s tourists were becoming a regular part of the western landscape, and the traders, including Turpen's father, added a new wrinkle to their trading business. "When the tourists started to pass through here, we all began to need a store on the main street where we sold the blankets, pottery, and jewelry," said Turpen. "In those days it was important to have a business near the motels and campgrounds—the places where people stayed when they came to town."

There was a good reason for going to the tourists: cash.

"Today if someone brings in a rug and we want it, we pay cash," said LeRoy Atkinson, who came to the Indian trade in the thirties and grew to be a large wholesale dealer in native arts and crafts. "You don't have to go to the trouble of giving them socks and shoes and canned goods—you just give them money, and they spend it where they

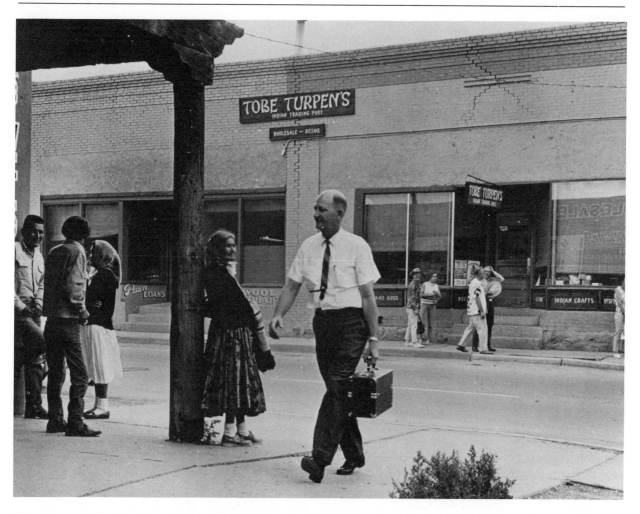

Tobe Turpen's Trading Post, Gallup, New Mexico: In 1927, Tobe Turpen, Sr., opened a shop on Front Street, in Gallup, near the hotels that served travelers on Highway 66. SOURCE: Tobe Turpen, Gallup, New Mexico.

want. But back before World War II there was no such thing as money. They would bring in a rug, and we would give them ten dollars for it—a dollar in cash and the rest in credit," he said, describing the cash-poor economy of the still-isolated Southwest.

"We took Indian jewelry, rugs, and that kind of thing, but it wasn't easy to dispose of. We finally built a store out on the highway—that was about the only way we could get any cash."

After World War II the traders became competitive in their efforts to get cars to stop, and one shop's gimmick became more outrageous than the next. Before the war, however, the shops themselves were novelty enough for the tourists as well as the traders, who were still dealing with

wool and cattle but were earning more and more of their income from the highway trade.

During the 1930s, Route 66 inched westward. As glad as people had been to see the pavement in New Mexico, they were even more pleased in Arizona. Like New Mexico, Arizona's economy before World War I developed around the railroad that ran through the northern part of the state and what business could be generated by dealing with the Indians. When the highway came through, the enterprises that existed for the railroads and the Indians were translated into new forms to serve the automobile-driving public. Holbrook and Winslow, which had been railroad towns, became highway towns. In Winslow, Indian traders like the Bruchman family opened shops with an eye to the tourist trade, and in Holbrook, the nearby Painted Desert and Petrified Forest National Monument took on new significance as automobile tourists made their way down Route 66.

Jack Fuss was one of the people who helped see to it that travelers on the highway found their way to the natural wonders that filled northern Arizona. A native of Philadelphia, Fuss attended the Academy of Fine Arts there before moving out west to Arizona, where he worked as a cowboy, Grand Canyon guide, taxi driver, game warden, and government naturalist before he came into his own as an artist of the highway. Fuss's career in the sign business spanned the heyday of highway travel, from 1925, when people were first beginning to drive across the country, to 1972, well after the federal Highway Beautification Act had limited the number of signs that could be placed along the roadside. "I built big road signs," said Fuss, a garrulous old man who wore the requisite silver-and-turquoise tie slide and lived with Marie, his wife of sixty years, in a stone house on the road leading up the mountainside from Flagstaff to the Lowell Observatory. "The signs were ten feet by thirty or forty feet. I

had them for the Painted Desert and Fred Harvey places: I had signs for the Painted Desert at Holbrook, and in Winslow I had eight signs for Fred Harvey. At Williams, Ash Fork, Seligman—I had signs at all the Harvey Houses. I built the signs and kept them painted and rented them by the month.

"I did signs for local businesses, too. Any business that wanted to rent a sign, I'd paint them one."

Fuss spent several years roaming around the West before he moved to Flagstaff and ran a taxi service in 1918 and 1919. "The taxis were the first cars in town," he said with some pride. "I took a lot of people out on trips and up to the Grand Canyon. I used to take four or five schoolmarms to the Canyon every Sunday. When I had my taxi there was no government at the Canyon, and you could camp wherever you wanted. Twenty feet down the Canyon was a cave, and I'd take these girls down there to camp overnight. They'd take their little bedrolls, and we'd have a hell of a time!" Fuss's home was filled with treasures from those days when Arizona was still the "Wild West": a trophy deer's head over the fireplace, shards of prehistoric Pueblo pottery, Indian beadwork, and a fireplace that he built of petrified wood from out near Cameron, where he and Marie had lived on a trading post for a few months after their marriage. The house also contained a number of paintings by Jack Fuss of the people and places he had come to know in his long life.

He began painting signs one summer when he worked at a lumber camp. "I was boss painter, and I earned ten dollars a day, plus room and board. I painted all the signs they needed: the ones that said "No Trespassing" and things like that." His career began in earnest when an elderly German man who owned the Commercial Hotel in Flagstaff sought him out. "He said to me, 'Why not make a sign and rent it to me?' I thought that was OK, so I built a sign and rented

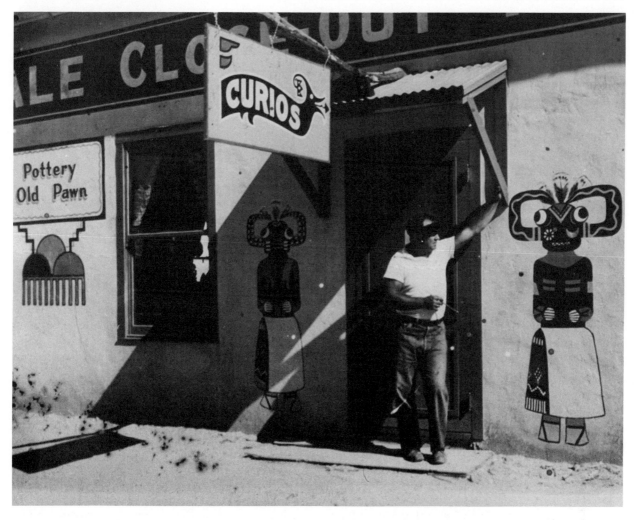

Sign painter Jack Fuss, Flagstaff, Arizona: Fuss painted signs on souvenir shops and gas stations, as well as signs along the highways in Arizona. SOURCE: Margaret Learn, Jack Fuss's granddaughter, Flagstaff, Arizona.

it to him for ten dollars a month. After that I just began to expand like an octopus, up and down the highway. I was eighty when I quit—afraid I'd fall off the scaffold." For Fuss, the sign business included far more than just designing and painting. "I rented spaces to put up the signs from people who owned the property. I paid rent yearly, and my customers paid me monthly for the signs.

I used to camp while we were building the signs. It was too much trouble to pack up the paint, tools, and so forth every night. I'd take my lumber, the tools to dig postholes, the paint; that was a lot of work."

Fuss's signs lined the highway across northern Arizona and decorated the sides and backs of several buildings in the town of Flagstaff. "I built the

signs for the Meteor Crater, six of them," he said. Another time he painted an eighty-by-thirty-foot scenic panorama of mountains, forests, and wild animals on the back of the Orpheum Theatre to advertise Flagstaff's Boulevard on the Peaks and lure tourists off the highway through town.

When he was not painting signs, Fuss occasionally did a stint painting scenery and other needed background for the movie companies that filmed on location in that area. And when he was too busy, he hired "floaters," itinerant sign painters who would stay a month or two and work for him before moving west down Route 66.

Another of Fuss's projects had very little to do with sign painting but a great deal to do with the highway. Not long after the Ceremonial got under way in Gallup, some canny businessmen in Flagstaff hatched the idea of their own Indian event to augment an annual Elks Club Fourth of July celebration. Once they had the idea, they went to Fuss for help.

"Jack traveled all over painting his signs," explained Flagstaff insurance man Andy L. Wolf. "He knew the Indians. He went to the Navajo supervisor and promised that if they would allow the Navajo off the reservation for the show, the Powwow would feed them, take care of them, and make sure they got back safely." Wolf, a big man who looked like the former college football player that he was, sat in his plaque-decorated office in Flagstaff's Monte Vista Hotel, a place that had been built in the late twenties by local businessmen to serve the highway traffic. His involvement in the Powwow did not even begin until the event was well established with nearby Indian tribes, townspeople, and the touring public, and he was more than eager to give credit to Fuss.

Fuss remembered the travel, the meetings, and the personal promises he made to turn the Powwow idea into reality. "They gave me three hundred dollars to go out on the reservations and get the Indians," he recalled. "I closed up my sign shop and went to Tuba City [on the Navajo Reservation] and told them we wanted to do an Indian show. The supervisor there said, 'You've got to be responsible for them,' and I agreed.

"Then I went out to the Gap Trading Post and took Joe Lee and Preacher Smith, who were the most loved out there, and we put on a little sing to tell the Indians what I wanted. I still have the contract—it's signed with thumbprints. Joe, he talked Navajo like an Indian, and he promised we would feed and take care of them and their horses, then I went to the Hopi village and met the head of the Hopis. He liked the idea and gave me a Hopi prayer feather and promised three good dances: Horse, Hoop, and Butterfly. Then I went on to meet with the head of the Maricopa and talked with them."

When it was all put together, the Powwow became a week-long event. The Indians—representing as many as fourteen different tribes—competed in a rodeo in the daytime, with wagon races and chicken pulls—"nothing for the queasy," said Andy Wolf. In the evenings, in the flickering light cast by big bonfires, they performed traditional dances, chants, and other ceremonies for the tourists.

To get ready for the Powwow performers, Fuss said he bought five tons of hay so that every Indian family who came by in a wagon got two bales for their horses. "I had the bakery bring a truckload of bread every night, and I got five tons of flour from Tuba City and gave each woman a sack of flour. Then we had a truckload of twenty-five live sheep. I distributed them alive to the women of each group to feed their group. They butchered them right there, all the mutton they could eat and take home."

For the program, Fuss and his sons built a round Hopi ceremonial hut called a kiva in front of the grandstand and a stage set of another Indian structure next to an artificial spring of water. "I had a Hopi brave come out of the kiva each

night and announce with a megaphone. The show always was started by two Indians with white horses: the horses would drink at the 'spring' while the Indians performed the Navajo Chant at the Water Hole. It was beautiful."

Fuss ran the Powwow for five years, and during that time, he said, "it was an all-Indian Powwow. There were no white men in the deal. I stayed out of the picture entirely except to pay the top men every night in cash after the ceremony."

He remembered the year 1933 with special relish. "The banks had closed just before the Powwow, and our chamber of commerce thought we should postpone it. I said, 'No way!' and on the Fourth of July we had the Hopi band standing in front of the Flagstaff bank with black crepe on the bank door. The band played 'Bury Me Not' for us, and everybody was so tickled it broke the silence and brought a lot of money into town. I saved the show that year." Not long after that, Fuss gave up his role in the event. "The sign business was too busy in the spring," he said, "but when I gave up the Powwow, it was in good shape, damned good shape."

Beginning in the mid-twenties, when Fuss painted his first signs, and continuing through the Depression and up to the beginning of World War II, Fuss's customers were increasingly aware of the tourists on their highway and the need to get them to stop and spend money. Over the years, the signs—and not just those built by Jack Fuss—got bigger and bigger. Across the Southwest the Whiting Brothers gas-station chain planted bright-yellow signs that were three hundred feet long and six feet high and were painted with red letters.

"It seemed like those colors would show up," said Arthur Whiting, the last living of four brothers who expanded their gas station in Saint John, Arizona, into a chain of stations and motels that stretched from California to Oklahoma. "We was in the lumber business to start with. We had a lot

of lumber, and those signs provided us with a lot of advertising."

The Whitings started to build stations after 1926, when they realized that U.S. 66 was not going to come through Saint John as the Old Trails Highway had. "We started in Saint John with one little gas pump," said Whiting. "Then when we came up to Holbrook, we bought out the Ford dealer. In order to expand we took on the Union Oil Company as commission agents, but when the independent gasoline business opened up in New Mexico, we dropped Union and began trucking gasoline out of New Mexico. We undersold the majors to the point that it was a lucrative business in those days." After Holbrook they went to Winslow and then moved on and built a couple of stations in Flagstaff.

"We slowly moved up and down the line," said Whiting. "You didn't have to have real fancy buildings in those days. You could get by with just about anything for a building if you had some gas pumps." The expansion continued even during the thirties. "We could do it," explained Whiting. "We had a little lumber mill out here, we could get lumber cheap, and we could make a little gas station for almost nothing. A couple of gas pumps and we were in business."

The stations themselves were operated on a commission basis, with the operator sharing profits with the Whitings. "And we always built a house right with the station on the premises, so we provided their living quarters and the utilities, and we made them a minimum guarantee, but they could make more if they sold more gasoline. We liked that because there was an incentive there to work."

The Whitings kept building stations, and their customers kept coming down Route 66, even during the Depression. "You know people were going through here from Oklahoma, and our gasoline was the cheapest along here—twenty cents, nineteen cents a gallon. We were far un-

der the major oil companies, so we were just in tall timber." As independents the Whitings could buy gasoline in bulk from the major companies and sell it for less than the name-brand stations owned by the oil companies were allowed to do.

They expanded their chain the same way that the Spearses in Missouri fixed up their tourist court: as they had the cash available. "We never did borrow money, never did in our lives," said Arthur Whiting. "We'd get some surplus in the bank, and we would invest it in our own outfit. We never did buy stocks or bonds or anything. If we had some money, we'd build a station or a motel."

In 1930 the Whitings introduced a white discount card as a gimmick to get people to stop at their stations. "We used to give these little cards with all our stations listed on it, and it entitled the person to a one-cent-a-gallon discount. That worked real good. People would wear those little cards out and come in for another, to get their discounts.

"But we never did deal in credit until they started Master Charge. Our customers were poor people going through and the poor people locally. You couldn't give gasoline to poor people on credit or you'd be broke in thirty days," said Whiting. "A poor person can be a good person

and a good friend, but that is the person we dealt with both locally and on the road: people with a mattress tied on top of their car and getting through the country from Oklahoma cheap as they could, you know. Good people, but you couldn't extend them credit."

Despite their reluctance to issue credit, the Whiting brothers and other businessmen and women on Route 66 noticed that even the most down-and-out travelers had some money to spend, and they were only too glad to give them an opportunity. Unlike many other parts of the United States economy, highway business remained relatively good even during the darkest years. Some observers have even suggested that the Depression actually encourged the growth of the motel industry, forcing owners to upgrade and modernize in order to keep business.[24]

Sometimes business on Route 66 was a torrent, sometimes it was just a trickle, but it never stopped completely. The automobile had brought profound changes to American life, and any American during those times would readily say so. What they did not recognize so readily were the equally profound changes that were being wrought by the national highway system and the hard pavement.

CHAPTER 4 : **DUST BOWL**

ON MAY 10 and 11, 1934, a dust storm blew 300 million tons of topsoil away from Texas, Oklahoma, Arkansas, Kansas, and Colorado. This storm and others like it were what ultimately caused the flight of John Steinbeck's "Okies" and "Arkies" down U.S. Highway 66 to California.

"Those years of 1934 and 1936 were hot," said Lester Dill, the flamboyant owner of Meramec Caverns, just off Route 66 in Stanton, Missouri. "The dust came from Oklahoma and Texas. It was all over the cars and came in the windows. You could smell it. Those were hot, dry years, and that's when people just packed up and began to leave."

It was one thing to be in eastern Missouri and smell the dust that blew off the Great Plains. It was something else to live with the dust and the high winds that roared across the broad, rolling, gray-green land of western Oklahoma. "We were scratching, believe me," recalled Bob Lee a half century later, from his comfortably furnished office as former chairman of LeeWay Trucking, in Oklahoma City. "We were dirt poor and living in the middle of the Dust Bowl. There were three of us children, and when we went to bed at night, Mother would hang wet dish towels down from the open windows—there was no air conditioning, no, nothing like that, of course—and she would put a wet dish towel over each of our

faces. The next morning the whole thing would be red, just red. Red dirt. This went on day after day, and we got used to not even seeing the sun."

Bob Lee was a child during those years. Leon Little, on the other hand, was a young man who was building a new gas station on the edge of Route 66. "The dust came in one afternoon," said Little. "The sky was black down on the horizon. The dirt and sand and dust moved in one afternoon, and at four o'clock it got black. We were building that old station, and it was so dark you had to turn the lights on. We had put up a wall that morning, and I was worrying about it, so I told the boys that we had to get up there and stucco that wall or we would lose it with the wind as high as it was. Stucco," he explained, "is Portland cement with a little brick-laying cement. We'd set this wall up—laid it up—and the stucco cement on the outside would bind it that much better. It gives more strength. So we dashed up there after lunch and quick stuccoed the wall we was working on so it wouldn't fall down, and then we quit."

The dust storms happened regularly enough that the people who stayed in Oklahoma and Texas and Kansas learned to live with them, even though they never got used to the onslaught. Little's wife, Ann, was chief cook for the construction crew while they were building the new station. "I would fix lunch," she related, "and

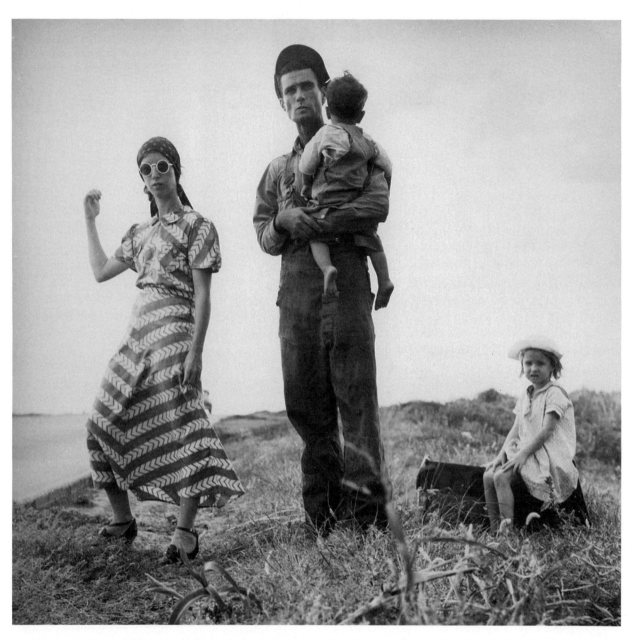

Family on the road, Oklahoma, 1938. Photographer: Dorothea Lange. SOURCE: Courtesy of the Dorothea Lange Collection. The City of Oakland, Oakland Museum.

wait for all these men to come and eat it. I had a table pretty close to the window. I'd put the plates on the table and, even with the window closed tight, I'd cover them with two thicknesses of cloth to keep the dust off. Then when the men came to eat, I would have to fold back the cloth at the corners to lift it off, and the dust would be thick on it. They was that bad, the dust storms."

They were too much for some people. Small farmers who had already suffered through the poverty-induced indignity of selling their land and were living as tenants had no more resources left when the dust came. They loaded up their families and their furniture in whatever vehicles they had, and they moved away—and they had plenty of company in the small shopkeepers, tradesmen, and others whose businesses were dependent on the economy of rural farm communities.[1]

Over the years, thanks largely to the genius of novelist John Steinbeck and movie producer John Ford, U.S. Highway 66 became closely associated with America's memory of the Great Depression. In his Pulitzer Prize-winning novel, *The Grapes of Wrath,* Steinbeck described the flight of the mythical Joad family out of rain-starved Oklahoma and down Highway 66 to southern California. He wrote that "66 is the path of a people in flight, refugees from dust and shrinking land, from the thunder of tractors and shrinking ownership . . . they come into 66 from the tributary side roads, from the wagon tracks and the rutted country roads. 66 is the mother road, the road of flight."[2]

So strong was Steinbeck's imagery—and so equally great was the movie that followed the book—that in many minds the road, the Joads, and the migration became inseparable. Route 66 was indeed the road of flight, but that image by itself was only a part of the story. In fact, the highway between Chicago and Los Angeles was the road of opportunity as well as flight: it brought business to the impoverished Southwest and provided new ways to earn a living for multitudes of people along its course—even during the Dust Bowl years that decimated much of the country through which Route 66 ran.

Despite the dust and the Depression and the flight of their neighbors, there were people who saw an opportunity in what was happening. Those were the people who bought or built highway businesses on the edge of Route 66 and cashed in on what had become a torrent of traffic, catering to the basic needs of food, shelter, and fuel for the people in flight. Because they were on the edge of the highway and because their livings were dependent on the traffic, those Sixty-sixers recorded vivid pictures of what the highway was like in those days. The ones in harder-hit Oklahoma had more sympathy with the parade of wanderers; farther west where the Depression was less severe but the migrants were more desperate from having been on the road longer, the highway business people remembered those days with less emotion and more as an unpleasant situation that had to be dealt with.

"Just before World War II started, there was a lot of Okies and Arkies on the highway with mattresses on their cars," said Lucille Hamons, who ran a service station and tourist court at Hydro, Oklahoma. "I've kept people in the rooms that couldn't pay their room rent. They've sold me all kinds of things for gas—clothes, cars, everything."

All along Route 66 the migrants were described as Lucille Hamons described them—"those people with mattresses on top of their cars"—and in time, the title of John Steinbeck's novel became shorthand for the group.

"Sure," said Marita Bumpers, who had been helping her husband run a grocery store and gas pumps in the Texas Panhandle, "The 'Grapes of Wrath' went through here in the thirties, all these

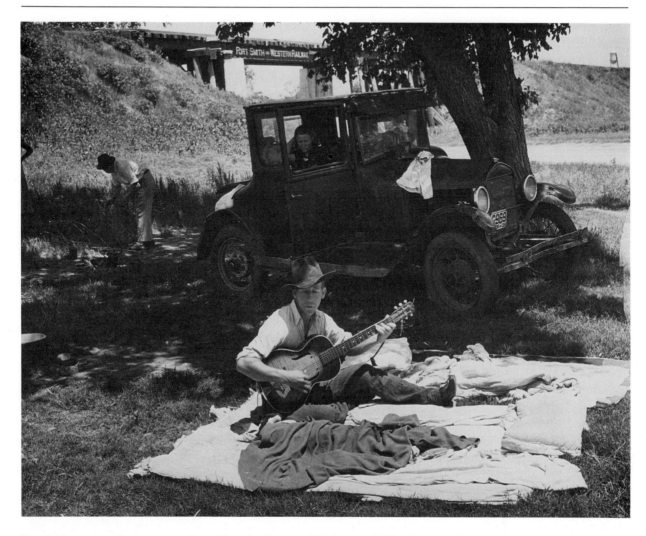

Roadside camp of migrant workers, Lincoln County, Oklahoma, 1939. Photographer: Russell Lee. SOURCE: Farm Security Administration Collection, Library of Congress.

Arkansawyers going to California to pick grapes. They had everything with them: pigs in a crate, chickens in a crate, and a dog on top. One day this fellow stopped and asked how far it was to Amarillo. I told him it was seventy-five miles, and he drove off, but that night he was back again. He had taken a wrong turn and gone around in a big circle." That kind of accident, although not common, was not too unusual in those days before the roads were paved and well marked.

"People were good, though," she continued. "We didn't have any problem with them not paying us. We did a lot of credit business in those days. The migrants had money because we sold

them gas for twelve-and-a-half cents a gallon. A lot of time they'd stop and work a while. They'd work for a dollar a day out on a farm, and everybody trusted everybody then. If a man said he'd pay you, he would, but maybe not right then. In the grocery business we sold to people who moved away, then they'd come in two or three years later and say, 'you don't remember us but we owe you some money,' and they'd pay up."

The migrant with the conscience did exist, but not everywhere. At Glenrio, on the Texas–New Mexico state line, where Homer Ehresman and his wife operated a café, Ehresman recalled that "people come through here with no money. We had a lot of 'em. We'd usually give them something to eat, and we had a few who'd come back and pay us. Occasionally."

"We had some people out of Texas and Oklahoma out of the oil fields," recalled Joseph Smith of his childhood in Santa Rosa, New Mexico. "They were rich. Then we had the poor farmers blown out of the Dust Bowl, and they didn't have any money. We'd classify the poor people as first class or third class depending on how many mattresses were on top of the car. Sometimes you couldn't see the car for all the stuff tied on. Sometimes they would try to pawn things like furniture or spare tires for gasoline, but we didn't take it. When my dad first went into business, he tried to help some of those people who didn't have any money, but he couldn't afford it and finally got hardhearted."

Farther west, in Grants, New Mexico, Bud Gunderson recalled that a few of the hoboes who came through town "kind of liked the looks of Grants and stayed and became our leading citizens. They'd go door to door and ask for work in exchange for food. It was a pitiful situation, but we handled it on an individual basis. People got to Grants with no money, no food, and carloads of children. Merchants would help them; it

was everybody's duty. If you had something, you helped. My dad probably gave away half a million dollars in loaves of bread and two-gallon donations of gas."

Alan Hensley, who was working for the Whiting Brothers at a Holbrook, Arizona, station, noted that "Holbrook got by better than the majority of the country. There was not the unemployment here as in Texas and Oklahoma, maybe because this region just wasn't so thickly populated." Nonetheless, said Hensley, during the late thirties "some people were having it pretty rough getting through the country. They'd break down or have flat tires. A lot would want to work long enough to pay for their gas or tires or whatever, and then they'd go on."

"Hell, yes," agreed Bill Nelson, as he sat under a tree in back of his house, in Truxton, Arizona. "I remember them Okies coming out west like flies. We had garages and blacksmith shops to take care of them. Some would even come and leave their cars and go walking off. One guy come by my dad's station on foot going west. It was hot that day, 120°, and my dad told him to sit down in the shade, that he would be going over to Hackberry that evening, which was in the right direction. The guy said, 'No, I'll walk,' and he did. Then about four P.M. my dad started out, and he found the guy about ten miles down the road. 'Get in,' said my dad, 'and I'll take you on up to Hackberry,'" Nelson continued. "But the guy just stared at him and said, 'What the hell would I do in Hackberry once I got there?' He was just walkin' cause he didn't have nothin' else to do or no money or no place to go."

Fred Nackard, who supported himself during the twenties as a bootlegger in Flagstaff, Arizona, recalled the travelers on Route 66 during the thirties. "I remember the 'Grapes of Wrath,'" said Nackard. "They came by the thousands, the poor devils—with washtubs on top and stuff tied on

the sides of their cars. In the thirties I was in the automobile business down on the south side of town, and they'd come here and be down and out. I used to buy some of their cars, then I'd fix 'em up and sell them. A lot of people stayed here instead of going to California."

In Kingman, Arizona, Glenn Johnson said, "when the Okies got here, the merchants had an agreement. They would give 'em enough gas to get to California. What happened was that the merchants would fill the gas tanks to get the Okies to Needles, and then the station owners in Needles did the same thing—gave them enough gas to get to Barstow. Same thing happened in Barstow to get them to San Bernardino, then once they got there, they'd scatter.

"They were all good, hardworking people," continued Johnson, "not any bums among them. A few stayed here and worked in the mines and became leading citizens."

The untold lesson of Route 66 during the Dust Bowl migration was not that people helped or did not help the pilgrims, but rather that there were people at the roadside, plenty of them, where there was a living to be made. The fact that there were people left behind, hardworking, successful sorts of people, caused some consternation in Oklahoma when Steinbeck's novel was published and in the years since. Not too surprisingly, Steinbeck was a sore point with some people in Oklahoma, and more than one town library banned *The Grapes of Wrath* when it came out in 1939.[3] "I can remember plainly when the book came out my parents and other people who stayed here were just real upset," admitted Nyla Tennery, city clerk in Erick, Oklahoma. "That book gave all Missouri, Arkansas, and Oklahoma people a shiftless, bad name, like that was the only kind of people who were here."

What the book also did was imply that everyone in Oklahoma and the Dust Bowl states fled to California. "We thought mighty hard about it,"

acknowledged Leon Little, "but we were eating regular, and we had a stoop over our head, and the people that worked for us, they weren't drawing that much money, but they were about as well off as we were. We were all living, see?"

Little and his wife had owned one service station on prepavement U.S. 66, in western Oklahoma near the swinging bridge over the Canadian River. Then they built another one on the new pavement. "We had made arrangements for a fellow to help build us a small station at the point a mile west of this new bridge," said Little. "The day the traffic moved, we moved with them, which wasn't much of a job. We didn't have too much to move. Our equipment mostly consisted of a couple miserable gas pumps—a ten-gallon number with a bowl at the top and a hand-operated pump—and, of course, we had an air compressor. We carried water to the station in a bucket, had a well out in the yard, you know."

Little and his wife were too busy making a living during those hard years of the late thirties to give much thought to the "insult" of Steinbeck's book. They did, however, pay somewhat more attention to the film: it was a Route 66 event.

"After we had been in the new place about five or six years," said Little, "some friends headed out of Bridgeport one day and said, 'There's a movie company down at the head of this bridge makin' a picture.' I said, 'Let's go down and try to get in the movie.' Ann, my wife, says, 'Laws, I'm workin',' but two or three other girls went. They got down there—course we didn't know what was going on. These women went down and found out that they were filming *The Grapes of Wrath* play and Grandpa died on the road to California. So supposedly they were burying Grandpa down there at the west end of what we call the new bridge, but the girls didn't get in the picture. They didn't get in the movie, but they did see it."

John Ford's award-winning film was mainly

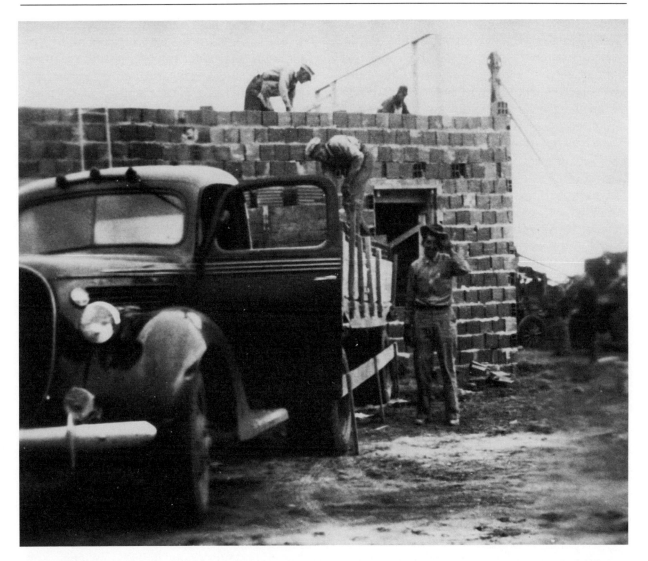

Leon Little's service station, Hinton, Oklahoma, 1940: Little built a succession of service stations along 66, between Bridgeport and Hinton Junction, changing the location each time to improve business. SOURCE: Leon Little, Hinton, Oklahoma.

something to talk about from time to time as far as the Littles were concerned. Because they met highway travelers from all over the country, however, they did have to deal with the public's reaction to both the book and the movie.

"You know, people that come by," related Ann Little. "It was lonely looking out there where we were, and they'd say, 'What in the world do you do for entertainment out here?' and I'd say, 'We work most of the time, and after we run out of work, we run jackrabbits,' and they'd look at me so funny, and I'd just laugh. I'm sure they

thought, 'Oh, those poor people.' Well, there was a lot of that going on, moving west and all."

There was also business growth in that part of the country. Contrary to popular belief, businesses were begun during the *Grapes of Wrath* era, growing out of ideas that were conceived during the 1920s. Whit Lee, who had ridden out the early Depression on his bus line, sold LeeWay Stages for the second time in 1934 and bought three trucks.

Even though Lee's trucking company was begun only eight years after Franklin Campbell had gone into business in Missouri, those years were enough to change trucking from a freewheeling operation to a regulated industry. Besides weight limitations in various states, the regulations required that trucks be certified for each interstate route they traveled. "It was highly competitive at the time," said Bob Lee. "The railroads would fight very bitterly when you applied for a certificate over routes that they served, but the trucking business really started because of lack of service from the railroads for small shipments. When we started, we would unload boxcars from Saint Louis at Oklahoma City, then take the contents to Amarillo, Albuquerque, and that part of the country. The rail service just wasn't very good from Oklahoma City to Amarillo. It was good from Wichita to Albuquerque, so we were the connecting link between the East and the Texas Panhandle."

What LeeWay had to offer was short-haul service; that is, distances of five hundred to seven hundred miles that could be covered in an overnight round trip. "We started overnight service when the railroads would take two days to get from here to Amarillo," explained Lee. "We could do it overnight on Highway 66. "The other thing we had to offer was door-to-door delivery. You didn't have to go to the rail station to get your freight when you shipped by truck." Despite those advantages, however, the Depression was not

an easy time to start a business: "If we could fill two of our three trucks, we were very fortunate," said Bob Lee. Besides the economy of the times, LeeWay business was also limited by the size loads that trucks could carry and the weight variation from state to state. Even in the early days Texas had a load limit, a regulation not shared by Oklahoma, on the east, or New Mexico, on the west, and one that Lee blamed on the Texas Railroad Commission. Shamrock, on the eastern edge of the state, became a switching-off stop, where trucks would dismantle big loads so that the products could be transported into or through Texas. "Shamrock was our unloading point," said Lee. "We had a terminal there and used it as the breakpoint between Oklahoma City and Amarillo."

As men like Whit Lee began to use the highways to carry people and products, they helped further the growth of other independent businesses, including cafés, motels, and service stations. Often operated in conjunction with one of the other businesses, such as John Geske's truck stop or the Spearses' tourist court, cafés were oases of cold water, hot coffee, hamburgers, and breakfast for travelers who had lately begun to leave behind their bedrolls and were more than willing to forget the frying pan and campstove as well.

The 1920s had seen the beginnings of what became the fast-food industry: the first White Castle hamburger stand opened in 1921, in Wichita, Kansas, and the first drive-in opened its doors in Dallas, also in 1921.[4] In the mid-thirties, Gus Belt started Steak'n'Shake, another early drive-in, in Normal, Illinois. Though never a national chain, Steak'n'Shake's standardized portions, limited menu, carhops, and readily recognizable facilities made Steak'n'Shake a fast-food pioneer and an institution in Illinois, Missouri, and Indiana. It all began when Belt salvaged the old Shell Inn out of the Depression and started a combination

tavern and café business, specializing in chicken and fish. He was experimenting with a grease-less grill for cooking ground steak when Normal passed a "No Liquor" ordinance, so he borrowed money and turned the place into a hamburger stand.[5] "After that," he said, "things grew like topsy. We had no idea that switching from beer to milkshakes would do this."[6] Steak'n'Shake was a middle-western phenomenon, but America was ready for hamburgers and french fries: at the other end of Route 66, a couple of brothers in San Bernardino were every bit as successful as Gus Belt when they opened their own hamburger stand in 1939. Nine years later, when Maurice and Richard McDonald dismissed their carhops and pared down their menu, their McDonald's drive-ins became the prototype for the fast-food stands of the future.[7]

Not every food shop on Route 66 was a drive-in. Some were diners—prefabricated metal buildings that resembled railroad cars and could be shipped into town and put into business almost immediately. Many others were small rectangular buildings, bigger than diners, that adjoined a gas station or tourist court and served full meals. Several had designs all their own and became well known even to the people who did not choose to stop there. The outrageous architecture of a highway café in Shamrock, Texas, certainly made it a landmark if not a culinary institution in the region.

A small, dusty town located at the place where the land begins a gradual rise from the plains of Oklahoma, Shamrock had become a stopping point for automobile travelers as well as the changeover spot for LeeWay truckers. By the time Route 66 was paved, the town boasted several motels and one of the most memorable gas station–café buildings anywhere in the country. Opened April 1, 1936, the Tower Station rose high above the low skyline of Shamrock and marked the intersection of U.S. Highways 66 and Canada-

to-Mexico Highway 83 with two towers sprouting out of the otherwise flat roof of the beige-and-brown tile building: a high top-knotted clock tower over the service station and a smaller tower over the café.

"It was unusual to build a big building in those days in the Depression," said Bebe Nunn, a widow whose husband, John, had drawn the original design for the building in the dust with a nail, "but 66 was the only big road, and we thought we could get people to stop. When we started, we didn't have the cash, but the banks said to go ahead. They knew everything that my husband started, he'd make a go of." And he did. The local paper described the place as "the swankiest of swank eating places . . . ultramodern . . . the most up-to-date edifice of its kind on U.S. Highway 66 between Oklahoma City and Amarillo."[8] After Nunn designed the art-deco building, the sketch-in-the-dust was transferred to paper by Shamrock business leader J. M. Tindall and given to an architect for execution. Although the café obviously served local folk, too, the Nunns catered to highway travelers by remaining open twenty-four hours a day. "We fed busloads of people in the dining room from the beginning. When Mr. Tindall built the building, we knew that there was a highway coming through but not when," remarked Mrs. Nunn, from her living room in a little house that sat a block off Route 66, in Shamrock, but still in sight of the Tower Station. "Then when the road was paved, they took off part of our sidewalk and moved us back from the edge of the road."

When the building opened, the Nunns sponsored a contest to find a name for their restaurant, offering a five-dollar prize. "Back then," said Mrs. Nunn, "when a hamburger only cost a dime, five dollars was a lot of money." The winning name—U-Drop Inn—was submitted by a local eight-year-old boy, who carried off the equivalent of a week's pay for the young women who had gone to work

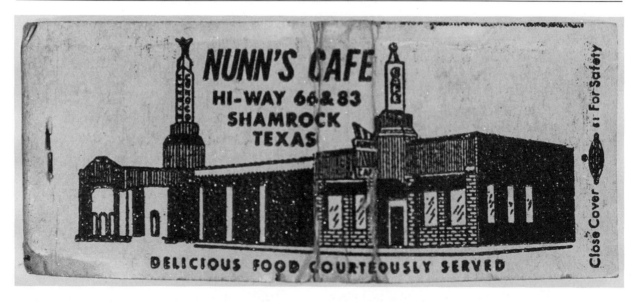

U-Drop Inn, Shamrock, Texas: The Nunns, who had earlier sold the U-Drop Inn, repurchased it in 1950 and renamed it Nunn's Cafe. It was located at the intersection of U.S. Highways 66 and 83 (a highway that linked the Canadian and Mexican borders). SOURCE: Bebe Nunn, Shamrock, Texas.

in the restaurant as waitresses. They could afford to do that, even during the Depression, at a place that had highway travelers for customers. "You could count on the highway to bring business," said Bebe.

About the same time that the tower station was growing taller than the skyline in Shamrock, Alma and Mildred Moore used what savings they had to start a grocery and service station down the highway in Wildorado, Texas. "I had my own money," pointed out overall-clad Alma from his desk in the linoleum-paved office of an aging Phillips 66 station. "I never did borrow any money—haven't yet." First as an independent distributor who handled gasoline, kerosene, oil and lube jobs and then as a Phillips dealer and distributor, Moore and his wife, Mildred, worked to serve local farmers, the Rock Island railroad that came through town, and the passersby on the highway. The thing about starting a business in those years

out in the flat lonesomeness of the still sparsely settled Texas Panhandle, said Moore, was that "there was only but one way to go, and it was up. You couldn't go any further down. Of course," he admitted, "the only thing that brought us out of the Depression was when they started the war and put everybody to work.

"When we was first in the service station business, we'd look out and say, 'Can you see a car coming in any direction?' and we'd look and maybe it would be nine-thirty at night or eleven or twelve and if there was a car coming that might need help, we'd stay to service it, and if there wasn't a car in sight in any direction, we'd turn out the lights and go on home. Now you just look down the road, and it would be impossible to close."

That traffic, such as it was, kept the Moores fed and clothed and brought Homer Ehresman and his wife to the highway, in Glenrio, New Mex-

ico. "We was in East Colorado running cattle up there," remembered Ehresman. An octogenarian, Ehresman was nattily dressed in slacks, a fresh cotton sport shirt, maroon three-button golf sweater, silver tie slide, large gray felt cowboy hat, and black sunglasses. "The drought came along, and we had to do something. My brother-in-law was furnishing gasoline to this station here, and they had just voted liquor into New Mexico, and the people running the store weren't doing too good and wanted to lease it out."

The Ehresmans left Colorado and moved to Glenrio, settling on the edge of what was still a dirt road all the way from Amarillo. "We came in thirty-three or thirty-four. The highway used to turn here at the state line and go south about a mile and then go west again, but it was all dirt roads then. We had a little old cafe and ran a bar," Ehresman said. Besides the dirt road, Glenrio had a railroad stop with cattle pens (in Texas), a post office (in New Mexico), a mercantile store, and a dilapidated (to hear Ehresman tell it) collection of adobe tourist cottages.

The year 1934 was the best tourist year in the United States since 1929.[9] The tourists—even on the dirt road—were what kept the Ehresmans alive. "You depended on the traffic," he said. "This was the main highway all the way through. We had lots of Okies going to California—and Arkies and Missourians—in the thirties."

Another source of at least some business for Ehresman was truckers. "This was a port of entry on the state line, and they stopped everything here: cars, trucks, and didn't allow anything in Texas but bobtailed trucks, no trailers or nothin' like that, and they had a load limit. What happened was the trucks would come through and sit here 'till dark and then go on through. At that time, though, there wasn't many trucks, just mostly tourists."

The dirt road in front of Ehresman's place became concrete in 1937, and that year the paving

crews kept him busy. "When they paved this road out here," he said, "we was feedin' three times a day, family style, all you could eat for a dollar a day. When they was building this highway they was doing it all by hand—they didn't have any of this modern equipment—and those people were getting thirty cents an hour and only worked forty hours a week. They slept out along the road and in tents. Seems to me that lasted all through the summer and into the fall that year—not too long." The Ehresmans stayed on Route 66 through the war but sold out in 1946—scared away by talk of an interstate highway coming through. They moved to Plainview, Texas, for four years, but when nothing happened to Route 66 during that time, they shrugged and went back to the highway. They even built a new motel in 1950 and ran it until the interstate did come through in the 1970s.

Just as it did Glenrio and the Ehresmans, the construction of the interstate highway system in the 1960s and 1970s scared people and eventually caused many businesses to close up. What people tend to forget is that Highway 66 was equally disruptive. During its day, Route 66 was rerouted several times, uprooting or displacing businesses at every shift in the road. Roy Cline, for example, was displaced at least three times while he struggled to keep one of his highway businesses going. Cline, a highway pioneer who had moved from Oklahoma to eastern New Mexico in the twenties, was also an Arkie—having been driven off an Arkansas farm in the mid-thirties—and a real Route 66 character.

Cline had arrived in New Mexico in 1926, along with his wife, six daughters, and a son. He tried farming—"That was a good starvation place," reported Roy Cline, Jr.,—then he ran a post office at Ruthern. A short time later he bought another farm, outside Moriarity ("with no house on it," recalled Cline, Jr.), which he then traded for a small hotel in the highway town of Moriarity. "He

couldn't make no living there," said the son, "so he moved out to the little place called Lucy, on the Santa Fe Railroad, and built a little service station. At Lucy, the pickin's were very slim, so we tore the station down in sections and moved out to Highway 6 [the future U.S. 66].

"Then," said Roy, Jr., who by that time was out of high school and working for a construction company, "he sold that for a farm in Arkansas. I called it a tick farm. Dad never did want to work too hard." Farming in Arkansas in the early thirties was a challenge to the hardiest. Cline soon gave up on the "tick farm" and moved back to New Mexico about 1933. "Dad sold the farm and traded for an old Chevrolet truck. The cabin was broke, and it was all swayback, but he loaded all the kids and all the canned goods and came out.

"Right then," said his son, "they were setting up camp to pave the road on to Moriarity. 'Fore he came out, he told me to see if I could get the land at the corner of Highway 2 and Highway 6. I went to see the land commissioner up in Santa Fe, and he said we could have the land, so I wrote and told my dad, and before I knew it he was here.

"He had five hundred dollars when he came from Arkansas in that old truck. He used my money to get the lease, then we came over and bought five hundred worth of lumber and started building the place."

The junior Cline, who eventually retired to a comfortable home in the Albuquerque suburbs, spent much of his life helping his father build and operate a variety of highway businesses. This particular one, however, was the most significant.

"When we got there, they were grading Highway 6 with an old World War I Liberty Truck with a pull blade, getting ready to pave it, and they had made a camp shack out of an old truck trailer on our corner there. They said we could use that as long as we were there." Cline, who was settled in a plush recliner chair in his living room, shivered. "It was cold. We went out and got rocks for the foundation and then built the station.

"I was driving a bus then. Dad said, 'I want all this on the map. I've got all this eighty acres here, what should I call it?' I said, 'Clines Corners,' and that was that.

"About 1937," recalled Roy, Jr., "they moved Highway 6 north, so Dad moved, too. Then they came along and moved Highway 2 about three-quarters of a mile east, so he had to get a mover to come and move him again. Somewhere along there they changed the highway numbers to 285 and 66. Dad had all four corners there, but he had to go buy a lot more land every time they moved the roads." Off and on during this period, Roy, Jr., was driving nine-passenger buses on the unpaved New Mexico roads, and some of the time he was in business with his father. "He wanted me to go into business with him," said the long-suffering son, "but he never was fond of payin', so I went back to driving a bus. When one of my sisters got married to a carpenter, Dad got him to come and build an addition to the service station and a café."

In 1939, when "Dad was making a better living than he ever did before," the elder Cline sold out and moved to Kingman, Arizona, where stayed a while, then moved on to Vaughn and then back to Arkansas before returning to eastern New Mexico, in 1945, to open the Flying C service station and café on Route 66, which he operated until 1963. Clines Corners remained, even without the Clines, and was one of the businesses that was lucky enough—after all its moves in the early days—to find itself on Interstate 40 after Route 66 was bypassed, becoming a regular lunch stop for tour buses.

The paving and rerouting of Route 66 caused the Clines to jack up their service station and physically move it to where the highway had moved. In other places, people just built new

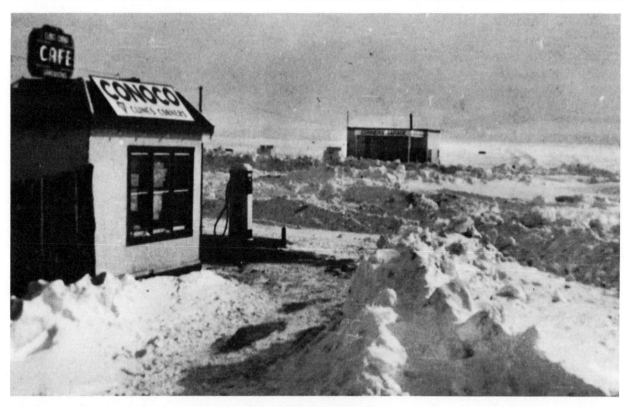

Clines Corners café and service station, Clines Corners, New Mexico, ca. 1937: Roy Cline, Jr., called Clines Corners "the coldest, the meanest, the windiest place on Highway 66." SOURCE: Roy Cline, Albuquerque, New Mexico.

buildings when the highway shifted its course. On the other side of New Mexico from Clines Corners, the paving of Route 66 caused a rerouting that cut nearly a hundred miles out of the highway, bypassed Santa Fe, and sent the road in a straight line from Albuquerque—through several Indian reservations—to Gallup. The coming of the pavement, plus the potential to deal in cash, caused one family of Indian traders to go into the motel business. Their trading business with Laguna Pueblo was housed in a tin-fronted building in the tiny community of Cubero, which had replaced a trading post built in the 1860s. After the turn of the century and the introduction

of automobiles, the business had expanded from a livestock trade with the Indians to one of the first service stations in the area (also serving motorists passing on the still-dirt road out in front).

In 1937, when the highway was paved and moved away from the old tin-fronted building, they decided there was some value in having a real highway business as well, so they built La Villa de Cubero, a stucco motel and cafe, at the juncture of the new paved highway and the old dirt road to Cubero.

Wallace Gunn, a relative who had been working at the trading company since 1928, had de-

signed the motel. After it had been open about a year, he and his wife, Mary, took over operation of La Villa and eventually purchased it.

"Here's what happened," explained Gunn, comfortably retired since the mid-seventies to a house built just after the turn of the century in the village of New Laguna, New Mexico. "The highway had moved, and we had to get on the highway, but we decided to keep the old store and credit business at Cubero and cater to tourists out on the highway.

"Ours was more-or-less a cash business. We left buying lambs and wool over at the store at Cubero, and we dealt with tourists. We had a motel, a place to eat, and a store, and we traded for Navajo rugs and jewelry with the Indians that came along. Naturally, having a café there, people stopped."

When it was built, La Villa de Cubero was the first stopping place west of Albuquerque on U.S. 66. "People would plan to stay in the west end of town," Gunn said of his many motel guests, "but there was not anything in the west end of Albuquerque, and all the land between there and here belonged to the Laguna Pueblo, so they would end up with us."

A striking Spanish-style structure, La Villa had ten guest rooms, a cafe, a store, and a residence in the back. "We thought it was quite modern in those days," remarked Gunn. "We had hot and cold water and tile showers. Mary managed the motel and the girls who worked for us; I main-

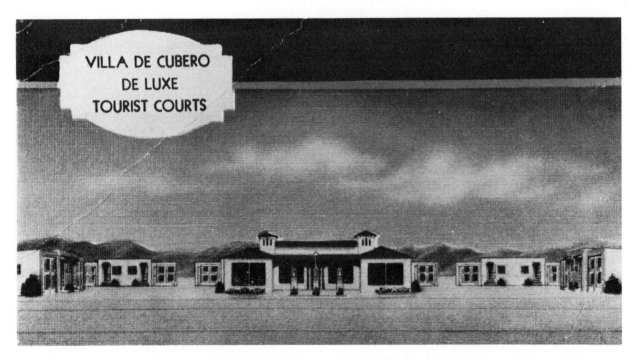

La Villa De Cubero, Cubero, New Mexico, ca. 1950: La Villa was the first stop west of Albuquerque. It was one of the few motels in the Pueblo country between Laguna and Grants, New Mexico. SOURCE: Wallace Gunn, Laguna, New Mexico.

tained the upkeep: sewer, water, carpentry, and she supervised the help, checked the laundry, and, after 1940, ran the café. She had quite a clientele of people who would drive out from Gallup and Albuquerque on Sundays to eat with us."

When the Gunns took over the motel, their first overnight customers were officials of the construction company that was in charge of paving Route 66, and the place was full from then on. Most guests, Gunn said, were just "normal tourists—anybody out on the road." Not all, however, were the faceless, nameless variety of middle-class travelers. La Villa was location headquarters for several film crews making movies in the area and attracted other creative types as well. "We had Hemingway stay a couple of weeks with us while he was writing *The Old Man and the Sea;* some General Motors designers; the Trapp family; the boys building the A-bomb would want a holiday, and they'd come and spend a week with us incognito; and oh, gosh, any number of artists." Located as it was in the pueblo country, La Villa was a good place for people to stay and take day trips to the so-called Enchanted Mesa of the Acoma Indians or out into the high desert country.

Until Route 66 was bypassed, the Gunns were busy. They never had television in the rooms. They never handled liquor. "We were just out in an area," said Gunn, "where people wanted to stop."

Farther west, where petrified wood lay scattered across the Arizona desert, was another area where travelers liked to stop. That stretch of the highway was the safe haven, in 1936, for a machinist and former miner from the Inspiration copper mine at Rome, Arizona. Out of work like so many other miners across the country, Frank Dobell pulled up stakes and moved with his wife back to her home outside Holbrook, Arizona. There he collected bits of petrified wood from nearby private lands and sold them on the high-

way. His wife, Edna, went to work with her father, John Paulsell, at the Rainbow Forest Lodge, serving hamburgers to tourists who came through the Petrified Forest National Monument.

"Frank put up a little stand on the highway that came into the park," noted Mrs. Dobell, a solid woman who had obviously worked hard all her life, "and he sold petrified wood for five cents. It wasn't a great business—in fact, we almost starved. But it got better. It got a lot better."

The Petrified Forest, one of the first tourist attractions along U.S. Highway 66, actually predated the national highway system by about twenty years—and the petrified wood that was to be found there predated the United States by several million. In prehistoric times huge fallen logs had floated down long-gone North American rivers into a swampy basin, where they were covered with sediment and volcanic ash. Circumstances and time allowed the logs to become perfect quartz fossils of themselves, even down to age rings, knots, and bark. As centuries passed, earthquakes caused the trees to crack and buckle, and ground waters bleeding through the cracks left new fillings inside the logs of amethyst, rose quartz, smoky quartz, and other gemstones. As early as 1851, U.S. Army explorers had described the petrified wood in their official reports, and in 1890 the railroads established a tour stop so that visitors could stay over and investigate the marvels of the fossilized logs. In 1906, President Theodore Roosevelt named the Petrified Forest a national monument—it did not become a national park until 1962—and even more public interest was generated in the area. As tourists began to arrive in eastern Arizona to look at the Petrified Forest, small businesses grew up to meet their needs. During the 1920s, Paulsell helped open the Rainbow Forest Lodge, an eating place inside the Petrified Forest that also sold souvenirs and had a few tourist cabins out in back.

In the mid-thirties, when the Dobells came to

make their living from travelers who came to marvel at the petrified wood, their ambitions—and the results—were modest. To assure a supply of petrified wood, Dobell leased about four hundred acres of land from the New Mexico–Arizona Land Company, a subsidiary of the Santa Fe Railroad. In the beginning, Dobell gathered all the petrified wood himself. "There was so much of it lying around at that time, we'd just go out and pick it up off the ground," he said. He was a tough, gnarly man who looked exactly like he had spent most of his life wandering the ridges and valleys of the Arizona desert. Dobell designed and built machines that could handle the diamond-hardness of the petrified wood, cut the pieces into exact shapes, and then polish the raw wood into a smooth sheen. His workshop was an old railroad caboose that sat in the yard behind their house— the same house where they lived fifty years later, even though the rock shop had long since been superseded by a business empire that sold petrified wood all over the world.

Tourists in the Petrified Forest, where the law prohibited them from picking up any of the petrified wood, had been only too willing to buy small bags of polished chunks supplied by Frank Dobell. "At one time they couldn't buy wood in the park at all," said Dobell, "so they'd ask the rangers where they could get some, and the rangers would sent them here." Growth came slowly, with experience on the Dobells' part and with increases in the number of people who came to see the Petrified Forest. During the war, when government rationing brought almost all nonmilitary travel to a halt, Edna went to work at a local Safeway store, and Frank went back to the mine at Rome. "But he got sick of that and come home," said his wife.

After the war, business picked up: "During the war the companies that made souvenirs went into other businesses, and there wasn't too much

down at the Petrified Forest to sell," said Edna. "The men came out of the service and they'd buy great big bunches of just, I thought, junk." The Dobells bought Rainbow Lodge in 1947 and ran it until they were bought out by Harvey Enterprises in the mid-sixties. "We did all right, and every year it got a little bit better," said Edna. "By the time we sold it, we had a good business down at the Lodge. The reason we sold, I wasn't able to do it any longer. We couldn't keep both places, and this one was more our own."

Just as the hardships of the Depression had caused the Dobells to move to the Petrified Forest, a disaffection for the hard life of an American farmer in the 1930s led another young couple to seek their fortune on the edge of Route 66, in western Arizona. Beatrice Boyd was a bride when she came down Route 66 from Kansas in 1938, landing at the Hualapai Indian Reservation town of Peach Springs, in the mountain country west of Flagstaff. There she and her husband purchased the Caravan Inn, a small motel between the highway and the railroad tracks.

"My husband graduated from high school in 1934; that was the beginning of the Dust Bowl and the end of the Depression," said Beatrice, a thick-set lady in her sixties. She had a living room full of the kind of possessions a person acquires during four decades of living in the same place. "My husband and his parents were farmers, but he never liked farming. He was a quiet person, but it come out slow over the years." He attended college in California and, during those years, spent his summers in Peach Springs, where his brother had migrated some years earlier. Eventually, he purchased the motel and went into business.

"We charged a dollar a night, and by the end of the first summer, we almost had the place paid for," said Mrs. Boyd.

"We were always busy. I did all the laundry. There was Indian help, but sometimes they didn't

come, and then it really was a lot of work. One day I stopped and said to myself, 'I've been here two months, and I've been so busy it doesn't seem like anytime at all.'"

She shook her head. "I was newly married and new to the motel business. I was dumb and really pulled some goodies. I met so many new people I got them confused.

"One day a young lady came to the door and rented a room from me. My husband had always rented the rooms, but she gave me her check for $1.50, and I took it. When he came back, he asked why I had taken a check. I told him the lady looked familiar, but he told me never to take a check. I really sweated that one. Then, not too much later, somebody came along with a traveler's check, and I wouldn't take it." Beatrice Boyd stopped talking and laughed. "You know," she finished, "in all the years, we've never had a bad traveler's check!"

Peach Springs at best was never much of a town: a stop for the Santa Fe Railroad, a head-quarters for the reservation, and an oasis for travelers following Route 66 through that high, dry desert country southwest of the Grand Canyon. Nonetheless, the Caravan Inn's sixteen units were often full by midafternoon, whether it was summer or not. "We had a lot of people traveling through the winter months in the bad years," remarked Beatrice. "The big farmers from Kansas came in July after the wheat harvest was over. You could almost look at the license plates and know when the other harvests in other states were over.

"Then once California was settled with people from the Midwest, there were families going back and forth.

"It was exciting to be on Highway 66. I used to say I couldn't live without all this clutter and noise—the railroad over there and the highway over here." She added, "You change." It took her a long time, though, to change. She operated the

motel and a gas station several years after her husband died and her son grew up and left home, finally selling out and moving in the early 1980s. "In summers it would be almost like a city street, a city boulevard," she reflected, "ping, ping, ping, car after car."

A few people away from the highway took note of all those cars and the businesses they were supporting. In 1933, *Harper's* magazine observed "three hundred thousand shacks lining the road-side—one of the few features of the American landscape that the Depression is causing to grow by leaps and bounds."[10] In 1937 an American Automobile Association (AAA) survey of the traveling public revealed that 12½ percent stayed in motor courts, 61 percent stayed in hotels, and the rest stayed in tourist homes. Only two years later, a similar survey revealed that the percentage of travelers who stayed in motor courts had more than doubled—to 26 percent.[11] As Beatrice Boyd said, those cars just kept coming.

That was true all the way across the country, from Chicago to the California coast. During the years of the Dust Bowl migration, Jack Belsher was living in Barstow, California, the first real town that travelers reached after crossing the Mojave Desert on Route 66. He operated the family's Texaco station at the corner of First and Main, right on the highway. "Our station probably sold the most gallonage of any Texaco station in the U.S. in the 1930s. There was only one stop sign in town, and it was right on our corner. Tourists must have hated it, but Barstow was the logical stop—last from L.A. before the desert and first after the desert—and Texaco was one of very few national brands, so people did stop.

"The hotter the summer, the more business we'd get here, too. The southern route across the desert to Indio was even hotter than here. In winter sometimes our business would drop off because Flagstaff was up in those mountains, and

the way would be closed from time to time. But in the summer we had business, and we did as much business at night as in the daytime because that was when people would drive across the desert.''

Belsher had grown up driving a family-owned oil tanker to customers who lived in desert communities outside Barstow, and by the early thirties he had graduated to operating the family station.

"The Okies all came here, but they didn't stay,'' he said. "There wasn't anything here to keep them. We would see an old car with three or four mattresses, pots and pans hanging off the sides. You were never really in personal contact with them. Local police, ministers, and people like that would deal with them, but as families living in Barstow, no contact.''

No contact, that is, unless the travelers had some money in their pockets.

CHAPTER 5 : **WARTIME**

C. H. GUNDERSON, JR., known as "Bud" so as not to be confused with his father, grew up watching the traffic roll past the Bond-Gunderson mercantile store on Route 66 in Grants, New Mexico. When he was a child, a railroad spur crossed the highway on its way from the Santa Fe tracks to the warehouse behind the store, and he remembered that when people drove too fast across those tracks, their tires would blow out.

"That was an exciting place to be," recalled Gunderson, a heavy-set man who came to run the Gunderson Oil Company, in nearby Milan. "When I was in the fourth grade, my father put me to work pumping gas. We used to have local characters and interesting tourists come by; every once in a while a nervy movie star or famous person would decide to drive to California."

He was a college student at the University of New Mexico, in Albuquerque, when the United States entered World War II, throwing the whole country into a turmoil and permanently changing the way life was lived on Route 66. "The highway between Grants and Albuquerque was only a single lane then," he recalled. "I remember 1943, when I was still in school in Albuquerque. Many times a friend and I would come home from school in the middle of the night: we'd go to a college dance; then at midnight we'd put on our sheep-lined jackets, get in the car, and drive sev-

enty-five miles home. We wouldn't see anything but maybe a couple of Greyhound buses. It would take us four hours to drive—one of us would sit on the fender and shoot jackrabbits when the car lights picked up their eyes in the dark. We wouldn't see another car."

Wartime—with rationing, the military buildup, and the exodus of the country's young men—was an odd time all across the United States. Automobile production ceased in 1942, gasoline rationing began that year, and tires became scarce, all of which affected the doings along Route 66, sometimes to the point where you could count more jackrabbits on the highway than automobiles. Yet, while a number of businesses did close down or were abandoned until the war's end, a great many others stayed open, and a few flourished during those years.[1]

Between 1941 and 1945 more than $40 billion was invested in capital projects in the West, mostly by the federal government, and mostly in California. In many cases, the money paid not to increase output of existing manufacturers but to build and staff whole new industries, the most obvious being the Kaiser move into steel production in Fontana, California. Obviously, such a massive creation of jobs led to an equally massive migration of people to fill the jobs. Many of those people traveled down Route 66. The ultimate changes brought about in the western economy

were reflected in the changes that occurred along the highway during and after World War II. During the war, Route 66 was a fascinating, if not always financially satisfying, artery of military commerce. After the war, people along the highway were caught up in the excitement of a world on the move and the boom times of the postwar economy.

"Ford built wings for planes in Detroit, then carried them down the highway to Saint Louis," remembered a banker in Litchfield, Illinois. "It was really something; the trucks were so big, and the wings were so long. They had two Ford engines in each truck, shipping them down south for assembly."

People in Mitchell, Illinois, just across the Mississippi River from Saint Louis, never forgot the traffic. "Everything passed through here: airplane parts, tank parts, everything," noted Pete Routh, a trustee of the Mitchell Fire Department. "A lot of tank parts were made right near here, in Granite City, and the airplane parts went through here to Curtiss Wright in Saint Louis. This was one of the hottest spots in the U.S. with all this equipment going through. A lot of people don't realize it now, since this used to be a little ol' two-lane road, but they had to stop traffic on the Chain of Rocks Bridge [the U.S. 66 bridge between Illinois and Missouri] to get the parts across, because of the curve." Probably one of a kind, the Chain of Rocks bridge made a forty-five-degree angle turn halfway across the river, causing surprises, if not problems, for motorists.

Bill Roseman, who grew up at his family's 66 Terminal truck stop and tourist court on the southern Illinois prairie, recalled that "one time the army air force decided to do invasions with gliders, and they transported them on flatbed trucks down 66. I remember seeing them and then seeing a write-up about it later in *Popular Mechanics*."

During those years, Roseman watched his fa-ther build the truck stop and add a tall tower to serve as the signpost and attract attention. "Dad was very much aware of 66 and its meaning to this part of the country," said Roseman. "I was made aware very quickly that the 66 Terminal name meant the highway and the gas that we used. I felt a sense of adventure about being on Highway 66. Saint Louis had been the starting place for a lot of wagon trains, and people were still going west. California to me was still new and exciting and meant deserts and cowboys and all sorts of wonderful things." The truck stop had opened just before the United States entered World War II: "I remember being around there in the summer of 1941 and seeing big holes in the ground where the gasoline storage tanks would be. I'd hang around the carpenter, and I remember that the service station complex was pretty well up that summer."

The Rosemans began with a station and added a restaurant shortly thereafter. Motel units were added next, double units with no showers. There was a common shower building behind the family's unit. Single units with full bathrooms were added after the war. "During the war my dad really scrounged around," remembered Roseman, a tall, good-looking man with dark reddish hair. "I remember going with him in a truck to Saint Louis to plumbing-supply places and other places where we could get used building materials. During the war business was good, but afterward Dad always talked about how during the war we couldn't do this or couldn't do that.

"We had a monopoly in the area: there weren't any other truck stops around. There was a place in Joliet, one near Springfield, the Dixie, and us. Those years were wonderful for me, watching the army convoys roll past. It seemed like something to do with the military was continuous on the highway." He also remembered people in uniforms coming to the motel or stopping there for meals. "My Dad always said if the military people didn't have the money to pay, it was OK. That was

the way he showed his patriotism. He probably could have volunteered, but he was over forty when the draft came."

Young Roseman's memories of the war years were most vivid where military convoys on the highway were concerned, but he also was aware of some of the troubling aspects of doing business in those years. "Dad had a story about coming to Saint Louis one time and buying black market potatoes," he said. "We had a liquor license, too, and it was no big thing, but to get, say, Old Grand Dad, you had to take all kinds of other weird liquors. We carried some of those for years."

Besides bringing new and unusual traffic, the war caused population and economic booms in remote rural areas wherever the federal government decided to build military facilities. Basket-maker Amy Thompson shook her head as she remembered what happened in the Ozark hills while Fort Leonard Wood was under construction and full of people. "My oldest son was born in 1932," said Amy, from her comfortable mobile home alongside an almost deserted road that had once been Route 66. "When he was eight years old, he was hit by a car on that highway right there. The traffic was so thick you couldn't cross the road hardly, when they were putting the Fort in. People came here from all over, and they all needed a place to stay. You could donate any kind of a place, even chicken houses, for people to live in. Why, we moved out of our kitchen and rented it. We had a big wood stove in the living room and a bedroom, so we just fixed up a door to the kitchen. Two different couples lived in there. There was all kinds of cabins around here. They would just put up anything people could live in. Families would live where they could just eat and sleep."

Outside Galena, Kansas, under shady old trees at the Kingdom Campground, the Reverend Will Pennock recalled that he had a car and plenty of gasoline during the war. "They give us stamps because we done such a job helping people, building morale during that hard time," he explained. "We went and had meetings all over to help people get through the war."

A person did not have to be doing God's work, however, to get financial support from the government during the war; meeting Uncle Sam's needs paid fairly well, too. "We had a tremendous increase in business," noted Bob Lee of LeeWay Trucking, "from hauling war supplies for government contractors, and in shipping engines to the West Coast, ammunition from McAlester, Oklahoma, ordnance from Kansas City and outside Saint Louis, and we'd bring empty steel shell casings there to be loaded and shipped out. The war really made LeeWay Motor Freight."

LeeWay's government business dropped off after the war, but since the company had been careful to keep serving its nongovernment customers during the war years, it survived. "There was a real shakeout in the trucking industry," Lee noted. "Some carriers had been primarily working for the government, and they faded out, but those of us who had taken care of our regular customers—the general public, if you will—we stayed in business." LeeWay had been part of a pool of trucking companies that joined forces to haul for the government so that they would have carriers available to also serve their civilian customers. After the war, as industry and population grew throughout the Southwest, the LeeWay network expanded into Kansas City, Saint Louis, and other parts of the country.

The federal government's presence was in evidence the length of U.S. 66, in the form of new military installations, training bases, manufacturing plants, and the like. "They built an air force base southwest of here, and it caused people to move to Clinton and went to other cities around here, too," recalled Gladys Cut-

berth. "Clinton was more or less dormant until the forties, then the war took off, they built that air force base, then after that there was a lot of tourism, then the oil boom." Mrs. Cutberth, a trim gray-haired woman who lived in an equally trim house on a quiet Clinton street, was the widow of the 66 Association's postwar executive director, Jack Cutberth. In 1949, Cutberth, a barber by trade, became associated with the Sixty-Sixers and spent the rest of his life producing brochures, maps, billboards, and other kinds of publicity for the highway.

Farther west, the people in Shamrock, Texas, also remembered the highway during wartime. "We had a prisoner-of-war camp between here and McLean," reported Marita Bumpers, a former grocery store and café owner. She was also a waitress at her friend Marie Taylor's Western Cafe, in Shamrock. "The German prisoners would work in our fields around here. Their guard would sit on the cab of a truck, and they'd work in our fields. A lot of them came back later to settle around here."

Because Shamrock was not blessed with a miltiary base nearby, Mrs. Bumpers said, "During the war our customers were mostly homefolks." She did recall that an air base for training pilots went in at nearby Pampa, "and sometimes they would have dirt storms that were so bad the planes couldn't land. We hauled deheaded bundles of feed and packed them around the airstrip so planes could see to land.

"On 66," she recalled, "there were a lot of convoys and a lot of military vehicles. When they come by, you had to pull off the road and let them go past."

Population booms—like the ones around Fort Leonard Wood and Clinton—were something of a mixed blessing. "There really wasn't much civilian construction during the war," said Irene Friou, who grew up in Amarillo and worked in a local armaments plant during the war. "People couldn't get materials, and there weren't enough people around to do the work. All the buildings out there by the airport were tar paper, but when the base was in operation, they had to have a place for people who were visiting servicemen. There was a building on the grounds run by officers' wives, but people just couldn't hardly find places to live."

Wartime was a quixotic time along the highway, especially so compared to what had gone on the decade before. "During the war people had plenty of money. Everybody had money," said Mildred Moore, who worked with her husband in their several service stations and cafes around Wildorado, Texas. "Money wasn't the story. The problem was getting things to sell and rationing. If you could get the product, you could sell it, regardless of what it was." During the war the Moores' service station and grocery were the only places open in the whole town except for the post office. "The others all closed up," reported Alma Moore. "A lot of folks went into the army, and a lot to defense plants in California. The young ones were all gone, and other people were not traveling. All the people we saw on the highway were servicemen and some tourist folks. And the materials for the army. They were all moving back and forth."

The Moores remembered war rationing as needlessly complicated. "If you sold five or six thousand gallons of gas in five-gallon stamps, you had to stick them on a sheet. It was awful. We had a stack of sheets a foot high. People in town, they got A, B, and C stamps, depending on what they needed," said Moore. Now our wholesale business was selling to the farmers, and they had E stamps, and they also had a checkbook, and they would deposit their stamps in a bank and write checks. I kept all the checkbooks where they signed all the checks, and I'd go out in the country and deliver their gas and oil. I'd just fill in their checks without gallons, or with five hundred gallons when it was delivered. That's the way it

worked because there was no way you could catch a farmer out on the farm each time you would go to deliver a product."

It was a hassle, but the Moores stayed busy. "In forty-four, when we was running the station," said Moore, "we stayed open all night, and we opened the store seven days a week. We got Christmas Eve off and Christmas Day, and that was all."

For the Gundersons, who operated a mercantile company as well as a petroleum business, rationing was equally awful. "Rationing was a big pain in the neck·for the merchants during the war," said Bud Gunderson. "Everyone was short-handed, and the government required stamp accounting as well as financial accounting. My parents worked nights and Sundays and whenever else they could, separating ration coupons. Where they once had one account at the bank, people in their business might end up with fifteen—one for dollars, one for shoe coupons, one for gasoline coupons, and so forth.

"Rationing," said Gunderson, "slowed traffic almost to nothing. In 1943 the traffic on 66 was practically at a standstill other than military convoys."

In Gallup, New Mexico, where the economy was shifting from the Indian reservations to the highway, things looked bleak for many businessmen. "We were setting there on the highway depending on tourists, and during the war they rationed gas," recalled LeRoy Atkinson. "The first day they rationed gas I went out in front of our store and I looked up and down that highway and the only thing I could see coming was one of those eighteen-wheel trucks, and I thought, 'My God, what are we going to do?'"

The panic for Atkinson and the other Indian traders was fairly short-lived. The government, which had frozen the use of silver, decided to let the Indian traders have silver so they could keep Indian smiths working. With the Indians turning out silver jewelry, the traders had something to sell, unlike many other retailers. "Nothing was for sale during World War II," noted Atkinson. "There were ration stamps for cars, shoes, and everything else. Stores couldn't get anything to sell, and that led to the first boom in Indian jewelry. People came in here from New York and Chicago to buy jewelry. It was good. We were selling to what we called jobbers. They'd buy five thousand pieces, ten thousand, twenty thousand—whatever we could let them have and they'd go east and sell it."

In Winslow, Arizona, business boomed at Bruchman's, another reservation-trading operation that had moved to town. Bruchman's high-ceilinged store sold moccasins, velvet shirts, bolts of cloth, and other goods to the Indians, as well as jewelry, baskets, rugs, and carvings to tourists.

"During the war when anything was selling, Dad Bruchman would go to Mexico and buy things there to sell because he couldn't get anything else," said the old man's daughter-in-law, Hazel Bruchman. "He had a route—a wholesale jewelry route across the Southwest. When the war came along, we had a steady stream of military wives, travelers, and ones who were at the navy facility west of town. Winslow really boomed: we had twelve thousand people here during the war. Afterwards it stabilized at about eight or nine thousand." Winslow and its neighboring community, Holbrook, were among those that benefited from more than $230 million funneled into Arizona for war-facilities projects.[2]

In Holbrook, although the community survived, Dick Mester said he would never go through another time like he experienced in trying to keep a restaurant open during the war. "I did not like it," said Mester, who wore a purple-brimmed Elks cap on the back of his head and held up his trousers with wide, rainbow-striped suspenders. "Meat points [the rationing system] and help problems nearly killed me. We'd stay closed three

months at a time. A lot of people come out of the war wealthy, but not me. I sweated along. I wouldn't do that again.

"Everything the general public was rationed on, we were too. We could get only 50 percent of anything we had before the war, and there were other problems. I used to contract to buy chickens for twenty-five cents each and sell dinners at sixty-five cents. The next time I went to renew my contract they said the chickens would cost me a dollar and a quarter each, but the government wouldn't let me raise my price or take chicken off the menu, so for a long time I didn't have any chicken if people asked. Beef was a little more stable, and eggs, milk, things like that came from the ranchers around here." Mester's restaurant did survive, and after the war he and his wife made a tidy living from expanding into the bus-station and local-tour business.

The farther west down Route 66 a person traveled during World War II, the more the war seemed to affect the highway economy, for the good or bad. In Flagstaff, wholesale-liquor distributor and former car dealer Fred Nackard said that "nearly all the locals went to work in the war industries in California, and new people moved in. The military built an ordnance depot west of town, where ten thousand to fifteen thousand people were put to work. A lot of the old-timers never came back from California."

In Kingman, close to the California border, Glenn Johnson noted that, while the town survived nicely during the war, the highway itself suffered, thanks to all the travel of war equipment, people, and the military maneuvers carried out in the nearby desert. "They just tore up 66 between Needles and Barstow," noted Johnson, an early migrant who had arrived in Kingman at the age of twelve and had held a variety of jobs before going into the floor-covering business. "If you were driving across, you'd have to wait, then they'd escort

you in a convoy, ten or twenty miles at a time. By the time you got to the next stop, that bunch ahead of you would be leaving. If a guy broke down, that was just too bad. They'd push the car over to the side; he'd get in with somebody else and go on. We were in a *war,* and unless you were a VIP, you did what they said. Anyway they didn't want you out there with live ammunition. Patton fought the African war there first.

"We had 15,000 men here in Kingman at a gunnery school, and you couldn't get a place to rent. Every week they were graduating 250 or so and bringing in more to replace them. The house next door to mine rented two rooms to officers. My present wife came here with her late husband about halfway through the war, and the only thing they could get to live in was a chicken coop. The man cleaned it out, put in a wood stove, and they moved in. She'd never cooked on a wood stove before, but she learned. They finally found a house to rent. I had one customer who had an attic made into three rooms for GIs and converted a chicken coop she's still renting out."

In the desert west of Needles, at the railroad section stop of Amboy, California, war and postwar traffic enabled Buster Burris to expand his father-in-law's service station into a garage, wrecker service, café, and tourist cabins. "We had a lot of traffic during the war," noted the big well-tanned man with blue eyes and a permanent squint from the desert sun. "People were moving back and forth, military families coming out here to tell their men good-bye. And Patton's maneuvers, they were all through here, heavy. We had a lot of soldiers."

Across the desert in Barstow, Jack Belsher agreed that the military buildup affected business during the war, but not necessarily for the good. "The economy around here boomed during World War II," he said, "but tourism died off, and the gas business was hard. We had that

rationing. My father, who was a wholesale distributor, cut back and drove a truck himself during the war."

Victimized by the tight economy in another 66 small town, Clydene Deatherage became part of the wartime migration to California. "I rode the bus out here from Joplin with two kids," said Mrs. Deatherage, a woman in her mid-sixties with permed brown hair and blue eyes. She had come to lunch at the Retired Steelworkers Hall on Foothill Boulevard (the city name for Route 66), in Fontana, California. "My husband was in the marine corps overseas, and my parents had come out here during the war to go to work. They wrote and told me if I came I could get a real good job.

"I got a job at Firestone doing retreads on those big ol' tires. You had to weigh a certain amount and be strong even to be hired, and I was kind of on the heavy side. It was a good job.

"I went back to Joplin when I knew my husband would be discharged. We stayed there a year, but he couldn't find work. We had to sell everything and still didn't have enough money to take the train."

They scraped together enough money to pay $32.00 to share a ride to California, an experience Mrs. Deatherage would have rather avoided. "The man driving, he had a job promised and had to be here at a certain time. The only thing he'd stop for was gas. We'd have to run in and get things to eat and use the restrooms when he stopped. The only thing I could think of was getting out of Missouri and getting to a better living. All my husband

could get was rocking-chair money—relocation pay from the military. We got to California on Friday, the thirteenth of July. My husband walked from where we were to find a job. When he come back that night, he had five different jobs."

Transplanted Missourians that they were, the Deatherages made an effort to go home for a visit at least every other year, no doubt becoming part of the June 16 migration that the cafés, service stations, and souvenir shops waited for, following the end of the California school term on June 15. "I used to know every rest area, every stop on the highway. We always stayed in Albuquerque the first night out. We usually tried to stay in the same places and tried to get to Missouri in the daytime."

Military traffic, a dearth of tourists, and gasoline rationing made Route 66 far different during wartime from what it had been previously. Movement of heavy military equipment also foretold the end. While the cross-country highways like U.S. 66 were important for transporting troops, supplies, and equipment, the roads simply were not adequate for the traffic they carried, and the difficulty of maintaining them grew throughout the war.[3] A proposal had already been drawn up for a limited-access interstate highway system, and after the war it was clear that such a system had acquired support in Washington and among the public. Before that new highway system and after the end of World War II, however, was a golden age for highway travel and tourist businesses in the United States.

PHOTOGRAPHIC ESSAY

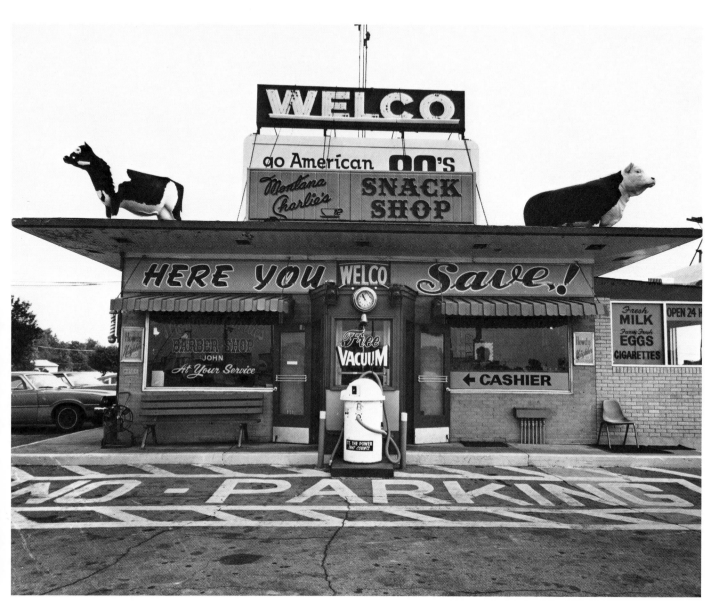

Welco Corners, 1934–84
"Montana Charlie" Reid
Welco Corners, Illinois

"He was a showman. He brought that with him in anything he did. You could see it in the colors of the building, the way he greeted people, the way he made friends."—DAVID DALE, PROTÉGÉ OF "MONTANA CHARLIE" REID.

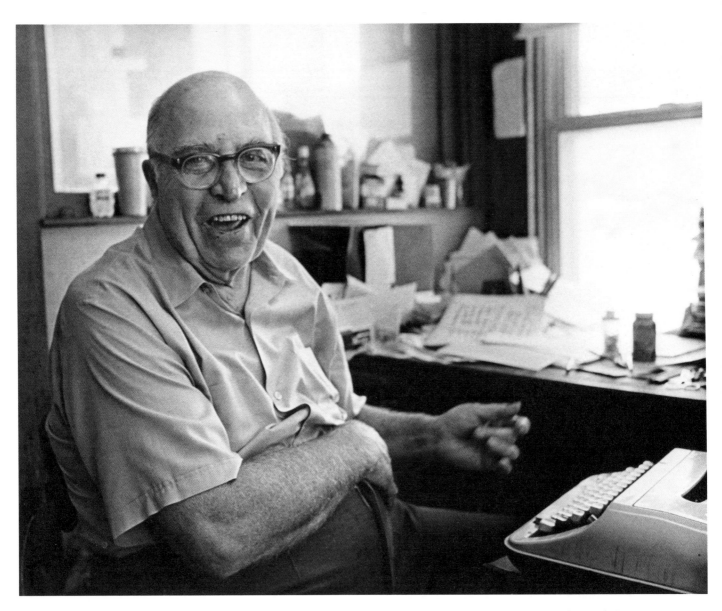

Michael Burns
Michael Burns and Sons, 1919
Springfield, Illinois

"We were on the north side of Springfield on Route 66. We started there in 1919. See, 66 went right by here, and right through town, and went out what they call Peoria Road, and turned and went to Chicago. Old 66, which is now known as 55. It was for years and years 66, even though they had 55, but they couldn't change it. The reason they couldn't change it, it was so imprinted in the mind of the people all over the country that they would come in and ask, 'Is this 66? Is this 66?' 'No, it's 55.' They'd think you were drunk."—MICHAEL BURNS.

Elkhart, Illinois

"There was a time, when the state fair was on in Springfield, when you would sit on that corner a half hour waiting to get on the road."—FLORENCE CRANER, ELKHART, ILLINOIS.

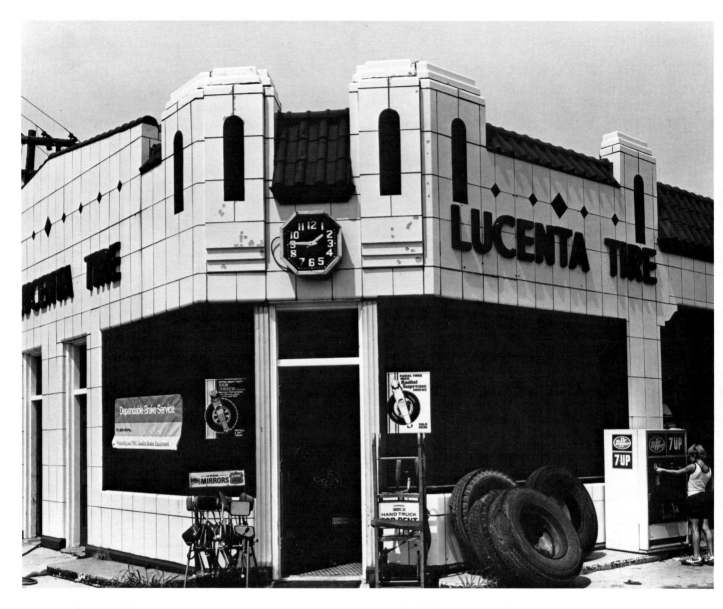

Lucenta Tire
Formerly Rossi's Service Station, 1939
Braidwood, Illinois

"God, 66 was a continuous stream of cars. We had a four-way stop here, and we had a gas station here on the corner that did a terrific business."—PETER ROSSI.

Steak 'n Shake, ca. 1950
Bloomington, Illinois

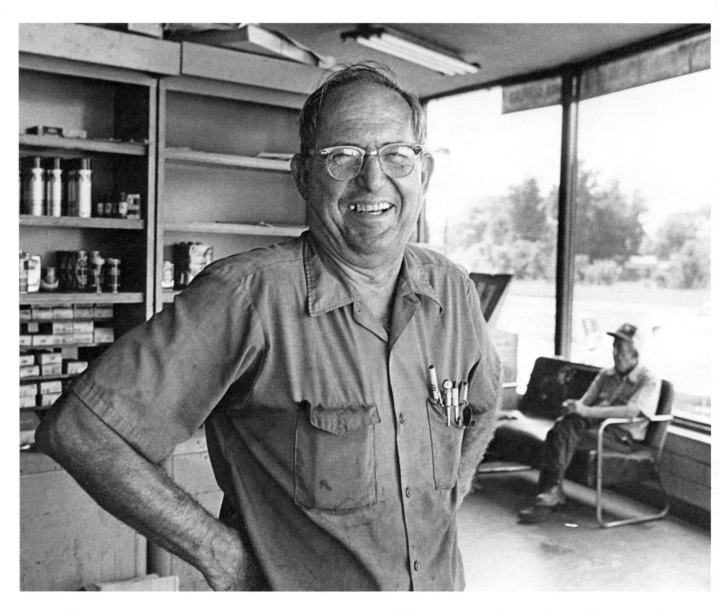

Fenton Craner
Elkhart Texaco, 1946
Elkhart, Illinois

"This used to be a penny business when you could buy the product for nine cents. Now the cost is $1.09, and it still's *a penny business."*—FENTON CRANER.

Art's Motel, ca. 1950
Divernon, Illinois

Russell and Ola Soulsby
Soulsby Shell, 1927
Mount Olive, Illinois

"We were here in 1926, before the highway, but they had already surveyed and we knew it was coming. The building was up and we were ready with gas before the pavement was laid. We built ourself a real good business, and all of a sudden the bottom drops out. They moved 66 from here to west of town. This road here doesn't have no name anymore. Old 66, that's the last name it had, just old 66."— RUSSELL SOULSBY.

66 Terminal, 1940
Staunton, Illinois

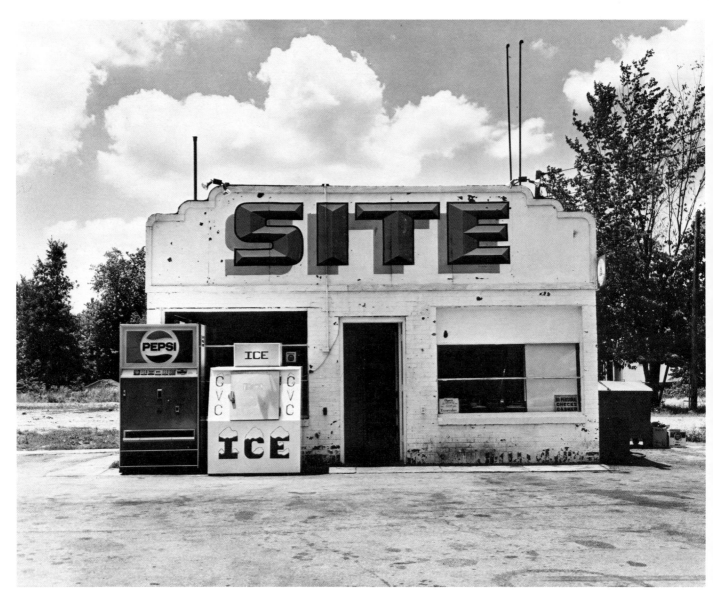

Site Service Station, 1940
Edwardsville, Illinois

"Phil Siteman really got the independents going through this area. He was a strict independent. He must have had people who let him have money. He bought those stations and put them in, and he had a low price."—MICHAEL BURNS, SPRINGFIELD, ILLINOIS.

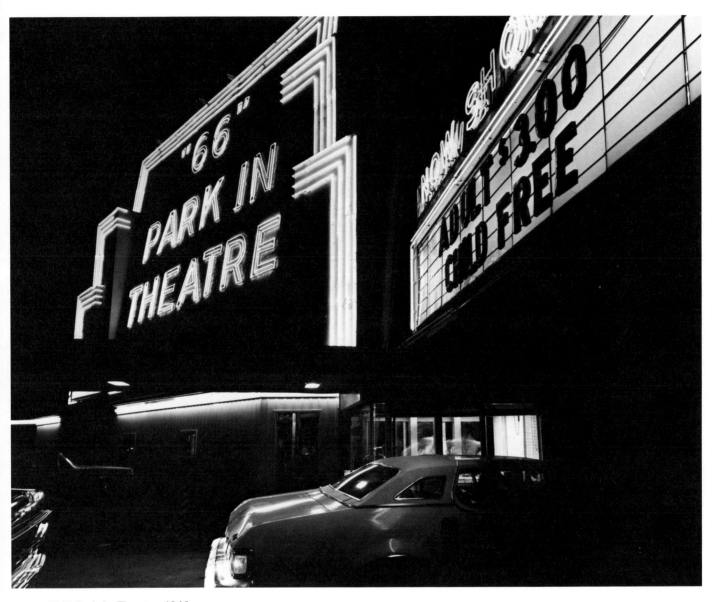

"66" Park-In Theatre, 1946
Saint Louis, Missouri

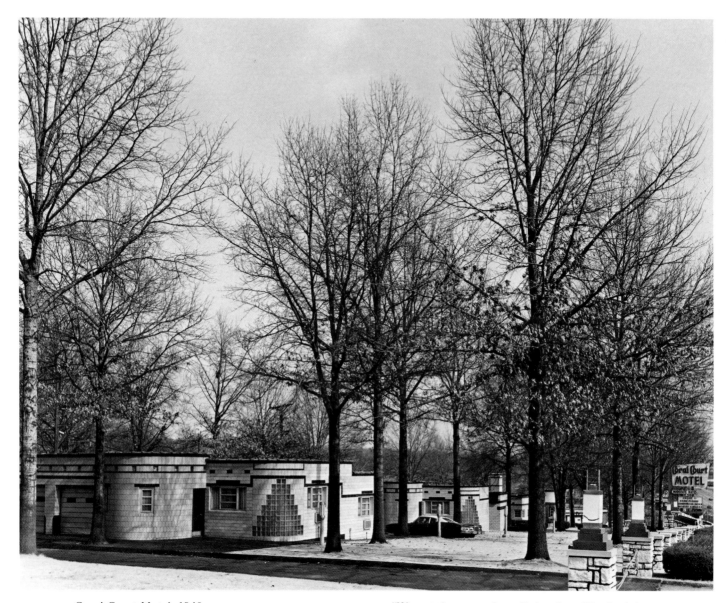

Coral Court Motel, 1940
Saint Louis, Missouri

"We get that question all the time. We don't know who the architect was."—UNIDENTIFIED MANAGER, CORAL COURT.

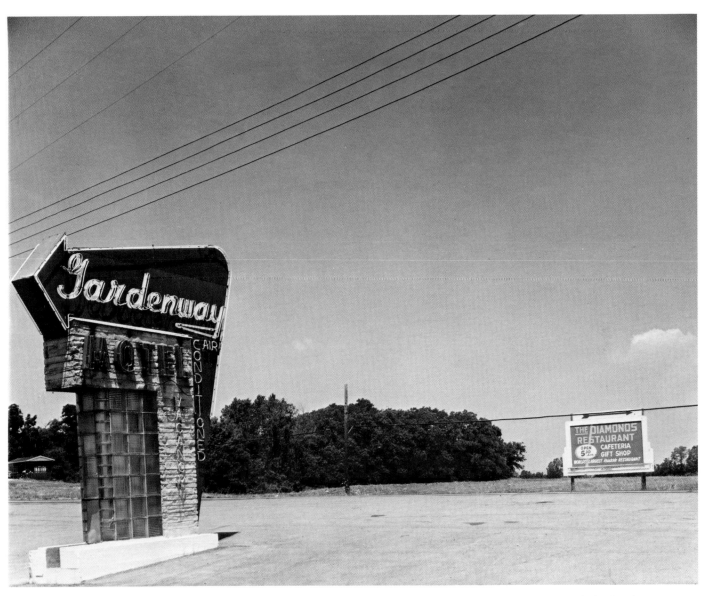

Gardenway Motel, 1940
Gray Summit, Missouri

"Route 66 went from Needles almost to Saint Louis. None of the hotels in Saint Louis would act like there was a damn road and the people in California didn't care. But the highway sure was important to the folks in the middle."—LYMAN RILEY, PRESIDENT, MISSOURI 66 ASSOCIATION.

97

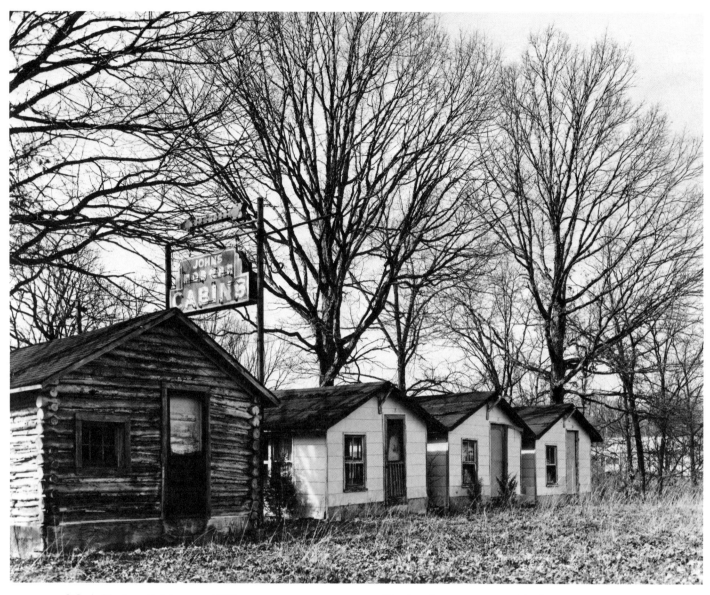

John's Modern Cabins, ca. 1942
Clementine, Missouri

"During the war you could donate any kind of a place—even chicken houses—for people to live in. There were that many people working at Fort Wood. There was all kinds of cabins around here. They would just put up anything that people could live in."—AMY THOMPSON, BASKET MAKER.

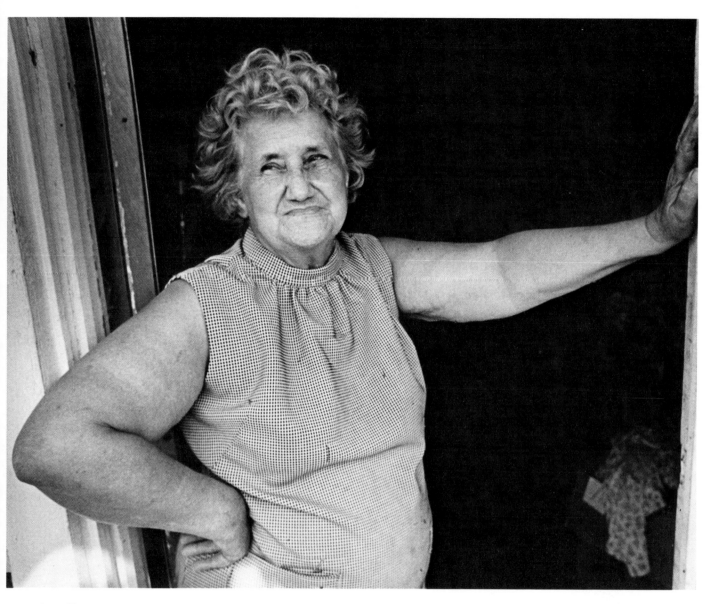

Amy Thompson

"I moved here in March, 1929. I was with my parents then, and we come from Cabool. My brother had come up here. We made baskets and chairs and things like that and sold them on the highway. He said it would be better up here to sell our things. We had a shop. Other people learned the trade. There were several shops."—AMY THOMPSON, BASKET MAKER.

Hooker Cutoff
Devil's Elbow, Missouri

"Bloody 66—it was a thing. Devil's Elbow was supposed to be the death corner of the world. I remember Dad would get white knuckles ten minutes before we'd go through there."—BILL ROSEMAN, 66 TERMINAL, STAUNTON, ILLINOIS.

100

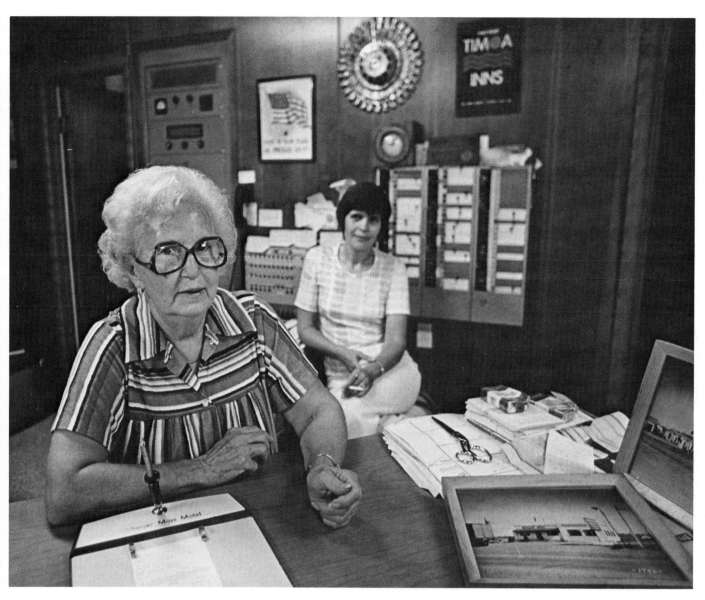

Jessie Hudson
Ramona Lehman
Munger Moss Motel, 1946–72
Lebanon, Missouri

"Our first progress was in the restaurant. We changed it from the Chicken Shanty to the Munger Moss and put in a barbeque. Our next progress was fourteen stucco rooms—a room at each end, garages in the middle, then a gap. We had seven of those units."— JESSIE HUDSON.

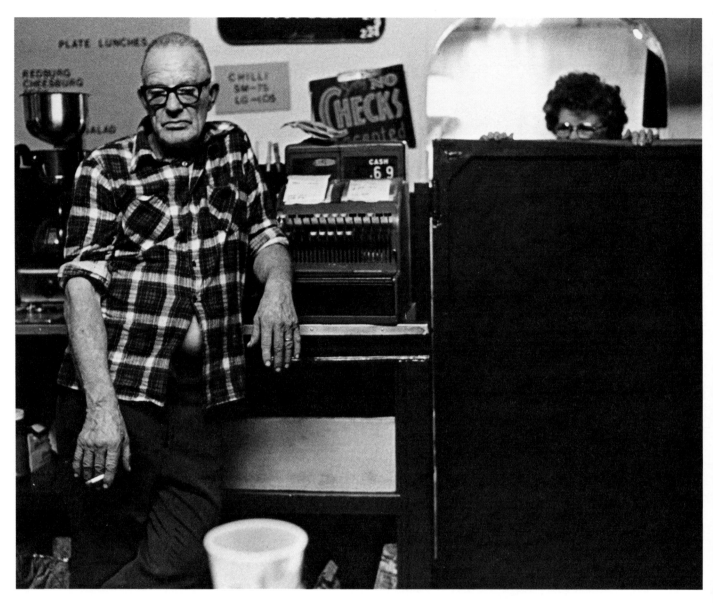

Sheldon ("Red") Chaney
Red's Giant Hamburg, 1946–84
Springfield, Missouri

*"The ceiling is this color blue, like the sky. It's got a
certain tint to it. Flies won't land on it. They're al-
lergic to that. The sidewalls: white with a little bit
of peach in it. The seats: green like you're sitting in
an area where there's green bushes. The floor is
as much like dirt as possible, and make it look as
much like a picnic as you possibly can. It stimulates
the appetite and people enjoy it."*—SHELDON ("RED")
CHANEY.

Las Vegas Hotel and Barber Shop, ca. 1935
Halltown, Missouri

"This fellow went to California. He worked out there and come back and built this thing and called it the Las Vegas. His name was Charlie Dammer. He had four rooms upstairs and a cafe downstairs. That tiny little building next door is his barber shop."— KENNETH GOODMAN, SERVICE STATION OWNER, HALLTOWN, MISSOURI.

Modern Cabins, ca. 1940
Rescue, Missouri

The Reverend William Pennock
Gospel Kingdom Campground
Galena, Kansas

"We had a soup kitchen at Picher and one at Galena and one at Joplin. That was 1930, 1931. Sometimes we fed a hundred a day. They was out of jobs, and walking. Come down to the end of the day, they'd just roll in the ditch. They didn't have nothing."—
THE REVEREND WILLIAM PENNOCK.

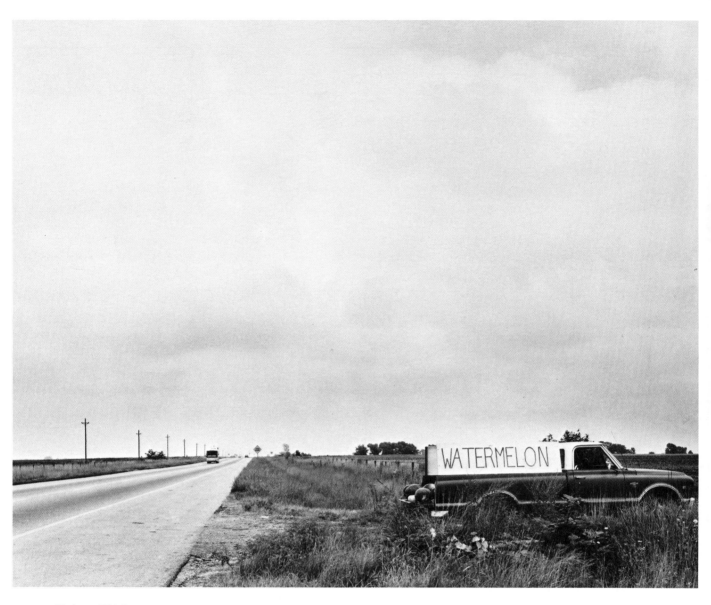

Picher, Oklahoma

"When I was at Miami High School, I got Will Rogers to come up and speak at the Coleman Theater, in Miami. We charged $1.00 a seat for 1,600 seats. We raised $4,500. He didn't do nothing but tell jokes and spin his rope. We turned the money over to Picher, and they built a bridge there."—THE REVEREND WILL PENNOCK, GOSPEL KINGDOM CAMPGROUND.

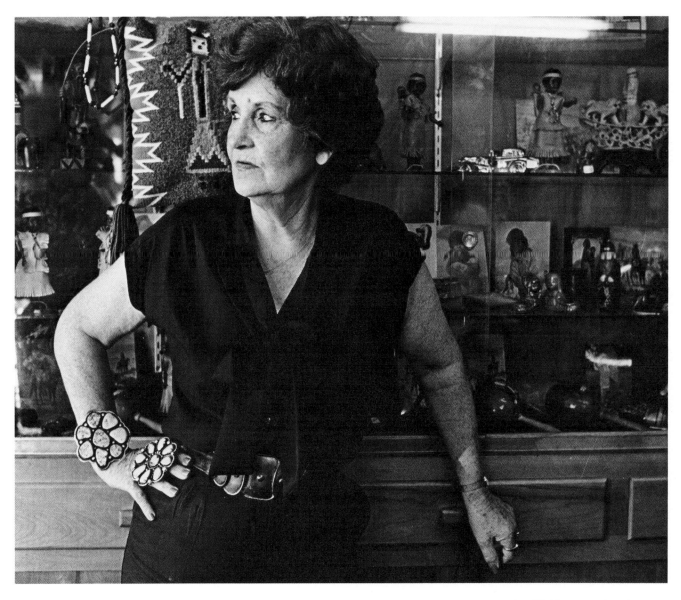

Norma Cullison
Dave's Trading Post, 1953
Claremore, Oklahoma

"My husband was a horse trader. We'd go west and pick up Indian stuff, and then we'd go east and sell. Then we'd pick up stuff in the east and go west. We drove a Cadillac and we loaded it down, and we pulled an eight-foot trailer on behind that. And everybody from coast to coast would tell you they know Dave Cullison and his family that drove a yellow 1955 Coupe de Ville Cadillac. We had 300,000 on that car."—NORMA CULLISON.

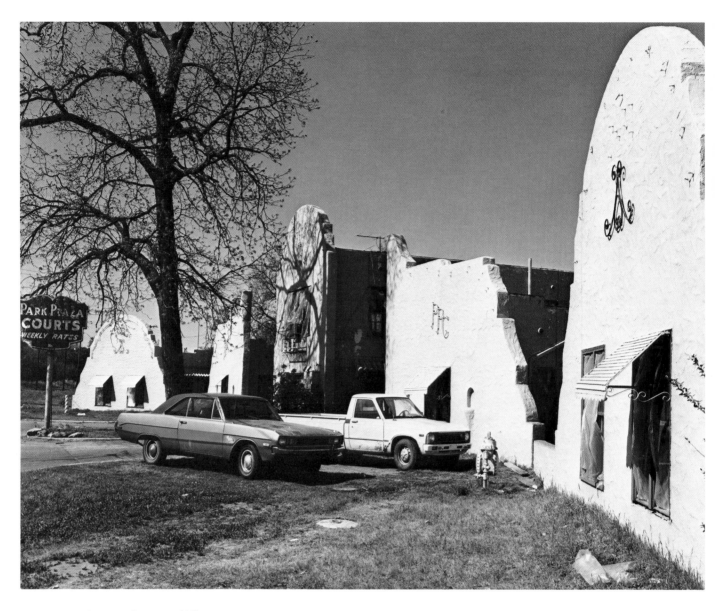

Park Plaza Courts, 1935
Tulsa, Oklahoma

"When I was a little girl, it was a white hacienda trimmed in red. It looked like a little Spanish village."—DOROTHY HARRISON, OWNER.

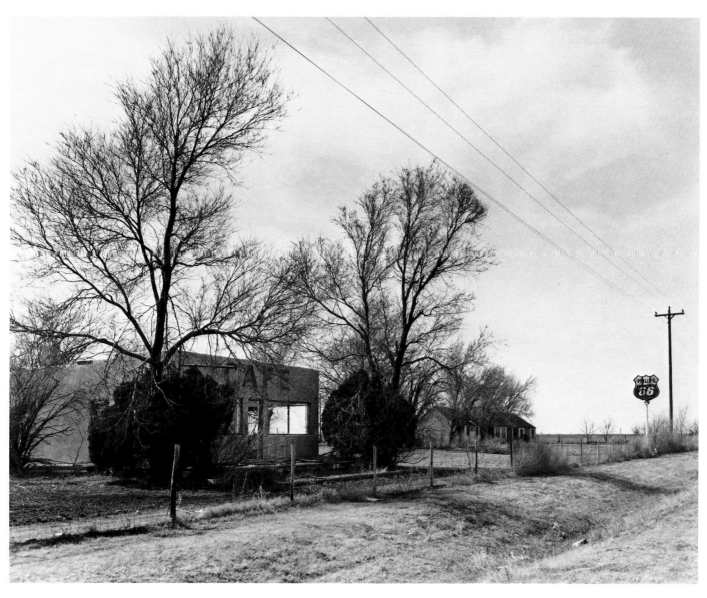

Leon Little's Service Station and Motel, 1934–62
Hinton, Oklahoma

*"It was lonely looking out there where we were.
People that come by would say, 'What in the world
do you do for entertainment out here?' And I'd say,
'Well, we work most of the time, and after we run
out of work, we run jackrabbits.'"*—ANN LITTLE.

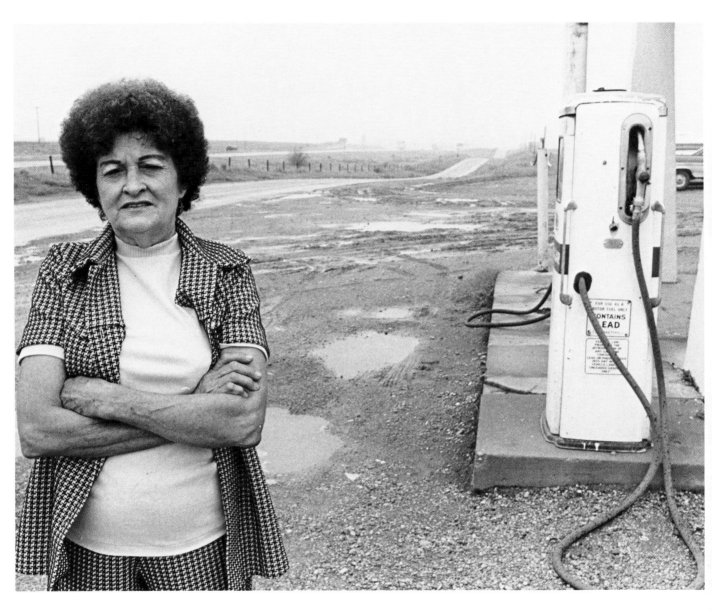

Lucille Hamons
Hamons' Service Station and Motel, ca. 1936
Hydro, Oklahoma

"I've kept people in the rooms that couldn't pay their room rent. They've sold me all kinds of things for gas—clothes, cars, everything."—LUCILLE HAMONS.

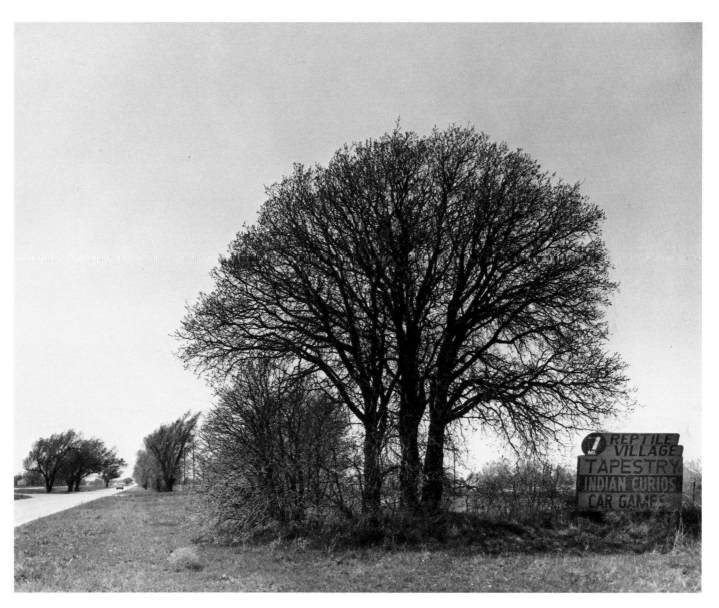

Reptile Village sign
Erick, Oklahoma

"The worst things along the highway were these zoos all through Oklahoma with signs all along about the huge man-eating pythons. They'd have snakes and reptile gardens and free admission. Anything to get you to stop, and then they'd get you in a bunco game, not poker or dice, but in the old shell game. One whole year all I did was check them.—
LYMAN RILEY, PRESIDENT, MISSOURI 66 ASSOCIATION.

111

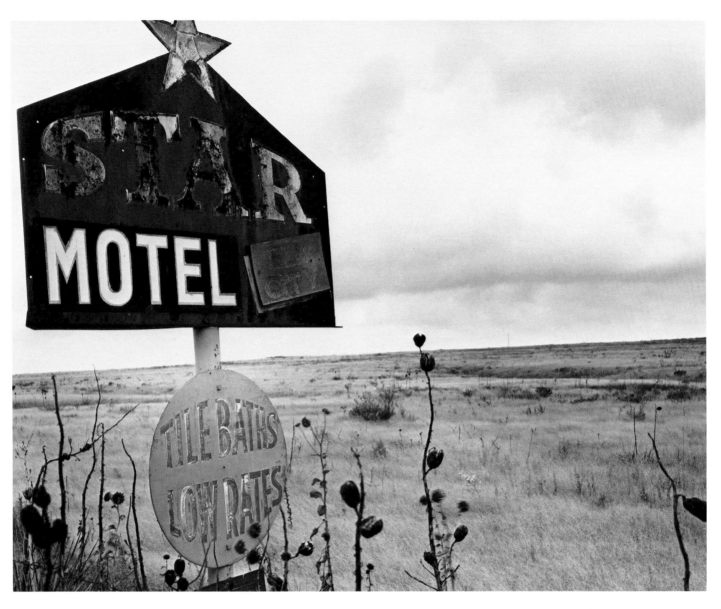

Star Motel, ca. 1948
Elk City, Oklahoma

*"We just drove. And then we'd just stay in a motel.
And after we saw Louis Armstrong in Saint Louis,
there was nothing to do. We never even went to a
movie. There must have been a movie in Elk City.
There must have been a restaurant to go to, a movie,
a little western nightclub or something. I'm sure if
there was, we would have found it. It seems to me it
was just a long road with cheap motels and restau-
rants."*—CYNTHIA TROUP.

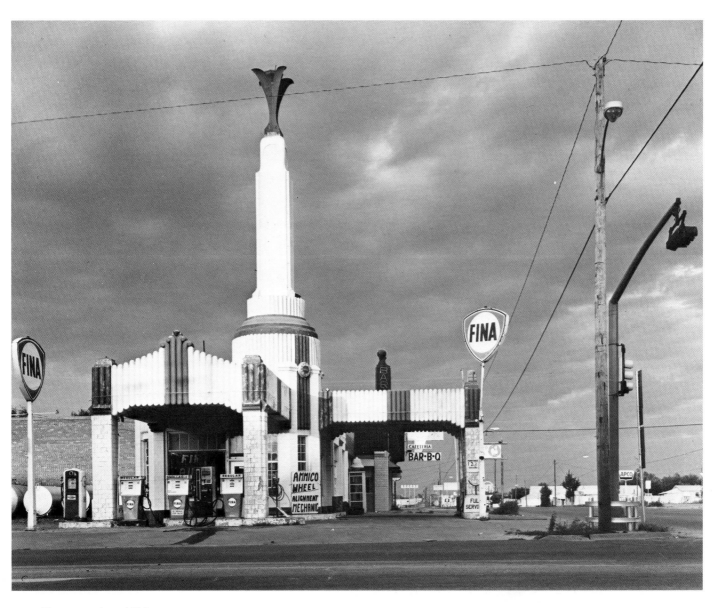

Tower station, 1936
U-Drop Inn
Shamrock, Texas

"J. M. Tindall built the tower station. We were all great friends. He come down one day, and my husband, John, took a rusty nail and drew the plans for the building in the dirt. It opened in April, 1936."—
BEBE NUNN.

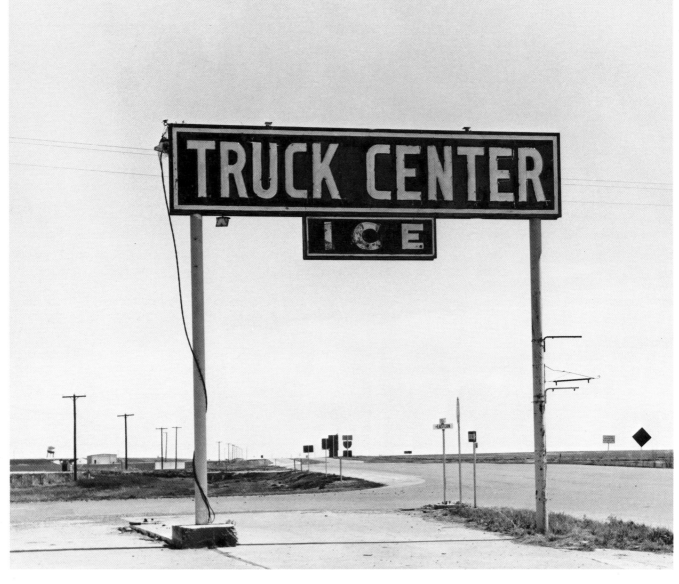

Truck Center
Groom, Texas

"A stretch of 66 right down here they called Death Alley or Blood Alley. There was something wrong with the blacktop, and if it was wet, you didn't have any control. While they was working on it, it went from four lanes to two, but they just kept driving on it like it was four lanes—killing them, coming and going, in spite of the signs."—RUBY DENTON, OWNER, GOLDEN SPREAD CAFÉ.

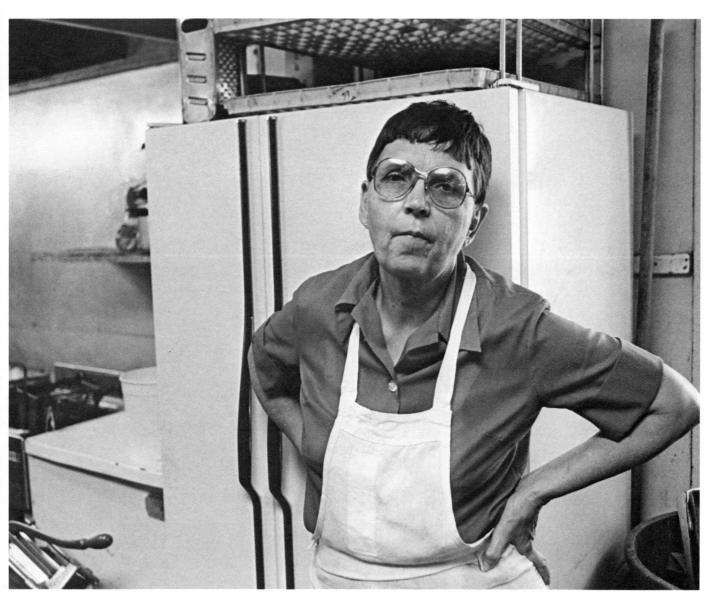

Ruby Denton
Golden Spread Café, 1958
Groom, Texas

"People who run cafés are women. I'll tell you why: most men don't like to work that hard and don't like to take the guff. When you operate a café, you don't travel—you stay home and tend to business. The café business is fun if you like it, and I like it."— RUBY DENTON.

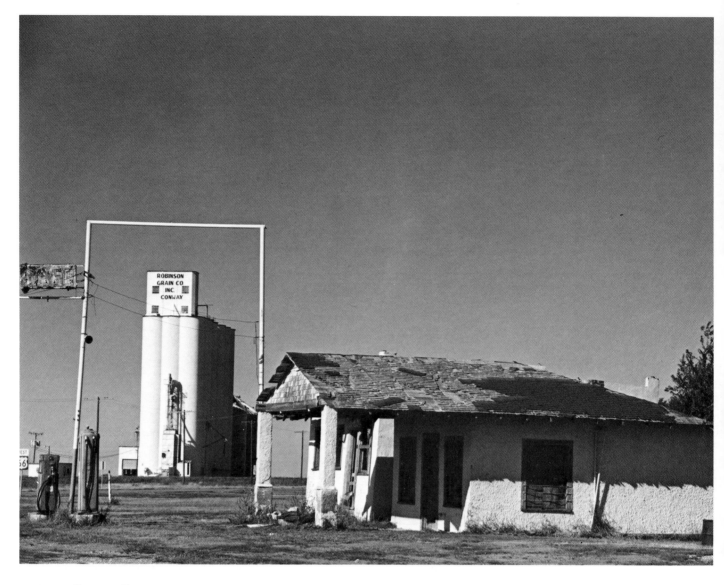

Conway, Texas

"You want to see the traffic. It runs all year round. The California schools get out about the fifteenth of June, and twenty-four hours after those schools close up, there is a solid line of transportation going east. All those people with kids have to go back to Oklahoma, Arkansas, or East Texas every two or three years. June is your best tourist month. Then July and August. September comes, they have the fair in Albuquerque for ten days. Okay, you get all those people going west, and they all go back home. Then your deer hunters come from Florida and East Texas, going to Colorado and New Mexico. That's another month. They all get settled down, then your old folks come. They're going to Phoenix and Tucson."—A. F. MOORE, PHILLIPS DISTRIBUTOR, WILDORADO, TEXAS.

116

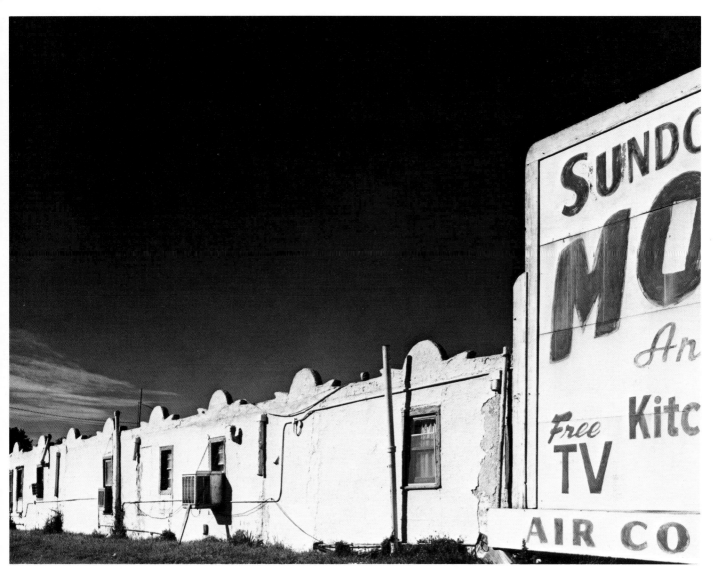

Sundown Motel, ca. 1948
Amarillo, Texas

"Amarillo was almost like it is now. Amarillo has changed less than any town I know of."—PAULINE BAUER, ALBUQUERQUE, NEW MEXICO.

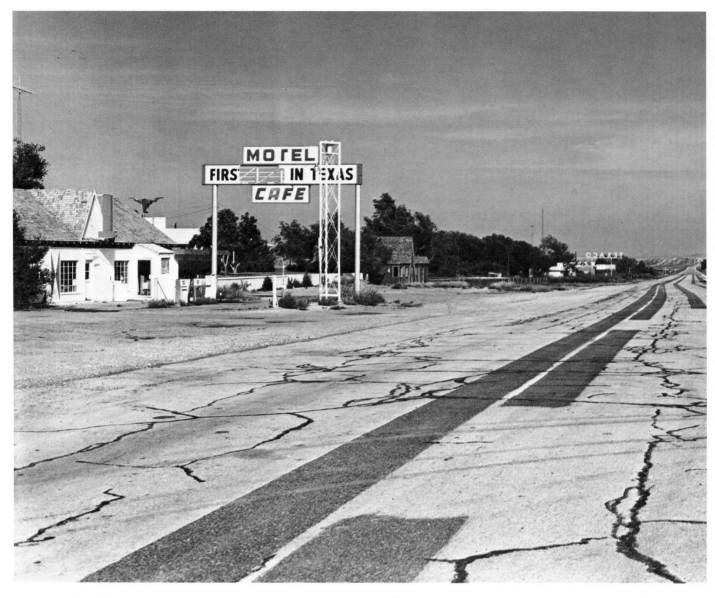

Last Motel in Texas/First Motel in Texas, 1950
Homer Ehresman
East Glenrio, Texas

"If you want to be lonely, you make it lonely. Some people never would have stayed here."—HOMER EHRESMAN, OWNER, LAST MOTEL IN TEXAS/FIRST MOTEL IN TEXAS.

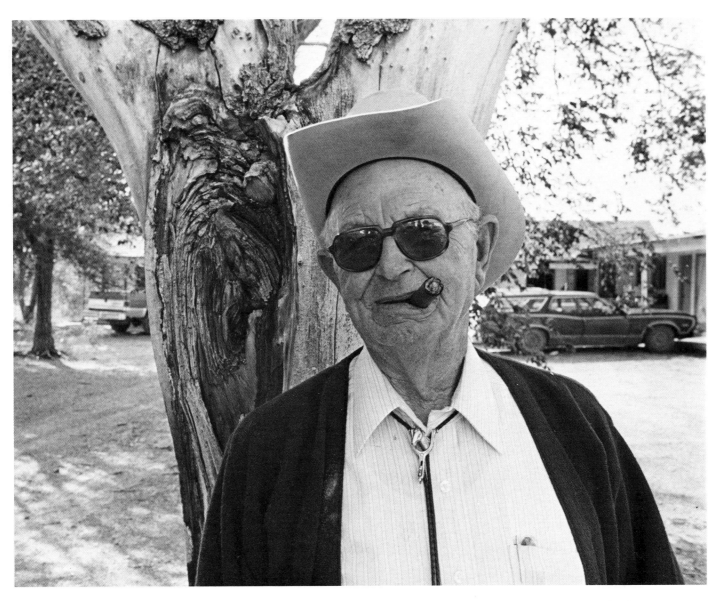

Homer Ehresman
Last Motel in Texas/First Motel in Texas
East Glenrio, Texas

"When they paved this road out here, we was feeding the crews three times a day, family style, all you could eat for one dollar a day. Those people were getting thirty cents an hour and worked only forty hours a week. They slept along the street and in tents."—HOMER EHRESMAN.

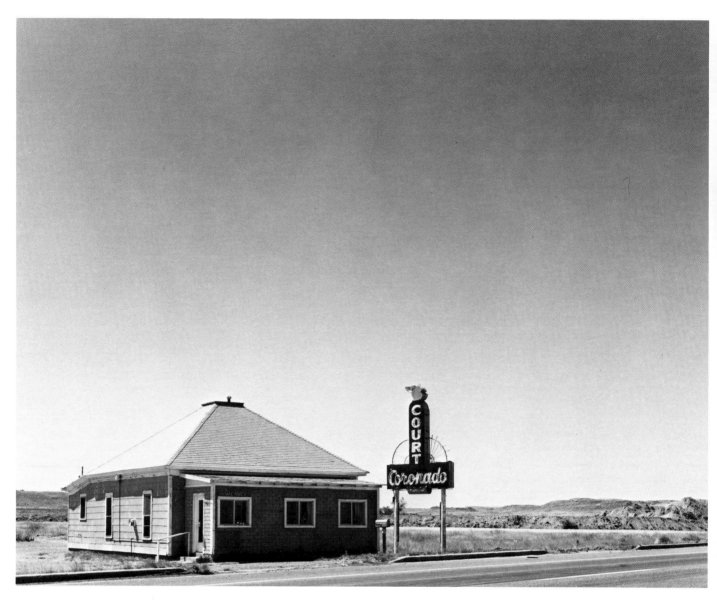

Coronado Court, ca. 1935
Tucumcari, New Mexico

"When I came here in 1922, the only paving was from downtown up Gaynell Street. It was paved to the top of the hill. And it was paved with clinkers and cinders from the coal plant. We had a highway made of clinkers."—BOB BURNHAM, TUCUMCARI, NEW MEXICO.

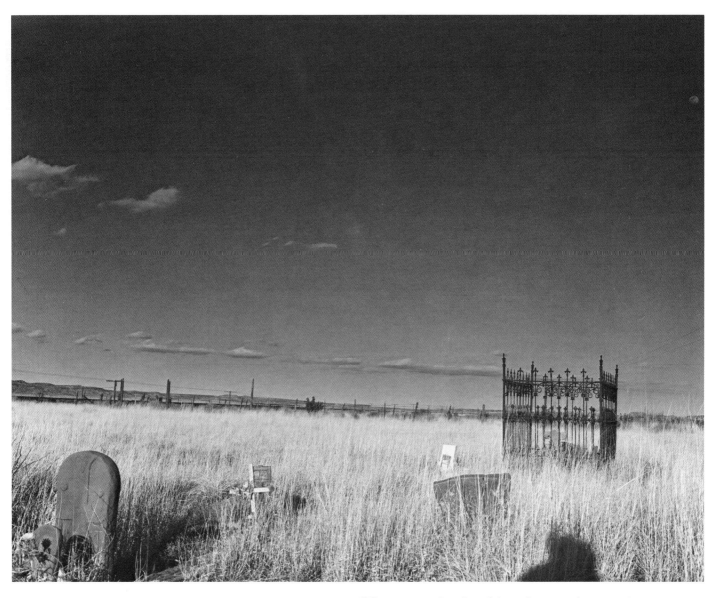

Spanish cemetery
Newkirk, New Mexico

"There was a few Spanish settlements down on the Pecos, south of Santa Rosa and on up in Las Vegas, but most of the people east of Santa Rosa were English who came before homesteading."—ROY CLINE, CLINES CORNERS, NEW MEXICO.

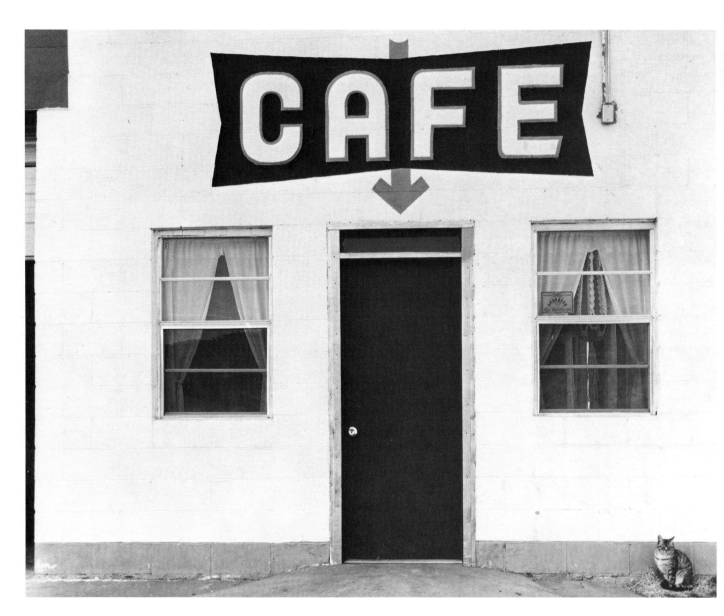

Café, ca. 1955
Cuervo, New Mexico

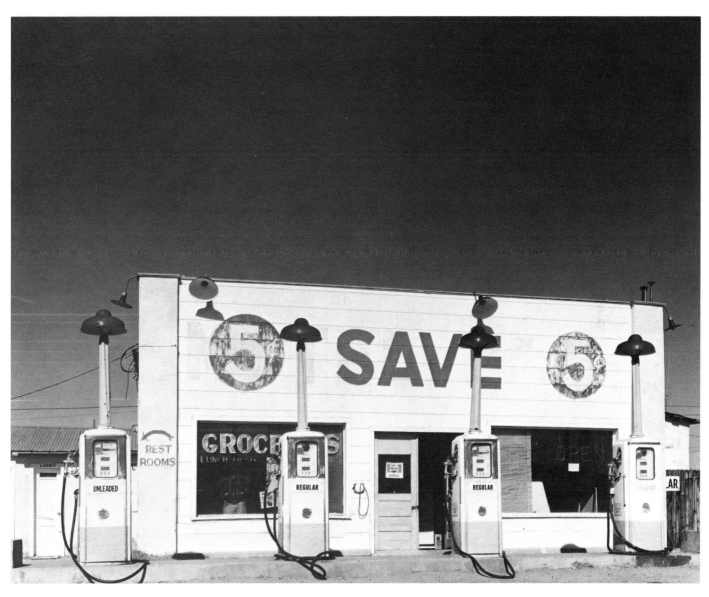

Save 5 Cents, 1947
Santa Rosa, New Mexico

*"Santa Rosa was a tourist town. Business was 75
percent tourist and 25 percent local."*—JOSEPH SMITH,
STANDARD OIL JOBBER, SANTA ROSA, NEW MEXICO.

Floyd Shaw
Club Café, 1938
Santa Rosa, New Mexico

"Well, we picked up and went to advertising pinto beans. People here like pinto beans, but tourists didn't know what pinto beans were. But these people here, these Spanish people, they could live on pinto. They got a lot of protein in them. So we started advertising sourdough biscuits and pinto beans."
—FLOYD SHAW.

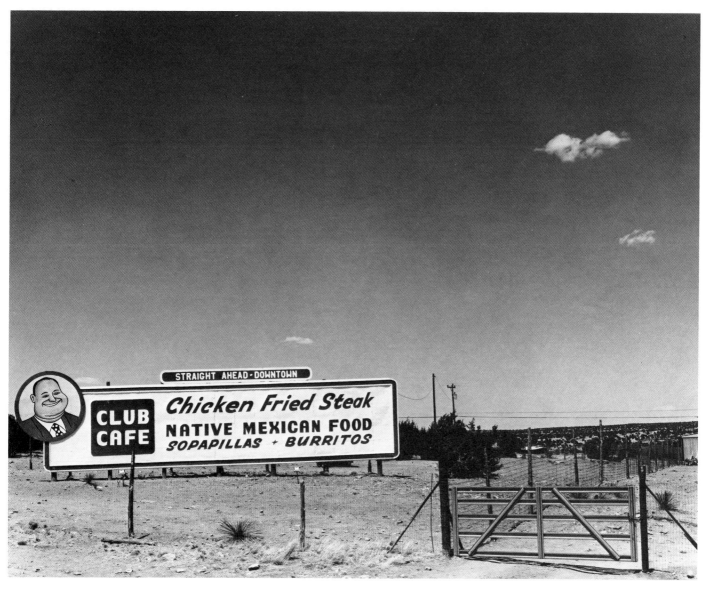

Sign, Club Café
Santa Rosa, New Mexico

"That fat man come off a postcard. There was just something about it. He was ugly, and people would remember him. We put up one or two and got a lot of comment on them. Got a sign painter who could take this picture postcard and transfer it, transplant it on the billboards."—FLOYD SHAW.

Hi-way Host Motel, ca. 1948
Albuquerque, New Mexico

Uranium Café, ca. 1955
Grants, New Mexico

"We had no paved roads off 66, in 1955, when these uranium companies came in. They said they would not come here and explore and develop without a hospital, which we didn't have, and without paved roads to the mills. We had to get busy and do all that."—MARVEL PRESTRIDGE, FIRST TELEPHONE OPERATOR, GRANTS, NEW MEXICO.

LeRoy Atkinson
Box Canyon Trading Post, 1941–52
Box Canyon, Arizona

"We were setting there on the highway depending on the tourists. And during the war they rationed gasoline. There was no tourists. There just wasn't any. The first day they rationed gasoline, I went out in front of our store, and I looked up and down that highway, and the only thing that I could see coming was one of those eighteen-wheel trucks, and I thought, 'My God, what are we going to do?'"—
LEROY ATKINSON.

128

Trading Post and Motel
Lupton, Arizona

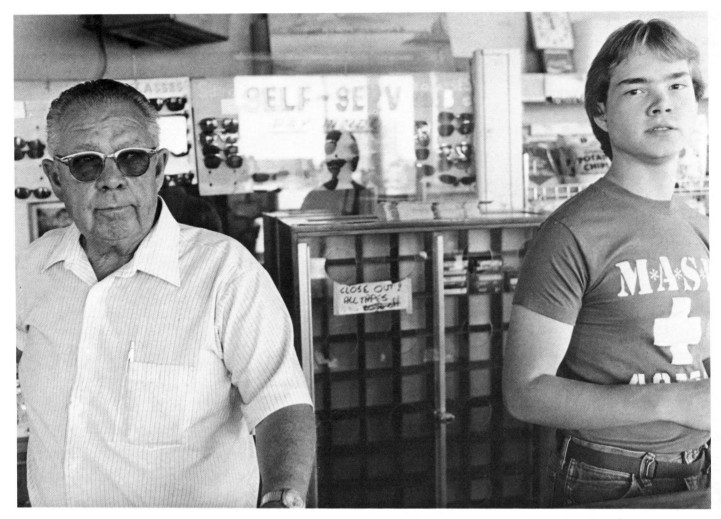

Allen Hensley and Dennis Hensley
Whiting Brothers' Service Station, 1945
Holbrook, Arizona

"Ration stamps. Couldn't buy new tires. Guys come from the West Coast with recaps, patched-up tires, vulcanized, any old used tire. We used to sell 'em by the truck load. Just didn't buy new tires. I don't remember the gas being such a hassle. Everybody got gas who wanted it."—ALLEN HENSLEY.

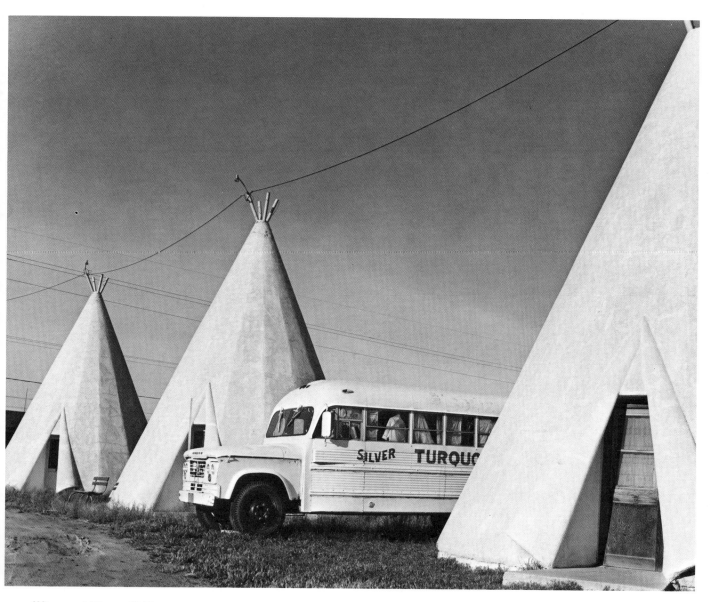

Wigwam Village, 1946
Holbrook, Arizona

"Dad was in Kentucky and saw a tepee motel. He got the blueprints and started working on them in 1946. He finished in 1950. He did most of the work himself."—CLIFTON LEWIS.

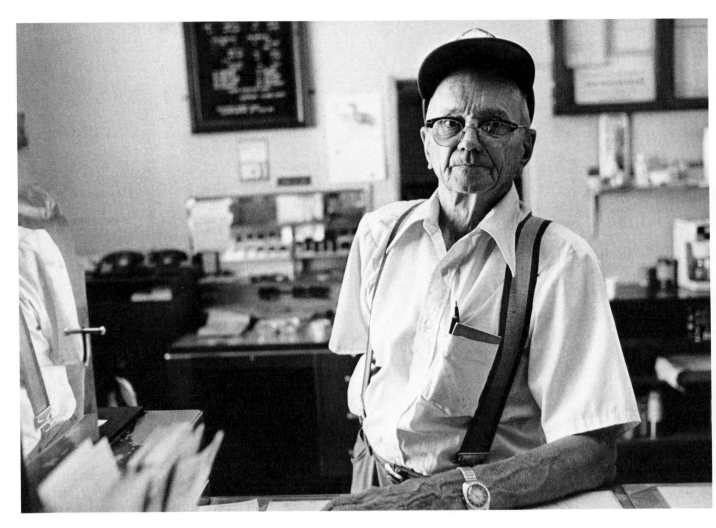

Richard Mester
Richard's Café and Bus Center, 1935
Holbrook, Arizona

"Yellow-way Bus was the first bus line that come
through here from Kansas City going to Los Angeles.
Left Albuquerque early in the morning and got here
in the evening about five or six. Spent the night over
here, and took out the next morning to go to King-
man that day, and spent the night there. And on
down to Barstow the next day. It took several days
to get from here to Los Angeles."—RICHARD MESTER.

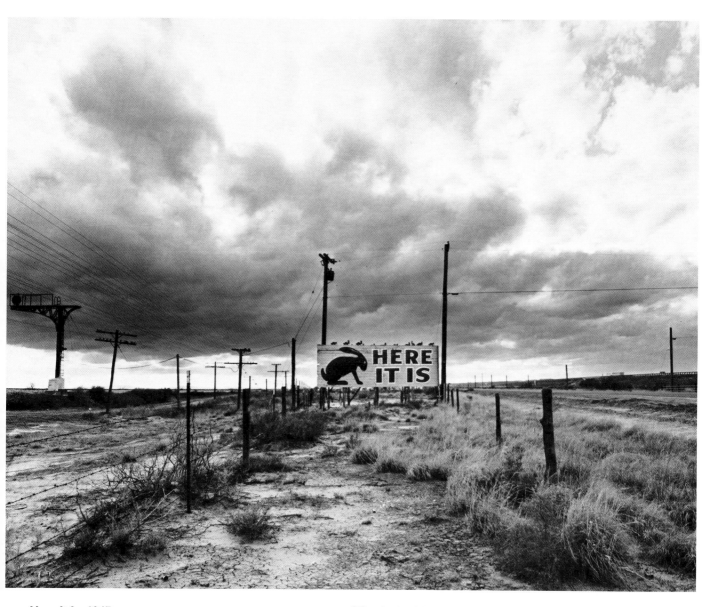

Here It Is, 1947
Jackrabbit Trading Post
Joseph City, Arizona

"The Jackrabbit. That little old place has made three or four different owners rich. The guy who started it, I don't know how long ago, he just had a bunch of junk."—ALLEN HENSLEY, HOLBROOK, ARIZONA.

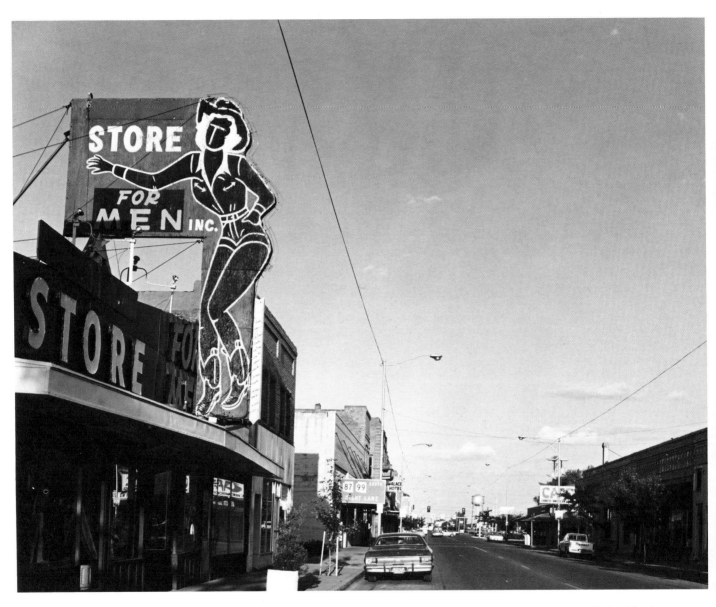

Store for Men, ca. 1948
Winslow, Arizona

*"One of 'those places' on Highway 66, in Winslow,
Arizona."*—POSTCARD FOR THE STORE FOR MEN.

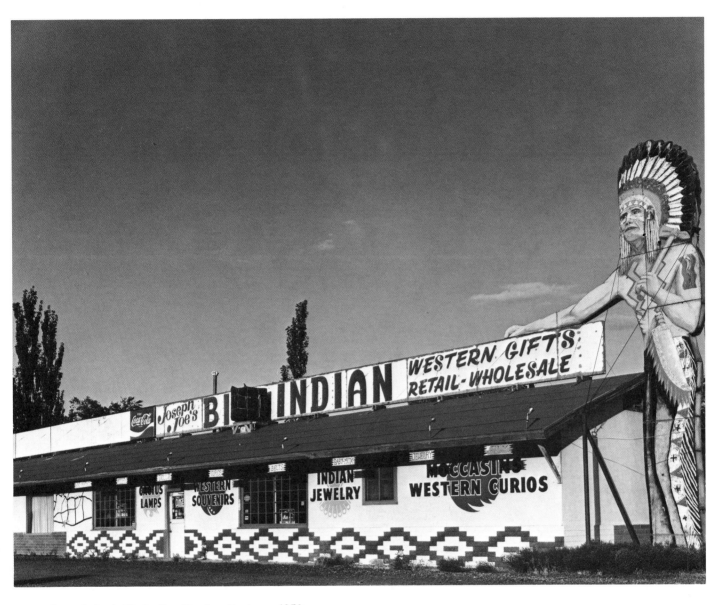

Joseph Joe's Big Indian Trading Post, ca. 1950
Winslow, Arizona

Garage, ca. 1927
Peach Springs, Arizona

"In the summers this would almost be like a city street, a city boulevard. Ping, ping, ping, car after car."—BEATRICE BOYD, PEACH SPRINGS, ARIZONA.

Beatrice Boyd
Peach Springs Auto Court, 1937–82
Peach Springs, Arizona

"The big farmers from Kansas came in July after the wheat harvest was over. You could almost look at the license plates and know when the harvests in the other states were over."—BEATRICE BOYD.

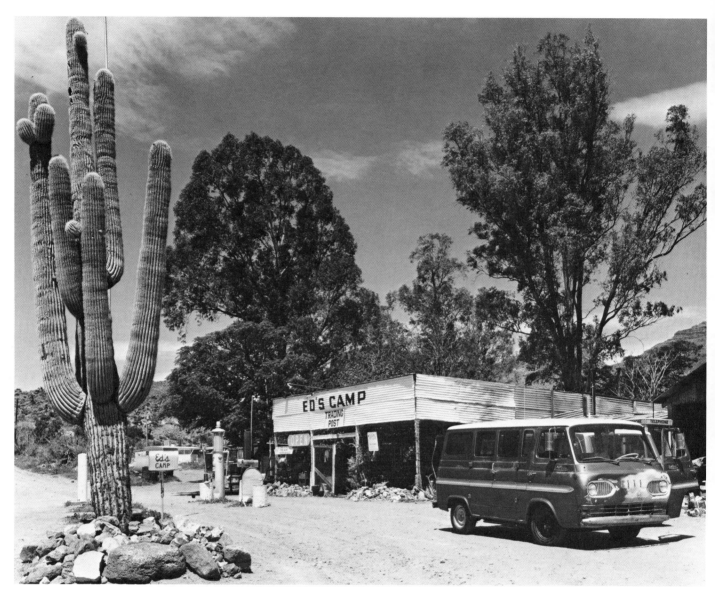

Ed's Camp, 1919
Sitgreave's Pass, Arizona

"Ed (Edgerton) came here in 1917. He was a miner. He built a camp here. What happened was when the buses started coming by, he put this up. He started with the foundation. He was going to put a building in here, but business progressed so rapidly, he said, 'The hell with the building, we will leave it open.' So he threw up a roof over the foundation."—KEITH GANNET, ED EDGERTON'S NEPHEW.

138

Café, ca. 1955
Needles, California

"The summer was when the tourists would go through, and they were the ones who would come in, 'Aggh, is it always this hot here'? My husband, he was kind of a kidder, would say, 'Aggh, it gets hotter then this once in a while.'"—MILDRED ARMES, CARDY'S CAMP, NEEDLES, CALIFORNIA.

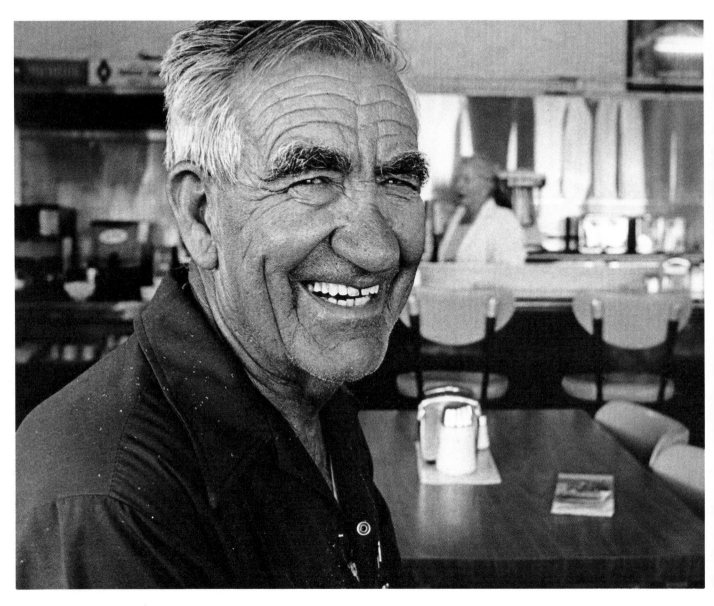

H. B. ("Buster") Burris
Roy's Garage, 1927

*"We had seven wreckers in town, and I assure you
of one thing: I never lost."*—H. B. ("BUSTER") BURRIS.

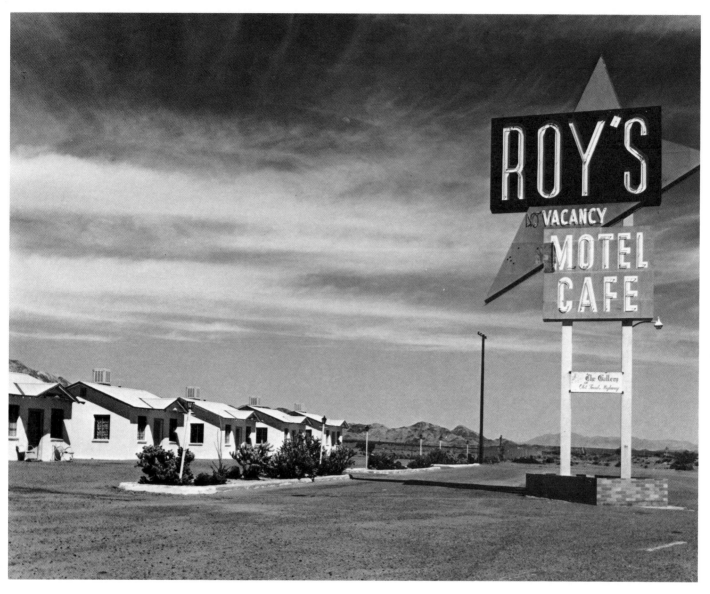

Roy's Café, 1945
Roy's Motel, 1948
Amboy, California

"I built two cabins: one and two was put up in about 1944. That was to take care of people whose cars had to stay overnight. They were sleeping in their cars, and their cars would be tied up. I started building the motel in 1948 and completed what you see out there in 1952. We had over 100 percent occupancy. We rented them night and day."—H. B. ("BUSTER") BURRIS.

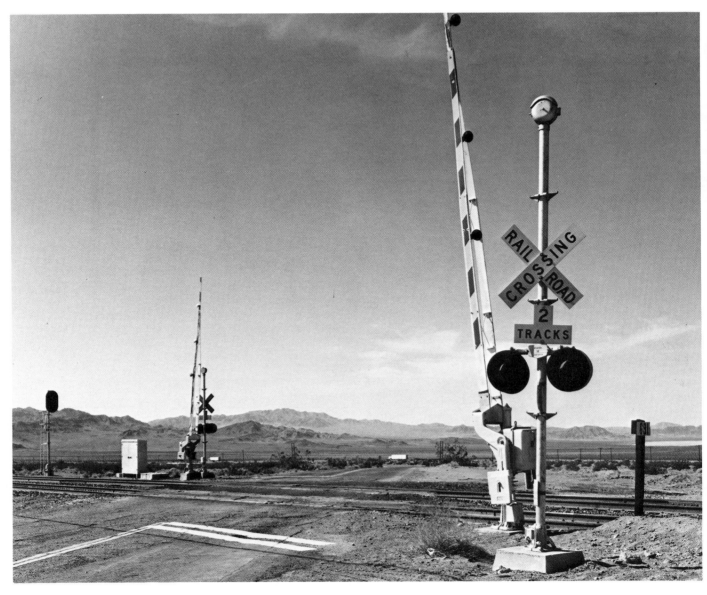

Ludlow Crossing
Ludlow, California

"When we came to the top of a rise, the terrain flattened out and the pavement just stopped. There were no signs—nothing—and we just drove off into the sand. The sand was real deep, and the motorcycle came to a stop four feet from the end of the slab. We stood there a while, and my wife said, 'This is the Mojave.'

"There was just two ruts in the sand from there on. Most of the way the railroad was in sight of us. We'd see it sometimes right next to us, other times we'd see the telegraph poles a mile away. We'd see the poles there, following the railroad."—GEORGE GREIDER, TULSA, OKLAHOMA.

142

El Rancho Motel, ca. 1935
Barstow, California

"Cliff Chase built El Rancho out of railroad ties from the Tidewater and Tonepaugh Railroad, a narrow-gauge railroad from Tonepaugh, Nevada, to Ludlow, California."—WILLIAM BUTLER, FORMER TEXACO DISTRIBUTOR, BARSTOW.

Duane Meyer
Meyer's Service Station, 1948
Cucamonga, California

"I had two uncles out here already. My dad died when I was fifteen, and when I got to be nineteen, I decided there had to be a better, easier way of life than spending it back in Nebraska in the heat and the cold. So I came to California."—DUANE MEYER.

McDonald's Hamburger, 1954
Azusa, California

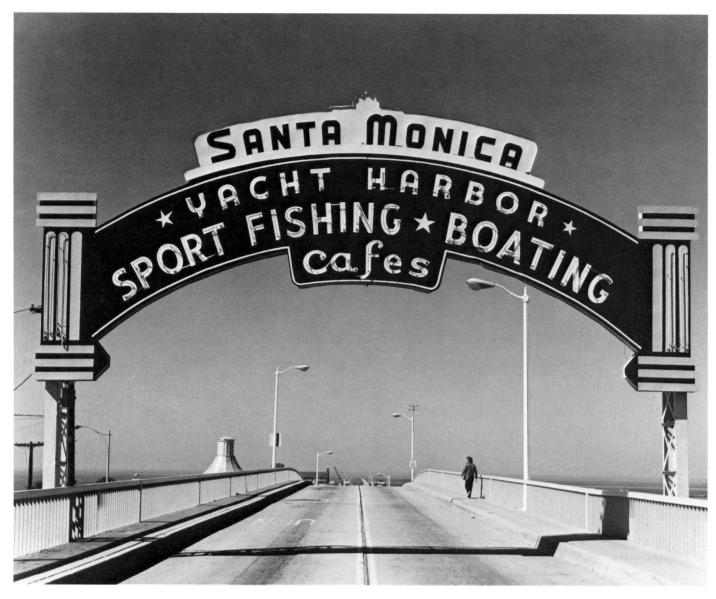

Santa Monica Pier
Santa Monica, California

"Bobby just painted it, he was a dreamer, 'All the glamour and the studios, and you'll be in the sun!' Glamour: it just sounded exciting. When he came back from the war, that had a lot to do with it. He stopped here, and that's when he said, 'Oh, we've got to go to California.'"—CYNTHIA TROUP.

146

CHAPTER 6 : **BOOMTIME**

WHEN WORLD WAR II ended in 1945, a lot of people did not go home; they went traveling instead. "After the war," said Bud Gunderson, "there was a traffic jam." As a college student during the first years of the war he had seen times when his was the only automobile on Route 66. As a war veteran, he returned home to see that same highway black with automobiles traveling bumper-to-slow-moving-bumper across the country.

"One of the things every GI had fought for in World War II was to protect his rights as an American," said Gunderson. "And one of those rights was to be able to get in his car, turn the key, and go anywhere he wanted to. There are no boundaries here; the highways are not closed in the dark, or at state borders. As long as he had the money for a car, he could go anywhere he wanted."

And he did. Those GIs loaded up their wives and families and drove everyplace there was to drive in the United States, taking vacations, visiting relatives and war buddies, and finding new places to live and work. They drove everywhere there was to drive on the (by then deteriorating) national highway system, but mostly they drove westward. And when they got to the West, many of them stayed. During that era more than 8 million people moved into the trans-Mississippi

West—3.5 million of them into California alone.[1] In fact, the end of the war triggered a migration west that was far greater than anything that happened during the Great Depression.[2]

Many of the people in that postwar migration did not follow Route 66, of course, but many did. A sizable number of them, like Bobby Troup, had passed through southern California on their way overseas and decided to return there to live. Troup turned his trip down Highway 66 into a private fortune and a public icon: the song he wrote, "Get Your Kicks on Route 66," became a musical road map for generations of westbound travelers.

The trip began in Harrisburg, Pennsylvania, where Bobby's family owned a number of music stores. "I had written one hit before the war, and I was determined to go to Hollywood and see if I could make it as a songwriter," he reported. Troup took his wife, Cynthia, and drove west, first to Chicago and then down Route 66 to Los Angeles. On the way, with a title suggested by Cynthia, he wrote his song. "Get Your Kicks on Route 66" was picked up and recorded by Nat King Cole almost as soon as the Troups arrived in the land of palm trees. "The fortunate thing I did when I wrote that song: it's blues. That's why all the rock groups do '66.' They know blues," reflected the white-haired Troup, long since di-

vorced from Cynthia, remarried to singer Julie London, and living in a sprawling house in the wooded hills overlooking Los Angeles.

The Troups' trip was fairly typical, to hear them both tell the story. Their car was a 1941 Buick that Troup had bought with the first royalty check from his prewar hit "Daddy." Five years later, the car swallowed seventy-five quarts of oil on the ten-day trip across the country.

"We left Harrisburg," said Troup. "My mother was in tears. We drove the Pennsylvania Turnpike and then hit 66. We saw the stalactites at Meramec Caverns. We stopped at the Will Rogers Memorial, in Claremore. We ran into a snowstorm outside Amarillo: it was about eleven or twelve at night and absolutely blinding. I was really frightened. Then I stopped for a haircut in one western town. In some places, there was a lot of traffic, and in some other places, not any. I'd never seen a desert before, so that was fascinating. I had talked about writing a song about Highway 40, but Cynthia suggested, 'Get Your Kicks on Route 66.' I said that was a cute title." And so the song was written as they drove. "I finished the song with a map after we got to Los Angeles," said Troup. "I wasn't aware of what a great lyric I had written. I do remember it was possibly the worst road I'd ever taken in my life."

After Cole had latched onto Troup's song and they had bought a house with the promise of money to come, Cynthia Troup had the map framed and saved the scrapbook of postcards and snapshots from the trip.

In the meantime, Cole's recording of the song was a big hit, as were several of the dozens of other recordings made by a variety of groups over the next forty years.[3] "Get Your Kicks on Route 66" was recorded as a rock piece, as western swing, as blues, and strictly as an orchestral piece and became a movie theme. But it never made it to television. "One of the big disappointments of my writing career was when I heard that a TV show

was in the works about Route 66," said Troup. "My publisher called and said they would probably use my song as a theme. But they didn't. They got Nelson Riddle to do the music, which was probably smarter for them because it was their piece and they didn't have to pay royalties, but I was disappointed."

Bobby made no bones about the condition of the road being the worst he had ever encountered. Cynthia Troup's version of the trip was little different from that of her former husband—certainly not more positive. "What I really can't believe," she said, "is that he doesn't have Albuquerque in the song."

A Philadelphia socialite before she married, Cynthia Troup lived in the "66 house," a small California ranch house, surrounded with artifacts of her Middle Atlantic upbringing. "I know we took ten days to drive across the country—it took ten days!" she said. "I'd never do that again.

"We tried to be tourists. We stayed with friends in Ohio before we started, and in Saint Louis we stopped somewhere to see Louis Armstrong. After Saint Louis we just drove, and then we'd stay in a motel. We stopped at some caverns. Then we did Will Rogers. Where is that? They have a glass thing, remember, with the clothes he had on when the plane crashed. I mean, really!

"After Chicago there was no nice place or we would have stayed at it. We were spending money like we had it.

"Bobby took my picture standing in the Painted Desert. I remember that by then I wanted to get to Los Angeles. I think we went off the highway and went to Las Vegas and stood up high on something concrete and looked down at Boulder Dam." Her scrapbook showed pictures of a motor court in Oklahoma; the Will Rogers Memorial in Claremore, Oklahoma; the Painted Desert; Boulder Dam; and a sign welcoming people to Arizona.

"It seems to me it was just a long road with

cheap motels and restaurants. I wonder how we even knew where to go."

The song was only half-finished when Bobby showed it to Nat King Cole, but that was enough. Cole pushed several other songs out of the way to record Troup's travelogue, and the public loved it. And why not? A big portion of the public was making the same trip that the Troups had made, down the same narrow, crowded highway, with the same hopes of a better future Out West.

While they were busy moving west—even if they did not like the road—all those travelers were good for the highway economy. After years of Depression, when money was scarce, and years of war, when things to buy were scarce, people were finally able to spend money. New businesses sprang up along the highway to help traveling Americans spend their money, and old businesses thrived. For those people who cast their lot with Route 66, the years of relocation and travel that followed World War II were a time of change, innovation, and tremendous opportunity.

People who came to the highway after the war found a new face on the still-evolving tourist industry. Travelers—with more money to spend and more options to choose from than those of the recent past—had become more picky. As a result, business owners were forced to compete more seriously. Tourist courts, which had survived the Depression by adding necessities like bed linens and indoor plumbing, streamlined into motels, with televisions, air conditioning, and swimming pools. This meant that the hand-built, freestanding cabins that dotted the roadside in Missouri needed to be replaced with something "modern" and "sophisticated" to match the travelers' new images of themselves.

Jessie and Pete Hudson came to Highway 66 in Lebanon, Missouri, in 1947, a generation after Lois and Emis Spears had sat at the edge of a gravel road in southwest Missouri, counting cars in order to determine whether to go into business there. The Hudsons' goal was the same as the Spearses' had been, only updated: where the Spearses had begun by renting tents to passing motorists, the Hudsons came to Lebanon to build the town's first real motel.

No strangers to Highway 66, the Hudsons had sold a tavern in Saint Louis in 1945 and moved south along the highway to Devil's Elbow, a small fishing community on the Gasconade River, just south of Fort Leonard Wood. There they purchased a barbecue restaurant with the unlikely name of Munger Moss. "You see," said Jessie, "they named it that when Mrs. Munger married Mr. Moss. We bought it from them. I felt it was a privilege to keep the name."

The town's equally curious name came from a treacherous bend in the nearby river, a bend followed by the engineers when they laid out and paved two-lane Highway 66 through that especially hilly section of central Missouri. The highway and the busy army base brought business to the Hudsons, but the "devil's elbow" in the highway was so hazardous that the Missouri Highway Department bypassed that section of road—and the town—in the first round of highway improvements following the war. "They just left us sitting down there by our little self," sniffed Jessie, a plump woman with pink, beauty-salon hair and a voice that bore traces of both her native Kentucky and the Missouri Ozarks. The Hudsons did not sit for long, however. They sold out and followed Highway 66 a little farther south, this time to Lebanon.

"When we got here, Green Gables was across the street with four units, and next door was the Rock Court with ten or twelve units," reported Jessie. Camp Joy, with its cabins and wide lawn, was nearby. All those places, and a few others, had served tourists since before the war. Jessie and Pete brought a new generation of tourist accommodations to the Missouri roadside.

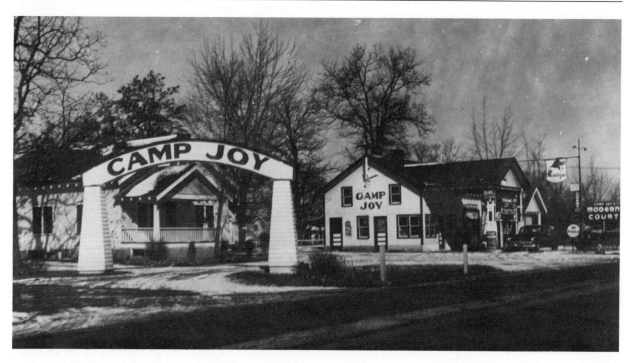

Camp Joy, Lebanon, Missouri, ca. 1945: Camp Joy and other motels were evolving entities that changed as the demands of the public changed. Photographer: Emis Spears. SOURCE: Joy Spears Fishel.

"This road here was Highway 66 when we first come to Lebanon," continued Jessie. "We bought a café named Chicken Shanty and some land to build a motel." Long after her motel had been sold to a young couple with the energy needed to keep such a place going, Jessie remained in the tidy brick house her husband had built only a few steps from the back door of the motel's office. She liked living on Route 66, and she liked knowing what was going on at the motel, although she did not always approve of the new owners' methods or priorities.

"We changed the name of the cafe from Chicken Shanty to Munger Moss," she said, "and we put in a barbecue. That was our first progress."

The Hudsons' "progress" at their motel was a classic example of the development of motels in the postwar but prefranchise, prechain days. "Our next progress was that my husband built fourteen stucco rooms—a room at each end, garages in the middle, then a gap. We had seven of those units. We didn't even have plumbing ourselves: we just moved in here and made do, but the cabins always had plumbing in them days, and they had a little cupola over each door and the number in neon on the front. We didn't even have sidewalks in front of them," she recalled. "Neon," she said, "was the cheapest kind of sign material available, and you had to have something loud and flashy in them days to get the people to stop.

"We made progress as we could get the money together and a loan at the bank." That meant that, as soon as he was able, Pete Hudson expanded

Munger Moss Motel

HIGHWAY 66 - LEBANON, MO.

Munger Moss Motel, Lebanon, Missouri, ca. 1947: In its first phase, the Munger Moss Motel was a series of small cabins. The garages attached to the cabins and the gaps between the cabins were later filled in with motel rooms. SOURCE: Jessie Hudson.

the motel to twenty-two rooms, then thirty-nine. "My poor husband," said Jessie, shaking her head. "He always thought if he could get a hundred rooms, everything would be wonderful. Then he added twelve more units, then more— up to seventy-one units. Then, bless his heart, he had cancer of the throat, so he never finished." As he built new rooms, Hudson also went back and created rooms out of the garages, which had been so necessary in the early days but were no longer required as cars got bigger and Americans became more blasé about automobile ownership.[4] "Then," continued Jessie, "we put in a swimming pool. We were the first ones around here ever to have a pool, but by then we thought the public demanded a pool."

When the Hudsons went into the highway-lodging business, the average motel had fifteen rooms, and nearly all were, like theirs and Camp Joy before them, owner-managed and informal. There were no chains, no franchise groups, and referral groups such as the AAA were just beginning to get a toehold. By the time that Pete Hudson died in the early 1970s, the average motel had more than thirty rooms, the cost of building one room had risen to more than ten thousand dollars, and the chain operations were beginning to take over the business.[5]

Like those of most of their contemporaries along the highway, the Hudsons' workdays were twenty-four hours long. "I used to get up and do the maid work in the morning, then go over to the restaurant for the noon business, then come back and finish if I wasn't done with the maid work," said Jessie. "Our first episode with linens was that I got a little red wagon with sideboards to carry them, but eventually I got a golf cart that pulled rollaway beds and cribs, too, which made things much easier."

Most of the time Jessie worked alone or with the assistance of her daughter. One time, though, she had volunteer help. "Harry James's bunch, they stayed here two or three times when they come to play at Fort Leonard Wood," said Jessie, "and they were always surrounded by autograph hounds. One morning there was a lady here, and

she was determined she would make the bed that Harry James had slept in. Just for meanness I told her another room, and later, when I told her right, Laws! I thought she would whip me!" Jessie chuckled.

Jessie Hudson was one of the people who believed that the edge of Highway 66 was about the most interesting place a person could be during those boom years after the war. "You just always look forward to the different people," she said. "We had movie dogs; we had a giraffe stay all night one night on his way to the Oklahoma City Zoo; we had helicopters land in the yard to stay all night; a priest who came and stayed a long time and cooked in his room and smoked smelly cigars.

"There's never been a time in all these years I ever wished I was anyplace else."

A lot of people shared Jessie's sentiments. Red Chaney, a former GI who had grown up in Illinois, came to Route 66 following a postwar cross-country trip with his parents. Instead of returning home, the former high-school track star purchased an old frame gas station on the outskirts of Springfield, Missouri, and turned it into a roadside café, which he named Red's.

"Before I moved in, this was Wayne Lillard's gas station," related Chaney, who was lanky enough to pass for a native Ozarker and was soon accepted as such, "and before that, it was McGill's. That side," he said with a wave of a long arm, "was the gas-station office, and there was a little counter on this side. But," he continued with a straight face, "it was difficult to do an oil change and make a hamburg at the same time." Chaney brought a business degree from Bowling Green University with him to Springfield, plus knowledge absorbed from his father's career in the restaurant business in northern Illinois. And, although there was something incongruous about needing a business degree to run a hamburger stand in a converted gas station, Chaney made

the most of the situation, embellishing his restaurant management techniques and food preparation with special touches all his own.

Because Chaney's move to Springfield occurred during the time when the highway was thick with traffic, he was busy from the first day. "After the war when people were traveling around, we'd stay open until two or three A.M.," he recalled. "If it was a busy weekend, we'd stay here from the time we got here Friday straight through until Sunday. There was a lot of traffic in those days." He and his wife were perfectly willing to stay open as long as they had legitimate business, but the time came when the only people around at three in the morning were drinking coffee. "That's when we cut back," noted Chaney. "You can't make any money on coffee drinking." Even with cutting back, Red's remained the focus for Chaney's life. He and his wife never had children, which Chaney said would have been in conflict with the café. "You've got to be in love with your kids or your restaurant," he said. "We worked five days a week from seven in the morning till eleven at night, and then we had to have two days to catch up."

Something of an efficiency expert, Chaney kept water in a metal construction jug on one end of the small counter so that customers who wanted water could serve themselves, leaving him free to do what they could not. With a nod to his high-school track record, he wore gym shoes long before they were fashionable for adults and sort of bounced from the counter to his half-dozen formica tables to take orders, bring hamburgers, and visit with his customers. Red did most of the preliminary food preparation himself, but during business hours, he was the front man, and his wife worked in the kitchen.

Red's specialized in root beer, giant "hamburgs," senior fries, fish, shakes, and chili, everything prepared by Chaney's own unique recipes. "I make my root beer out of licorice," he ex-

plained during a quick tutorial session held one night after the place closed. "Persian licorice is the best, but it is hard to get now, so I use American licorice." He also used magnets to bring out the flavor of the root beer, claiming that he could change the taste in ten minutes simply by storing it over a magnet. "For one thing, the magnets take the nitrogen out of the water," he explained solemnly.

Magnets—and pyramids—figured strongly in Chaney's special storing and flavoring of food. "Meat tastes a lot better with the nitrogen out," he affirmed, but he admitted he was not sure how the magnets managed to draw nitrogen from meat. He stored his meat at 30°F—under a magnet to age the meat and keep it tender—and made a practice of handling it as little as possible. His hamburgs were made from a combination of all the normal beef cuts, plus kidney suet—"a storehouse for minerals and vitamins," according to Chaney. "I trim and grind all the meat, and use all the fat. Then I add the suet. I ball the burgers with a hand dipper because you can't run kidney suet through a machine. For the cheeseburgs, we use real cheese.

"We peel and process our own potatoes; we keep them a week at our temperature to get the sugar content just right, and we add a little citric acid to improve the flavor."

Fish at Red's was fried twice. "It always tastes better that way," said Chaney. "Cook, cool, and recook."

"I learned a lot from my Dad," said the roadside restaurateur, "and I learned a lot from going to American Restaurant Association meetings." A graduate of the ARA's meat classes and potato classes, Chaney said, "I used to find old guys and say, 'I'm having a problem, what do I do?' Now the young ones come to me."

When Red's opened, it was outside the city limits of Springfield, a real Highway 66 business. By the time Chaney retired, almost forty years later,

his café not only was surrounded by the sprawling city but had become a local institution. Of all the 66 businesses that grew and boomed after the war, cafes seemed the most able to maintain their integrity after the interstate and survive as part of the surrounding community. Some of the other businesses—especially the ones that contributed to that special flavor that made Route 66— were uniquely highway enterprises, not only dependent on travelers for their income but entirely devoted to the idea of being new and different and something a passer-by might never have the opportunity to experience again. These were the businesses known specifically as "tourist businesses," and if they did not rate an exit ramp during the building of the Interstate, they generally could not survive the change.

Allene Kay and her husband came to Route 66 not long after the war with the specific goal of opening one of those "tourist businesses" that seemed to flourish in the years following World War II. Theirs was a buffalo ranch.

"We spent two years hunting and researching traffic maps. The first location we bought was in Nebraska—Ogallala, Nebraska. We bought it as a prospective location for a tourist place; then we came down and found this location and liked it better," said Mrs. Kay. The chosen spot was a patch of land near Afton, Oklahoma, not far from where Route 66 sliced through the southeast corner of Kansas. They had decided early on that they would raise buffalo as the main part of their new business. "The buffalo is one of America's first animals, and we knew a lot of people had never seen them," she said. "We opened with the idea that we wouldn't charge to look at the animals because if people had to pay, too many children wouldn't be able to see them. We never charged for seeing the animals."

When the Kays came to U.S. 66, in 1953, the highway was buzzing with automobiles full of people who wanted to see buffalo. They opened

the Buffalo Ranch with seven head of buffalo, which were free, plus a trading post, which was not. "The trading post is more or less a souvenir stand now," said Mrs. Kay, "but then we had moccasins and Indian handmade jewelry. And then we opened this western store. There wasn't a good western store in the area, and today this is the best western store in all of northeast Oklahoma." They expanded as their finances allowed, and before they were finished, they had also added an ice-cream stand and a barbecue restaurant.

In the first years Mrs. Kay ran the stores; her husband oversaw care of the animals and advertising, beginning with highway signs and eventually getting into television. "In the early days you'd just go out and put up road signs. Now you need a license on everything," she observed.

"We started out with the seven head of buffalo; then we learned about them as we went along. There weren't very many around in those days, and we had a hard time locating the first ones," she said.

As the stores expanded in number and kind, so did the Kays' menagerie. From seven American bison, the population of the Buffalo Ranch grew to include llamas, elk, deer, a variety of exotic chickens, rabbits, sheep, and goats.

Allene Kay's husband died a decade after the Buffalo Ranch opened, leaving her in charge but fairly ignorant of much of the business, especially the buffalo part. "I didn't know a cow from a bull," she admitted. "It was pretty rough. I was alone ten years before I remarried. The first two years I spent half of it crying and fighting to survive, but people helped me by being sure I was going to go broke. I wouldn't say I'm ornery, but when somebody told me I was gonna go broke, I made up my mind I wouldn't go broke. And not a soul come to offer help in any shape or form, and I didn't have one relative in Oklahoma."

The Buffalo Ranch did survive. It survived Kay's

death, and later it also survived the construction of Interstate 40, which replaced U.S. 66 as the main thoroughfare in that part of the country.

Because of the several businesses they managed and also because of the animals that had to be cared for, the Kays rarely left the Buffalo Ranch, even to buy goods. They depended instead on wholesalers to come to them with western clothes and also with the crafts and curios they sold in their trading post. One of the people who came on a regular basis was Dave Cullison, a colorful character from Claremore, Oklahoma, who pulled an eight-foot trailer full of goods behind his big Cadillac and brought his whole family along. Originally a horse trader, Cullison cared more about the trading than he did about horses, and he used the highway to indulge his passion.

"He called me at home one day," related his widow, Norma, "and said, 'I just traded the farm off for a café.' That was just after 1950," she remembered, placing both hands on her hips and shaking her head. "My husband was a horse trader. He didn't care what it was as long as he was trading." A woman of medium height with a set to her jaw that indicated a certain firmness in her own business dealings, Mrs. Cullison dressed dramatically to show off the heavy silver jewelry that she wore and sold.

Widowed during the 1970s, Norma Cullison operated Dave's Indian Trading Post—for which the café had eventually been exchanged—across the street from the dowager Will Rogers Hotel, in downtown Claremore. At Dave's, she sold silver and turquoise necklaces, earrings, rings, and concha belts; other handmade silver items; and a collection of tourist items, ranging from rubber tomahawks to cowboy hats to dinosaur bones to postcards.

Before they traded the café for the trading post, the Cullisons spent a portion of each year on the road. They would run the café for a while, and then they would take off on buying and selling

trips, joining the cavalcade down Route 66. "We'd lease the café out or let the help run it while we were gone, and it would be in the hole when we got back," she commented. "He'd just get tired sitting there in Claremore, and we'd take the kids and just take off.

"We drove a Cadillac and loaded it down and we pulled an eight-foot trailer on behind that. And everyone from coast to coast would tell you they knew Dave Cullison and his family that drove a yellow 1955 Coupe de Ville Cadillac," she said. "We traveled coast to coast and sold this stuff. We'd go west and pick up Indian stuff, then go east and sell.

"We did a lot of trading with the Indians. One time, down old Oak Creek Canyon by Phoenix, we got a bull head like this one for thirty-five dollars," she said, pointing out the turquoise-encrusted skull of a Shorthorn steer that rested on top of one of her jewelry cases. "We sold it in Albuquerque for fifty. The last time I was in that place, they wanted five thousand dollars for one like it.

"It used to be when we went to Old Town Albuquerque, they'd call in the Indians to bring their jewelry, and we'd trade it for horns, leather goods, arrowheads. We'd stay there maybe two weeks at a time trading with the Indians, then we'd go east and sell what we got. My husband liked doing that, being on the road."

One of the most memorable people she dealt with was a trader named Don Pablo, from whom they bought jewelry. "We went to his place once to buy jewelry, and I tell you, he don't believe in a lot of things," she said with some disgust.

"Things like cookin' food.

"Like sleeping in a bed.

"He never wore no clothes much. He was an Indian, wore his hair in a braid. He got married when he went to college and had a son, but they wouldn't have anything to do with him. He died a millionaire many times over." Her disgust at his personal habits was never enough to prevent her from buying the jewelry that he made, however.

She told a story about selling a load of horses in New Jersey and picking up a load of dolls. When they got home and opened the boxes, they found out that the criers were all out and the dolls condemned. Another time they took five hundred pairs of Longhorn cattle horns to New York only to find at the end of their cross-country journey that their customer could not afford to buy more than one pair. The rest, though, they sold to a man in Buffalo.

"I used to just wear a whole lot of Indian jewelry," said Mrs. Cullison, launching into another story. At that time she had on a belt, earrings, bracelet, and a ring the size of a large daisy. "Anyway, we were at Wisconsin Dells and a man bought every piece I had on. I just had to go back to the car and put on some more. That man also knew my husband had some arrowheads, and he said he'd buy all we had." She paused. "But he didn't know how many we had with us."

Another time, she said, some people who made leather goods were going broke and called her husband and said they would sell their inventory for half price. "He bought $50,000 worth of leather-tooled purses. We'd take those purses and travel all over. In Marion, Indiana, we had a friend who made silver saddles. We sold him purses and got saddles, and sold those out at the Buffalo Ranch up on 66."

In those years after the war there was enough traffic on Route 66 to support people like the Cullisons and the Kays who sold nonessentials. There were also enough people traveling that basic highway businesses such as gas stations and cafés found themselves—as Red Chaney had done—staying open twenty-four hours a day. Leon Little, who had sat out the war because he suddenly found himself too old to be drafted—but not until after he had leased out his Okla-

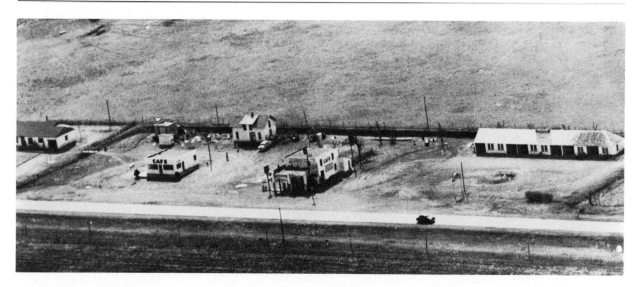

Leon Little's café, service station, and motel, ca. 1950: The last time Little relocated his service station, he added a motel. SOURCE: Leon Little, Hinton, Oklahoma.

homa gas station and café—was glad to be back in business. He was equally glad to be busy: "In the thirties and then again after the war, we stayed open twenty-four hours," he recalled. His wife, Ann, completed the picture: "Instead of working like eight-hour shifts or twelve-hour shifts, we'd work eighteen- or twenty-hour shifts. About the only sleep he'd get, maybe, per night would be to stand back behind the showcase with his elbows on the counter and his hands under his chin. He'd sleep like that four or five nights in a row on the showcase, and if a car would hit the driveway, why he'd be way out and have to jump up and give them service."

While Leon ran the gas station, Ann was busy in the café. "Prices were much higher after the war," noted the Littles. "When we went back into business, we got a quarter for a sandwich instead of ten cents like we used to and fifteen cents for a nice big hunk of pie instead of a dime. A ten-cent hamburger was fifteen cents, and so forth."

For the Littles, the postwar boom allowed them to make more money doing the same things they had been doing all along—pumping gas and feeding travelers. For other people, the traffic on the highway allowed them to add innovations to their basic businesses. Beginning in 1952, Dick Mester expanded his Holbrook, Arizona, café and bus station to include short tours to the Petrified Forest—in the style of Fred Harvey's old Indian Detours for train passengers. "We bought a three-seat station wagon. My wife, she'd get up and make up all the sandwiches. If a tour come along, she'd take it, come back for lunch; then if another tour come along, she'd take that, too," said Mester. "We run those tours out to the Petrified Forest until it got to be a losing proposition then quit. That was in about 1974."

There was also enough traffic that some of the migrant GIs themselves turned to the highway for a living. Loren and Mildred Armes were postwar migrants from central Illinois who came to

Holbrook Bus Station, Holbrook, Arizona, ca. 1962: In order to expand his café and open a bus station after the war, Richard Mester built this building. He added the automat in 1962. SOURCE: Richard Mester, Holbrook, Arizona.

Needles, California, to operate a service station on the edge of the desert. "In 1948 when we come out," said Mildred Armes, "I was asthmatic, and our little boy had the croup every winter. I thought this was the end of the world. Now, I love it." Widowed during the 1970s, she chose to remain in Needles after her husband's death. She lived alone in a small modern apartment upstairs from a brick shopping center. It overlooked a McDonald's and a Union 76 service station.

The Armeses came to Needles because they knew people there: relatives from the Midwest had preceded them to the area and had encouraged them to relocate. Once the Armeses got to Needles, they likewise persuaded some good friends of theirs to leave Illinois and join them in business on the edge of the desert.

Their place was called Cardy's Camp, and it in-

cluded a gas station where they also served sandwiches and sold novelties. The station came with a small apartment attached, and with the addition of a center wall, the apartment became home for the two couples and their children. "We put up the wall to make it into two apartments then built extra bedrooms and bathrooms on the back," she explained. Both families lived there together, sharing the business responsibilities and the same backyard, until their children were grown.

Route 66, said Mildred Armes, was a gold mine. "It was the main artery that come across, and we were the last stop before the desert. We had a lot of business." Nonetheless, she said, "we worked our tails off. The four of us ran the place; it opened at six A.M. and closed at ten P.M., and since we lived right there, it was nothing to get up in the middle of the night and wait on customers."

Even though they came to Needles after World War II was over, the advent of the Korean War kept the military active in the Southwest. For much of the time that the Armeses were in business at Cardy's Camp, they had to contend with military maneuvers in the desert west of Needles. "We serviced their trucks, and the guys would come in and eat hamburgers at our place," said Mrs. Armes. "If they got there at three A.M., they'd come around and knock on the door and get us up."

Because Cardy's Camp was the last stop before the desert, the Armeses paid special attention to preparing customers for the journey. "The first thing the fellows would do would be lift the hood and check the radiators on the cars. My husband and our friend were good service-station people," she said. "They never cheated anybody." They worked closely together and would take double duty when the others went on vacation.

"You were very silly if you left here without water. We sold what was called desert bags. That was canvas bags full of water in case you needed water to drink. We sold a lot of them and always kept them on hand. A lot of people from the Midwest or the East had no idea what the heat gets to on the desert in the summer."

Those were the people who got to know Amboy.

At Amboy, about halfway across the Mojave Desert from the Armes place on the edge of Needles, Buster Burris and his father-in-law had opened a service station to deal with distressed motorists but ended up with a self-contained oasis that included a café, motel rooms, wrecker service, and a garage, all of which operated around the clock.

"I was just going to be here a short time," drawled Burris, with a nod toward the yellow-gray land, the black railroad tracks, and his own compound of low white buildings on the edge of the highway, "but I've been here more than forty years." Originally Roy's—it was named for Bur-

ris's father-in-law—was one of three stations in the small community that had begun as a railroad section stop and kept on going because it had salt mines. To augment the station, Burris opened a repair shop in 1940 and the café in 1945. "This building was originally built for a garage," he said as he set a cup of coffee down in front of him on one of the formica-topped tables in the café that was a haven for sweating desert travelers. "This here would have been the parts room, but it came up we needed a café much worse than we needed a parts room, for all the people who were stranded." That was in 1945, and he opened with three people in the shop and his wife and mother-in-law in the café.

In those early days it was "tuck and go," he said. The "real business" did not come along, said Burris, until about 1948, when everybody in the country seemed to be traveling. "After the war everybody who had a car, it was wore out. We'd work an average of eighteen hours a day in the shop to get out the cars we could get out. The next morning they'd be lined up out here a block long to get in."

Nor did it hurt his business that he was in the middle of the desert, with not much alternative for his frantic customers. "During the forties and fifties we had ninety people here, and we were open twenty-four hours a day. We had four or five guys at the station, two or three girls, two or three cooks, and we'd rent out our rooms two times a day for people crossing the desert at night and in the daytime. We had more than 100 percent occupancy in a year. We rented them day and night." In the auto shop, he said, they averaged a motor a day. "By the time a person paid the tow charge to Barstow, I could put in a new engine and have him back on the road in three hours."

Although they usually knew how to handle the climate and used this knowledge to make a living off ignorant travelers who did not, sometimes the desert was even too much for those who lived

there. "Back in the 1950s it got up to 130° for about ten days," recalled Burris. "I couldn't keep help. I couldn't keep anything cool. When it got up to 135°, I finally closed up and put a big sign across the front that said, 'We've gone fishing, too,' and went to Hawaii.

"Even during normal summers the desert could do real damage to cars. Cars should be put up in shape before they go across," said Burris. "The ones that's not, those are the ones we get."

He said that to deal with the desert all the rubber on a car should be changed every two years and the radiator cleaned every year. "The desert is a big deal in winter," he said, "but when it gets to 120°, the highway temperature is 145°—that's like driving across a stove."

Like Buster Burris, many of the people who passed through Amboy in the early days were traveling west looking for work. Duane Meyer certainly was. Meyer migrated to California from Nebraska in 1939 and came to the highway after the war. "My dad had died when I was fifteen, and when I got to be nineteen, I decided there had to be a better and easier way of life than spending it back in Nebraska in the heat and cold," said Meyer, "so I come out to California."

He was able to find jobs almost as soon as he arrived: "First I went to work digging ditches, then as a plumber's helper, then in a machine shop a while, then a house mover—that was hard work—then U.S. Tire Company.

"By the time the war come along I was working for Douglas Aircraft, so I decided to join the Marine Corps." Following his military duty, he came to Cucamonga. "It had nice restaurants, a couple of gas stations, some stores, but it was mostly all orange groves and lemons, and I liked that."

Meyer went to work in a gas station, and then, in 1949, he joined his father-in-law in a garage across the street. In 1950 he went into partnership with his brother-in-law in a service station and garage at the corner where U.S. 66 joined the Cajon cutoff.

The inside of Meyer's station had once been painted yellow. It had an old-fashioned cash register that matched the style of the building itself, a concrete floor, and a calendar with photographs of Indians on it. Meyer talked slow, smoked Camels, and wore a gray sweatshirt underneath his short-sleeved jumpsuit. Although the orange groves were long gone, the area around the station had remained fairly rural by southern California standards. He said that when he first came to Cucamonga "you'd see deer run across the road and occasionally see a bear. Used to be I could go across there and shoot pheasants and quail.

"In 1947 there wasn't any freeway down there, and all the traffic came this way. We saw a lot of transients—people who come to visit or come to see California—they all come 66 all the way and come right past here. Movie stars on their way to Las Vegas: people like Tony Martin, Bing Cosby. Dean Martin come by every other Sunday, and several of the girls—I don't remember."

When they opened their station, said Meyer, "One of our first customers who broke down was a guy named Buster Crabbe. He was all kinds of champion swimmer. He had a big Cadillac, and it took us a week or ten days to get the work done. We took him to Fontana to get a motel room, but he spent a lot of each day watching us work. It was an engine job, and we had to go to San Bernardino to get parts and then rebuilt the engine. At that time, right after the war, you couldn't always get all the parts you needed."

All told, Meyer was in the service-station business on Route 66 for more than forty years. "You don't make good money, but it's kind of interesting, and you meet all types of people," he acknowledged. "Of course, it's getting so anymore you don't want to see some of the people who come along. In the fifties my brother-in-law would

open up at six A.M. and work till four in the after-
noon. I'd come in at eight in the morning and
work until five or six, and we had a guy who
worked till midnight. Now I open at eight and
close at a quarter to six. It used to be fun, but it's
getting so it isn't anymore. You don't know who's
behind you."

Another thing happened to Meyer's business,
too—the same thing that began to happen to
Route 66 businesses everywhere. In the 1950s
business boomed. After that, as highway crews
began to build the interstates, life began to be a
bit more chancy.

Since long before it was paved, Route 66 had
attracted people with ideas and imagination and
energy. Through the 1920s and early 1930s they
built new kinds of businesses on the edge of the
road; through the Depression the road and those
businesses kept people fed and kept them from
having to join the great migration out of the farm
belt of the Great Plains; through the war years the
highway continued to provide a living by bring-
ing military recruits and their families, but it was
after that when highway life truly lived up to the
dreams of those who had cast their lot with Route
66. In those years there was no place better to be
than on the edge of the crammed, cracking high-
way. Like any boom, though, it could not last
forever.

All told, it took almost thirty years to com-
pletely bypass Route 66 after Congress passed the
Interstate Highway Act, in 1956. Nonetheless, that
law, and the first bits of new concrete that were
poured, cast a cloud over the Great Diagonal
Highway. People were not so likely to seek their
fortune on the edge of a doomed road, and of
those who were already there, fewer and fewer
saw any value in upgrading or expanding or—
sometimes—doing basic maintenance. After
1956, Route 66 remained important, but its im-
portance was slowly moving away from the con-
crete toward the glorification of what the highway
had been.

CHAPTER 7 : **HIGHWAY HYPE**

ONE OF THE THINGS people remembered about traveling down Route 66 were the places they stopped and the things they saw: the souvenir stands where they bought everything from rubber snakes to handwoven rugs, the Indian dancers they watched, the caves they toured, and the alligator farms they did not. Signs let people know what was up ahead and provided entertainment of a sort during the trips. Buildings were built and painted and landscaped to attract travelers to stop on the spot, and events were staged so that people would plan their overnight rests accordingly. Competition, which was fairly limited during the 1920s and 1930s, grew fierce in the years after World War II, and by the 1950s promotion had become a requirement for business success on Route 66. Business owners, forced by time and circumstance to be promoters as well as vendors, spent an increasing amount of time making their signs and buildings—and services—more desirable than those of the man across the street.[1] These promotions, in all their forms, played a significant role in fixing Route 66 in the American memory.

The petroleum companies probably started it. They began building standardized stations and selling franchises very early, and during the 1920s the people who operated those stations learned the benefits of being on the receiving end of the oil companies' national advertising campaigns.[2]

As more people built gas stations they began to vie with each other for the motorists' dollars. The *Filling Station*, a magazine that was published during that decade, devoted itself to illustrating ways that station operators could lure customers off the road. Many of the articles dealt with such obvious assets as a clean coat of paint, well-dressed attendants, and landscaping, but one of the most intriguing articles reported on a new feature in many California stations that was having truly amazing results: bathrooms. "More companies each month are adding this feature to their business," noted the article. "It has been found that in many instances the restrooms draw trade. The percentage of automobile drivers who stop for use of the restrooms without making some kind of purchase is very small."[3]

Phillips Petroleum went into the retail business in 1927 when they opened a station in Wichita, Kansas. As part of the opening celebration, Phillips offered coupons for ten free gallons of gas with a fill-up of 66 gasoline—another not-so-subtle bit of publicity for the main highway that ran through Oklahoma. Like other things that seemed to just happen along Route 66, the gasoline was not exactly named after the highway, but the highway figured into the equation nonetheless. The official story is that in the scramble to open that new station, Phillips executives had been unable to agree on a name for the gasoline.

Research scientists, pushing the idea that the high specific gravity of their product was synonymous with gasoline quality, suggested 66, a number in the gravity range of the new fuel. The advertising department suggested 66 because of the highway near the Phillips refinery. Both ideas were rejected as being too limiting for a company that would be expanding. Sometime later, as the story goes, one of the executives was en route to a last-minute naming session at company headquarters, in Bartlesville, Oklahoma, and commented that the car in which he was riding "goes like sixty on our new gas." Glancing at the speedometer, his driver answered according to Phillips tradition—"Sixty, nothing. We're doing 66!" Where did that conversation occur? Near Tulsa, on windswept Highway 66. The coincidence was duly reported at the meeting, and having no better alternative to propose, the officials adopted Phillips 66 as the name for the new gasoline—in time for the station opening in Wichita.[4]

A few years later, when gasoline revenues fell during the Depression, Phillips and other oil companies began to rely on the sale of tires, batteries, accessories, and other items to keep the money coming in, and they developed prototype stations to showcase these products and also to project a modern image to the traveling public.[5] Those stations, in their various forms, were some of the first examples of using a building's architecture itself as an advertising gimmick. And the gimmick worked: not only were people developing brand loyalties to virtually indistinguishable gasoline products, but the standardized buildings were readily recognizable and did their part to draw travelers off the road.

In the 1930s restrooms had taken hold as a valuable sales promotion tool. Texaco began a program of "registered" restrooms in rural stations, guaranteeing their cleanliness and comfort, and Phillips introduced a cadre of Highway Hostesses, six registered nurses whose jobs were to cruise the Phillips marketing territory, provide assistance to motorists, and inspect their "certified" stations.[6]

Bill Butler, a Texaco distributor and station owner in Barstow, California, recalled those days. "Those certified restrooms were a big deal," he said. "Union Oil had a national campaign about service and cleanliness too, and always you would see signs on old stations that said 'Free Air, Free Water.'"

People who built their own stations were equally cognizant of the value of image in getting traffic to stop. Some added and advertised restrooms. Others added new coats of paint or just put up signs.

Roy Cline, who helped his father open a series of businesses on Route 66 in eastern New Mexico, recalled the importance of small changes. The elder Cline had just built his station at the corner of two New Mexico state highways (one of which would become U.S. 66) and had no money left. Roy had only fifteen dollars, "but Dad, he was determined to have lights and he had a friend who would sell him a thirty-two volt Delco light plant for fifteen dollars," Cline recalled years later, shaking his head. "There was nothing to do but for me to give him my money, then I went back to a job in a garage. Dad, he strung lights on a wire all along the front of the station and hooked them up to the light plant. At night when he saw a car coming he'd turn the lights on. If the car would pass, he'd turn them off till the next one come along. Lights is what helped him get business at night."

Another time, Cline remembered coming back to Clines Corners to do some general repairs. He removed some old slabs of stucco from the front of the building, painted the whole place white, and swore that the paint job caused business to double.

The Clines also parlayed their location into an opportunity for a big chunk of the tourist traffic

along one of the emptiest stretches of Route 66: they saw to it that Clines Corners was identified on highway maps. Free road maps were some of the earliest of the oil companies' giveaways and certainly some of the most valuable to cross-country travelers. Once one company began distributing maps, the rest followed, and before the oil companies phased them out in the 1970s, more than 160 million free maps a year were being produced for the benefit of American automobile owners.[7] This trend was not lost on the Clines. By being on those maps, Clines Corners would become a planned lunch or gasoline stop for people who had never been in eastern New Mexico before. Thanks probably to their Conoco distributor as much as to the Clines' own initiative, the Clines Corners cafe and station was marked on the Conoco maps and also in the travelers' bible: the *Rand McNally Road Atlas.*

First published in 1924, the *Road Atlas* combined and clarified information from government mapmakers across the country, adding places like Clines Corners from time to time. The criteria for inclusion had much to do with what else was in the vicinity, the population, whether it was located at a significant highway junction, and whether the place in question was known as a landmark to the local population.[8] Located as it was on the sparsely populated plains of eastern New Mexico, fifty miles west of Santa Rosa and twenty-one miles east of Moriarty, Clines Corners was, indeed, a local landmark even though it never grew to be more than a highway oasis. In one way, though, the Clines deserved their map placement: they not only had built up their business during those early years, they also had moved it several times—just to keep it where it was. Even after the Clines sold out in 1939, the gas station, cafe, and (later) souvenir shop remained in the *Rand McNally Road Atlas,* remained on Route 66 as long as that highway existed, and

continued to be an off-ramp stopping place after the interstate was built.

Gas stations and expanded gas stations like the Clines' were the first to engage in serious competition, but as the thirties turned into the forties and then the fifties, advertising and special gimmicks became as much a part of doing business on Route 66 as pumping gas or frying hamburgers. Probably the best-known and most professional promotion on the highway was carried out in behalf of Meramec Caverns by cave owner Lester Dill and his protégé, Lyman Riley.

The entrance to Meramec Caverns is located in an oak forest near Stanton, Missouri, just three minutes off Route 66 and a short stroll from the meandering Meramec River. It was an easy drive for Saint Louisans, who would bring picnics, tour the cave, and spend the rest of the day on the riverbank. Because it was located so close to the highway, it was also readily accessible to tourists.

Dill, a loose-boned, laconic Ozarker with a quick wit and a shrewdness for his business, had grown up in nearby Meramec State Park where his father was the first superintendent. Truly interested in caves all his life, he acquired Meramec Caverns in the early 1930s through a combination of horse trading and political manipulation. When he died in 1980, Dill was described by the Saint Louis newspapers as a "self-styled cave-ologist, promoter of the P. T. Barnum school and a quiet benefactor of both causes and persons in need," and they quoted one of Dill's associates as saying, "if you see Lester Dill and his mouth's open he's either eating or he's lying."[9] Dill's "lies" were generally in the category of what he called "Ozark truth"—and often told solely for the furtherance of Meramec Caverns.

One of Dill's first public appearances was in the parade at the 1931 highway-paving celebration in Rolla. Cyrus Avery was probably on the reviewing stand that March afternoon, sitting in judgment of

more than a hundred floats that had been built to commemorate the paving of Route 66 in Missouri.

No doubt the judges were beginning to weary of the procession of vehicles all draped with pretty girls and crepe paper and wonder how they could fairly pick a winner from the entries, which were neither that unusual nor that different from one another, when a flatbed truck carrying a log cabin broke down right smack in front of them. The driver of the float with the convenient engine trouble was Lester Dill, and it was no accident that his float stopped when and where it did.

"We dressed my dad up as Daniel Boone and took a log cabin from the park around the cave and cut it down so it would fit on the back of the truck," Dill recalled years later after he had become something of a legend himself as the "cave man" from Missouri. "I drove the truck. I was going to win first prize or nothing," he chuckled, a raspy, eighty-year-old chuckle deep in his throat. "I drove it up to the governor's reviewing stand— there were six or eight thousand people there, more people in Rolla than I ever saw before or since, and every one wanted a drink and a room at the hotel. Anyway, I stopped the truck in front of the reviewing stand and couldn't get it started again." That gave Dill the opportunity to shake hands with Avery, the governor, and the other officials of the Route 66 Association. He won the blue ribbon.

Dill's maneuver in Rolla was an early preview of the attention-getting tactics he would use to lure two generations of families into Meramec Caverns.

Riley, a schoolteacher by training, happened across Meramec Caverns one summer during the mid-thirties. He returned the next summer to work for Lester Dill. The summer following, he came once again to Meramec Caverns, but that time he stayed. A loquacious fellow with a ripe sense of humor and twinkling blue eyes, Riley clearly seemed capable, even in retirement, of filling Dill's description of "the best promotion man I've ever seen."

The duo's promotional efforts began small and in the early days were directly concerned with the cave itself. In his first years with Dill, Riley said his job involved "whatever needed to be done: I cleaned toilets, took admissions, guided people through the cave, and in the winter we enlarged the passages." Dill's push to make the cave safe and interesting for casual tourists consisted of clearing passages and stringing electric lights next to underground streams, through narrow corridors, and in the echoing, high-ceilinged chambers, and it also included the construction of food and souvenir shops, bathrooms, and a group of cabins on the riverbank for overnight guests. In addition, Dill and Riley recognized that the cave could not sell itself to people who were only going to pass by one time, so they put a tremendous effort into making sure that travelers on Route 66 knew about Meramec Caverns. They did this first and foremost by painting black-and-white Meramec Caverns signs on the sides and roofs of hundreds of barns from Ohio to Texas.

Dill's barns attracted the same kind of notice as the red-and-white Burma Shave signs that had become highway fixtures. "I was down through Virginia and Tennessee and saw some painted barns," said Dill. "I found out I could get barns for nothing if I painted the whole barn, so I got an ol' boy from Tennessee who knew how to paint barns to show me how. At first, I used to do it all myself: I had to make enough money to hire other people."

Barn painting was not an artistic endeavor for Dill, but a quick-and-dirty advertising campaign. The barns generally were painted black and then in large white letters said, "See Meramec Caverns, Route 66 Mo.," on the side facing the highway. And after people had passed enough barns, sure

Meramec Caverns sign, Stroud, Oklahoma. The first Meramec Caverns sign was painted on a barn overlooking the Ohio Turnpike. Other signs were painted on barns on major highways between Ohio and Texas and on minor highways in Missouri and Illinois. SOURCE: Quinta Scott.

enough, when they got to Stanton, Missouri, they turned off and visited the cave.

Dill painted his first barn in the thirties, and then "I really poured it on after the war. Every time I painted a barn, my pocketbook would get fatter and fatter. Those barns really done the trick."

It was those years after the war when Dill and Riley really made a name for themselves and their cave. Once the barn painting was well in hand, they began to stir up public interest with stories about buried treasure, Civil War hideouts, and notorious Missouri outlaws.

"At one point we began to call the cave Jesse James' hideout," recalled Riley of his early days

with Lester Dill, "and we would 'find' rusty guns or Wells Fargo bags when we were guiding people through the cave. After a while, the big lie became the truth. Why, I could go over now and tell some of the cave guides what really happened and they'd call me a liar. Some of the stuff we used to tell about the cave we told tongue-in-cheek, with no thought of bamboozling the public, but it just got away from us." That particular story got so out of hand that an old man appeared on the scene who actually claimed to be Jesse James. At that point, what could Riley and Dill do but take him in? They even took him to New York and took in the press as well.

Even before they "found" Jesse James, Riley and Dill were perfecting the art of highway publicity. "Les's father, he'd be what you call a lead man," said Riley. "He'd set up there on the parking lot and tell all kinds of stories and get people to come down to the cave. We had another old boy at the Diamonds [a nearby highway stop popular with bus and truck drivers as well as automobile travelers]. He was a tall, white-haired, former real-estate salesman. He'd give people brochures about the cave and a personal guarantee of money back if they didn't like it."

The job of being Lester Dill's promotion man was not always glamorous. If cars pulled into the graveled Meramec Caverns parking lot and pulled out again without visiting the cave, Riley would chase them down the highway. "I'd offer them a free visit if they'd tell us what was wrong and why they had gone on," he recalled. He also swore that in those years he personally silk-screened the first bumper stickers ever made. "We had been tying them onto the cars, then we tried some two-sided tape from the 3M company, but the bumpers had been waxed so that the tape wouldn't stick. Then we found a company that had sticky paper, and I got them to send me a large sheet of it. I made a silk screen and we made some stickers, but they stuck too hard. I wrote to them, and finally they wrote back that they had some that didn't stick too hard. That put them and us in the bumper-sticker business."

As time passed, Riley and Dill went farther afield in their cave promotion. "We did a lot of roadwork," Dill said. "That's finding places to distribute your literature, getting articles in newspapers, and finding people to make speeches for you." The roadwork carried both men to Chicago and New York, where they were guests on radio and, later, television shows, talking about highway travel and Meramec Caverns. Primarily, however, roadwork involved long, slow trips down Route 66. "I would be gone five or six days a

month," recalled Riley, "and one time I did it for a full year. I bought a station wagon and went to every service station and every restaurant on Route 66 and invited them all to the cave. Often, I'd just go as far as Needles [California]. A lot of the traffic west of Needles wasn't coming as far as Missouri, but from Flagstaff east, you could just about be sure if people got on 66, they'd come this way.

"I'd go up and down highway 66 in Missouri, too," continued Riley. "I'd get the station attendants and the waitresses to come on a tour, and I'd take them to dinner.

"The highway patrol used to help us. They would tell people to go down in the caves to get out of the heat, but our best help was the waitresses and service-station attendants, the people who talked to the tourists."

Dill, in the meantime, was garnering national publicity for his "lies" about the cave. As a regular guest on local and national radio and television talk shows, he always had a story ready. They ranged from the Jesse James story, which everyone wanted to believe, to an announcement, in 1950, that he would file for a million-dollar loan from the Reconstruction Finance Corporation to turn Meramec Caverns into a bomb shelter. Another time he paid two New York actors to dress in animal skins and run up and down the halls of the Empire State Building. Not surprisingly, the "cave men" were arrested and thrown in jail; they also were written up in magazines and newspapers all over the country. Most of Dill's lies were good for Meramec Caverns.

Like Cyrus Avery before them, Dill and Riley saw the promotion of Route 66 as beneficial to the roadside businesses, and—like Avery—they rarely left such matters to chance. Dill had been somewhat active in Cyrus Avery's Route 66 Association in the 1930s; Riley was elected president of the Missouri Association when it was reorganized and revived after World War II, a position he

held until the early 1960s. Part of the job was keeping 66 safe for the members of the 66 Association: "The worst things along the highway was these zoos all through Oklahoma with signs advertising pythons. They'd have snakes, and reptile gardens and free admission—anything to get you to stop—and then they'd get you in a bunco game. One whole year all I did was check them out," said Riley.

"There was a speed trap down here in Missouri, one of the worst in the nation. I went down and put myself on as a Triple A man and got them to stop. You had to do those things. Your signs didn't mean anything and could be wiped out by these illegitimate places.

"In 1948, 1949, 1950 we were trying very hard to get a four-lane highway from Chicago to Los Angeles," he remembered. "Oklahoma, New Mexico, and the Panhandle of Texas were interested in working with Missouri and Illinois to get people to stay on 66 and not go other routes, but it was hard to get Illinois businessmen and Missouri people around Saint Louis to support the 66 Association. There were a few, though." Later, when there was no hope of keeping Route 66 intact, Riley and the 66 Association were key workers in the effort to keep the highway businesses accessible to travelers and to hold off the interstate as long as possible.

Riley's perspective on Route 66 was that it went from Needles, California, almost to Saint Louis, Missouri. "It really started at Meramec Caverns. None of the hotels in Saint Louis would act like there was a damn road, and the people in California didn't care either. But that highway sure was important to the folks in the middle."

One of the fun duties of his 66 Association job occurred in 1952 when Riley represented the Route 66 Association on a cross-country caravan to designate Route 66 as the Will Rogers Highway. Staged by Warner Brothers Studio, in Los An-

geles, the caravan was part of the publicity for the movie, "The Will Rogers Story," but it was also good publicity for Route 66. Every newspaper or magazine article about the much-publicized caravan down Route 66 identified Riley not only as a Route 66 Association official but as manager of Meramec Caverns in Missouri, and every time he made a speech, no matter how brief, he never failed to mention his favorite hole in the ground. At the end of the trip, with Warner executives and movie stars in attendance, he even dedicated a small, palm-studded square of grass next to the Santa Monica Pier as the official end of the Will Rogers Highway.

"Meramec was delicious to publicize," said Riley several years after he retired to a cozy log home on a hill overlooking a wooded Meramec River valley. "It is close enough to the highway but still far enough away to be rugged. It really is a beautiful little cave."

Promotion came easily to Dill and Riley; it was also a necessity from the outset if they were to attract travelers from Route 66 to Meramec Caverns. For many others, however, promotion was just more work.

"After the war, after all those years of shortages and we began getting things we couldn't get before, well, so did everyone else," sighed Mildred Moore, from the office of the Moores' Wildorado, Texas, gas station. "We had to start in with a real good salesmanship program. You know, you had to say, 'Say, next week, we're going to get in some more whatever. . . .' You really had to sell it."

Salesmanship took many forms. At the Phillips 66 Terminal truck stop in southern Illinois, young Bill Roseman remembered his father watching closely the progress and changes made by others in business along the highway. "He was always very observant, wanting to know what they were doing he could use. He'd take ideas and sort of change them to fit our place. It was just a progres-

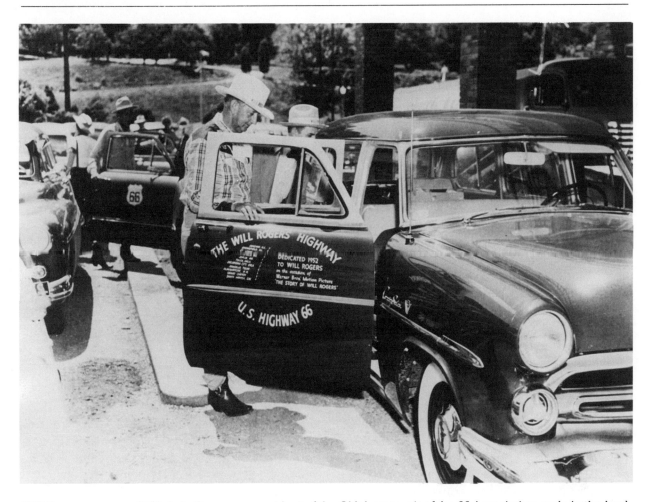

Will Rogers caravan, 1952: Lyle Overman, president of the Oklahoma unit of the 66 Association, rode in the lead car of the caravan. SOURCE: Gladys Cutberth, Clinton, Oklahoma.

sion of businesses for my dad. When he saw an opportunity, he'd take the chance." He also noticed when others did the same. "In the late forties someone built a cafe not far from us using the same materials we had, and Dad really resented it. He said, 'They're trying to copy us.' It was true, of course; you'd go up and down 66 and see pieces of your business all along the way.

"Our place, with the big tower, was a landmark.

I meet people today and tell them where I grew up, and they say, 'Oh, yeah, we used to go there.'

"Everything my dad did, he'd say, 'Would this make people stop?' He'd do something, paint a wall a certain color, say, and then change it the next day after he drove up and down a few times. He thought of things like if he wanted to attract family business then the place had to be bright with lots of windows, not just like stopping at

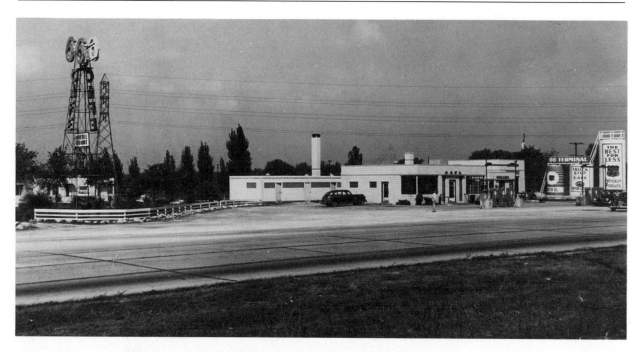

66 Terminal, Staunton, Illinois: SOURCE: Bill Roseman, Saint Louis, Missouri.

some roadhouse. He built the tower in the middle of the building, then he had to build up something behind it. He put in glass blocks for windows. They let in light, but you couldn't see through them. He was very concerned about eye appeal. He used a lot of light blue, and he hated the Phillips signs: for a long time they were black and orange.

"I remember traveling with him to the Ozarks, and everybody down there seemed to have a cave in the backyard. We came home and put Ozark rocks along the driveway at the motel."

The elder Roseman was a builder, a trader, a tinkerer. "He always wanted to be an inventor," said his son. For a time he went into the neon-tubing business in a friend's basement, but they lost out as the market and the products got bigger and bigger.

Roseman noted, "Everything you did was geared to trying to get a way to get people to stop. You're not in the newspapers, you're not on tv. It's just a way to say, 'Hey, we're here!'"

Especially after World War II, Route 66 was lined with establishments that seemed to wave their arms, whistle, blow bubbles, sing, dance, flash lights, and make outrageous promises just to get drivers to slow down and pull off the highway. Clearly, Red Chaney who was frying hamburgers in an old gas station on Route 66, outside Springfield, Missouri, subscribed to the belief that the first rule is to attract attention. Not long after he opened for business, Chaney parked an old Willys Jeep in front of the former service station, put a washing machine motor inside the jeep, and rigged it to rotate two large foil-covered spheres hanging on the ends of rods

that came out of the top of the jeep through a hand-painted sign that said Red's. Over the years the car changed—once because a kid had a similar vehicle and needed the bearings out of the wheels—but the rotating balls and old car were a permanent invitation to passers-by to stop and see what was inside the building. Next to the car Chaney erected a large yellow Latin cross with black letters that said GIANT on the crossbar and HAMBURG on the upright, with the two words sharing the same "A." ("I would have put 'hamburger,' but I ran out of space," Red said.) Together, the cross and the old car with the rotating balls tended to stick in people's minds.

Later Red's Giant Hamburg added a drive-in window, "probably the first in the world with speakers," he explained modestly. "There were trees and drive-in parking in back and trash cans. I wanted to put a conveyor belt out there, but, instead, this guy had an intercom, so I built a cubby hole out from behind the counter and put the speaker on a post out in front. People would drive up and the speaker would talk. It sometimes scared them to death and they'd drive off, but they got used to it."

Inside, he painted the ceiling blue, the walls white with a touch of peach, the seats green, and the floor like dirt; "as much like a picnic," Chaney said, "as you possibly can. It stimulates the appetite and people enjoy it."

By the time Chaney retired in 1984, the management-school graduate, hamburg king, believer in the power of pyramids and business promotion had become a local celebrity and his café, an institution. When the doors opened in the late forties, however, Red's was still outside town, and Chaney had to depend on the highway for his living.

In the mid-fifties, when U.S. 66 was rerouted to bypass Springfield, Chaney turned his attention to the local community and worked hard to main-tain a presence in the Ozark farming center of 150,000 people. "I advertised, I sent postcards," he noted. "I still do. People like it here. Last year we had four graduation parties. The parents would ask their kids where they wanted to go for graduation, and they said, 'Red's.' Kids like us because we don't act like old people."

It did not necessarily take a degree in management to turn highway entrepreneurs into promoters. The Welco truck stop outside Joliet, Illinois, was built and operated by a man who had spent time in the circus and drew on that background for his highway work. Montana Charlie Reid had been a cowboy, had been with the Sells-Floto Circus, had played the calliope, had worked on the Delta Queen riverboat, and had been with the Browning Circus. "He was an old showman," said David Dale, who took over the Welco truck stop at the time of Reid's death in the early 1980s. "He brought that with him in anything he did. You could see it in the colors of the building, the way he greeted people, the way he made friends."

The building, an add-on, one-story structure painted a variety of bright colors, with large, plastic black-angus bulls holding down the four corners of the flat roof, was designed to attract attention. One of the early-day truck stops, it housed sleeping rooms, a truckers' lounge, a café, and a barbershop, with many of the walls graced by photographs of Montana Charlie performing in rodeos and various other events. "The barber, I've known him more than twenty years," said Dale. "He left here one time and went to Union Oil down the street. A while later, the old man asked me what we could do to improve business. I said, 'Bring the barber back.'" It was done, and business improved.

Truckers knew Welco the same way they knew the Dixie and other truck stops on Route 66: they passed by regularly and learned which place provided the service, prices, and atmosphere that

best suited them or their management. In that way the businesses that focused on truckers had an advantage over those that depended on automobile travelers. The highway businesses geared to automobiles had to capture the tourist's attention in one shot and could not depend on return trips for future income.

In the late forties two Arizona businessmen concluded that the best way to attract tourists was to put up as many signs on Route 66 as they could. One owned a real highway business—a souvenir shop—and the other, a men's clothing store, but both credited their signs with bringing in most of their customers. One of the signs was black with an outline of a curvaceous cowgirl on it and the legend, "For Men, Winslow, Ariz." The other sign, which was generally planted nearby, was yellow with the silhouette of a rabbit. Those signs appeared for years on Route 66 and points east.

"The signs paid for themselves," said Chuck Chacon, who later was an owner of the Store For Men. With its racks of jeans, casual shirts, and trousers, and more limited selection of suits, shoes, and sports jackets, Store For Men was a fairly typical small-town men's store. "If people made it here once because of the signs, they'd come back. Of course a lot of women thought it was a whorehouse and didn't want anything to do with us," he acknowledged. In the 1940s, 75 percent of the Store For Men's customers were from outside Winslow, a tribute to the value of highway advertising.

The Jackrabbit, of course, drew virtually all its customers from the highway. One of the highway stores that opened after World War II, the Jackrabbit was built in 1947 by James Taylor and Robbie Robinson at Joseph City, a small community about a third of the way from Holbrook to Winslow. "Taylor put those Jackrabbit signs all over the country, he and that fellow at the men's store in Winslow, Wayne Troutner," noted Phil Blansett, a latter-day proprietor of the Jackrabbit.

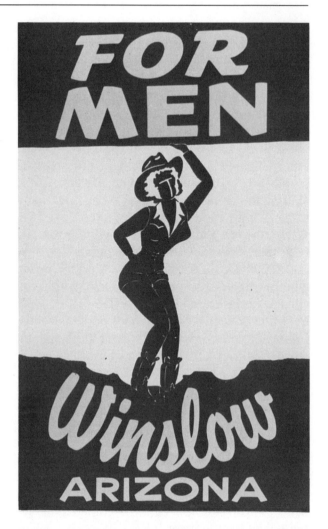

For Men, Winslow, Arizona: This sign and the Jackrabbit sign were built side by side across the country, with one set up at the entrance to the Holland Tunnel, in New York. SOURCE: Store For Men, Winslow, Arizona.

"They had this idea to put up signs everywhere, and they would go on trips together and do that, a rabbit next to the men's clothing store. He built his own signs."

Blansett, an affable fellow in a plaid shirt, grew up nearby in his family's Joseph City motel and

spent several summers of his childhood working for Taylor at the Jackrabbit. "As a kid, I handled the gas pumps and tied on bumper signs," he said. "I used to thread string through holes in the bumper stickers, then I would go tie them on every car I could find. Some people didn't like it, but it was good for business. People would see those stickers and decide this was a place where they should stop."

Actually, for people on Route 66, the Jackrabbit was hard to miss. A large yellow sign with the black jackrabbit silhouette and red letters proclaimed, "Here It Is," and a three-foot high, composition jackrabbit with yellow eyes crouched at the gate, where it could be ridden by children and photographed by their parents as they stopped off to see what was inside the store. The building itself, like many scattered along the highway in that part of Arizona, was a one-story, cement-block structure, painted white and then decorated across the front with murals of cactus and Indians.

The Jackrabbit began as an Indian craft shop but soon grew to carry a wide variety of merchandise, from bona fide Indian crafts to plastic copies of same, to pottery and other items from Mexico, to hats, to souvenir mugs, to a hundred and one other objects that a person might buy whether it was needed or not. When Betty Paulsell worked there, she did "everything there was to do in a place like that. I bought and sold rugs and rocks and souvenirs. I bought from Indians and salesmen. Navajo rugs and rugs from nearly every tribe that made rugs. Pottery from the Indians and all kinds of jewelry made by Indians. I must say the jewelry was a lot prettier then than it is now."

"The summer months," she continued, "they were exciting. I liked the kids. I liked the people who came in and their silly questions. When you work in a place like that, you see people from all over the world." Business was best after June 15, the day California children got out of school. "We were always prepared for the fifteenth of June—well stocked and ready for all those people from California," said Mrs. Paulsell.

Taylor owned the store on and off until 1961, when Blansett's father took it over, later passing it on to his son, who continued to operate the place successfully even after it had been bypassed by interstate highway construction. "A good share of our business is people who come back year after year," said Blansett. "About 25 percent. We get people all the time who come in and remember when they had their pictures taken on that rabbit and it was taller than they were—when they were little kids."

At the Jackrabbit, Blansett sold "gas, beer, liquor, food, and all this junk," he said, waving his arm to take in aisles of tables piled high with the kinds of things that children throw fits for.

His inventory came from all over the world and included pottery, jewelry, souvenirs, bolo ties, horns, wind chimes, cedar souvenirs, moccasins, and as the years passed, less and less handmade Indian jewelry. He also sold bits of petrified wood. "The petrified wood comes from a few people with property adjoining the Petrified Forest. Every once in a while someone will need extra money and they will load up a pickup full of petrified wood and come around and sell it," he said. Over time, Blansett said, he came to sell mostly useful, fairly valuable items. "One time, though," he said, "people used to come in and carry out bags of junk, and let's face it, we make more money on junk."

The Jackrabbit probably had the most highway signs, but it was not even in the running for the biggest or the most amazing. In Arizona the "trading posts" vied with each other for the most visual signs out front. One place constructed thirty-foot arrows that stuck in the ground. Others featured giant plaster Indians, large lifelike (or not so lifelike) buffalo, cavalry forts, tipis, anything that might be intriguing enough to get people to stop.

Christensens' Cliff Dwellings Trading Post, Lookout Point, New Mexico, ca. 1953: LeRoy Atkinson sold the Lookout Point trading post to the Christensens in 1953. They renamed it Cliff Dwellings Trading Post. The cliff dwellings in the background were built as a movie set for the film, *Ace in the Hole.* SOURCE: LeRoy Atkinson, Albuquerque, New Mexico.

Before it was all over, highway promotion went several steps beyond merely putting up larger and better signs. The really outrageous promotions seemed to begin with the Indian traders in Gallup, New Mexico, and then follow the highway west to Flagstaff, Arizona, although they certainly were not limited to that section of the road. "You had to have a gimmick to get people," said Velma Christensen, a latter-day Indian trader, in Gallup. "We had a place with some cliff dwellings to draw people in. Our neighbors down the road had a buffalo—every place had to have a gimmick. Ice

was another big thing. At that time ice machines were just coming out."

The twentieth-century careers of the Indian traders in the Southwest closely followed the growth of the car culture in America and the development of the national highway system. At the turn of the century the traders lived on the reservations, providing goods to their Indian customers in exchange for wool, sheep, and lambs. Indians would sometimes need supplies between the months when sheep were sheared or lambs were born, and they would take handmade craft

items to the traders instead. The traders took the items—silver jewelry or handwoven rugs or baskets or tribal pottery—but without much enthusiasm, because there was no market for Indian goods.

During the 1920s, however, things began to change. The first change was that as their customers began to own cars and trucks, the traders moved their businesses into towns near the reservations, like Gallup or Winslow. Because of trucks, some of the traders added petroleum products to their merchandise, but otherwise business continued on the credit basis that it had operated on for several generations. About this time, though, there was a renewed interest in native crafts, and as traffic picked up on Highway 66, the traders began to sell jewelry and rugs and other craft items to passing motorists. The best part about the new aspect of their business was that where they had always dealt in credit with their Indian customers, the traders discovered their highway commerce was bringing in cash.

As the years passed, many of the traders switched their focus from being Indian traders to becoming purveyors of Indian arts and crafts, selling to other dealers and to the passing motorists. The highway was a ready source of income, bringing new customers with every car that came down the concrete. To attract these customers, the traders began opening shops. The first ones were in town, on whatever main street was also U.S. 66, but by the time the war began, a number of trading companies had added a shop or two on out in the country. After the war those were the shops that rolled up their sleeves and slugged it out for the motorists' dollars.

The highway was already discovered when LeRoy Atkinson became a trader. He went to work for a Gallup merchant, and in 1938, to supplement the business of his boss's store in town, he opened up an Indian trading post on the two-lane highway. About three years later he opened his own shop, the Box Canyon Trading Post, right at the New Mexico–Arizona line, on Route 66. "It was Indian trade and a shop for tourists," Atkinson explained. He and his family lived in four Navajo hogans built together out of railroad ties into one structure. "We provided water, outside restrooms, and a café. We did a big tourist business there, especially when World War II was over." Forty-five years later Atkinson and his family owned four retail stores and an extensive wholesale Indian jewelry operation where they employed a number of Indian craftsmen on the premises, in Gallup, and dealt with other independent craftsmen, as well.

After World War II the Indian trading-post competition was fierce. "We had live buffalo and highway signs," said Atkinson. "We also had a couple of prehistoric—plastic, I guess it was—men. They were huge. People would stop there to get their picture taken, then they would spend money. Getting people to stop was the thing. If you couldn't get people to stop, they wouldn't spend money."

Tobe Turpen, a trader whose father had been in business on the Navajo reservation, acknowledged the importance of the highway to his business after World War II and the competition for that highway business that developed. "People had gimmicks on the highway. They had reptile gardens, buffalo, Indian ruins, all kinds of things. Our stores in town were not gimmicky. There we tried to set up displays of a silversmith working or a squaw weaving a rug, something like that."

Velma Christensen said that when she and her husband opened their store at the Cliff Dwellings, they had Indian dances every thirty minutes. "We had a stockade out our back door where they danced: Joe Deerfoot, Freddie Stephens, and three or four kids. But we stopped it before long. It was distracting to business."

Atkinson Trading Post, Box Canyon, Arizona: In addition to highway signs and signs on the building itself, every trading post on the New Mexico–Arizona border had a "gimmick" to draw travelers from Highway 66. The Atkinsons had Indian dancers, buffalo, and giant, prehistoric, plastic figures (in front of which tourists could have their pictures taken). SOURCE: LeRoy Atkinson, Albuquerque, New Mexico.

Gimmicks took top priority where the object was to get people to stop and purchase things they did not need, but promotion was also important to the people selling services. In Barstow, Bill Butler, who ran service stations before he became a Texaco distributor, recalled that after the war and before car air conditioning, "Our gimmick was a sign that said, 'Free ice for Jugs.'" He told about desert communities like Ludlow and Amboy that lured people to stop by putting in shade for their parking lots.

If people did not stop, it did not make any difference how good the service would have been, how delicious the food, how great the experience, or how amazing the curios. Fortunately for the business owners, there were a lot of people traveling on Route 66. Fortunately for the travelers, there were a lot of business owners as well. The resulting buyers' market for highway goods and services led to an atmosphere along the road that offended some people, delighted others, but definitely added an unforgettable quality. There was no official slogan for people who chose to go into the highway business; if there had been, the message was clear: "You Gotta Have a Gimmick" was as close to a guiding principle for the entrepreneurs as Bobby Troup's song title was for the travelers.

CHAPTER 8 : INTERSTATE

ROUTE 66 also had its dark side. Years after, people who lived along the highway would refer obliquely to bootleggers, bank robbers, gambling and prostitution operations, and more specifically to speed traps in small towns, dishonest service-station operators, and others who seemed to be in business to cheat the tourists. The most sobering—and pervasive—tales about U.S. Highway 66, however, had to do with the traffic accidents.

Across the country, it was known as "Bloody 66." In many areas, it had its own special nicknames. "Devil's Elbow [in the Ozarks] was supposed to be the death's corner of the world," recalled Bill Roseman. "I remember my Dad would get white knuckles ten minutes before we'd go through there."

"There was traffic on 66 you'd never believe for a little two-lane road," said Lyman Riley, who traveled the road regularly for the 66 Association and for Meramec Caverns. "From what we used to call the Top of the Ozarks, west of Waynesville, to Conway [an area that included the town of Devil's Elbow], that was a two-lane killer, it seems to me, until the early sixties."

Jessie Hudson, in Lebanon, said, "They called this Bloody 66, there were so many accidents. There was just too much traffic for the road."

In Groom, Texas, Ruby Denton said, "There was a stretch of 66 right down here that was called Death Alley or Blood Alley. There was something wrong with the blacktop, and if it was wet, you didn't have any control."

In Arizona it was "Camino de la Muerte," and in 1956 one of every six traffic deaths in that state occurred on U.S. 66.[1] "Dad had a wrecker way back in the early days," said Clifton Lewis, a dark-haired man with a goatee, who grew up working in his family's Wigwam motel, in Holbrook, Arizona. "He used to sleep in the garage. The first one out was the one who got the business with the wreckers."

Terrible as they were, the accidents could make a significant contribution to service-station income. "My father-in-law had an ol' Studebaker roadster, and he made a wrecker out of it," said Buster Burris, who ended up owning most of Amboy, California. "We always had two or three wreckers here; we've still got one. Somebody would come in and say that somebody was broke down—that was an every fifteen- or twenty-minute event—and then we'd have two or three accidents a day."

Reports of an accident down the highway triggered a grizzly race of wreckers vying with each other to be first at the scene. Burris explained: "There were seven wreckers here in Amboy. I assure you of one thing: I never lost. I had the fastest

wheels in town. I could let 'em get to the second bridge and I'd take 'em." If the wreck was bad and people were hurt, he would have to drive back to Amboy's one telephone to call the highway patrol. "We'd tell them how many were dead, how many hurt, how many cars involved, then we had to go back to the accident and wait.

"Most of these accidents we had out here, no first aid would have helped. They was bad. We all carried wood saws because the bridge railings were wooden and people would miss the bridge and the railings would go through the car, the fire wall and the driver's chest. We'd saw it off in front and back and pull them out. Some I've gone to where you just take a sack. It's gruesome. That's why the wrecker is parked up there.

"These days the wrecks on the interstate are not so bad: if people get killed, it's from going off the road. Out here when 66 was full of people, they was head on."

By the mid-1950s, the wrecks, the breakdowns, and the congestion had made their point: even the people who needed 66 the most understood that it had to change. Many of them had known about the studies that began even before 66 was completely paved and had some awareness of various laws passed before and during the war that set the stage for a limited-access highway system. They may not have liked it, and they may not have known what to do about it, but few people on Route 66 were surprised when the old road was replaced.

In 1956, Congress enacted legislation that mandated America's Interstate Highway System and provided most of the money—90 percent—for its construction, up substantially from the 50 percent federal funding allotted to major highway construction in the past. Work was duly begun on those new superhighways, and although it took much longer and many hundreds of millions of dollars more than anyone had predicted, they

eventually replaced and bypassed the old federal highways like U.S. 66, giving American travelers a safer, more efficient highway system than they had ever had before.

A system of limited-access highways had been talked about since before paving was finished on Route 66. Studies had been undertaken in the late thirties and again in the early forties. In 1944, Congress passed a Federal Aid Highway Act that expanded funding for highway construction, established separate, proportional authorization for three categories of highways—primary, secondary, and urban extensions of the primary system—and authorized designation of a forty-thousand-mile system of interstate highways. The 1944 law offered no special incentive to begin building interstates, so the biggest effect it had was to initiate a series of repairs and renovation of the existing national highway system.[2]

In Illinois, for example, Route 66 underwent a major facelift that began during World War II. The construction, which had the effect of bypassing several segments of the original highway, especially those that wound through small tree-shaded towns in southern Illinois, was aimed at widening, straightening, and making U.S. 66 a major four-lane highway. The *Chicago Tribune* noted that this was one of the few highway projects the government permitted as necessary to the wartime transportation machine.[3] Necessary it may have been, but the Illinois reconstruction caused the first bypassing of parts of Route 66 since the gravel route had given way to concrete. After the war there was a big push to make 66 a four-lane highway across the country, an effort that did nothing to fend off eventual construction of the interstate highways but did begin the methodical sidelining of old Route 66.

Russell Soulsby was bypassed early. All his life, he had only worked one place, and that was a square, yellow, frame service station with a red

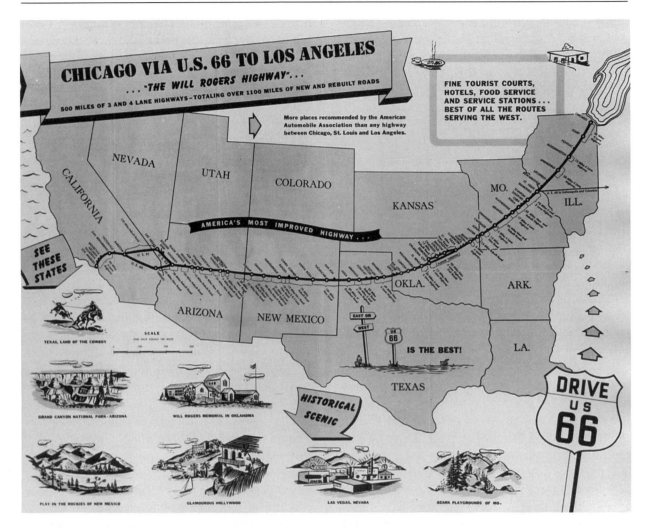

"Drive U.S. 66, The Will Rogers Highway" map. Published by the National U.S. Highway 66 Association in January, 1953, the map was designed to encourage tourists to travel Highway 66 by advertising the condition of each mile of the road. SOURCE: Gladys Cutberth, Geary, Oklahoma.

shingle roof, in Mount Olive, Illinois. Soulsby was in high school when he helped his father lay the cement blocks for the foundation; once he graduated, he went to work there full time. "We were here in 1926—before the highway," said Soulsby, "but they already had surveyed, and we knew it was coming. The building was up and we were ready with gas before the pavement was laid." Molded scallop shell lights out front proved how long the Soulsbys had been in business; a forty-five-year plaque from the Shell Corporation was hanging inside the station and confirmed the length of service with the same oil company. "The plaque is old," said Soulsby. "They got cheap and

quit giving them out a long time ago." Not all those years, however, were good ones.

"We built ourself up a real good business," said Soulsby, "and all of a sudden the bottom drops out. This street here was Route 16 to begin with, and back in those days there wasn't too much traffic. What year was it changed to 66? About 1932, I think, and business was good. Then when I was in the service in 1944, they come along and moved 66 from here to west of town. Later they come along with the I-55 bit and moved it a little farther west.

"This road here doesn't have no name anymore. It's just a paved piece of road. Old 66— that's the last name it had, just old 66." Soulsby had joined his father at the station because being in the gasoline business on a national highway in the 1920s offered an opportunity for a young man to make a good living. None of his three sons had joined him, however. "Chances are, when we quit the door will be locked and that will be it," he said grimly. "My sons are all out in Denver. I don't want any of them to follow in my footsteps. You can make money a lot easier than the way I've made it for the last forty years."

While the 1944 law had triggered the first wave of postwar highway repair and reconstruction, it had also established procedures for selection of intercity routes for the new superhighways. As a result the interstate system was designed in 1947, but no specific construction funds were appropriated at that time.[4]

In 1954, President Dwight D. Eisenhower established a President's Advisory Committee on a National Highway Program. That committee issued a report that pointed out problems with the current highway system (ranging from congestion, to Civil Defense needs, to safety factors, to roadbed deterioration) and recommended better ways to finance the interstates.[5] The Advisory Committee's report eventually led to the Federal Aid Highway Act of 1956, which designated a forty-one-thousand-mile interstate-highway system, and the Highway Revenue Act of 1956, which established a Highway Trust Fund and pay-as-you-go financing for the new roads at a rate of 90 percent from the federal government to be matched by 10 percent from the states.[6]

Originally the interstate highways were to be completed in 1972—sixteen years after the bill was passed—and to cost $26 billion. By 1982 the highway system was still not finished, and the estimates had been pushed up to a 1990 completion date and a cost of $275 billion.[7]

The interstates came slowly, a piece here, a stretch of new concrete there, a bypass around a city. Where it had taken twelve years to pave U.S. Highway 66 the first time, it took two-and-a-half times that long to replace it. Besides finally taking the traffic away from the deteriorating two- or three-lane highway, the long gestation of those interstate highways had the effect of scaring many business people into years of inaction. From the mid-1940s word was out that a new generation of highways was coming to replace Route 66, and even during the postwar spending spree, that knowledge sent chills down the spines of the highway entrepreneurs.

In many places any kind of upkeep on highway property, much less progress, was halted because people felt that buyout and bypass were imminent. "Back in the forties we got all excited thinking they was coming through here," said Mildred Moore from the office of their service station in Wildorado, Texas. "Then they didn't. They kept us torn up because here would come another government man and say they were just about ready to start. Of course you didn't know it was going to take another twenty years."

"Right after the war things really boomed for about ten or fifteen years," reflected Santa Rosa, New Mexico, oil distributor Joseph Smith. "Then they began talking about the interstate, and people wanted to know where it was going to be. For a

five- or ten-year period there was no progress at all, I'm sure." Because he took the rumors at face value and was financially able, Smith began buying up property on the edges of town for new service stations that would serve the interstate. That effort eventually paid off for Smith, but not everyone in Santa Rosa was so fortunate. For a town with an economy based on passing traffic like Santa Rosa was, the coming of the interstate was serious. Smith estimated that at one time Highway 66 supported sixty-three service stations, about twenty motels, and fifteen to twenty restaurants—and the town never had more than three thousand people. "The interstate hurt this town pretty bad," he said.

In Hinton, Oklahoma, Leon and Ann Little saw what was coming, as Smith had. "I was quite concerned when they built the first turnpikes over in eastern Oklahoma," said Little. "Those turnpikes were just the tip of the iceberg, and, of course, we all knew the highway needed to be replaced, but we had no idea how much traffic there was going to be." Anyway, the Littles got ready for the superhighway: "We were up at that old station until 1961. They didn't move the traffic till 1962, but we knew this was coming, of course, and so I came down to Hinton and took the postmaster job, and Ann managed the business out there until the traffic moved in 1962. And, of course, the day the traffic moved, well that was it."

Little had enough foresight to find another living and get out in time, but that did not suit him completely. "I just miss the business," he said wistfully. "Why, it was our life. We were kids when we got married, and we just grew up with it. We had a good living, raised two boys, and put them both through college."

Others also prepared for the interstate by leaving, but some of them, unable to find a comfortable life away, came back to Route 66. Homer Ehresman had sold out his holdings and moved away from Glenrio, New Mexico, when he heard that Route 66 was to be bypassed. "They was always talking about building an interstate through here," he said. "That's why we left." Ehresman and his wife went to Texas for several years, and then, he noted with some disdain, "When we come back they hadn't done nothin'."

By the time they sold out, the Ehresmans had owned a service station, a café, and an old adobe tourist court on the New Mexico side of the line, and Mrs. Ehresman had run the post office. When they returned to Glenrio to await the coming of the interstate, they built a new motel on the Texas side of the line. "The interstate finally ran around Glenrio about 1973," said Ehresman with a snort.

After the new superhighway had cut Glenrio off from the rest of the world, making a dead end of old 66 just past the Ehresmans's tidy, turquoise-painted motel, they stopped renting rooms to tourists. Fortunately, however, they had been able to take advantage of the interstate and had built a modern motel with dining room, swimming pool, and the other amenities at the Ende exit, about a mile west and a world away from the crumbling blacktop, lonesome railroad tracks, and chest-high weeds of Glenrio. The old motel became sleeping quarters for people employed at the big modern motel, and the modern motel, which was operated by the Ehresmans' son, became the business focus for Ehresman, who spent four or five hours there every day. "I guess I could have retired," he mused. "I did retire once, but now I get up at 5:30 every morning and go up to Ende. I stay until 2:00 every day. People stop up there from pert near every state in the union, and I enjoy visiting with them."

Out in the far desert village of Amboy, California, Buster Burris had the same reaction to the interstate as Homer Ehresman had had in New Mexico—and he came back, too. "Our plans called for fourteen more motel units," said Burris,

"and I didn't build them because of the scare of the highway. I was afraid it would move away from here, so I sold in 1965." He repossessed his place in 1972, just in time to watch the bulk of the cross-country traffic move off the old concrete highway onto a new white slab, ten miles to the north. He said that Interstate 40 took away about 90 percent of his business. It drained a big part of the (already tiny) resident population from Amboy as well.

Like Burris, Ehresman, and the Littles, almost everyone knew that interstate highways would eventually bypass U.S. 66. Some, like Ehresman and Burris, sold out. Others banded together to fight for interstate access to their communities or overpasses that would enable interstate travelers to get to the Highway 66 businesses. This fight, and a publicity campaign to remind interstate travelers that they were just a stone's throw from Route 66, fell in part to the postwar incarnation of the U.S. 66 Highway Association. Gladys Cutberth, widow of perennial 66 Association Executive Secretary Jack Cutberth, recalled those days. "Most of the business routes through our towns are old Highway 66," she commented, "and now the traffic is too congested for all those tourists to go through all the towns, but they demand the services anyway. At first, the interstates were just fenced off and there was to be no business except on the interchanges. Well, the people on 66 just panicked. They fought the bypasses. They lost that fight and then they said, 'OK, let's bring the bypasses into the towns.' That worked out beautifully. We've kept our tourists, and they've kept out of city traffic."

Many of those who depended on the highway for a living would not agree with Mrs. Cutberth. In Hydro, Oklahoma, Lucille Hamons remembered the erection of a chain-link fence between her gas station and I-44 and the fight for exit ramps with bitterness: "I tried every way in the world to get an outlet off the highway," she said. "They told me

they were trying to get little places like this off the highway; that's one reason I stayed. The interstate hurt my gasoline business, but I've been here so long I know people from miles around. Of course, I had to start selling beer when my youngest daughter went to college."

As far as the fence between the interstate and old 66 was concerned, Mrs. Hamons was even more angry. "That fence is terrible. People get in trouble, run out of gas, you should see them trying to climb that fence. In Oklahoma, you can't sue the state for loss of business, but, believe me, there has been a lot of good businesses close up because of this." She paused for a moment and then continued, "I'd retire, but I think I'd go crazy, so I guess I'll just stay here."

Juanita and Laverne Snow built a restaurant in Weatherford, Oklahoma, in 1963. "We just never thought they'd come along three years later and put up that fence," she said, with a shake of her head. "I'm very bitter about it. I hope I live to see the day that fence comes down over there. It won't benefit me, but other states don't have that."

In the 1960s, when the coming of the interstate was a sure thing, Tom Roberts bought the Cabana motel in Erick, Oklahoma. "My wife and I started looking for something to trade some rental property for and found this place. We had a store in Littlefield, Texas. The traffic was busier then by several thousand cars a day," he acknowledged. "We made an appeal to the federal government to get the openings and overpasses and the date the highway would come through here," he said. "They had a hearing in Oklahoma City. We made an appeal, then they would decide what to do. Later we found out that the government wasn't planning to maintain 66 in town, but I asked them to change the agreement so they would, and they said, 'Sure enough,' and did. That saved us hundreds of dollars that we don't have to maintain these six miles through here."

In western New Mexico, Wallace Gunn did his

share of fighting the government, too, in behalf of La Villa de Cubero, his striking adobe motel and café. From the time it was built in the late 1930s, La Villa stood alone on the edge of Route 66, without the security of any kind of surrounding community. "Originally," said Gunn, "they were going to put interchanges every eight miles indiscriminately. There wasn't going to be one at Bibo's [the old Solomon Bibo trading company, a trade center for Indians in the area]. We fought that at the state and finally won. My wife and I survived five years when the road went through; then we got out. Course there were other things, too. Our physical health was not such that we could afford to work twenty-four hours a day, which running a motel entails. You had to be a jack-of-all-trades, too. The interstate really bothered us—it put us out of business—but it helped some of the other towns." Nor did Gunn feel that the process involved an overwhelming amount of politics. "The federal surveyors came and designed where the interstate would be. There was some controversy, of course. Some towns fought it for a long time. Santa Rosa, San Jon, and Gallup fought it, and Grants did not want it to bypass them. It did bring out more traffic, but it hurt the little tiny roadside places. We fought one time-delaying tactic; we wanted decent access."

The U.S. Highway 66 Association was often part of the fight for access to the interstates. While it was never a major voice in the proceedings, the 66 Association reflected the feelings of many of the small business owners along the highway during those years. In September, 1962, at the 66 Association's annual meeting in Shamrock, Texas, the group passed a resolution urging and requesting the retention of the identity of U.S. Highway 66. They registered "deep concern and regret that the present unnumbering system for the nation's interstate highways is designed so that the identity and historical significance of the name 'U.S. Highway 66' appears destined to

cease to exist," in the official document. The action taken was to urge the American Association of State Highway Officials to do something to right the situation and for 66 Association members to publicize the issue through chambers of commerce, state highway directors, and the media.[8] A year later, at the Barstow, California, national meeting, they passed another resolution, this one in protest of a pending House of Representatives bill that would allow certain service facilities on the interstate. Not only would that increase the chance of accidents, resolved the group, but it would destroy the existing highway business and be destructive to the general economic welfare of towns along the way.[9]

Seven years later, to salvage what pride they had left, the annual meeting of the U.S. 66 Highway Association voted to change their name to The Main Street of America Association. "Today," explained the letter written by Jack Cutberth to the membership, "the Association promotes tourism. In the beginning, in the twenties, it was to promote a paved road from Chicago to Los Angeles open year around. The war came along and the association faded from the scene." When the organization was reactivated in 1947, Cutberth continued, "the goal was to four-lane the entire 66 and advertise twenty-two hundred miles of scenic splendor along the road." The name was duly changed, but the times had changed as well, and the 66 Association managed to limp along for only a few more years before it quietly faded away altogether.

In the meantime the highway businesses had a new dragon to battle. In the mid-1960s, President and Mrs. Lyndon B. Johnson began beating the drum for highway beautification, taking special aim at billboards and junkyards. Roadside appearance had been an issue off and on since the 1920s, and several laws had been passed, without much effect, over the years to limit and regulate the numbers of billboards on the highways. A

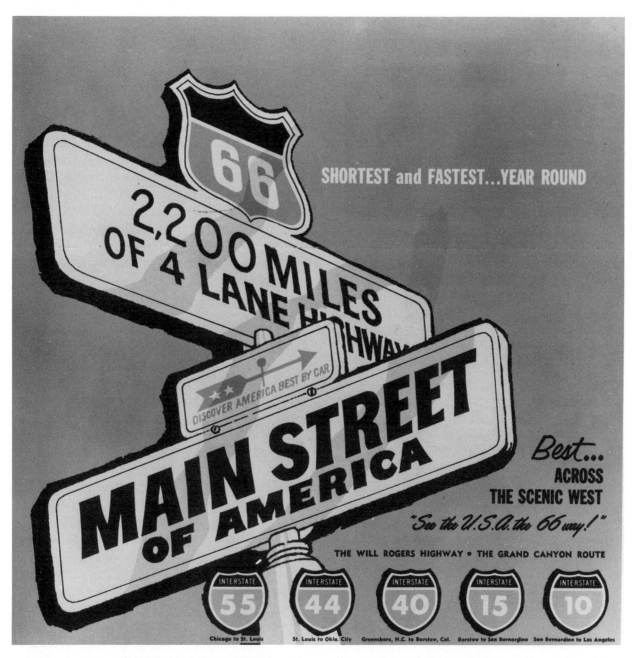

Brochure published by the U.S. Highway 66 Association, dated 1974: The 66 Association changed its name to the Main Street of America Association in 1970. It disbanded in 1976. This was the last of a series of brochures that the 66 Association published, beginning in 1949, to advertise travel on U.S. Highway 66. It was still being handed out by the city of Tucumcari, New Mexico, in 1982. SOURCE: City of Tucumcari, New Mexico.

1958 billboard law was updated in 1963, allotting a bonus—an additional half percent added to the federal share of interstate construction dollars—to states that would ban the placement of billboards less than 660 feet from the interstate right-of-way.[10] When that particular law expired in 1965, twenty states had agreed to limit their billboards, but only ten had received bonus payments (for only 209.2 miles of interstates).[11]

In 1965, Mrs. Johnson held a White House Conference on Natural Beauty, where she called for "pleasing vistas and attractive roadside scenes to replace endless corridors walled in by neon, junk, and ruined landscape."[12] The Highway Beautification Act was passed in 1965 and led to a cleaning up, fixing up, and mansarding of the gas stations, but more important, it limited the number of signs that could be placed on the highways. Billboards were bought up by the government; those that were left remained as long as the current owner continued to pay rent. State permits and a standardized level of upkeep were also required. Loss of their advertising signs, along with limited access to passing tourists, was a heavy blow to many of the 66 businesses.

In 1967 the Bureau of Public Roads reported that 839,000 billboards on the interstate and primary Federal-Aid Highways outside industrial areas had to be removed by July, 1970, and estimated that 178,000 signs in commercial or industrial areas would also need to be removed. Of those, 50,000 would come down in 1970, with the rest down in 1973.[13] That was a lot of signs.

"The state bought the signs," explained Phil Blansett at the Jackrabbit, in Joseph City, Arizona. "You had to sell, too. The ones they didn't buy stayed up, but you had to have a state permit and then keep them up. They finally quit two or three years ago—they realized they were putting people out of business."

Lyman Riley, who, as a manager of Meramec Caverns, probably represented a greater number of Route 66 signs than anyone else, acknowledged that there was some value in the Highway Beautification Act. "A few signs are beneficial, but when it gets like it was outside Springfield (Missouri). . . ." He shook his head. "The only people who got rich from those signs was the sign companies."

But the loss of the signs rankled, and it did affect business, often as much as having been bypassed. Years after, although many 66 businessmen and women still bemoaned the coming of the interstates, they recognized the inevitability of new roads. The Highway Beautification Act, on the other hand, they took personally, and they held Mrs. Johnson personally responsible for any damage done to their businesses. Lester Dill referred to her disparagingly as "Ol' Lady Bird." Others talked about her at great length and with great rancor but refused to be quoted. A man standing outside an old motel east of Albuquerque looked across an empty 66, through the chain link fence on the other side, and up a hill to where cars and trucks were roaring up Interstate 40 toward the Sandia Mountains. "You know what hurts a little business out here the worst?" said the man, a short, burly fellow with a hole just below the neckband of his white undershirt. "We can't go out and put a sign up on the highway. There's a big signboard out there right now, but I can't put anything on it, and if I did, the highway department would come along and tear it down—because the permits weren't paid up year after year. That's what really hurts our business."

The highway signs were one thing. Many of them disappeared. The highway itself was quite another. Despite its physical displacement, Highway 66 did not fade away. Even as it became a "ghost highway" to the interstates, Route 66 remained more vivid in the imaginations of traveling Americans than any of the newer, safer, faster, superhighways.

In the early 1960s, well after the Interstate

Highway Act had been passed and well into the construction of the roads that would bypass the Main Street of America, television producer Sterling Siliphant created a long-running television series titled "Route 66." Siliphant's show followed the adventures of two carefree young men who zoomed around the United States in a white Corvette. The fact that most of the episodes took place away from Route 66 was irrelevant to either the show's popularity or its title. When asked about this, Siliphant summed up the mystique of the highway: "It just seemed to be right. We shot just a couple of dozen of the shows along Route 66, but it was a symbolic title. . . . It's an expression of going somewhere . . . the best-known American highway, cutting across America. It's the backbone of America."[14]

Siliphant's assessment of what the highway had become was apt. By the time his television show was produced, the *idea* of Route 66 served traveling America far more effectively than did the narrow, cracking roadbed, which was rapidly being replaced by wider, smoother, dual-lane, limited-access superhighways.

The new construction continued throughout the 1960s, the 1970s, and into the 1980s. It was built in pieces: a bypass completed around a town in one place; several miles of countryside covered in another, which shifted traffic away from several fifty-year-old businesses; and a four-lane bridge addition in a third, affecting the traffic pattern of a whole county. The Turner Turnpike, which connected Tulsa and Oklahoma City in 1953, and the Will Rogers Turnpike, which opened between Tulsa and Joplin in 1957, were step-cousins to the interstate highways and were the first major bypasses of Route 66 in the Southwest. Not long after that, the winding, desolate climb through the Black Mountains from Kingman, Arizona, to Needles, California, was circumlocuted by a new road to the south, through Yucca, Arizona. Most of the towns in Texas were

bypassed during the seventies, and the final town in Illinois, where Route 66 had become a dual highway years before, was bypassed in 1980. In all, it took nearly thirty years for the various pieces of interstate built between Chicago and Los Angeles to finally come together into one continuous piece.

Jessie Hudson, long retired from the motel business, sat in her living room and recalled the day that Interstate Highway 44 was opened outside Lebanon. "That day got my husband so bad he just wanted to get out of town and go to Joplin," said Mrs. Hudson gently. "We didn't know if we would go out of business or what. Thank God, they opened up the road, and we were rented out by nine that night. The cutoff still was not finished, but the people came anyway. We thought then, 'Everything's OK. If they'll come in that ditch to get here, we're OK.'"

In Weatherford, Oklahoma, Juanita Snow thanked heaven for the steady local customers at their U.S. 66 café. "On December 23, 1966, at 11 o'clock, they opened the interstate," said Mrs. Snow. "I thought we was ruined. If we hadn't had the local business when the interstate come in, we would have had to close up. The reason we did make it, though, was this guy who had the Tropicana up the road. He came out and said we wouldn't be in business in six months. He was such a smart aleck. I said, 'You wanna bet?' And we stayed in business." People on Route 66 were tough.

The Golden Spread Grill had opened in 1957 in the shade of the towering grain elevators that dominated Groom, Texas. Ruby Denton took over the Golden Spread before it was a year old and operated it successfully for almost twenty-five years, catering to the traveling public and the local people who needed a good quick meal. "There used to be quite a bit more traffic come by," noted Mrs. Denton, "but on June 2, 1980, at 1:15 P.M., they tore us apart. They opened

that interstate and the 'on' and 'off' ramps were not done, and we had not sign one. It's not good for business, doing that. In fact, you go from a full house to absolutely nothing. There weren't enough people in Groom to support that kind of change so what happened was that in 1957 there were four very active restaurants. Now, there's one."

One of the interesting things about the coming of the interstate was not that it was built, nor that it bypassed the towns, but that the business owners remembered the day and often the hour that the ribbon was cut, diverting traffic off Route 66, away from their businesses and onto the new expressway.

By mid-1985 only one main street of one town was still part of the national highway system. Every other town that had welcomed U.S. 66 during the 1920s and 1930s had seen the coming of the interstates, and every one of those towns had been bypassed to a lesser or greater extent. The last town was Williams, Arizona, and when the time came that the highway crews outside Williams poured the last segment of concrete into the last remaining wooden frame to finish Interstate 40 all the way across the state, plenty of people were on hand to watch it dry and harden. By then the notion of Route 66 had become so romanticized that a large number of reporters had been sent into Williams from all over the United States to watch the Arizona Highway Department open the interstate highway across Arizona and bypass Route 66 forever. The ribbon cutting and closing of 66 was described in hundreds of newspapers and on national television news. A few weeks later at their annual meeting, the American Association of State Highway and Transportation Officials voted to decommission U.S. 66, and the Main Street of America was no more. At least not officially.

"What they did," Lester Dill had observed several years earlier from behind the old wooden desk in his office just outside the entrance to Meramec Caverns, "the interstate took all of us guys and ruined us. They could have named the interstate 66. Now nobody knows what highway we're on, and before, everybody knew 66!"

Actually, it took not one but five different interstates to replace the great diagonal highway from Chicago to Los Angeles. Interstate 55, a north-south highway from Chicago to the Gulf Coast, replaced 66 in Illinois. Interstate 44, which ran from Saint Louis to Wichita Falls, Texas, took over the bend of 66 from Saint Louis to Oklahoma City, and Interstate 40, the major east-west route from North Carolina to California, usurped the Route 66 traffic from Oklahoma City all the way to Barstow. The final few miles that Route 66 covered in Southern California were replaced by Interstates 15 and 10.

All the stray federal Highway 66 shields were taken down after the 1985 meeting of the highway officials. By that time, however, it was clear that it would take more than a meeting—or five interstate highways—to obliterate Route 66.

Even without highway signs, bits and pieces of the old road remained in the Illinois cornfields, in the Missouri hills, in Kansas and Oklahoma cattle country, and on the Texas plains. Remains of old 66 could be found in the red-rock country of New Mexico, the high desert of Arizona, and the low-down desert of California. More important, where the highway pavement remained, people also remained. Old gasoline stations were still open for service; not every roadside café sold standardized fast food; and while many of the alligator ranches were closed, Meramec Caverns still advertised itself as the Jesse James hideout, petrified wood was still available on the old road outside Holbrook, and the Jackrabbit souvenir store continued to open its doors every day of the year but Christmas.

The road that had been created by a Tulsa businessman and sent from the populated center

of the United States across the great wilderness of the Southwest had taken on a life of its own. There had been a book, a song, a television show, and three generations of people who grew up and grew old with Route 66. When it was born, traveling Route 66 was an adventure. Later, it was the mother road for destitute farmers and a haven for small businessmen fleeing the ravages of the Great Depression. Later still, it became the great military road to the army bases and airfields and armaments factories of World War II. After the war, Route 66 became the golden road west, carrying thousands more people than it had in the Depression on a great fortune-seeking migration to the infant industries on the West Coast or the glamour of Hollywood.

For fifty-nine years that highway was a factor in millions of trips, vacations, and relocations. It provided a living to countless men and women, ran down main streets of the hometowns of millions more, and figured in a billion personal experiences. It brought wealth and recognition to people like Bobby Troup and John Steinbeck. It brought destruction and death to others who did not respect its twists and turns and peculiarities.

After it was routed and numbered, Cyrus Avery had written to the Secretary of Agriculture promising to make Route 66 a highway that the United States would be proud of. Route 66 was that, but over the years it became something more: it became a highway the country could not forget.

NOTES

CHAPTER 1

1. Phil Patton, *Open Road,* p. 16.

2. See U.S. 66 Highway Association advertisement, *Saturday Evening Post,* July 16, 1932, p. 52.

3. Helen Leavitt, *Superhighway—Superhoax* (New York: Doubleday, 1970), p. 22.

4. Stephen W. Sears, *The American Heritage History of the Automobile in America,* pp. 76–80.

5. Leavitt, *Superhighway,* p. 21.

6. Sears, *American Heritage History,* p. 186.

7. August Zellner, "How Highway 66 Became a Reality," unidentified clipping in Avery Papers, 1927.

8. Charles W. Wixom, *Pictorial History of Roadbuilding,* p. 86.

9. Wixom, *Pictorial History,* p. 86.

10. Rex Harlow, *Oklahoma Leaders* (Oklahoma City: Harlow Publishing Co., 1928), p. 158.

11. Cyrus Avery, quoted in Harlow, *Oklahoma Leaders,* p. 158.

12. Cyrus S. Avery, "Tulsa Chamber of Commerce—Activity in Highway Development," 1952, typed document.

13. Riley Wilson, "Those Curves on old Roads Not 'Errors,'" *Tulsa World,* May 1, 1955.

14. Avery, "Tulsa Chamber of Commerce."

15. Wilson, "Those Curves on Old Roads Not 'Errors.'"

16. Interview with J. Leighton and Ruth Sigler Avery at their home in Tulsa, Okla., June 15, 1981.

17. Harlow, *Oklahoma Leaders,* p. 160. Also, "History of Experience of Cyrus S. Avery," typed document among the papers of Cyrus Avery.

18. "Cyrus Avery, Tulsa Civic Leader, Dies," *Tulsa World,* July 4, 1963.

19. Avery, "Tulsa Chamber of Commerce."

20. "Avery National Road President," *Tulsa World,* April 23, 1921.

21. "History of Experience of Cyrus S. Avery."

22. "State's Road Plan Copied," *Los Angeles Tribune,* 1925, Avery papers.

23. Thomas H. MacDonald, "The Engineer's Relation to Highway Transportation," *The Sixth Annual Salzberg Memorial Lectures and Symposium* (Syracuse: Syracuse University, April 28, 29, 1954), p. 5.

24. "Report of the American Association of State Highway Officials," Washington, D.C., 1925.

25. "The Work of the Joint Board on Interstate Highways," *American Highways,* January, 1926.

26. Letter, Gary (last name illegible) to Cyrus S. Avery, Avery papers.

27. Letter, W. C. Markham, executive secretary of the American Association of State Highway Officials, to Cyrus S. Avery, Feb. 9, 1926.

28. B. H. Piepmeier, chief engineer, Missouri State Highway Department, to Cyrus S. Avery, Feb. 13, 1926.

29. Ibid., Feb. 15, 1926.

30. Letter, Cyrus S. Avery to Elmer Thomas, 1926, Avery papers.

31. Thomas H. MacDonald, chief, Bureau of Public Roads, United States Department of Agriculture, to Cyrus S. Avery, March 30, 1926.

32. B. H. Piepmeier, chief engineer, Missouri State Highway Department, to Cyrus S. Avery, May 28, 1926.

33. E. W. James, chief, Division of Design, Bureau of Public Roads, United States Department of Agriculture, to Cyrus S. Avery, July 23, 1926.

34. Letters from chief, Division of Design, Bureau of Public Roads, and from W. C. Markham, to Cyrus S. Avery. Both dated July 23, 1926, Avery papers.

35. W. C. Markham, executive secretary, American Association of State Highway Officials, to State Highway Departments of Virginia, West Virginia, Kentucky, Illinois, Missouri, Oklahoma, Texas, Kansas, New Mexico, Arizona and California, "Notification Relative to Routes Nos. 60 and 66," Aug. 11, 1926.

36. Letter, Cyrus S. Avery to the chief, Division of Design, Bureau of Public Roads, Washington, D.C., July 26, 1926, Avery papers.

CHAPTER 2

1. Robert P. Howard, *Illinois: A History of the Prairie State*, p. 491.

2. Russell Byrd, *Russ's Bus*, p. 10.

3. "U.S. Highway No. 66 From Chicago to Los Angeles," *St. Louis Post-Dispatch*, 12/15/29 (copyright Texaco National Road Reports).

4. U.S. Public Roads Administration, *Highway Practice in the United States of America* (Washington: Federal Works Agency, 1949), p. 5.

5. Ibid., p. 4.

6. Ibid., p. 156.

7. Ibid., p. 169.

8. Ben H. Petty, "Highways Then and Now," *Engineering Bulletin—Purdue University*, p. 11.

9. U.S. Public Roads Administration, *Highway Practice*, p. 12.

10. Wilson, "Those Curves on Old Roads Not 'Errors.'"

11. Unidentified newspaper editorial clipping in Cyrus S. Avery papers, circa, 1950.

12. "Save Federal Aid, Road Chief's Plea," *Tulsa World*, undated clipping in Cyrus S. Avery papers, June, 1927.

13. "Albuquerque is Willing to Dig Up for Highway," *Albuquerque Journal*, Oct. 11, 1927.

14. "U.S. Route 66 Becomes A Super Highway," *Missouri Good Roads* (Jefferson City: Missouri Good Roads Assn., June 15, 1954), p. 10.

15. Ibid.

16. Charles L. Dearing, *American Highway Policy*, p. 118.

17. Ibid., p. 86.

18. Ibid., p. 88.

19. Ibid., p. 95.

20. Cyrus S. Avery, "History of U.S. 66," speech given at Vinita, Okla., Aug. 24, 1933. Manuscript in Avery papers.

21. "7000 At Highway 66 Celebration At Rolla," *Missouri Motor News*, April, 1931.

22. "Directors of 66 Split after Avery is Double Crossed," *Tulsa Tribune*, May 29, 1928.

23. "Bridgeport Bridge," copy of a 1932 report from the State of Oklahoma Department of Transportation Planning Division, n.d.

24. Mary Ann Anders, editor, "Route 66 in Oklahoma: An Historic Preservation Survey," unpublished research project for the History Department, Oklahoma State University, Stillwater, 1984.

25. "The Land of Enchantment, Tourism in New Mexico, 1934–41," exhibit at the Albuquerque Museum, March, 1985.

26. WPA Writers' Program, *New Mexico: A Guide to the Colorful State*, p. 434.

27. "The Land of Enchantment," exhibit at the Albuquerque Museum, March, 1985.

28. Walton Bean, *California: An Interpretive History*, p. 376.

29. Walton Bean and James J. Rawls, *California: An Interpretive History*, p. 305.

CHAPTER 3

1. Letter, C. C. Pyle to Cyrus S. Avery, Feb. 10, 1928, Cyrus Avery papers.

2. "275 Runners Start Today in Coast-to-Coast Race," *St. Louis Post-Dispatch*, March 2, 1928.

3. James H. Thomas, *The Bunion Derby*, p. 4.

4. *Saturday Evening Post*, July 16, 1932, p. 52.

5. Gladys Cutberth interview, June, 1982.

6. Oscar Theodore Barck, Jr., and Nelson Manfred Blake, *Since 1900*, p. 318.

7. Barck and Blake, *Since 1900*, p. 399.

8. Warren James Belasco, *Americans on the Road, From Autocamp to Motel 1910–1945*, pp. 121–22.

9. Daniel I. Vieyra, *"Fill 'er Up": An Architectural History of America's Gas Stations*, p. 8.

10. Sears, *American Heritage History*, p. 193.

11. Gary M. LaBella, *A Glance Back, A History of the American Trucking Industry*, p. 46.

12. "Dixie Truckers' Home" (unidentified magazine article reprint provided by John Geske, n.d.).

13. Belasco, *Americans on the Road*, p. 135.

14. LaBella, *A Glance Back*, p. 9.

15. Ibid., p. 12.

16. Felix Riesenberg, Jr., *Golden Road, The Story of California's Spanish Mission Trail*, p. 230.

17. Joseph Miller, ed., *New Mexico, A Guide to the Colorful State* (New York: Hastings House, 1953), p. 434.

18. Warren A. Beck, *New Mexico, A History of Four Centuries*, p. 329.

19. Frank McNitt, *The Indian Traders*, p. 211.

20. Betty Toulouse, *Pueblo Pottery of the New Mexico Indians*, p. 47.

21. Ibid., p. 53.

22. Ibid., p. 49.

23. Ibid., p. 50.

24. Belasco, *Americans on the Road*, p. 142.

CHAPTER 4

1. Gerald D. Nash, *The American West Transformed*, p. 9.

2. John Steinbeck, *The Grapes of Wrath*, p. 128.

3. "Attempts to Suppress 'Grapes of Wrath,'" *Publishers Weekly*, p. 777.

4. Chester H. Liebs, *Main Street to Miracle Mile, American Roadside Architecture*, p. 208.

5. "Attributes Success to Principle of Highly Developed Automobile Industry," *Bloomington Pantograph*, Dec. 2, 1940.

6. Gus Belt, quoted by John Geske, Normal, Ill., during July 16, 1983, interview.

7. Liebs, *Main Street*, p. 212.

8. *Shamrock Texan*, March 31, 1936 (various articles).

9. Belasco, *Americans on the Road*, p. 155.

10. *Harper's* magazine, quoted in Liebs, *Main Street*, p. 179.

11. Liebs, *Main Street*, p. 180.

CHAPTER 5

1. Liebs, *Main Street*, p. 28.

2. U.S. Census, *County Data Book* (Washington, 1947), p. 7. Quoted in Gerald D. Nash, *The American West Transformed* (Bloomington: Indiana University Press, 1985), p. 218.

3. Public Roads Administration, *Highway Practice in the United States of America* (Washington: Federal Works Agency, 1949), p. 13.

CHAPTER 6

1. Nash, *American West Transformed*, p. 38.

2. Ibid., p. 9.

3. "Get Your Kicks on Route 66" has been recorded by the following groups or individuals: Nat King Cole; Manhattan Transfer; Andrews Sisters, with Bing Crosby; Bobby Troup; Rolling Stones; Bob Wills; Asleep at the Wheel; Earthquake; The Four Freshmen; and several jazz groups.

4. Belasco, *Americans on the Road*, p. 165.

5. *Tourist Court Journal*, December, 1963, clipping among Gladys Cutberth papers, no title.

CHAPTER 7

1. Liebs, *Main Street*, p. 5.

2. Daniel Boorstin, *The Americans: The Democratic Experience*, p. 430.

3. "Restrooms Favored in California—Particularly in Small Towns," *The Filling Station*, May 25, 1924.

4. *66*, brochure produced by Phillips Petroleum Company Advertising and Public Relations Department, Jan., 1968.

5. Liebs, *Main Street*, p. 104.

6. Public Affairs Department of Phillips Petroleum Co., William C. Wertz, ed., *Phillips: The First 66 Years* (Bartlesville: Phillips Petroleum Co., 1983), p. 65.

7. Riesenberg, *The Golden Road*, p. 224.

8. Conroy Erickson, Public Relations Director, Rand McNally & Company, Skokie, Ill. Interviewed April 16, 1986.

9. John M. McGuire, "Les Dill: Operator Who Told Ozark Truth," *St. Louis Post-Dispatch*, August 14, 1980.

CHAPTER 8

1. "Camino de la Muerte," *Chicago Tribune*, Oct. 9, 1956.

2. Wixom, *Pictorial History*, p. 135.

3. "State Selects Route for New U.S. Highway 66," *Chicago Tribune*, Aug. 4, 1947.

4. Congressional Budget Office, *Highway Assistance Programs: A Historical Perspective* (Washington: Congress of the United States, Feb., 1978), p. 6.

5. Ibid., p. 7.

6. Ibid., p. 10.

7. Patton, *Open Road*, p. 270.

8. "Resolution Urging and Requesting the Retention of the Identity of U.S. Highway 66," records of the U.S. Highway 66 Association, Sept. 13, 1962.

9. "Resolution of the National 66 Highway Association against HR6457, Barstow, Calif.," records of the U.S. Highway 66 Association, Oct., 1963.

10. *Congress and the Nation*, Vol. II, *1965–1968*, p. 478.

11. Ibid.

12. Lady Bird Johnson, quoted in Chester H. Liebs, *Main Street*, p. 65.

13. *Congress and the Nation*, p. 487.

14. Michael Seiler, "Backbone of America," *St. Louis Globe Democrat*, Aug. 20–21, 1977.

SELECTED BIBLIOGRAPHY

BOOKS

Armitage, Merle. *Stella Dysart of Ambrosia Lake.* New York: Duell, Sloan & Pierce, 1959.

Ash, Sidney R., and David D. May. *Petrified Forest: The Story Behind the Scenery.* Holbrook, Ariz.: Petrified Forest Museum Association, 1969.

Baeder, John. *Gas, Food, and Lodging.* New York: Abbeville Press, 1982.

Bahti, Tom. *Southwestern Indian Arts and Crafts.* Las Vegas, Nev.: KC Publications, 1977.

Barck, Oscar Theodore, Jr., and Nelson Manfred Blake. *Since 1900.* New York: Macmillan Co., 1965.

Barth, Jack, Doug Kirby, and Mike Wilkins. *Roadside America.* New York: Simon & Schuster, 1986.

Bean, Walton. *California: An Interpretive History.* New York: McGraw-Hill, 1968.

———, and Rawls, James J. *California: An Interpretive History.* 4th ed. New York: McGraw-Hill, 1982.

Beck, Warren A. *New Mexico: A History of Four Centuries.* Norman: University of Oklahoma Press, 1962.

Bel Geddes, Norman. *Magic Motorways.* New York: Random House, 1940.

Belasco, Warren James. *Americans on the Road: From Autocamp to Motel, 1910–1945.* Cambridge, Mass.: MIT Press, 1979.

Bennecoff, Ethel. *Travel Guide Along Route 66.* San Francisco: H. S. Crocker Co., 1965.

Benson, Jackson J. *The True Adventures of John Steinbeck, Writer.* New York: Viking Press, 1984.

Blow, Ben. *California Highways.* San Francisco: H. S. Crocker Co., 1920.

Bonnifield, Paul. *The Dust Bowl.* Albuquerque: University of New Mexico Press, 1979.

Boorstin, Daniel J. *The Americans: The Democratic Experience.* New York: Random House, 1973.

Byrd, Russell A. *Russ's Bus.* Los Angeles: Pacific-Western Publishing Co., 1945.

Chatburn, George R. *Highways and Highway Transportation.* New York: Thomas Y. Crowell Co., 1923.

Chronic, Halka. *Roadside Geology of Arizona.* Missoula, Mont.: Mountain Press Publishing Co., 1983.

Congress and the Nation. Vol. 2, *1965–1968.* Washington, D.C.: Congressional Quarterly, 1969.

Dearing, Charles L. *American Highway Policy.* Washington, D.C.: Brookings Institution, 1941.

Douglas, Clarence B. *History of Tulsa.* Chicago: S. J. Clarke Publishing Co., 1921.

Dunbar, Seymour. *A History of Travel in America.* 2 vols. Indianapolis: Bobbs-Merrill Co., 1915.

Fehrenbach, T. R. *Lone Star: A History of Texas and the Texans.* New York: Macmillan Co., 1968.

Frank, Donna. *Clay in the Master's Hands.* New York: Vantage, 1977.

Gittinger, Roy. *The Formation of the State of Oklahoma, 1803–1906.* Norman: University of Oklahoma Press, 1939.

Hacker, Andrew, ed. *U.S.: A Statistical Portrait of the American People.* New York: Viking Press, 1983.

Hess, Alan. *Googie.* San Francisco: Chronicle Books, 1985.

Highway Assistance Programs: A Historical Perspective. Washington, D.C.: Congressional Budget Office, 1978.

Holbrook, Stewart H. *The Story of American Railroads.* New York: American Legacy Press, 1981.

Horwitz, Richard P. *The Strip.* Lincoln: University of Nebraska Press, 1985.

Howard, Robert P. *Illinois: A History of the Prairie*

State. Grand Rapids, Mich.: William B. Eerdmans Publishing Co., 1972.

Hulbert, Archer Butler, et al. *The Future of Road-Making in America: A Symposium.* Vol. 15 of *Historic Highways of America.* Cleveland, Ohio: Arthur H. Clark Co., 1905.

Jackles, John. *The Tourist: Travel in Twentieth Century North America.* Lincoln: University of Nebraska Press, 1985.

Jackson, W. Turrentine. *Wagon Roads West.* Berkeley: University of California Press, 1952.

Jenkins, James T., Jr., ed. *The Story of Roads* [compiled from a series of articles in *American Road Builder* magazine, 1957–58]. Washington, D.C.: American Road Builder, 1967.

LaBella, Gary M. *A Glance Back: A History of the American Trucking Industry.* Washington, D.C.: American Trucking Associations, 1976.

Lacey, Robert. *Ford: The Men and the Machine.* Boston: Little, Brown & Co., 1986.

Lee, W. Storrs. *The Great California Deserts.* New York: G. P. Putnam's Sons, 1963.

Liebs, Chester H. *Main Street to Miracle Mile: American Roadside Architecture.* Boston: Little, Brown & Co., 1985.

Litchfield, Paul W. *Industrial Voyage.* Garden City, N.Y.: Doubleday & Co., 1954.

Luxenberg, Stan. *Roadside Empires.* New York: Viking Press, 1985.

McNitt, Frank. *The Indian Traders.* Norman: University of Oklahoma Press, 1972.

Margolies, John. *The End of the Road: Vanishing Highway Architecture in America.* New York: Viking Press, 1981.

Marling, Karal Ann. *The Colossus of Roads: Myth and Symbol Along the American Highway.* Minneapolis: University of Minnesota Press, 1984.

May, George S. *R. E. Olds: Auto Industry Pioneer.* Grand Rapids, Mich.: William B. Eerdmans Publishing Co., 1977.

Minge, Ward Alan. *Acoma: Pueblo in the Sky.* Albuquerque: University of New Mexico Press, 1976.

Missouri Democracy. Vol. 2. Saint Louis: S. J. Clark Publishing Co., 1935.

Missouri Secretary of State. *Official Manual of the State of Missouri.* Jefferson City: State of Missouri, 1927–28 through 1935–36.

Missouri: The Center State, 1821–1915. Saint Louis: S. J. Clark Publishing Co., 1915.

Nash, Gerald D. *The American West Transformed.* Bloomington: Indiana University Press, 1985.

Nunn, William. *Roads and Their Builders.* Jefferson City: Missouri State Highway Commission, Division of Public Information, n.d.

Oklahoma. Chicago: American Historical Society, 1916.

Oklahoma and the Mid-Continent Oil Field. Tulsa: James O. Jones Co., 1930.

Patton, Phil. *Open Road: A Celebration of the American Highway.* New York: Simon & Schuster, 1986.

Public Roads Adminstration. *Highway Practice in the United States of America.* Washington, D.C.: Federal Works Agency, 1949.

Riesenberg, Felix, Jr. *Golden Road: The Story of California's Spanish Mission Trail.* New York: McGraw-Hill, 1962.

Rust, Brian. *The American Dance Band Discography, 1917–1942.* New Rochelle, N.Y.: Arlington House, 1975.

Ruth, Kent. *Oklahoma Travel Handbook.* Norman: University of Oklahoma Press, 1977.

Sandman, Peter M., David M. Rubin, and David B. Sachsman. *Media.* Englewood Cliffs, N.J.: Prentice-Hall, 1976.

Schlereth, Thomas J. *U.S. 40: A Roadscape of the American Experience.* Indianapolis: Indiana Historical Society, 1985.

Sears, Stephen W. *The American Heritage History of the Automobile in America.* New York: American Heritage Publishing Co., 1977.

Steinbeck, John. *The Grapes of Wrath.* 1939. Reprint. New York: Penguin Books, 1981.

Stewart, George. *U.S. 40: Cross Section of the U.S.* New York: Houghton Mifflin Co., 1953.

Thomas, James H. *The Bunion Derby: Andy Payne and the Great Transcontinental Footrace.* Oklahoma City: Southwestern Heritage Books, 1981.

Toulouse, Betty. *Pueblo Pottery of the New Mexico Indians.* Santa Fe: Museum of New Mexico Press, 1979.

Vieyra, Daniel I. *"Fill 'Er Up": An Architectural History of America's Gas Stations.* New York: Collier Books, 1979.

Wertz, William C., ed. *Phillips: The First 66 Years.* Bartlesville, Okla.: Phillips Petroleum Co., 1983.

Wixom, Charles W. *Pictorial History of Roadbuilding.* Washington, D.C.: American Road Builders' Association, 1975.

Work Projects Administration, Writers' Program. *Cali-*

fornia: A Guide to the Golden State. New York: Hastings House, 1939.

———. *Missouri: A Guide to the "Show Me" State.* New York: Duell, Sloan & Pearce, 1941.

———. *New Mexico: A Guide to the Colorful State.* Revised edition. New York: Hastings House, 1953.

———. *Oklahoma: A Guide to the Sooner State.* Norman: University of Oklahoma Press, 1941.

———. *Texas: A Guide to the Lone Star State.* New York: Hastings House, 1940.

JOURNAL ARTICLES

Burnham, John Chynoweth. "The Gasoline Tax and the Automobile Revolution." *Mississippi Valley Historical Review* 48 (December, 1961): 435–59.

Fuchs, James R. "A History of Williams, Ariz., 1876–1951." *University of Arizona Bulletin* 24 (November, 1953): 1–168.

Paxon, Frederic L. "The Highway Movement, 1916–1935." *American Historical Review* 51 (January, 1946): 236–53.

Petty, Ben H. "Highways Then and Now: Milestones in the Development of Modern Roads." *Purdue University Engineering Bulletin* 25 (November, 1941): 2–27.

NEWSPAPER AND MAGAZINE ARTICLES

"Albuquerque Is Willing to Dig Up for Highway." *Albuquerque Journal,* October 11, 1927.

Arizona Highways, July, 1981. [Entire issue devoted to Route 66.]

"Attempts to Suppress 'Grapes of Wrath'." *Publishers Weekly,* September 2, 1937, p. 777.

"Attributes Success to Principle of Highly Developed Automobile Industry." *Bloomington* (Illinois) *Pantograph,* December 2, 1940.

"Avery Probable Contender in Gubernatorial Contest." *Tulsa World,* October 8, 1933.

"Avery Resigns as Land Buyer." *Tulsa World,* January 10, 1950.

"Avery, Stormy Petrel in Johnston Administration Is Pioneer Road Advocate." *Oklahoma City Times,* January 26, 1927.

Banham, Reyner. "The Haunted Highway." *New Society,* June 19, 1980, pp. 297–99.

"'Blue Bird,' Road Show, And 'Grapes' Set For Broadway Ballyhoo." *Variety,* January 10, 1940, p. 1.

"Bunion Derby Opened Up Sooner's Races." *The Daily Oklahoman,* September 19, 1977.

Coaldigger, Adam. "The Cock-Eyed World." *American Guardian* (Oklahoma City, Oklahoma), March 20, 1940.

Corbett, Peter. "A Sentimental Journey down Route 66." *Verde View* (Flagstaff, Arizona), January 14, 1982.

"Cyrus Avery, Tulsa Civic Leader, Dies." *Tulsa World,* July 4, 1963.

"Directors of 66 Split After Avery is Double-crossed." *Tulsa Tribune,* May 29, 1928.

"Fifty Years Ago." *Clinton* (Oklahoma) *Leader,* July 30, 1981.

The Filling Station: A Journal for Filling Stations and Petroleum Jobbers. Vol. 1–6. Issues for 1922–28.

"Final Chapter Is Written for 66." *New York Times,* June 29, 1985.

"First Cross Country Trek by Car Took 32 Days." *St. Louis Post-Dispatch,* August 2, 1981.

"Front Desk." *Tourist Court Journal,* December, 1963.

Fuson, Ken. "A Weekend's Jaunt to Joplin, Queen City of the Boondocks." *Missouri Life,* March-April, 1981, p. 69.

"G. L. Noel Added 11 Cabins to White Grocery and Service Station and Auto Camp." *Holbrook* (Arizona) *Tribune,* June 10, 1927.

"Gary Kept Promise to Western Oklahoma." *Clinton* (Oklahoma) *Daily News,* July 20, 1969.

Gatty, Bob. "Highways That Changed a Nation." *Nation's Business,* May, 1981, pp. 24–31.

"Get Your Kicks on I-44? Route 66 Signs Off." *St. Louis Post-Dispatch,* January 16, 1977.

Gillenkirk, Jeff, and Mark Dowie. "The Great Indian Power Grab." *Mother Jones,* January, 1982, pp. 18–27, 46–52.

"'Grapes of Wrath' Banned by Buffalo Library." *Publishers Weekly,* August 12, 1939, p. 453.

Gray, Theodore. "Some Important Facts on State Road Program." *Macon* (Missouri) *Republican,* February 14, 1928.

"Highway Gospel Is Preached to Tulsa Realtors." *Fort Smith* (Arkansas) *Times Record,* n.d. [1923].

"Hundreds Arrive for Main Street Conference Here." *Springfield News,* May 2, 1927.

"Interstate System 30 Years Old." *St. Louis Globe-Democrat,* June 27, 1986.

Jenkins, J. L. "OK Road Plan in Chicago Area as Show Closes." *Chicago Tribune*, n.d. [1926].

Johnson, Burke. "Route 66." *Arizona Republic Sunday Magazine*, August 15, 1965.

"Just Between Us." *McLean* (Texas) *News*, November 7, 1963.

Kelly, Susan Croce. "Just for Kicks! Route 66." *Chicago Tribune*, Travel Section, May 22, 1983.

———. "Route 66." *St. Louis Magazine*, June, 1984, p. 64.

———. "Ma and Pa Motels Fade into the Sunset." *Midwest Motorist*, March-April, 1983, pp. 6–8.

———. "The Inside Story on Missouri's Caves." *Midwest Motorist*, July-August, 1981, pp. 5–7.

———. "Route 66: 50 Years and Holding." *PD: The St. Louis Post-Dispatch Sunday Magazine*, May 17, 1981, pp. 6–11.

———. "There Are No More Kicks on Old Route 66." *Midwest Motorist*, February, 1980, p. 16.

———. "Haven of the Road." *Sunday Pictures* [magazine of *St. Louis Post-Dispatch*], September 30, 1979, pp. 6–13.

Lamm, Lester P. "Finish the Interstate System." *St. Louis Post-Dispatch*, July 27, 1986.

"A Legend's Eleventh Hour." *Shield* [publication of Phillips Petroleum Co.]. Vol. 7. Fourth Quarter, 1982, pp. 14–23.

"Let's Get Rid of Slaughter Lane." *Tucumcari* (New Mexico) *Daily News*, August 6, 1969.

Loeffelbein, Bob. "With No Roadside Verse, the Country Is Worse." *St. Louis Globe-Democrat*, September 21, 1981.

MacDonald, T. H. "Our Present Road System: How It Was Created and How It Grew." *Engineering News*. Vol. 102. January 3, 1929, pp. 4–7.

McGuire, John M. "Les Dill: Operator Who Told Ozark Truth." *St. Louis Post-Dispatch*, July 14, 1980.

Moffett, L. W. "Highway Construction Knows No Business Depression." *Iron Age*. Vol. 126. October 23, 1930, pp. 1121–1124.

"Muskogean Says Highway Official Took City's Road." *Muskogee* (Oklahoma) *Daily Phoenix*, January 8, 1927.

"New Route for U.S. 66 Draws Ire at Hearing." *Chicago Tribune*, January 8, 1965.

"Nobel Prize to Steinbeck." *Oklahoma City Times*, October 25, 1962.

"No Left Turn Here—Two Rights Make a Left on Highway Grade Sep at Kirkwood." *Missouri Motor News*, February, 1932.

"No Wrath over 'Grapes' in Cal., Okla." *Variety*, March 6, 1940.

Nunn, Bill. "There'll Always Be a 'Route 66.'" *Missouri Life*, November-December, 1983, pp. 15–19.

Page, Frank. "President's Annual Address." *American Highways*, vol. 6. January, 1927.

Patton, Phil. "Route 66, Where are you?" *Ozark Magazine*, May, 1986.

Putman, Jack. "Agronomy 'Prof Without Portfolio' Can Recall Rich, Varied Experience." *Tulsa Daily World*, July 15, 1959.

Rinne, Carol. "The End of the Road for Route 66." *Missouri Highway and Transportation News*, September, 1985.

"Road of Death Is Route 66 Through Arizona." *Chicago Tribune*, October 9, 1956.

"St. Louis Termed Hub of U.S. Highways." *St. Louis Globe-Democrat*, January 10, 1927.

"Seven Thousand at Highway 66 Celebration at Rolla." *Missouri Motor News*, April, 1931.

"State Helped by National Road System." *Tulsa Tribune*, January 30, 1927.

Stockton, Allen. "The Changing Face of America's Main Street." *American Motors Magazine*. Vol. 1. November-December, 1965, pp. 3–7.

"The Story of the U.S. Numbered Highway System." *American Highways*, Vol. 35. April, 1956, pp. 11–15, 31.

"Tulsa Linked with Nation by Board." *Tulsa Tribune*, May 31, 1925.

"Tulsan Is Named Head of 66 Highway Association." *Joplin* (Missouri) *Globe*, March 12, 1929.

Upton, Lucile Morris. "Crowd Cheers Highway Finish." *Springfield News & Leader*, March 22, 1981.

"U.S. Highway No. 66 From Chicago to Los Angeles." *St. Louis Post-Dispatch*, December 15, 1929.

"U.S. Route 66 Becomes a Super Highway." *Missouri Good Roads*. Vol. 1. June 15, 1954, pp. 10, 22–24.

U.S. 66 Highway Association. Advertisement. *Saturday Evening Post*, Vol. 205. July 16, 1932, p. 52.

Velotta, Rick. "Dead Chicken, Jokes, Peddled at This Diner." *Arizona Daily Sun*, November 23, 1980.

"What Prevented Tunnel at Gray Summit on U.S. 66." *Missouri Motor News*, August, 1932.

Wilson, Riley. "Those Curves on Old Roads Not 'Errors.'" *Tulsa World*, May 1, 1955.

Young, Jim. "Route 66 to Bite the Dust." *The Daily Oklahoman*, April 2, 1985.

ARCHIVES AND PAPERS

Atlantic Richfield Company. Archives. Los Angeles, California.

Avery, Cyrus S. Papers. In possession of Ruth Sigler Avery, Tulsa, Oklahoma.

Cutberth, Jack and Gladys. Papers of the post-war National U.S. 66 Association. In possession of Gladys Cutberth, Clinton, Oklahoma.

Rand McNally and Co. Archives. Skokie, Illinois.

Scott, Leslie Lon. Papers. In possession of Mrs. Leslie L. Scott. Tulsa, Oklahoma.

MISCELLANEOUS

An Abbreviated History of the U.S. Road System and the Benefits Which Have Accrued. Reprint of speech presented to Australian Automobile Association Roads Symposium, Canberra, Australia, March 13, 1980.

Anders, Mary Ann. "Route 66 in Oklahoma: An Historic Preservation Survey." Unpublished paper for Oklahoma State University. Stillwater, Oklahoma, 1984.

Bassett, Mabel (Oklahoma State Commissioner, Department of Charities and Corrections). Letter to Mr. H. Robert Wood, April 14, 1940.

Famous Old Roadside Rhymes. Detroit: Dealer's Safety & Mobility Council. January, 1975.

Fellin, Octavia. "Gallup the Way It Was." In *First State Bank of Gallup, N.M., Annual Report,* 1980.

Great Transcontinental Footrace. Flier. 1927.

"The Land of Enchantment, Tourism in New Mexico, 1934–41." Exhibit at the Albuquerque Museum, March, 1985.

Pruett, Haskell. Letter to Kent Ruth, Geary, Oklahoma, February 14, 1977.

"Report of the State Highway Commission to the Governor of Oklahoma," 1925–26, 1929–30, 1933–34. Oklahoma City, Oklahoma.

"Special Traffic Study Including Origin and Destination on Proposed Realignment between Flagstaff and Winona on Federal Aid Route 3 (U.S. 66 and U.S. 89)." Arizona Highway Planning Survey, August, 1941.

Why 66? Bartlesville, Oklahoma: Phillips Petroleum Company Advertising and PR Department, January, 1968.

MAPS

Drive U.S. 66. Clinton, Oklahoma: National U.S. 66 Association, 1953.

General Highway Map: State of Arizona. Arizona Department of Transportation, Photogrammetry and Mapping Services in cooperation with United States Department of Transportation, Federal Highway Administration. Phoenix: Arizona Department of Transportation, 1984.

Hobbs Grade and Surface Guide: Santa Fe Trail, Los Angeles-Denver. Akron, Ohio: Mohawk Rubber Co., 1923.

Map of Missouri State Highway System. Jefferson City, Missouri: Missouri State Highway Commission, 1931, 1934, 1945, 1946, 1949.

Map Showing Marked Through Routes in Illinois. Springfield: Illinois State Highway Department, 1917.

Missouri State Highway Commission Map of 1927: Summer Traffic Census Showing Average and Maximum Daily Motor Vehicle Traffic and Average Daily Truck and Motor Bus Traffic on State Highway System. Jefferson City, Missouri: Missouri State Highway Commission, 1927.

Rand McNally Road Atlas. Chicago: Rand McNally and Co., 1980.

Rand McNally Road Map: United States. Chicago: Rand McNally and Co., 1945, 1955, 1960.

Rand McNally Senior Auto Road Map of the United States. Chicago: Rand McNally and Co., 1937, 1938.

Texaco Road Map: Arizona and New Mexico. Chicago: Rand McNally and Co., 1929.

Traffic Map of Missouri. Highway Planning Department, Missouri State Highway Department in Cooperation with the Bureau of Public Roads, Department of Commerce. Jefferson City, Missouri: Missouri State Highway Department, 1949.

United States System of Highways: Adopted for Uniform Marking by the American Association of State Highway Officials. November 11, 1926.

PERSONAL INTERVIEWS

Illinois

Nick Adams, Ariston Restaurant, Litchfield
Mrs. Pete Adams, Ariston Restaurant, Litchfield
Frank Berringer, banker, Litchfield
Michael Burns, Burns & Son, Springfield

Fenton Craner, service station, Elkhart
Florence Craner, Elkhart
David Dale, Welco, Joliet
Cecil P. Daniels, Daniels Auto Parts, Braceville
*Lorraine J. Davis, Trini's Number 7 Tavern, Pearl City
Ruth Drnec, tavern owner, Gardner
Carol Fritzsche, Schlechte Cafe, Worden
John Geske, Dixie Truckers Home, McLean
William Henke, State Highway Maintenance
 Department
Chester John Jerantowski, Pine Lodge, Braceville
Lester Kranich, Belvedere Motel, Litchfield
Wilbur F. Meyer, mayor, Hamel
Mary Ogg, Rossi's Motel, Braidwood
Wyatt Patterson, Patterson Propane, Williamsville
Lee Paul, fire chief, Mitchell
Marian Rodino, Rodino Square, Pontiac
Bill Roseman, 66 Terminal, Staunton
Peter Rossi, Rossi's Motel, Braidwood
Pete Routh, trustee, Mitchell Fire Department, Mitchell
Dora Schlechte, Schlechte Service, Worden
Orville Schlechte, Schlechte Service, Worden
Ola Soulsby, Mount Olive
Russell Soulsby, Soulsby's Service, Mount Olive
M. Otto Sternagle, retired, Pearl City

Missouri

Bill Aaron, Sr., Rolla
Lynna Aaron, Rolla
Loren Alloway, Satellite Cafe, Sleeper
Norma Alloway, Satellite Cafe, Sleeper
Rachel Asplin, Boots Motel, Carthage
Leslie Burrow, Sandwich Shops, Saint Louis
Franklin G. Campbell, Campbell 66 Express, Spring-
 field
George Carney, Melody Museum, Rolla
Sheldon ("Red") Chaney, Red's Giant Hamburg,
 Springfield
†Nancy Cullers, early traveler, Trenton
Lester Dill, Meramec Caverns, Stanton
John Dobrauc, Koronado Motel, Joplin
Frank Farmer, farmer, Ash Grove
Alex Goldstein, used-car dealer, Saint Louis
Joy Spears Fishel, Joy Motel, Lebanon
Melva Formato, Rock Haven, Conway

*Individual interviews by Quinta Scott.
†Individual interviews by Susan Croce Kelly.
All other interviews conducted jointly by Kelly and Scott.

Kenneth Goodman, retired service-station owner,
 Halltown
George T. Guernsey III, Pierce Pennant Motels, Saint
 Louis
Jessie Hudson, Munger Moss Motel, Lebanon
Frank Hurley, Jacob's Cave, Versailles
Naiomi Kittle, city collector, Rolla
William August Otto Lenz, Lenz Homotel, Lebanon
Florida Melugin, Friendly Cafe & Tavern, Avila
A. T. ("Jiggs") Miller, grocer, Devil's Elbow
*John Miller, Saint Louis
Tom Moore, Trail's End Motel, Springfield
A. George Morris, retired State Hatchery director,
 Springfield
†Sherman Nutt, Nutt Used Cars, Springfield
Mildred Preslar, TaysTee Cafe, Waynesville
Lyman Riley, Onondaga Cave, Leasburg
†Ken Rischbieter, Crystal Courts, Saint Louis
†Audrey Burtrum Stanley, used-car lot, Joplin
Amy Thompson, Clementine

Kansas

Reverend William H. Pennock, Kingdom Camp-
 ground, Galena

Oklahoma

†Allie Abla, retired, Erick
*J. Leighton Avery, Tulsa
Ruth Sigler Avery, Tulsa
George Bell, service station, Oklahoma City
Jeffie Blair, postmistress, Texola
*Roy Burns, pawnshop owner, Weatherford
Norma Cullison, Dave's Trading Post, Claremore
Gladys Cutberth, secretary, Route 66 Association,
 Clinton
Eldred Lee Condry, Shady Rest Court, Tulsa
Ross H. Davis, Ross's Drive Inn, El Reno
Zelta Davis, Blue Whale, Catoosa
Hugh Davis, retired Tulsa Zoo director, Catoosa
*Ura Dorsey, grocery, Clinton
Lillie Ferris, Commerce
†Rosetti Gephart, Erick
Bill Goucher, radiator service, El Reno
Lucille Hamons, station owner, Hydro
LaVerne Harris, Laverne's Marriage Parlor, Miami
Dorothy Harrison, Park Plaza Courts, Tulsa
*Glenal Hunt, Wolf Robe's Trading Post, Catoosa
Grady Jones, service station, Arcadia

Allene Kay, Buffalo Ranch, Afton
*Robert Lee, retired chairman, Leeway Trucking, Oklahoma City
*Ann Little, Hinton
*Leon Little, Little's Service Station, Hinton
Allen Long, retired school superintendent, Geary
Garland Lowry, barber, Canute
*LeRoy Martin, antique shop, Elk City
*Georgia Meredith, waitress, Little's Cafe, Hinton
Edna Prokup, Greyhound Station, Luther
Tom Roberts, Cabana Motel, Erick
Kent Ruth, historian, Geary
Margaret Shamas, Anchor Drive Inn, Bristow
Grace Lee Frank Smith, Frankoma Pottery, Sapulpa
Juanita Snow, retired cafe owner, Weatherford
Laverne Snow, retired cafe owner, Weatherford
Atmer Taylor, Red Rock Oil Co., El Reno
†Nyla Tennery, city clerk, Erick
*Elizabeth Threat, Threat's Cafe and Service Station, Luther

Texas

Belah Allen, Adrian
*Addie Allred, snake farm, Allenreed
Tom Baynham, Vega Drug, Vega
Marita Bumpers, Western Cafe, Shamrock
Ethel Carpenter, Amarillo
John Darrell, Ford Brothers Circus, Shamrock
Ruby Denton, Golden Spread Grill, Groom
Walt Donais, FSW Cattle Co. feed yard, Wildorado
Homer Ehresman, motel, Glenrio
Jesse Fincher, Jesse's Cafe, Wildorado
Irene Friou, Amarillo
*R. C. Lewis, retired, Shamrock
Leslie Linger, Oldham Hotel, Vega
Johnnie Mertel, Boots, McLean
O. J. Milham, junk shop, McLean
*Alma Moore, Phillips distributor, Wildorado
*Mildred Moore, Wildorado
Joe Montgomery, Vega Drug, Vega
Bebe Nunn, Nunn's Cafe, Shamrock
*Bill Scott, Farel Manor, Amarillo
*Reba Scott, Farel Manor, Amarillo
Jesse Smith, gift shop, McLean
*W. T. Smoot, Amarillo
Marie Taylor, Western Cafe, Shamrock
*Maymie Tindall, Shamrock
*Byron Vermillion, Amarillo
John L. Wilson, Wilson Implement Company, Vega

New Mexico

Margaret Ascencio, potter, Acoma Pueblo
LeRoy Atkinson, trader, Albuquerque
*Pauline Bauer, La Puerta Lodge, Albuquerque
Ernie Bulow, bookstore owner, Gallup
*Robert Burnham, Tucumcari
Pete Chandis, Western Host Restaurant, Grants
Placido Chavez, Furniture Mart, Grants
Morey Christensen, Paramount Curio, Gallup
Velma Christensen, Paramount Curio, Gallup
Roy E. Cline, Clines Corners, Corales
Eula Edwards, San Jon Museum, San Jon
Vernon Finnell, Royal Palacio Motel, Tucumcari
Keith Gottleib, Cubero Trading Post, Cubero
C. K. ("Bud") Gunderson, Gunderson Oil Company, Milan
Wallace Gunn, La Villa de Cubero, Laguna
*Herschel Harris, Tobe Turpen's Trading Company, Gallup
Maubin Jenkins, Gallup
Joy Johnson Lee, El Rancho, Gallup
Juana Leno, potter, Acomita
Bonnie Liles, postmistress, Bard
Martin Link, director, Red Rock State Park, Gallup
Albertine Menini, former Harvey Girl, Gallup
Rudi Menini, carpenter, Gallup
Ernest Dean Misseldine, Dean's Restaurant, Tucumcari
Marvel Prestridge, Grants
Marge Richardson, Richardson's Cash Pawn & Indian Jewelry, Gallup
Mamie Dovie Jackson Robbins, Bard Store, Bard
Bonnie Rodriguez, Milan Motel, Milan
*Floyd Shaw, Club Cafe, Santa Rosa
Joseph M. Smith, Jr., Smith Oil Co., Santa Rosa
Tobe Turpen, Tobe Turpen's Trading Company, Gallup

Arizona

John G. Babbitt, Babbitt Brothers, Flagstaff
Ella Blackwell, Ella's Frontier, Joseph City
Phillip E. Blansett, The Jackrabbit, Joseph City
Beatrice Boyd, Peach Springs Motel, Peach Springs
Hazel Bruchman, Bruchman's, Winslow
Phil Bruchman, Bruchman's, Winslow
Chuck Chacon, Store For Men, Winslow
Juan Delgadillo, Delgadillo's Sno Cap, Seligman
*Edna Dobell, Petrified Forest National Park, Holbrook

*Frank Dobell, Petrified Forest National Park,
 Holbrook
*Paul Dobell, Holbrook
Mrs. S. Esparza, Sierra Vista Motel, Flagstaff
Garnet Franklin, Holbrook
Jack Fuss, retired sign painter, Flagstaff
Marie Fuss, Flagstaff
*Keith Gannet, Ed's Camp, Sitgreave's Pass
Robert Goldenstein, Indian Trading Company, Peach
 Springs
Dona Harris, Bruchman's, Winslow
Glenn Johnson, flooring dealer, Kingman
Allen Hensley, Whiting Brothers, Holbrook
Clifton Lewis, Wigwam Village, Holbrook
Richard Mester, Greyhound Station, Holbrook
Richard E. Molin, E-Z Motel, Kingman
Fred Nackard, Pepsi Bottling Plant, Flagstaff
Bill Nelson, State Highway Department, Truxton
Don Patton, Sr., Patton & Sons, Holbrook
Betty Paulsell, Holbrook
Alma Pouquette, White House Hotel, Ash Fork
*Arthur Whiting, Whiting Brothers, Holbrook
Andy Wolf, Flagstaff Powwow, Flagstaff
Albert Wong, Grand Canyon Cafe, Flagstaff

California

Franca Acuna, Acuna's Service Station, Los Angeles
Mildred Armes, Cardy's Camp, Needles
J. F. Belsher, Jr., Texaco station, Barstow

H. B. ("Buster") Burris, Roy's Service, Amboy
Bessie Burris, Amboy
Bill Butler, retired Texaco distributor, Barstow
Edith Butler, Barstow
Jack Brotherton, Brotherton's Family Restaurant,
 Pasadena
Luella Brotherton, Pasadena
Russell A. Byrd, retired bus driver, Los Angeles
Clydene Deatherage, retired cigar-box maker, Fontana
Tony Finazzo, Mid-Way Honda, Fontana
*Rudy Gazvoda, car dealer, Fontana
Dixie Lambert, Boulevard Cafe, Duarte
John Malin, retired Kaiser steelworker, Fontana
Duane Meyer, Union 76 Station, Rancho Cucamonga
Ed Operini, Kaiser Steel, Fontana
Ted Porter, former mayor, Fontana
George Sinner, Steelworkers Oldtimers Foundation,
 Fontana
Susie Thomasanian, Boulevard Cafe, Duarte
*Agnes Thompson, Needles
*Sam Thompson, Texaco distributor, Needles
Bobby Troup, songwriter, Encino
Cynthia Troup, Studio City

Miscellaneous

Richard O. Moore, KTCA, Saint Paul, Minnesota
*George Greider, traveler, interviewed at L. Avery's,
 Tulsa, Oklahoma

ACKNOWLEDGMENTS

THIS is the list of thanks to those people whose dedication to our idea have made its execution possible.

Barrie Scott took the original research plan and organized it into a clear, doable book proposal. He traveled the road twice, contributing his observations, advising on the architecture, and conducting traffic around Quinta when she made photographs in the middle of the road.

Jerry Pratter encouraged Quinta to apply to the National Endowment for the Arts for a Design Arts Fellowship, which was awarded to Quinta for the purpose of documenting the architecture on Route 66 and provided her with funds for travel, research, and photography for this project.

The Charles Ulrick and Josephine Perfect Bay Foundation provided funds for Susan's travel, additional travel to finish the manuscript, transcription of taped interviews, and manuscript preparation costs.

John Shewmaker and the Media School sponsored us, making it possible to receive the grant from the Bay Foundation.

The Reverend William Faherty, Martin Quigley, Robert Vogel, James A. Burke, Edward D. King, Constantine Michaelides, George McCue, Robert Duffy, Robert LaRouche, and Jean Tucker wrote letters of support for the many grant proposals we made.

Dick Miller led us through a careful dialogue that resulted in the realization that the only way to do a history of U.S. 66 was to start with an oral history from the people on the roadside; then he and George Rawick helped us justify our decision to use roadside buildings to identify our informants.

Mike O'Brien, a newspaperman, and Jim Fullinwider, a historian, counseled and advised us on chapter organization and wording and read many drafts of the developing manuscript.

The team of Lucile Morris Upton and Betty Love went through Route 66 country interviewing people and taking pictures long before we ever heard of the highway and gave us an example to strive after.

Ruth Sigler Avery and her husband, Leighton, who is now deceased, opened up their house, their files, and their histories to us and gave us the information that made the project fall together.

Hugh and Zelta Davis were always there when we needed them, providing us with leads to informants and sharing their historical photographs with us.

Joy Fishel, Jessie Hudson, Leroy Atkinson, Dona Bruchman Harris, Roy Cline, Jr., Lucille Slack, Ruth Sigler Avery, Gladys Cutberth, Mary Rossi Ogg, Tobe Turpin, Margaret Learn, Bebe Nunn, Leon and Ann Little, Wallace and Mary Gunn, Richard Mester, and Bill Roseman searched their attics and found old photographs, matchbooks, brochures, postcards, and maps, which they have allowed us to use to illustrate the text.

Anna Novakov, of the Oakland (California) Museum, and numerous helpful voices on the phone in the photographic department of the Library of Congress helped us to select the photographs of Dorothea Lange and Russell Lee that appear in the text.

John Ross, of the map department of the Saint Louis Public Library, helped us find maps of Route 66 in the different periods of its life.

The other people of Route 66, who are too numerous to name here but who are listed in the bibliography, let us into their lives and took time out from business to tell us their stories and let us take their photographs. This book would not be possible without their generosity.

203

Bess and Al Long took us in on every trip west, and their house in Geary became our Oklahoma home. While we were in Geary, Kent and Helen Ruth listened carefully to what we were about and encouraged us. Ruth Sigler Avery and Jessie Hudson also generously fed us and provided us beds after long days of work.

Most of all we are grateful to Vivian Eveloff, who introduced us; to John Drayton, of the University of Oklahoma Press, who saw merit in our project and shepherded us to a successful conclusion; to Mildred Logan, of the University of Oklahoma Press, who edited the manuscript; and to our families: Brendan, Fred, June, Peter, Mary, Barrie, and Kalon.

S.C.K.
Q.S.

INDEX

Abla, Allie: 29
Accidents: 178–79 ff.
Acoma Indians: 48 ff., 71
Afton, Okla.: 29
Albert Pike Highway: 12
Albuquerque, N.Mex.: 24, 30, 46, 48, 64, 75, 81, 117, 127, 132, 149
Amarillo, Tex.: 4, 12, 14, 24, 29, 45, 46, 60, 64, 65, 117, 149
Amboy, Calif.: 4, 80, 140–41, 159–60, 178–79, 183; *see also* Burris, H. B.; Mojave Desert
American Association of State Highway Officials: 13–17, 184, 188
American Automobile Association: 6, 37, 73, 152, 168
American Restaurant Association: 154
Arizona: 4, 149, 188; early road conditions, 20–21; paving, 22 ff., 30–31, 52; U.S. 66 Highway Association, 24; accidents, 178
Arizona Highway Department: 30, 188
Arkansas: 15, 68; in Good Roads Movement, 7, 9, 12; in U.S. 66 Highway Association, 24
Armes, Loren: 139, 157–58
Armes, Mildred: 139, 157–58
Armstrong, Louis: 112, 149
Art's Motel, Divernon, Ill.: 91
Ascott Speedway (Los Angeles): 33
Ash Fork, Ariz.: 52
Asphalt: 6
Associated Highways Associations of America: 12
Atkinson, LeRoy: 50–53, 79, 128, 175–76
Atlanta, Ga.: 13
Automobile: 3, 6, 148
Automobile Gasoline Company: 40
Avery, Cyrus Stevens: 4, 5, 10, 32, 36, 164, 167; as father of U.S. 66, 4, 189; in Tulsa, 4; as leader in formation of

national highway system, 4, 9, 12–17, 18; in Good Roads movement, 7, 9, 12; early life of, 9; as Tulsa County Commissioner, 10, 11; as farmer, 11; civic endeavors of, 12; as State Highway Commissioner, 12; and highway engineering, 22–23; in U.S. 66 Highway Association, 23–24, 32–37; in WPA, 26–27; as highway entrepreneur, 37–38
Avery, Essie: 9
Avery, Leighton: 9–11, 37–38
Avery, Ruth Sigler: 5, 38
Avery Oil and Gas Company: 9
Azusa, Calif.: 145

Barstow, Calif.: 4, 14, 62, 73–74, 80, 132, 143, 188
Basketmaking: 44–45
Bauer, Pauline: 117
Beale, Edward: 20
Bell, Grady: 28
Belsher, Jack: 73, 74, 80
Belt, Gus: 64–65
Bethany, Okla.: 28
Bibo, Solomon (trading company): 184
Bicycles: 3, 5; *see also* League of American Wheelmen
Billboards: 184–86; *see also* signs
Black Mountains: 4, 187
Blair, Jeffie: 36
Blansett, Phil: 172–73, 186
Bloomington, Ill.: 14, 89
Bond-Gunderson (mercantile store): 75
Boosterism: 27 ff., 32–36
Boulder Dam: 149
Bowling Green University: 153
Boyd, Beatrice: 73, 136–37
Braidwood, Ill.: 38, 89
Brick (for paving): 25
Bridgeport, Okla.: 28, 62

Bruchman, Hazel: 79
Bruchman's, Winslow, Ariz.: 52, 79
Buffalo Ranch, Afton, Okla.: 154–56
Buick: 149
Bumpers, Marita: 29, 59, 78
Bumper stickers: 167, 173
Bunion Derby: *see* Great Transcontinental Footrace
Bureau of Public Roads: *see* U.S. Bureau of Public Roads
Burma Shave: 33
Burnham, Robert: 120
Burns, Michael: 18–19, 86
Burris, H. B. ("Buster"): 4, 80, 140–41, 159–60, 178–79
Buses: 19–20, 37, 45–46, 64, 68, 75, 80
Butler, William: 143, 163, 177
Butterfield Stage: 14
Byrd, Russell: 20

Cabool, Mo.: 44, 99
Cadillac: 107, 155, 156, 160
Cadiz, Calif.: 4; *see also* Mojave Desert
Cafés: 28, 37 ff., 61, 64–66 ff., 69–71, 78, 80, 153–54 ff., 157–59, 169, 187–88
Cajon Pass (Calif.): 4, 20, 31
Caliche: 29
California: 3, 14, 22, 28, 32, 33, 37, 40, 81, 188; paving in, 22, 24, 31; and 66 Association, 24; in World War II, 75 ff.; interstate in, 183
California Road: 14
Campbell, Franklin: 45–46, 64
Campgrounds: 28, 42 ff., 47, 50
Camp Joy, Lebanon, Mo.: 43–44, 150–52
Camp Verde, Santa Rosa, N.Mex.: 47
Canute, Okla.: 29
Capone, Al: 4

Caravan Inn, Peach Springs, Ariz.: 73
Cardy's Camp, Needles, Ariz.: 139, 158–59
Carthage, Mo.: 25–26
Catoosa, Okla.: 35
Caulfield, Henry: 27
Chacon, Chuck: 172
Chain of Rocks Bridge: 76
Chaney, Sheldon ("Red"): 102, 153–54, 170–71
Chase, Cliff: 143
Chevrolet: 68
Chicago, Ill.: 3, 13 ff., 24, 31 ff., 38, 86, 188; Board of Trade, 40; *Chicago Tribune*, 179
Chicken Shanty, Lebanon, Mo.: 151
Christensen, Velma: 174–77
Civil Defense: 181
Claremore, Okla.: 34, 107, 149, 155–56
Clementine, Mo.: 44–45, 77, 99
Cline, Roy: 67–69
Cline, Roy, Jr.: 67–69, 97–98, 121
Clines Corners, N.Mex.: 68–69, 121, 163–64
Clinton, Okla.: 19, 46, 77–78
Club Café, Santa Rosa, N.Mex.: 30, 124–25
Cole, Nat King: 148–50
Colorado Springs, Colo.: 12
Commercial Hotel, Flagstaff, Ariz.: 52–53
Concrete: 6, 20, 22 ff., 30, 31, 67, 188
Condry, Eldred: 35
Congress: *see* U.S. Congress
Conoco: 164
Continental gasoline: 47
Conway, Tex.: 116
Coral Court, St. Louis, Mo.: 96
Coronado Court, Tucumcari, N.Mex.: 120
Corvette: 187
Crabbe, Buster: 160
Craner, Fenton: 90
Craner, Florence: 87
Crosby, Bing: 160
Cruce, Lee (Oklahoma governor): 9
Cubero, N.Mex.: 69
Cucamonga, Calif.: 4, 144
Cuervo, N.Mex.: 122
Cullison, Dave: 155–56
Cullison, Norma: 107, 155–56
Curtiss Wright: 76
Cutberth, Gladys: 77–78, 183
Cutberth, Jack: 78, 183, 184; *see also* U.S. 66 Highway Association

Daily Oklahoman: 12
Dale, David: 85, 171
Dance halls: 37–39
Dave's Indian Trading Post, Claremore, Okla.: 107, 155–56
Davis, Hugh: 35
Denton, Ruby: 115, 178, 187–88
Denver, Colo.: 20
Depression: *see* Great Depression
Detherage, Clydene: 81
Detroit, Mich.: 6
Devil's Elbow, Mo.: 100, 178
Diamonds, Villa Ridge, Mo.: 167
Dill, Lester: 44, 164–67, 188
Diners: 64
Disneyland: 5
Divernon, Ill.: 91
Dixie: 41–42, 76, 171
Dobell, Edna: 71–72
Dobell, Frank: 71–72
Dodge: 21
Douglas Aircraft: 160
Drive-ins: 64–65
Dust Bowl: 47, 57–74

East Glenrio, Tex.: 118–19
Edgerton, Ed: 138
Ed's Camp, Sitgreave's Pass, Ariz.: 138
Edwardsville, Ill.: 25, 94
Ehresman, Homer: 61, 66–67, 118–19, 182–83
Eisenhower, Dwight D.: 181
Elk City, Okla.: 29, 112
Elkhart, Ill.: 87, 90
El Rancho Motel, Barstow, Calif.: 143
El Reno, Okla.: 14, 28, 46
Empire State Building: 167
Erick, Okla.: 29, 62, 111
Essex, Calif.: 4; *see also* Mojave Desert

Fairbanks, Douglas: 32
Federal Aid Laws: 18, 22, 25, 26, 179, 181
Firestone: 81
Fishel, Joy Spears: 43–44
Fisher, Carl Graham: 6
Five Civilized Tribes: 14
Flagstaff, Ariz. (highest point on U.S. 66): 4, 14, 21, 52, 55, 61, 72, 73, 80; Powwow at, 54–55
Flying C: 68
Fontana, Calif.: 4, 75, 81
Foothill Blvd.: *see* U.S. Highway 66
Ford, Henry: 6

Ford, John: 59, 62
Ford, Model T (automobiles): 6, 25–26, 38, 42
Fort Leonard Wood: 77, 150, 152
Fort Smith, Ark.: 12
Friou, Irene: 78
Fuss, Jack: 52–55
Fuss, Marie: 52

Galena, Kans.: 105
Gallup, N.Mex.: 14, 30, 79; Inter-Tribal Indian Ceremonial, 48–50, 52, 69, 71, 175; and interstate, 184; *see also* Indian traders
Gannet, Keith: 138
Gardenway Motel, Gray Summit, Mo.: 97
Gas stations: *see* service stations
Geary, Okla.: 19, 28
General Motors: 71
Gephard, Rosetti: 29
Geske, John: 41–42, 64
"Get Your Kicks on Route 66" (song): 5, 148–50; *see also* Troup, Bobby
Glenrio, N.Mex.: 61, 64–65
Glidden, Charles J. (early road enthusiast): 6
Golden Spread Grill, Groom, Tex.: 115, 187
Goldenstein, Robert: 30–31
Goodman, Kenneth: 103
Good Roads Movement: 3, 5–8, 14, 23, 30, 39
Gospel Kingdom Campground, Galena, Kans.: 105
Grand Canyon: 5, 52, 73
Grange, Red: 33
Grant Park (Chicago): 3
Grants, N.Mex.: 30, 61, 75, 79, 127, 148
Grapes of Wrath, The: novel, 4, 57, 59 ff.; movie, 59–60, 62; *see also* Steinbeck, John
Gray Summit, Mo.: 97
Great Depression: 4, 24–31, 34 ff., 44–45, 55, 149, 161, 163, 189
Great Transcontinental Footrace: 4, 32–37; *see also* Pyle, C. C.
Greider, George: 20, 142
Greyhound buses: 75
Groom, Tex.: 114, 115, 178, 187–88
Gunderson, C. H., Jr. ("Bud"): 61, 75, 79, 148
Gunderson Oil Company: 75, 79
Gunn, Mary: 70–71
Gunn, Wallace: 69–71, 183–84

Hackberry, Ariz.: 20, 30, 61
Halltown, Mo.: 103
Hamel, Ill.: 25
Hammon, Okla.: 46
Hamons, Lucille: 59–60, 110, 183
Harper's: 73
Harrison, Dorothy: 108
Harvey, Fred: 48 ff., 52, 157; and
 Harvey Enterprises, 72
Harvey, W. H. ("Coin"): 7, 9, 12
Hayden-Cartwright Act: 27
Hemingway, Ernest: 71
Henderson, Daisy: 43
Henke, Bill: 25
Hensley, Allen: 61, 130, 133
Hensley, Dennis: 130
Highway: markings, 3, 12, 18, 32, 188;
 beautification of, 11, 184–86; num-
 bering system of, 13; paving of, 3,
 18–31, 67 ff., 168; see also National
 Highway System
Highway Beautification Act: 52, 186
Highway Trust Fund: 181
Hinton, Okla.: 57–59, 62–64, 109,
 156–57, 182–83
Hi-way Host Motel, Albuquerque,
 N.Mex.: 126
Holbrook, Ariz.: 14, 30, 52, 55, 61, 71,
 79, 130–33, 178
Hollywood, Calif.: 5, 189
Hopi Indians: 54–55
Hotel Verde, Santa Rosa, N.Mex.: 47
Hot Springs, Ark.: 12
Hualapai Reservation: 72
Hudson, Jessie: 101, 150–53, 178, 187
Hudson, Pete: 150–53
Hudson automobiles: 46
Hydro, Okla.: 59–60, 110, 183

Illinois: 18, 37, 188; paving, 19 ff., 168,
 179; in 66 Association, 24; interstate
 in, 181
Illinois State Highway Maintenance
 Department: 25
Indian crafts: 45, 49–52, 70, 79,
 155–56, 173 ff.
Indian Territory: 10, 14
Indian traders: 49–52, 69, 79, 174–77
Interstate Highway Act: 161, 179 ff.,
 186–87
Interstate highways: 22, 27, 36, 67, 81,
 155, 161, 164, 168, 179–89
Inter-Tribal Indian Ceremonial, Gallup,
 N.Mex.: 48–50

Jackrabbit, Joseph City, Ariz.: 133,
 172–73, 186, 188
James, E. W.: 17
James, Harry: 152–53
James, Jesse: 166–67, 188
John's Modern Cabins, Clementine,
 Mo.: 98
Johnson, Glenn: 62, 80
Johnson, Lady Bird: 184; see also
 Highway Beautification Act
Johnson, Lyndon: 184
Joint Board of State and Federal High-
 way Officials: 13–14 ff., 18
Joplin, Mo.: 14, 25, 26, 81, 105, 187
Joseph City, Ariz.: 133, 172–73, 186,
 188
Joseph Joe's Big Indian Trading Post,
 Winslow, Ariz.: 135

Kaiser Industries: 75
Kansas: 4, 14, 77, 137, 154; paving, 19,
 22, 27; in 66 Association, 24
Kansas City, Mo.: 10, 13, 14, 18, 77, 132
Kassel, Art: 38
Kay, Allene: 154–56
Kentucky: 14–17
Key, George D.: 28
Kingdom Campground, Galena, Kans.:
 77
Kingman, Ariz.: 4, 21, 31, 62, 68, 80,
 132
Kirk, Dean: 49
Kirk, Mike: 49
Kokomo, Ind.: 6
Korean War: 159

Laguna Indians: 69
Last Motel in Texas/First Motel in
 Texas, East Glenrio, Tex.: 118–19
Las Vegas, Nev.: 5, 38, 149
Las Vegas, N.Mex.: 30, 121
Las Vegas Hotel and Barber Shop,
 Halltown, Mo.: 103
La Villa de Cubero: 69–71, 184
League of American Wheelmen: 6
Lebanon, Mo.: 26, 27, 42–44, 101,
 150–53, 178, 187
Lee, Robert: 19, 46, 57, 77
Lee, Whit: 19, 45–46, 64
LeeWay Trucking: 57, 77
Lehman, Ramona: 101
Leno, Juana: 48
Lewis, Clifton: 131, 178
Liberty, Mo.: 9
Liberty trucks: 68

Lillard, Wayne: 153
Lincoln Highway: 6
Link, Martin: 49–50
Litchfield, Ill.: 25, 76
Little, Ann: 57–59, 62–63, 109, 157,
 182–83
Little, Leon: 57–59, 62–64, 109, 156–
 57, 182–83
London, Julie: 149
Long, Huey: 9
Los Angeles, Calif.: 4, 14, 15, 17, 20,
 31 ff., 132
Los Lunas, N.Mex.: 14, 30
Louisville, Ky.: 14
Ludlow, Calif.: 142–43
Lupton, Ariz.: 129

McDonald, Maurice: 64
McDonald, Richard: 64
MacDonald, Thomas H.: 15, 17
McDonald's: 36, 64, 145, 158
McLean, Ill.: 41
McLean, Tex.: 29
Madison Square Garden, N.Y.: 33
Mail: 10
Main Street of America: 24, 36, 188
Main Street of America Association,
 The: 184
Maps: 7, 21, 149, 164
Maricopa Indians: 54
Markham, W. C. (executive secretary,
 American Association of State High-
 way Officials): 15, 17
Markings: see Highway, markings
Marland, E. W.: 29
Martin, Dean: 160
Martin, LeRoy: 29
Martin, Tony: 160
Massachusetts Institute of Technology:
 6
Maysville Road (Ky.): 7
Meramec Caverns: 44, 149, 164–68,
 178, 186, 188
Mester, Richard: 30, 79–80, 132,
 157–58
Meteor Crater: 54
Meyer, Duane: 144, 160–61
Miami, Okla.: 29
Migrants: 4, 41, 57–74, 75 ff., 148, 157,
 189; see also Great Depression
Miller, Mo.: 32
Mississippi River: 4
Missouri: 9, 10, 14, 81; paving, 22 ff.,
 26, 150, 167; in 66 Association, 24,
 111, 164–65, 167; Centennial Road

Missouri (*continued*)
Law, 26; State Highway Commission, 26; Highway Patrol, 167; interstate in, 187
Mitchell, John (National Mine Workers organizer): 4
Mitchell (Ill.) Fire Department: 76
Mobil: 28, 47
Modern Cabins, Rescue, Mo.: 104
Mojave Desert: 4, 20, 31, 33, 80, 142, 149, 158–60
Monte Ne, Ark.: 7
Monte Vista Hotel, Flagstaff, Ariz.: 54
Moore, Alma: 66, 78–79, 116, 168, 181
Moore, Mildred: 66, 78–79, 116, 168, 181
Moriarity, N.Mex.: 67–68
Morris, George: 25–26
Morris, June: 32
Motels: 28, 42–44, 50, 54, 67, 69–71, 73, 76 ff., 150, 159, 170
Motor Carrier Act of 1935: 45
Mount Olive, Ill.: 12, 92, 180
Movie industry and movie stars: 32, 40, 52, 71, 149, 160, 168
Munger Moss Motel, Lebanon, Mo.: 101, 150–53
Music Corporation of America, Chicago, Ill.: 38
Muskogee, Okla.: 10

Nackard, Fred: 61, 80
National Association of Rural Letter Carriers: 6
National Grange: 6
National Highway Act: 39
National Highway System: 3, 12, 23, 24, 56, 148, 173, 188
National Mine Workers: 4
National Old Trails Highway: 30
Navajo Indians: 50 ff., 175–77
Needles, Calif.: 4, 20, 31, 62, 80, 139, 158–59, 187
Nelson, Bill: 30, 61
Neon: 151, 170
Newkirk, N.Mex.: 121
New Laguna, N.Mex.: 70
New Mexico: 4, 188; early road conditions in, 20; paving in, 22 ff., 29–30, 67 ff., 168; in 66 Association, 24; State Tourist Bureau, 30; Relief and Security Authority, 30; Indian Arts Fund, 48; Territory, 50; interstate in, 182–84; highway department in, 186
Newport News, Va.: 14, 15

New York City, N.Y.: 6, 13; and Great Transcontinental Footrace, 4, 33, 36
Normal, Ill.: 64–65
Nunn, Bebe: 65–66
Nunn, John: 65
Nunn's Cafe (Shamrock, Tex.): *see* Tower Station

Office of Public Road Inquiry: 7
Oklahoma: 3, 4, 9 ff., 17, 19, 34, 149; Good Roads Committee, 14; paving in, 22 ff., 29, 168; and Bunion Derby, 34–36; and *The Grapes of Wrath,* 62–64; interstates in, 182–83, 187
Oklahoma City, Okla.: 4, 188
Old Trails Highway: 55
Old Wire Road: 3
Ozarks: 4, 77, 150 ff., 170
Ozark Trail: 3, 7, 9, 27
Ozark Trails Association: 7, 8, 12, 23

Pablo, Don: 156
Page, John M. (Oklahoma chief highway engineer): 17
Painted Desert: 52, 149
Panico, Louis: 38
Panic of 1873: 9
Park Plaza Courts, Tulsa, Okla.: 108
Pasadena, Calif.: 4
Patterson, Wyatt: 39–40
Patterson Propane: 40
Paulsell, Betty: 173
Paulsell, John: 71
Paving: *see* Highway, paving of
Payne, Andy: 34–36
Peach Springs, Ariz.: 72, 137
Pennock, Rev. Will: 77, 105
Pennsylvania Turnpike: 149
Peoria, Ill.: 40
Petrified Forest National Monument: 5, 52, 71–72
Petrified wood: 71–72, 173
Petroleum industry: 39 ff., 78 ff., 160–64
Philadelphia Academy of Fine Arts: 52
Phillips Petroleum: 66, 162–63, 170
Picher, Okla.: 105, 106
Pickford, Mary: 32
Pickwick Bus Company: 19, 24
Piepmeier, B. H. (Missouri chief highway engineer): 14, 15
Plank road: 20
Pontiac Trail: 7; *see also* Good Roads Movement
Popular Mechanics: 76

Populist movement: 7
Prestridge, Marvel: 127
Prohibition: 39
Purdue University (West Lafayette, Ind.): 6
Pyle, C. C. (promoter): 4, 32–37; *see also* Great Transcontinental Footrace

Railroads: 5, 7, 10, 45 ff., 52, 64, 66, 75, 159
Rainbow Forest Lodge: 71
Rand McNally Road Atlas: 164
Rationing: 75 ff.
Raton, N.Mex.: 46
Reconstruction Finance Corporation: 167
Red Rock State Park, N.Mex.: 49
Red's Giant Hamburg, Springfield, Mo.: 102, 153–54, 170–71
Reid, Charles: 85, 171–72
Reptile Village sign, Erick, Okla.: 111
Rescue, Mo.: 104
Restrooms: 163, 165
Riddle, Nelson: 149
Riley, Lyman: 111, 164–67, 178, 186
Roberts, Tom: 183
Robinson, Robbie: 172
Rock Island Railroad: 66
Rogers, Will: 34; Highway, 4, 168, 180; Park (Santa Monica), 4; Memorial (Claremore, Okla.), 149; Hotel (Claremore, Okla.), 155; *see also* U.S. Highway 66
Rolla, Mo.: 14, 26, 27, 164–65
Roosevelt, Theodore: 71
Roseman, Bill: 76–77, 93, 168–70, 178
Rossi, Peter: 38–39, 186
Route 66 (highway): *see* U.S. Highway 66
"Route 66" (television show): 5, 149, 187; *see also* Silliphant, Sterling
Route 66 Highway Association: *see* U.S. 66 Highway Association
Routh, Pete: 76
Roy's (Amboy, Calif.): 140–41, 159–60
Russo, Danny: 38
Ruth, Kent: 27–28

Saint John, Ariz.: 55
Saint Louis, Mo.: 4, 14, 19, 24, 41, 95, 96, 112, 149, 188
San Bernardino, Calif.: 4
Sandia Mountains: 4, 186
San Francisco, Calif.: 13

San Francisco Mountains: 4
Santa Fe, N.Mex.: 14, 30, 48, 69
Santa Fe Railroad: 48, 68, 72 ff.
Santa Fe Trail: 14
Santa Monica, Calif.: 4, 19, 146, 168
Santa Rosa, N.Mex.: 30, 47, 61, 121, 123–25
Sapulpa, Okla.: 10
Saturday Evening Post: 36
Save 5 Cents (Santa Rosa, N.Mex.): 123, 124
Sayre, Okla.: 14
Scott, Lon: 33
Secretary of agriculture: 7, 13, 17, 189
Seligman, Ariz.: 52
Service stations: 25, 28, 37–40, 55–56, 68–69, 73–74, 76, 156–64, 168 ff., 179 ff., 188
Shamrock, Tex.: 4, 29, 46, 64–66, 78, 113, 184
Shaw, Floyd: 124–25
Sheets, Frank (chief highway engineer, Illinois): 14–15
Shell Oil: 40, 180
Signs: 43, 52–56, 155, 165–67, 172–73 ff., 184–86
Silliphant, Sterling (television producer): 5, 187
Sinclair, Henry: 9
Siteman, Phil: 94
Site Service Station (Edwardsville, Ill.): 94
Sitgreave's Pass, Ariz.: 138
Sixty-Six Park-In Theatre (St. Louis, Mo.): 95
Sixty-Six Terminal (Staunton, Ill.): 76–77, 93
Smith, Jesse: 29
Smith, Joseph: 47–48, 61, 123, 181–82
Smith Oil Company (Santa Rosa, N.Mex.): 47, 181–82
Snow, Juanita: 183, 187
Snow, Laverne: 183
Soulsby, Ola: 92
Soulsby, Russell: 92, 179–81
Souvenirs: 81, 155, 162 ff., 173–74
Spears, Charles: 42–44, 56
Spears, Emis: 42–44, 64
Spears, Lida: 42–44
Spears, Lois: 42–44
Split-log drag: 10, 11
Springfield, Ill.: 14, 18–19, 26, 86, 87
Springfield, Mo.: 14, 18, 23, 45, 102, 153–54, 170–71, 186; Chamber of Commerce, 23, 26

Standard Oil: 40, 47, 123
Stanton, Mo.: 44
Star Motel (Elk City, Okla.): 112
Staunton, Ill.: 93
Steak 'n' Shake: 64–65, 89
Steinbeck, John: 4, 57 ff., 189; see also *Grapes of Wrath, The*
Sternagle, Otto: 25
Store for Men, Inc. (Winslow, Ariz.): 134
Stroud, Okla.: 35
Studebaker: 178
Sundown Motel (Amarillo, Tex.): 117

Taxis: 46, 52
Taylor, James: 172–73
Taylor, Marie: 78
Television: 5, 44, 167, 188, 189
Telford, Sir Thomas: 23
Tennery, Nyla: 62
Texaco: 22, 73–74, 143, 163
Texas: 10, 188; Panhandle, 4; paving in, 22 ff., 29, 168; U.S. 66 Highway Association, 24; interstate highways in, 187
Thomas, Elmer (Okla. congressman): 15
Thompson, Amy: 44–45, 77, 99
Tidewater and Tonepaugh Railroad: 143
Tindall, J. J.: 65, 113
Tingley, Clyde: 30
Tonepaugh, Nev.: 143
Topeka, Kans.: 20
Tourism: 12, 37–56, 80, 148–77
Tourist courts: 37–44, 56, 76 ff.; see also motels
Tower Station (Shamrock, Tex.): 64–65, 113
Traders: see Indian traders
Trapp family singers: 71
Travelers Protective Association of America: 6
Troup, Bobby (songwriter): 5, 146, 148–50, 177, 189; see also "Get Your Kicks on Route 66"
Troup, Cynthia: 112, 146, 148–50
Troutner, Wayne: 172
Truck Center (Groom, Tex.): 114
Trucking: 37, 45–46, 64 ff., 77, 159, 171–72
Truck stops: 41–42, 76 ff., 168–72
Truxton, Ariz.: 30, 61
Tuba City, Ariz.: 54
Tucumcari, N.Mex.: 14, 120

Tulsa, Okla.: 4, 7 ff., 14, 22 ff., 35, 108, 142, 163, 187, 188; Commercial Club, 12; Automobile Club, 12; Chamber of Commerce, 12, 23
Tulsa Tribune: 28
Turner Turnpike: 187
Turpen, Tobe: 49–52, 175

U-Drop-Inn: see Tower Station
Union Oil Company: 55, 158, 163, 171
U.S. Bureau of Public Roads: 6, 7, 15, 22, 186; as Office of Public Roads Inquiry, 7; in Department of Agriculture, 7
U.S. Congress, highway financing: 7 ff., 18, 26–27, 179
U.S. Highway 66: 81; location, 3–4; numbering, 14–17; paving, 18–31, 168, 179, 181; during World War II, 75–81, 179; growth of highway industry, 148–61; promotion, 162–77; replaced by interstate, 177–89; accidents on, 178–79
U.S. 66 Highway Association: 27; organization of, 23–24; highway promotion, 32 ff., 78, 164–68; and interstate system, 183 ff.
University of New Mexico: 75
Uranium Cafe, Grants, N.Mex.: 127

Valentine, Ariz.: 30
Victorville, Calif.: 4
Vinita, Okla.: 4, 9, 10, 14, 26
Virginia: 14–17
Virginia Beach, Va.: 17

Walters, J. P.: 41
Warner Brothers: 168
Warren, Richard: 20
Weatherford, Okla.: 187
Webb City, Mo.: 26
Welco Corners truck stop (Joliet, Ill.): 85, 171–72
Western Cafe (Shamrock, Tex.): 78
West Virginia: 17
White Castle: 64
White House Conference on Natural Beauty: 186
Whiting, Arthur: 55–56
Whiting Brothers: 55–56, 61
Wichita, Kans.: 64
Wichita Falls, Tex.: 188
Wigwam Motel (Holbrook, Ariz.): 131, 178

Wildorado, Tex.: 66, 78–79, 116, 168, 181
William Jewel College (Liberty, Mo.): 9
Williams, Ariz.: 188
Will Rogers Turnpike: 187
Wilson, Woodrow: 7
Winslow, Ariz.: 21, 52, 55, 79, 134–35

172
Wisconsin: 13
Wolf, Andy: 21, 52
Woodruff, John T.: 23, 24
Works Progress Administration (WPA): 26, 29
World War I: 23, 52

World War II: 41, 43, 47, 51, 55, 59, 75–81, 148 ff., 159, 162, 166, 167, 170, 179, 189
Wreckers: 80, 159, 178–79

Yucca, Ariz.: 187
Yukon, Okla.: 28